VOGUE

TWENTIETH CENTURY

FASHION

Editorial Manager: Venetia Penfold

Art Director: Penny Stock

Editors: Zia Mattocks and Alice Whately

Senior Art Editor: Barbara Zuñiga

Picture Researcher: Francesca Harrison

Production: Garry Lewis

THIS IS A CARLTON BOOK

The Vogue logo is a registered trademark
of Condé Nast Publications Limited

This edition published by Carlton Books Limited 1999
20 Mortimer Street
London W1N 7RD

A CIP catalogue for this book is available from the British Library

ISBN 1 85868 517 6

Printed and bound in Spain

PREVIOUS PAGE **Giorgio Armani's
understated elegance of 1996:
a black silk evening dress
suspended from a neck band
and sweeping to the floor.**

OVERLEAF **Gucci's Tom Ford swaps
East-coast minimalism for West-
coast colour, splashing vibrant
florals over dresses, skirts and
trousers, 1999.**

OPPOSITE **'Lovely in Leather':
Chanel's black leather single-
breasted fitted jacket, worn
over a matching pencil
skirt, 1995.**

VOGUE

TWENTIETH CENTURY
FASHION

Linda Watson

CARLTON

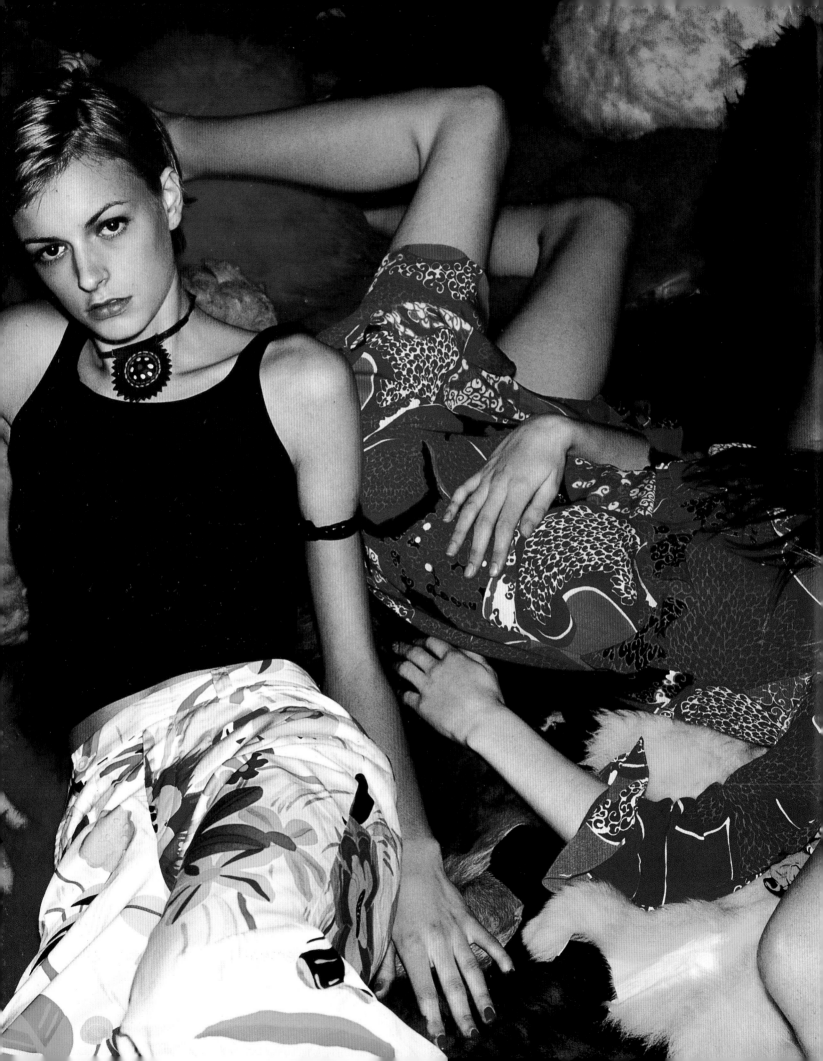

contents

She: "Straighten your tie! Everybody's staring at you!"

Introduction

Dressing is the fourth bodily function. After breathing, eating and sleeping – and excluding a couple of delicious optional extras – one of the fundamental pleasures of the human body is to clothe it. Which makes fashion – it's closest relation – pretty important.

The history of fashion touches everyone in its orbit. It runs far, far deeper than hemlines, silhouettes and colours. It is intrinsically caught up with social mores and mood changes in everything from food to mannerisms, music to sex. It lives and exists not only as one of the most ravishing and compelling of entertainments but as the surest indicator of time. Humour has always been part of its charm.

Throughout the twentieth century, *Vogue* has acted as a visual filter. Each season designers have thrown ideas into the air and *Vogue* has caught them and sprinkled them over its pages. It has always been down to the century's social animals – and significant figures – whether designs transcended history or froze in suspended animation. Diana, Princess of Wales had everything: genetic perfection, model dimensions, royal connections and the mystique of a silent-movie star. Add fashion, and you have the most photographed woman on the planet.

In 1909 electricity was a new sensation, and it was shocking if a woman showed an ankle. By 1916, if she smoked in public, *Vogue* concluded, 'She must be an actress.' If she wore red lipstick, she was the next best thing to a prostitute. The wearing of a veil had orgasmic powers. Trousers were slammed as 'audacious'. If bumsters had been around, Alexander McQueen would have been locked up and labelled certifiable.

Today, on the cusp of a new millennium, no one bats an eyelid if dresses skim the nipples, navels are exposed and the bottom half of the buttocks are aired to ancient relatives. Nudity – the natural conclusion – will never be in fashion not just because the weather wouldn't allow it, but because it is the only style that would put the whole industry on social security.

Ever since Eve wore a fig leaf, fashion has been associated with two things: defining sexuality and committing outrageous behaviour. Even fastenings aren't immune. Consider the zip – 'Zippergate' – a little metal fastening that almost brought down the president of America in 1998. The biggest change has been in the status of the designer, who until the 1950s was considered a dictator, then a director and a suggester. Now he or she airs

their opinions, controls huge empires and emblazons their name across every part of your anatomy. In turn, we want to see where they live, hear what they think, find out how they function. We sleep on their pillowcases, pull their curtains across our windows, spray ourselves with their scent: the most potent way to get style under the skin.

The fly-past of designers' behaviour throughout the century is a seminal lesson to those who are thinking of taking up fashion design professionally. The most financially successful designers have brilliant business partners; the most creative have a single vision; the most famous are those who either have visionary tendencies or big mouths. Sometimes both. Then there are the handful of geniuses who put beauty and art before everything – and inevitably ended up with nothing: the great Orientalist, Paul Poiret, once held the fashion world in the palm of his hand; the brilliant Ossie Clark, who could cut like a dream but couldn't handle his own talent; Charles James, who was posthumously revered, but spent his declining years in New York's seedy Chelsea Hotel with sketches, toiles and an Afro wig for company. Passion and fashion – unless there is a business brain in the frame – don't mix.

Age and body shape are part of the fashion template. In 1909 the face said 20, the waist said 15, the bosom 50. Flappers started smoking furiously in an attempt to echo the streamline shape of a greyhound. By 1960 there was the ludicrous situation where women of 40-plus were dressing like ten-year-olds. A hundred years from now, fashion historians flicking through this book, en route to a fortnight on the moon, may assume that millennium woman looked like Kate Moss. We don't.

Today, there is more choice than ever. Status symbols on every seam. We are in a world of international fashion, but the elegance on the street has gone. The skill which required, time, talent and a steady hand reached its peak of perfection in the 1950s and went rapidly downhill after the advent of television. Before 1960 women were fitted by their dressmakers. Now we make our own decisions on what size we are. Not wise. As Jean Muir once observed, 'People make pictures of themselves that other people have to look at.'

For fashion, read: prediction. In the 1920s Cecil Beaton imagined that nuns would wear cubes on their heads and brides would wear bodysuits. In the 1960s Yves Saint Laurent said he would prefer a pill to eating. He was not alone: almost everyone believed that by the year 2000 we'd be wearing spacesuits to the office and coming home to dinner with a robot.

What of the future? American minimalist Geoffrey Beene has been saying for years that 'the fundamental change will happen when the chemist meets the artist'. We already have temperature-sensitive and virtually indestructible fabrics. In the future, pundits predict clothes with in-built mobile phones; shops where we don't rifle through rails but pick prototypes, and our measurements are drawn up on a computer. No doubt, one day, someone will invent a range of skirts which have meaningful conversations with washing machines.

Designers are currently floating the idea of fashion shows on the internet. Can editors exist in a world devoid of gossip, seating arrangements and air kissing? Virtual reality in solitary confinement? Highly unlikely. For fashion is not – and never has been – about clothes. It's about people. Until genetic engineers decree otherwise. As long as the average human body is made up of four basic components – one head, two arms, two legs and fleshy undulations in the middle – fashion will continue to excite and delight within those strict, but endlessly fascinating, perimeters.

the decades

1900-09

The Vicomtesse des Touches was all in mauve mousseline de soie. Her great manteau, formed of cunning shirrs, loops and folds was lined with Liberty satin of a deeper shade. On her gloveless hands, were rings of yellow topazes. Silver shoes and silver woven stockings revealed themselves as she strolled over the grass under the bright electric lights.

Paris, *Vogue*, 19 August 1909

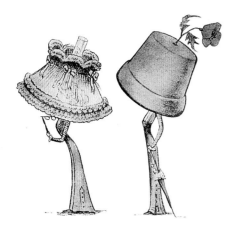

The Edwardian body beautiful had rotund breasts, a handspan waist, accentuated hips and a protruding posterior. The S-bend corset (christened 'The Health Corset' without any sense of irony) convoluted the spine. Feet were squashed into minuscule shoes, hats were balanced on a concoction of pads, wigs and human hair. The female anatomy routinely stood at an angle of 33 degrees. It was the only time this century that bodies were uniformly corsetted. Fashion was a form of legalized torture. The then *Vogue* editor, Mrs Josephine Redding, a maverick figure who wore sensible shoes, no corsets and a huge hat to receive guests in bed was not amused: 'Humps,' she declared. 'Today women are covered with humps. Big humpy sleeves, humps on their hips, humps on their behinds. It's nonsense.'

By 1900 the sleeves had been deflated, whalebone corsets were intact and the eccentric Mrs Redding – who was more interested in the welfare of animals than the vagaries of skirt length – had gone to pastures new. During the *belle époque*, fashion was divided into two types of women: those who wore corsets and those who did not. The latter formed a minute proportion of free thinkers and aesthetes who embraced the principles of the Arts and

LEFT **The absurdity of huge hats and sinuous figures was relentlessly satirized, and metamorphosed into flowerpots and lampshades, 1909.**

OPPOSITE *Vogue*'s cover of 18 March 1909 encapsulates all the elements of the Arts and Crafts movement, including rich colour and organic lines.

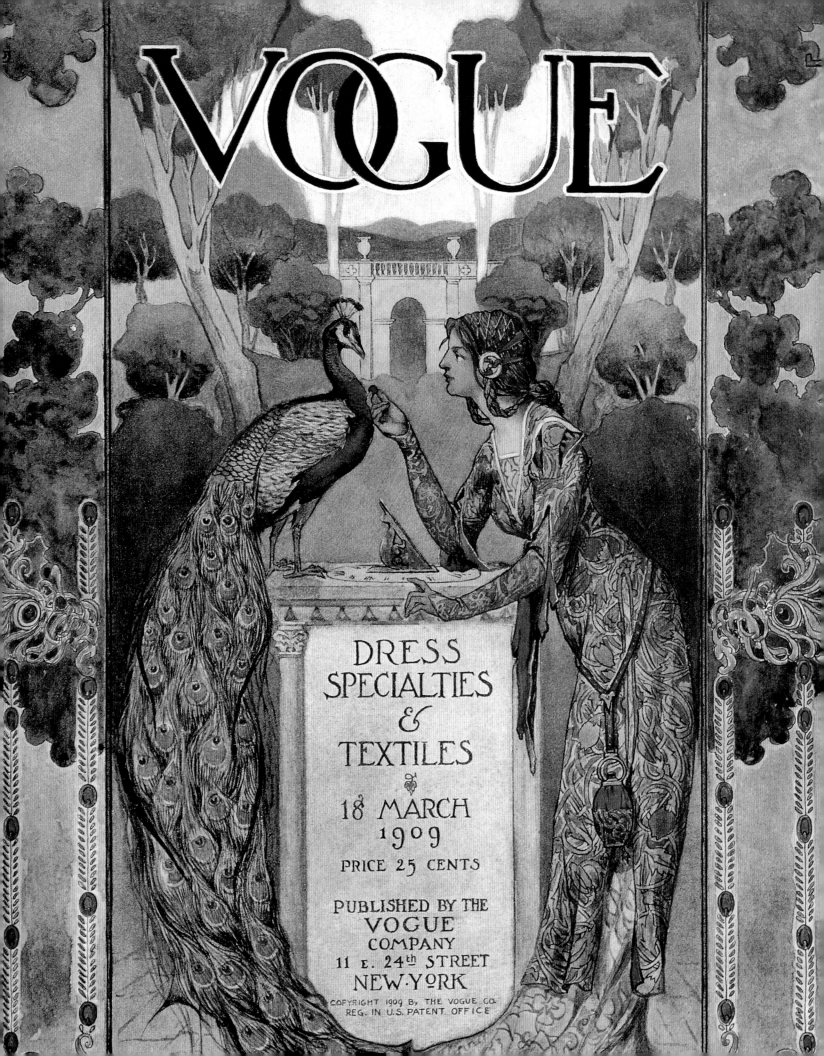

VOGUE

DRESS
SPECIALTIES
&
TEXTILES

18 MARCH
1909
PRICE 25 CENTS

PUBLISHED BY THE
VOGUE
COMPANY
11 E. 24th STREET
NEW·YORK

Crafts movement and aspired to universal Empire lines. Oscar Wilde was a principal advocate. Ninety years before Women's Liberation told its followers to burn their bras, Wilde was telling his audience to eliminate their corsets.

Vogue was launched in New York on 17 December 1892 into an era of aesthetic dress reform and fashion dictatorship with an illustration of a woman walking on air and the words '*Vogue* – A Debutante' on the cover. Published weekly and costing ten cents per issue, *Vogue*'s coverline cited 'Fashion, Manners, Society, The House, Literature, Art, Music, Drama' as its contents. The features extended far beyond the confines of corsetry. A popular column entitled 'Concerning Animals' carried a 'warning to flesh eaters' and a lecture on 'the gorilla, the chimpanzee and man'. Elsewhere, 'society's injustice to the child' was positioned opposite 'The Winter Mode as seen in France'. Fashion was not the main consideration. A natural reaction: when the first issue hit the newsstands, the fashion industry was in its infancy. By 1900 there was one world-famous fashion designer, no catwalks, no predictions pages and Paris was the undisputed instigator of every fashion revolution. There were only five notable names – Callot Sœurs, Madeleine Chéruit, Jacques Doucet, Jeanne Lanvin and Charles Worth, who founded his house in 1858, and made his name dressing Empress Eugénie.

by a dark-eyed beauty in the pesage', and 'an odd skirt, seen at the Paris races, [which] gave the effect of being turned upside down'.

Only a small percentage of *Vogue*'s readership had access to Paris. *Vogue*'s role was to pinpoint and popularize the look. Ready-mades – a system of mass production of clothes which later became known as 'off the peg' – had already started at the end of the nineteenth century. But this was largely confined to the most basic tailored pieces for everyday wear – the majority of fashionable women had their clothes made to measure. One section, 'Descriptions of Fashion', did exactly that. Page upon page of microscopic detail on individual garments– from colour to cut, from embellishment to button type. These were veiled instructions for dressmakers – to enable pattern-cutting – pages of fabrics shown in minute detail with information on trim, colour, texture and even length. 'Skirt and low corsage were joined by a three-inch belt of English embroidery on fine batiste. Fancy! From the shoulders, dropping to within a few inches of the belt, soft folds of satin formed the corsage below a modestie of white tulle shirred to a round yoke of embroidery.' *Vogue* not only gave its readers outlines of desirable garments, but put fashion in a social situation. 'Three Fetching Frocks seen at Monte Carlo' of 1909 evoked the atmosphere: 'Everyone streamed into the private baccarat room of the club. There, bending over a table deeply engrossed in the fate of her gold pieces, I saw a titled young New York woman. She was charming in a gown – a Chéruit, I divined – of greenish gold, embroidered filet and blue voile.' *Vogue*'s headings were plain and to the point. Notices included marriages and deaths. Advertisements listed boas and feathers, cleaners and dyers, corsets, furs, gowns and waists, hairdressing, massage, millinery and shopping commissions – a 1909 take on the personal shopper. Readers' preoccupations were defined as 'Seen in the Shops', 'Smart Fashion

Fashion movements did not spring from shows, but were publicized at the prestigious French racecourses – Longchamp, Auteuil – which were a magnet for stylish society and the Edwardian equivalent of the front row. *Vogue* turned voyeur, telling its readers what was going on, who was going where, but also – far more tantalizingly – who was wearing what. New sensations seen for the first time at the racecourses were relayed to the readers. In August 1909 *Vogue* reiterated their importance: 'At Auteuil, Chantilly and other noted French race-courses many of the newest modes are first seen in public and there frankly displayed for comment and criticism.' These included 'Moyen Âge effect in corsage and sash drapery', 'an Oriental turban worn

for Limited Incomes', 'Society Snapshots' and 'Haphazard Jottings'. Dressmaking was essential. *Vogue* advertised the pneumatic dress form – inflated to the appropriate size by using a bicycle pump. *Vogue*'s pattern service started in 1899. Readers selected a garment from the issue, snipped a coupon, paid 50 cents and received a hand-cut pattern by the originator of the service, Mrs Payne. The fluctuating body shapes of a wide readership did not present a problem. 'At that time and for several years afterwards the problem of pattern sizes was simple,' reported Edna Woolman Chase, later *Vogue* editor-in-chief, in her memoirs. 'There was one – and it was a thirty-six.'

As the decade progressed, *Vogue* covers, which had previously been strictly black and white, and reminiscent of the Arts and Crafts movement with woodcut borders and peacocks, changed. Colour crept in. By 1909 the *Vogue* coverline said simply, 'A Weekly Magazine of Fashion and Society'. *Vogue*'s first photographic cover showed a small black and white photograph of stylish racegoers sitting on a bench at Auteuil. With women changing their outfits up to six times per day, *Vogue* started dedicating individual issues to social occasions and specific items of dress: these included 'Southern Issue', 'Pattern Number', 'Textile and Dress Specialities', 'Millinery Number', 'Corset and Lingerie', 'Announcements of Autumn Fashion'

and even an 'Outing Number', which discussed the delights of house-boating, gymkhana games and canoe picnics.

Millinery was a big issue. As the silhouette grew slimmer and less complicated, hats were growing ever more elaborate and out of control. Even though *Vogue* was advocating the look, caricaturists were given free reign to highlight the absurdity of enormous hats, turning them into gigantic lampshades, flowerpots, cages and cabbages. 'Paris is laughing heartily over our contemporary freaks of fashion,' reported *Vogue* in July 1909. 'They are the subject of daily jokes in the papers and have inspired the comic artistry of the Boulevards in the form of post cards and toys.'

As the hats expanded, so too did the hair. The beauty ideal was one of fresh complexion. Tightly corsetted from armpit to thigh, collars

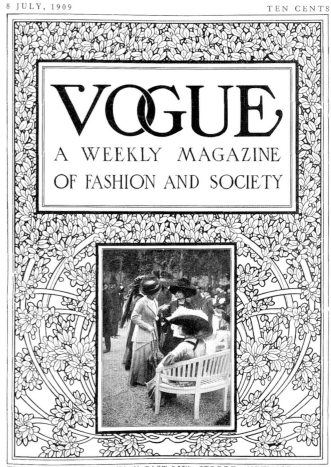

8 JULY, 1909 TEN CENTS

VOGUE

A WEEKLY MAGAZINE OF FASHION AND SOCIETY

THE VOGUE COMPANY 11 EAST 24TH STREET NEW YORK CITY
VOL. XXXIV, No. II Copyright, 1909, By The Vogue Company Reg. in U. S. Patent Office WHOLE NUMBER 865

featherboned to the chin, women were barely able to sit down – let alone take a brisk walk in the park. Instead, a rosy-cheeked look was achieved by stimulating the skin electronically. *Vogue* readers could try the Davis electric medical battery, which 'causes rich red blood to go leaping, bounding and tingling through the body. Recommended for chronic headaches and worn-out systems. Nothing like it.'

With a corset that was purporting ample breasts and a tiny waist, *Vogue* advertisements reveal the method and madness of simulating roundness in one area and starvation in another. There was no mention of eating less. Exercise was out of the question. Fashionable beauty aids included Dr Walter's medicated rubber reducing corset, Edna hip confiner or Louisenbad reduction salts which claimed to eliminate inches through evaporation. Poise was an important consideration. Instruction was given on how to sit, with *Vogue* stating: 'The manner in which women sit down in their present-day gowns deserves to be an object of special study on the part of all persons.'

Vogue's feature writers mixed social issues with fashion observations. *Vogue*'s Monte Carlo correspondent wrote a section between 'Parasols Very Lovely' and 'Shocking Indifference to Anguish' on the fashionable pursuit of pigeon shooting: 'Wavering a moment, it falls to earth; while still fluttering, a dog retrieves it, and the sport goes on. Passing on the beautiful terrace above this slaughter-ground with averted eyes, I noticed a silk coat of quite a new cut.'

Edwardian dressing was exhausting and confined to strict rules of propriety. *Vogue* gave suggestions for every occasion: ravishing carriage cloaks, handsome winter toilettes for 'Horse Show Wear', 'Pretty Dust Coats' for the traveller, club gowns for morning and afternoon. Mourning dress had specific and particular constraints. *Vogue* advised a black crepe veil worn over the face for six months, and back from the face for 12 months or two years – 'longer if one wishes'. *Vogue* readers had been prised from the roulette tables and encouraged to take part in country pursuits. Hats started to shrink in size. Practicality started to creep into *Vogue*'s vocabulary. Automobiles – by now so popular that models were being designed specifically for women – demanded a different dress code and accompanying accessories. Coats which had been extremely tight-fitting were now 'very baggy and loose ... across the bust and chest'. Wind cuffs were included to keep the wrists and arms dry. An adjustable motor cap, in the form of a knitted veil, came in 'pure silk with a wee invisible fuzz on the surface that makes it impossible for dust to penetrate to the face or hair'. Accessories included a folding footstool, goggles, touring bags and gloves. *Vogue* advised investing in a crystal vase and yellow chrysanthemums: 'a few of these, bunching with red, give a lively bunch of colour as the cars whiz by'.

By 1909 *Vogue* was more concerned with highlighting movements than protecting its readers from fashion faux pas. Sportswear was running parallel to the Paris collections. By the end of the decade, designers who had been recognizable only by their label started to air their views. Paul Poiret, a high-profile *enfant terrible* who made his name dressing Mrs Asquith, the British prime minister's wife, was asked about his 'Ideals of Elegance in Dress'. This was *Vogue*'s first designer interview. 'There are in Paris at the present time only ten entities, ten silhouettes – no more; that is to say ten categories under which nearly all women are to be ranked. The ones who escape this classification are, in my opinion, the only *élégantes* worthy of the name,' said Poiret, who upended the fashion world by reviving Orientalism, drawing the Directoire line and instigating the return of the natural figure. Mariano Fortuny took the idea of freedom to extremes, patenting a silk pleated tube in 1908. But it was Poiret's Orientalism, coinciding with the arrival of the Ballet Russes, which captured the world's imagination. Poiret was advocating individuality. 'I can hardly repress a shrug of the shoulders when I hear someone ask, at the beginning of Summer: What will be the fashionable colour? For the love of the *Bon Dieu*, I say, Madame, choose yourself the form and colour of your clothes.' By the end of the decade, women were standing up straight.

RIGHT **Fashion's first *enfant terrible*, Paul Poiret, changed the world with his radical ideas, love of Empire lines and insistence on eliminating the corset. The illustration is drawn by his 'artistic collaborateur', Paul Iribe.**

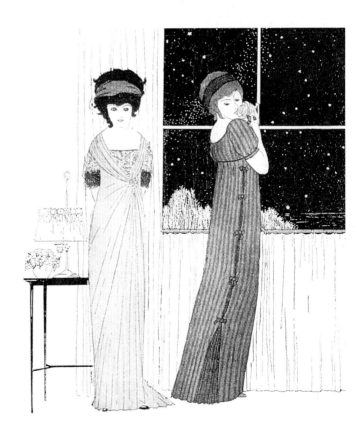

1910–19

They really shouldn't allow a veil like this. All the men should rise in a body and make it a law for any woman to be so attractive. It's just a frill of black lace, but it has been attached to the inside of the hat, just where the crown rests on the head. It really should be stopped – men have a hard enough time in this world as it is.

Makers of Mystery, *Vogue*, early December 1917

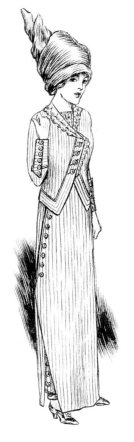

The ankle had been seen, corsets were sliding down a few inches and in April 1911 *Vogue* started talking about trousers. Throwing adjectives into the air, *Vogue* wondered whether they were 'audacious' and 'sensational', or 'demure' and 'coquettish', then threw down the gauntlet: 'HAS PARIS OVER-REACHED HERSELF IN HER LATEST DIVERTING SENSATION?' Even the designers – who floated the idea in the first place – were in shock. *Vogue* interviewed Worth in his salon on rue de la Paix about the possibility of women wearing trousers – the 1911 version consisted of voluminous pantaloons concealed beneath a long skirt. Would they become covetable? 'Yes, certainly they will,' declared Worth, 'they will accept it because it is vulgar ugly and wicked – those reasons insure the success of any article of feminine wear! The world has gone mad! All conversation concentrates itself on this most detestable garment!' Would Worth be showing them? 'I shall not endorse it, Madame; but if they demand it, they must have it.'

Within a decade, designers were producing clothes that were kick-started by the new issues of practicality and necessity. In an age of static beauty, activity had been

LEFT **A glimpse of a trouser leg, shown by Worth in 1911, was enough to shock fashion pundits. Earliest versions were Oriental pantaloons worn under side-slit skirts.**

OPPOSITE **By 1913 a new silhouette, created by Paul Poiret, had revolutionized fashion, comprising hobble skirt, smaller hat and free-flowing figure.**

RIGHT **Mrs Benjamin S Guinness, who brought the first Pekinese to America, photographed with Wung Tung in 1911. Miniature** dogs were the new must-have: **'the smaller the dog the more valuable, best weight under eight pounds', decreed** *Vogue*.

unthinkable. Now sportswear was gaining momentum. In January 1910 *Vogue* featured 'The Motor Girl' on its cover and inside debated the decline of the horse. Cycling, skiing, golfing and fishing were popular, as were yachting and tennis. 'Motoring is now so much a part of everyday life that one thinks nothing of a forty-mile run to polo or the races and back,' reported *Vogue* in 1911, 'but it is quite necessary to be prepared with suitable wraps, hats and veils to enjoy the trip comfortably and to be ready to start on a minute's notice.'

Although practicality was now part of *Vogue*'s vocabulary, there was still room for the frivolous and fanciful. *Vogue* carried advertisements for the tango brassiere and tango shoe, offsetting informative pieces on sports attire against flimsier features on 'Fashions and Foibles of Parisiennes', 'Boudoir Intimacies', 'Trivialities of the Summer Stage' and even 'Etiquette at Buckingham Palace', an in-depth analysis of royal protocol for New Yorkers who might find themselves taking tea with King Edward VII.

Paul Poiret invented the hobble skirt and, by his own admission, transferred restriction from one area to another. 'Like all great revolutions, that one had been made in the name of Liberty – to give free play to the abdomen,' he later stated in his biography

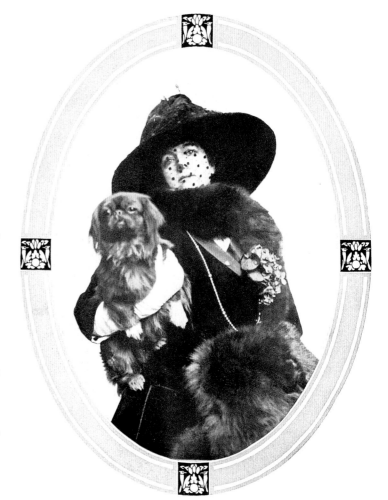

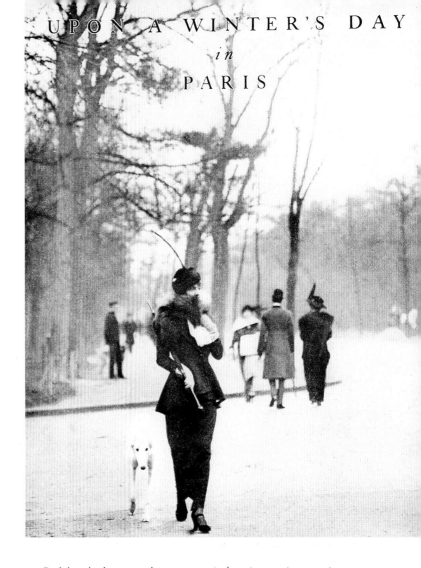

OPPOSITE TOP Last bastion of the *belle époque* – flyaway hats, here drawn by *Vogue*'s caricaturist in 1917 and described as 'freak' and 'aeroplanitory'.

RIGHT A high priestess of clothes, Lady Duff Gordon, alias 'Lucile', was advocating Empire lines. Her sister was the radical novelist and original It Girl, Elinor Glyn.

FAR RIGHT Some Parisians were already ahead of their time, wearing tight hobble skirts, snug-fitting hats, and accompanied by lean dogs – a look which was to characterize the 1920s.

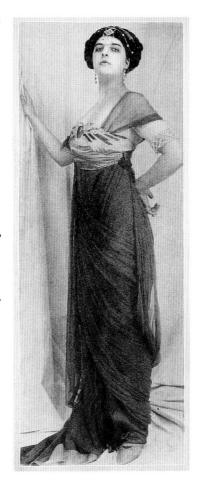

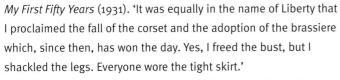

My First Fifty Years (1931). 'It was equally in the name of Liberty that I proclaimed the fall of the corset and the adoption of the brassiere which, since then, has won the day. Yes, I freed the bust, but I shackled the legs. Everyone wore the tight skirt.'

Poiret continued to set the standard, flying in the face of every preconceived idea, mesmerizing the world with his ability to translate the most opulent Orientalism into wearable works of art. In 1912 he designed fur-trimmed lampshade tunics for a ballet, *Le Minaret*. The following year he translated this outlandish theatrical idea into his collection. Its popularity was assured when Madame Georgette, a high-profile Parisian *vendeuse*, wore Poiret's invention at The Drags.

Impeccably bred dogs in exclusive varieties were the new fashion accessory. 'The Pekingese now Claims to be the Smartest Dog in Dogdom,' stated *Vogue* in 1911, reporting on a show in the ballroom of the Plaza Hotel, where the breed was launched. Preferred pedigrees included the Pekingese, Boston bull, Maltese terrier, Yorkshire terrier, French bull terrier – 'the height of fashion a few seasons ago – and English spaniel – 'in dainty sizes which fit snugly under the arm'. *Vogue* published portraits of owners and their pets – appropriately named Lady Prim, Gloriette Smith and champion English spaniel, Mamselle Fifi.

Parisian designers no longer expected customers to come to them; instead they crossed the Atlantic with samples from their latest collections. Paul Poiret, a supreme public relations strategist, was already well known in America, travelling there with his wife Denise, who acted as muse and walking advertisement. Lady Duff Gordon, sister to novelist Elinor Glyn, designed under the label 'Lucile' and was an aristocratic Englishwoman who built her look on Empire lines and illusions of languor. Claiming to be 'the greatest living creator of fashions', and already established in Paris, Lady Duff Gordon stormed New York, arriving in Murray Hill and inviting the smart set to inspect her wares. Designers had been christening their gowns for decades, but Lucile went into romantic raptures, with names such as 'Hesitate no Longer', 'His Lullaby' and 'Why so Lonely?'.

For centuries, fashion followed a single line; now it was careering in different directions. Innovations no longer took years to filter through; radical changes occurred seasonally. By 1913 collections were reported in their correct timescale, and fashion was considered a dictator, residing in Paris and often out of control. In September 1913 *Vogue* instilled the fear factor into its fashion pages, announcing 'The Tyranny of the Neck Frill'

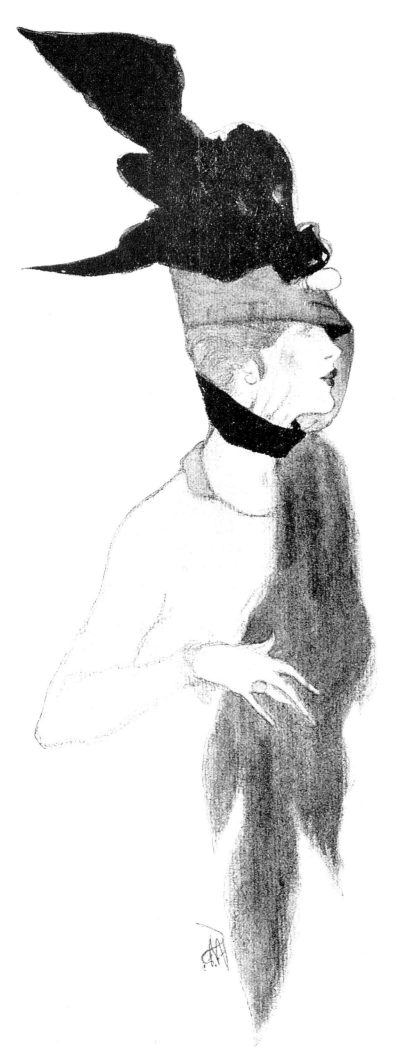

LEFT A tulle veil was considered a potent symbol of sensuality: 'a light and airy trifle, but oh, the powers with which it is invested!', *Vogue*'s 'Makers of Mystery', 1917.

BELOW Sportswear equalled liberation: Mrs Vernon Castle, in her white silk blouse and tennis skirt, demonstrated how to handle a tennis racket.

and 'The Tyrannizing Flounce', while Paris was ominously described as 'The City which must be Obeyed'. By October, *Vogue* felt designers were starting to believe their own publicity, and that egos needed to be suppressed: 'Every designer is a superman, a Nietzsche of the world, insistent that his own inflated egoism direct the trend of fashion. They stand in their booths in *Vanity Fair*, each crying his wares, each announcing that there is but one Mode and that he is its Prophet.'

Paris retaliated by resorting to shock tactics. In December 1913 *Vogue* reported Lucile's show. She had explored the American market and was no longer into neoclassical lines. Instead, she echoed Paul Poiret's Minaret silhouette, turning to flaring tunics and tango frocks with matching tango hair. *Vogue* was pleasantly surprised: 'Some of them wore green hair, some red hair, and some blue hair! Until one sees it, one has no idea how very chic blue hair can be. A violet frock demanded violet hair – of course

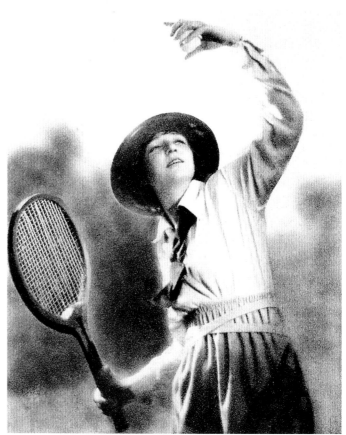

BELOW Paul Poiret's Minaret
tunics were both radical and
dramatic, and combined the
line of the hobble skirt with the
theatricality of the crinoline, 1913.

it did, what could be more natural – but with a green frock one would not think of combining green hair – why, red hair, of course, with a green frock!'

Despite being taken with the odd eccentricity, *Vogue* announced: '1913 will go down in history as the year when couturiers showed everything from fig leaves to hoop skirts, if one may dignify by the term "fig leaves" the very flimsy, transparent creations which are so décolleté and so split that a covering they certainly are not.' In the same year a new corset, 'The Debutante Slouch', was introduced, made from a combination of elastic and tricot. *Vogue* announced its first lingerie number in December, and the following May made a point of expressing its amazement at the newest sartorial affrontery – 'DÉCOLLETÉ IN BROAD DAYLIGHT?' On the edge of indecency, designers were brought back to earth.

The First World War broke out. In October 1914 *Vogue* reported, 'Paris is in a state of siege, but flags are fluttering gaily on all sides just as if the city were in gala dress to welcome a royal guest. But today Paris is not preparing to welcome a monarch – but to keep one out.' Paul Poiret, still under 40 years old, was among the first reservists to be called up to the French infantry. 'The Latest, perhaps the Last, Paris Fashions,' said *Vogue*, followed by, 'Paris is as arid of fashion material as the desert of Sahara according to one of *Vogue*'s Parisian artists, who arrived in New York recently.'

Couturiers carried on, but by November 1915, fearing isolation from Paris and knowing that there was no American fashion industry, *Vogue* set up a fund to help. A fashion fête of Le Syndicat de Défense de la Grande Couture Française, of which Poiret was the president, took place at the Ritz-Carlton hotel to benefit the widows and orphans of French soldiers.

When British *Vogue* was launched, on 15 September 1916, with 'The Forecast of Autumn Fashions' on the cover, *Vogue* switched its emphasis from reporting and discussing, to predicting and defining. 'Paris lifts ever so little the ban on gaiety,' reported *Vogue* in November 1916. 'Surprising things are likely to happen almost every day in Paris. One sees women clad in brilliant red when they should never come even within shopping distance of red material. One sees other women swathed to the very chin in green when green is the one colour that gives them the appearance of being visited with a severe attack of *mal de mer*.' In April 1917 '*Vogue* Points' predicted the most important looks of the next decade. First, the cloche hat 'is having an enormous vogue in Paris, where for months we have been devoted to the Russian turban'. Next, trousers: 'If womankind once gets over the stile and into the pantalon will she care to climb back and into the prosaic skirt?'

The following year, tapering skirts were given a trouser effect, gathered in the centre and clinging at the ankles. *Vogue* announced that the potato was no longer fashionable. By the victory spring of 1919, Paris reverted to the Tanagra silhouette, skirts were shorter than ever and silk jersey was the new sensation. Hair was now cut to the nape of the neck and smoking in public was still regarded as scandalous. *Vogue* observed: 'It wasn't so very long ago when, if a woman smoked in a London hotel, people gazed at her in wide-eyed wonder and murmured apologetically, "She must be an actress."'

While Britain reeled from the emotional and economic consequences of war, androgynous dressing was on the threshold. Fashion had reached a point of no return: 'He who Returns from the War May Find that the Only Profession Left him is that of a Female Impersonator', stated the headline in *Vogue*, August 1919. It was positioned above a feature discussing role reversal by Dorothy Parker, in which she said: 'The style in heroines has changed completely. In fact, the style in all women has changed. It is all directly due to the war – the war, which started so many things that it couldn't possibly finish.'

1920–29

The Vamp: A very special brand. You propose to her by telephone and marry her by wireless. You do not make a home and lead her in, but mix a cocktail and take her out. She will probably demand a divorce on the grounds of incompatibility of dance steps. Only suitable for millionaires.

The Woman of Your Choice, *Vogue*, early November 1923

The 1920s were the age of abbreviation – or as *Vogue* succinctly put it in 1924: 'This is the period of short skirts, shirt shrift, short credit and short names. How could one "make an effect" if one answered to the name of Tots, or Marg or Babs, or Sibbie?' The new signatures – straight lines, bobbed hair, flat breasts, boyish bodies – became the template for a decade of decadence. Fashion was no longer the sum of the parts, but a Rubik cube with endless permutations. The distasteful turned tasteful: Russian water-rat fur was used as trimming; a fan made from vulture feathers was dipped in gold. As thin equalled chic, the preferred pet of the time became a greyhound.

Women were now borrowing cufflinks and brandishing cigarette holders, but still wondering whether to bare their arms in daylight. *Vogue* covers reflected their dilemma. In January 1920 the magazine's cover was a Dickensian figure walking through a snowstorm with a plum pudding under her arm. By December of that year she had metamorphosed into a fully-fledged vamp, complete with a plunging bare-back dress and long, lacquered talons. The beautifully illustrated covers continued to flick backwards and forwards in time. No longer hesitant and monotone, editorial was spiced with humour and comment, analysis and predictions. Fashion had an esoteric edge; *Vogue* discussed 'Fashions of the Mind'.

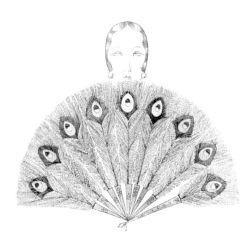

LEFT **The fan was the last bastion of flirtation: this 'gay fan of spreading peacock feathers' was worn with heavy eyelids and a shingle haircut, 1924.**

OPPOSITE **The deliciously sexy vamp: with long, red lacquered talons, visible make-up and a bare shoulder – a revolutionary *Vogue* cover in December 1921.**

VOGUE

Late December 1921

Condé Nast & Co Ltd
London

One Shilling & Six Pence Net

Aldous Huxley remembered 'Fashions in Love', Léon Bakst analysed the slim silhouette. Style was defined with absolute precision. 'What the Germans call *Zeitgeist*, I prefer to call fashion,' said *Vogue*. 'It's a prettier word.'

The term 'Mode' still denoted authority, but the favourite expression on the tip of everyone's tongue was 'modern'. Aldous Huxley wrote an essay on 'The Vulgarity of Modern Life'; the beauty pages talked about 'Chic and ultramodern hair'. In 1929 the Duchesse D'Ayen stated that, 'The modern ideal of loveliness is not a passive one. Statuesque beauty is out of date.'

Vogue featured its first fashion shoot, 'A Group of Paris Frocks that Posed for *Vogue*', in November 1920. Fashion was now as much about the basic ingredients – fabric and colour, length and shape – as poise and attitude. In 1922 *Vogue* spoke out: 'It is the fashionable – no matter how snobbish one feels in saying it – who set the fashion. The larger their number, the deeper their pockets.' International socialites were described and drawn in suspended animation by *Vogue*'s star photographer, writer and social butterfly, Cecil Beaton. He recalled Lady Diana Cooper's 'expression of mad surprise in her sky-blue eyes', heralded Edith Sitwell as 'a Gothic Madonna of unparalleled beauty', and gleefully related a tale of a private party in 1928 where George Gershwin sang 'S'wonderful! S'marvellous!' for the first time, noting a Miss Mary Baker – 'the shy bride of Chicago' – as having 'the smallest hands and feet in the world'.

The freedom to sit and stand at whim was a novelty. Simplicity was a modern concept, and fashion was mesmerized by it. In 1920 there were rumours of a renaissance of the crinoline and pannier.

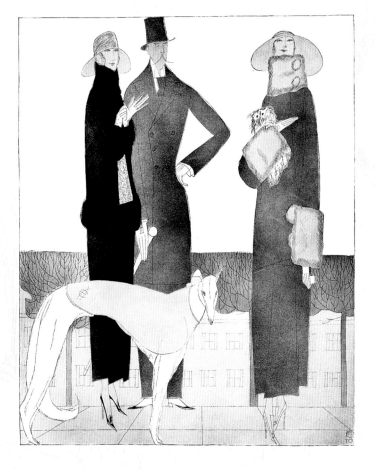

One year on, the notion was dismissed as ridiculous: 'Slip-on frocks, chemise frocks, and models of straight lines, carefully adjusted to each individual figure, prove that the vogue for simplicity will continue.' The 'new chemise frock' was not made up – as it had been originally – of rectangles and squares, but now slightly shaped at the shoulder and virtually identical, back and front. By 1923 the silhouette had turned into a tube.

The concept of the female designer was already firmly established. Coco Chanel had been admired for her use of jersey and a specially woven knit, kasha, during the 1910s, but by the 1920s she had come into her own. Madeleine Chéruit and Madeleine Vionnet, whose uncomplicated lines were nothing short of revolutionary, 'returned to the simple, absolutely straight frock which looks like a uniform of some religious order, save as to length', said *Vogue*. Two years previously, Vionnet caused a sensation by producing a gown that 'not only was not lined, but had not even a

LEFT **Smoking, which had been a strictly private pleasure in the 1910s, was a flappers' delight. It conveniently kept one's weight in check.**

ABOVE **Greyhounds, lean and fast – echoing the shape of their owners – appeared regularly. They later became a symbol of the British working classes.**

BELOW *Vogue*'s Composite
Wardrobe, early January
1924. The earliest kind of
capsule dressing showed how
separate pieces could comprise
a total look.

RIGHT By 1924 trousers were
boudoir attire and worn with
the new androgynous haircut.
Paul Poiret's washable satin
pyjamas were considered to
be 'of vivid importance'.

real fastening'. With fashion literacy in its infancy, readers still found it difficult to differentiate between designers. In January 1923 *Vogue* decided to run a prize competition to identify the works of 12 famous designers, including Jean Patou, Paul Poiret, Jeanne Lanvin, Jacques Doucet and Charles Worth. Each garment was illustrated and clues were given in the form of a 'problem play'. The first prize was a dress allowance of 100 guineas.

The competition was one of the few occasions when cash was mentioned. Prices were never printed in *Vogue*; economy was a dirty word. *Vogue* called the financially disadvantaged the '*nouvelle pauvre*'. The issue of purse-tightening was handled with absolute tact and diplomacy. 'A limited income wardrobe is like a cable,' announced *Vogue*. 'It must say what it has to say in a few words, with decision and clarity. And the woman who achieves it must know what to eliminate and when to say "stop".'

Elegant accessories – called the 'cleverly chosen etceteras' – provided a frisson of excitement. There were feathered fans for flirting, cigarette holders for smouldering. Optional extras included huge plumes, long strands of pearls, row upon row of plain bracelets and enormous single pear-shaped stones. Evening scarves were a new sensation; at first draped diagonally across the body, later knotted around the neck,

and made from silk, satin or a combination of leopardskin and monkey fur. Stockings were universally neutral, but analysed in-depth were four shades of grey, six shades of beige and three types of heel detail.

In the same way as the sportswear revolution was responsible for deconstructing corsets, fashion movements of the 1920s were sparked by social situations. Trousers had come in through the back door. In 1922 Paul Poiret showed pyjamas as 'original attire for the hours of deshabille'. By 1924, when *Vogue* announced 'Pyjamas become matters of vivid importance', it was time to put the cards on the table. '*Vogue* is not over-emphasizing a fancy of the hour, but it is giving fair notice to a new mode that is starting on a long career. The pyjama is not an amusing novelty; it has

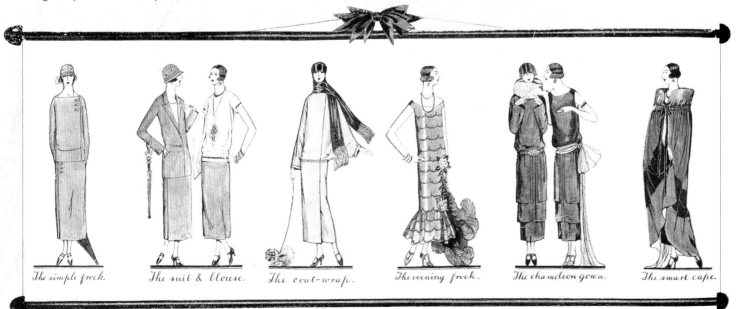

The simple frock. The suit & blouse. The coat-wrap. The evening frock. The chameleon gown. The smart cape.

become an essential part of the smart woman's wardrobe.' *Vogue* pinpointed three variations: sleeping pyjamas – 'a lovely, boyish thing of washing silk or crepe de Chine'; lounging pyjamas – 'when informal entertainments and masquerades are the order of the day'; and beach pyjamas – 'usually of gay printed cretonne, often worn with bright rubber wristlets to keep the sleeves in place when one loiters on the sand'. The bathing suit was no longer a useless *objet d'art*, but made from sea-friendly taffeta, Milanese silk or striped crepe de Chine. Stretch fabric was risqué. 'The newest thing for the sea is a jersey bathing-suit,' said *Vogue* in January 1924, 'as near a maillot as the unwritten law will permit.'

By 1926 genders were bending. Androgynous phrases – 'The Garçonne frock' and 'boyish bob' – slipped into the fashion curriculum. Women were not simply adopting male attire; they had actively invaded their territory. 'The Modern Rosalind – Notes on the Increasing Feminine Tendency to Borrow Men's Fashion' observed how 'the hosiers that was once a sanctum for the masculine shopper is now a battleground for women, while mere man cringes on the threshold'. Argument was provoked when Otto Weininger, a psychologist, pronounced that male and female were 'imaginary extremes rather than actual beings'. He then flicked from theory to hard fact: 'Women do the same work as men and play the same games. And until

ABOVE 'Evening wraps of brilliant tissue' – Jeanne Paquin's cloak of gold tissue and sable velvet summed up the unrestrained opulence of the 1920s.

RIGHT Midway through the 1920s, hemlines were shrinking to new heights – showing both the ankle and calf, as exemplified here by Jeanne Lanvin's 'graceful simplicity'.

they cease doing so the present tendency in their clothes is likely to continue. You cannot drive a Rolls Royce in a Gainsborough hat, amputate a limb in a crinoline, or play polo in stays.'

Women's wardrobes, once governed by strict rules of propriety, were now divided by timetables. They were unsure about what to wear in front of a typewriter. 'A Guide to Chic for the Businesswoman', suggested blending into the background with sombre colours and plain fabrics, and advised absolute caution when crossing the line between social and working hours: 'We must stoutly protest that the sport, garden party or reception dress is out of place in the shop or office. Short sleeves do not look well for such wear, ever. Elbow-length is permissible, but the really short sleeve is bad form and the sleeveless street gown is unspeakably vulgar.'

Hats echoed the shape of hair, which started the decade as a simple bob and turned, by 1923, into an undulated version called the shingle. Tongue firmly in cheek, *Vogue* imbued hats with cosmic importance, discussed the trials and tribulations of wearing silk stockings and advised that, 'The wearer must be treated like an odalisque and personally removed from the horizontal to the perpendicular.' Wrinkles could be dealt with by sticking plasters put in the appropriate place, 'particularly during moments of intense concentration'. In 1927 *Vogue* stated 'How demode it is to look chilly!' while identifying 'A Complete Set of Flappers' – six characters including 'The Go-getter': 'Scientists say this type is a cross between a standard vampire and a standard vacuum cleaner.'

By 1926 couturiers no longer concentrated solely on clothes. *Vogue* described 'The Perfume of the Couture', pointing out that Worth, the Callot Sœurs, Lucien Lelong and Poiret preferred intriguing titles, while Coco Chanel and Edward Molyneux adopted 'this restrained and cryptic method' of numbers for the fragrances they developed. Jean Patou produced three scents – one for blondes, one for brunettes and one for auburn-haired women.

Chanel opened her first London outlet in November 1927 and *Vogue* paid her the ultimate compliment: 'Mademoiselle

Chanel's dresses are peculiarly free from mistakes, either in taste or execution.'

In October 1928 the cocktail of the moment was made of Dubonnet and gin – 'half and half and shaken very cold'. *Vogue* declared 'the death of uniformity'. The art of luxury was never more mouthwatering: gold lamé over lace, over crepe satin; a brown velvet coat, with an inner casing of peach satin *fulgrante*, and an evening shoe constructed from silver tissue flecked with gold. Suntanning was chic and social values had changed so much that *Vogue* suggested 'The Dress for the Second Marriage'.

On the brink of a new decade, Aldous Huxley asked, 'Where are the Movies Moving?' and explored the extraordinary potential of cinema. He wrote: 'On the screen, miracles are easily performed; the most incongruous ideas can be arbitrarily associated, the limitations of time and space are largely ignored.' For the first time, cinema could be seen and heard. What no one could foresee was the phenomenal effect that movies with speech would have on fashion.

ABOVE **The Flapper: a good-time girl. 'Annabel is one of those little devils who starts out being the life of the party and is almost the death of it.'**

RIGHT **Chanel's 'sports ensemble' jersey sweater and wraparound skirt, 1928. Chanel was the first designer to show sportswear in a contemporary setting.**

1930–39

P is for prints – so classic and neat. T is for tulle that swirls round your feet. C is for contrast by day and by night. Also for corselettes that hug your ribs tight. B is for black, very trim, very sleek. Also for black and white – frantically chic. E's for the new eighteenth-century craze, which is pure Louis Seize.

Eye View of Spring Building, *Vogue,* 16 March 1938

'This is a town inhabited almost entirely by gods and goddesses of beauty,' wrote a breathless Cecil Beaton from Hollywood in March 1930. 'After a time, one loses one's sense of proportion, and nothing remains to stare at. The shop windows display attractions of such excruciating taste that one never before realised how dull good taste was, and how lovely bad taste could be. It is all very much what one was told Heaven was like, when one was a child.'

America had suffered the Wall Street crash, Britain was being means tested, unemployment was escalating and Hollywood pulled off the ultimate seduction: style in motion. Visual perfection met eternal beauty on screen. There was no better medium for fashion. Paris had directed for centuries, now Hollywood was poised for world domination. The question of who was influencing who became a tug of war for ten years, which *Vogue* underplayed, simply saying 'Film sways fashion.' Film gave fashion an animated glamour that was impossible to simulate on paper. In Hollywood, time was suspended, while in Paris, the direction of fabric moved from the straight to the bias.

Throughout the 1930s *Vogue* juggled issues of innovation and ideas with Paris on the one hand and Hollywood on the other, giving equal credence to both camps. *Vogue*

LEFT **Edward Molyneux's black and white fur and bias cutting in 1930. Fur was used to heighten the shoulder; satin highlighted the complexity of cut.**

OPPOSITE **The 1930s became more restrained – in colour, and the subtle use of bias cutting – *Vogue*'s cover of 14 September 1932.**

reported on the Paris collections, carried sketches of Greta Garbo's latest film costumes, and pinpointed the movers and shakers of the movie business. Paris was working on a seasonal timescale, Hollywood was years in advance; Paris was inspired by technique and tradition, Hollywood by scripts and screen beauties. Both worked on the principles of illusion.

Parisian designers quickly realized that film would be the future of fashion. In 1930 Coco Chanel signed a contract with Samuel Goldwyn to design costumes for the stars of United Artists. The following year she embarked on her first screen collaboration, designing gowns for Gloria Swanson in *Tonight or Never* (1931). Elsa Schiaparelli, although on the periphery of the industry since the early 1920s, became the new star of Paris. Launching a counterattack to Hollywood's populist appeal, she exploited her affinity with the surrealist movement – a circle of artists and writers who worked on Freudian principles – and put a new slant on Parisian tradition. The Paris stalwarts – Madeleine Vionnet, Jean Patou, Augustabernard, Edward Molyneux, Jeanne Lanvin – all continued to produce collections of unbelievable complexity, mixing knotting and draping. In 1931 Mainbocher, a former editor of French *Vogue*, made his debut with a silhouette of fitted tunic and flaring petal shapes called Le Douze.

As cinema audiences grew and the screen became more powerful than the salon, Paris began to steer its own course. What Hollywood could do with film, Paris could match in technical brilliance. Not content with drawing seams of the most mind-boggling variety, Patou and Augustabernard experimented with spiral wrapping running from the knee to the shoulder. The concept of fantasy created by cameras and lighting was not, of course, new; fashion shoots pre-dated the 'talkies'. *Vogue*'s 'Paris Fashions as Seen by the Camera' explored the tenuous link between Hollywood glamour and the mystique of a fashion shoot,

ABOVE **'Suits to dine in':** *Vogue*'s masculine look of 1935 took all the elements of a man's tuxedo and toreador, and threw in a few curves.

RIGHT **Charles James, a genius of cut and construction, was formulating pure lines and stark shapes in 1936, as seen here with his 'dead white slipper satin evening coat'.**

RIGHT **Surrealist tendencies had
knocked the ability to shock.
Dope for Debs illustration of
1936, showed surrealism taken
to ridiculous lengths.**

featuring photographer Baron George Hoyningen-Huene and
showing gowns by Patou and Vionnet. 'The great studio is in semi-
darkness. Huge shapes stand out of the gloom, the outline of
machinery. A tall silver screen gives off a ghostly radiance. We are
in one of the greatest fashion photograph studios in the world.'

Paris and Hollywood unanimously agreed on one point: the
exaggerated shoulder. Initially called the 'coat-hanger silhouette' for
obvious reasons, by 1933 shoulders came in infinite varieties. There
was Elsa Schiaparelli's Pagoda shoulder line, Augustabernard's
shoulder flares, the square shoulder and layers of flaring shoulder
tabs. Height – 'the effect of bulk which is so chic' – was added to
frame the face in the form of high collars, or scarves of silver fox. By
August of the same year the shoulder had gone as far as the camera
would allow, and was sharply pulled back to reality. 'Paris lost its
head, its heart, its judgement on shoulder exaggeration, on tulle and
sleeves, on organzas, on ruffles, on sings. Paris grew sentimental.
The story now will be the neck and bosom.' The emphasis switched
from shoulder width to anatomical elongation by October: 'A dress
starts as soon as possible, next to the chin, catches you at the
throat, and leaves you gasping in so many new ways. Vionnet
thought of it first.' In December *Vogue* wrote: 'There are ninety-
nine neat, throat-hugging, monastic necklines. The hundredth – a
dramatic exception – plunges down to the lungs. It isn't a freakish,
eccentric thing. Far from it. The story goes round that the play *The
Six Wives of Henry VIII* is responsible for this poitrine-exposing trend.'

Innovations in proportion were equalled by inventions in
fastenings: Schiaparelli understood the novelty value of buttons,
turning them into acrobats and lovebirds. The zip fastener was
invented. What started out on handbags was soon to be found in
every woman's wardrobe: 'Nowadays we pack so many activities
into twenty-four hours that the buttons or hooks which hold the
fitted line of our clothes take precious minutes to do up. This is
where Lightening fasteners come in.'

Pre- 'talkies', Hollywood had been a cloistered world where
clothes had limited influence beyond the confines of the film studio.
Costume was defined by script and historical context, which begged
the question: 'Does Hollywood Create?' Carefully giving credit where it
was due, *Vogue* asked, 'Does the new, enlightened, smart
Hollywood originate its own fashions? Does it come out with
brand-new ideas that never saw Paris? Or is it simply the most

She: 'Straighten your tie! Everybody's staring at you!'

VOGUE 75

perfect visual medium for the exploitation of fashion that ever
existed?' *Vogue* analysed individual scenarios: Greta Garbo's hair;
the famous feather boas of Marlene Dietrich in *Morocco* (1930);
Dietrich's ruff of cock feathers in *Shanghai Express* (1932). 'Today,
every smart woman has a feather ruff or boa. Score Hollywood 2,
Paris 0.' *Vogue* continued to play ping pong: 'Paris definitely had a
feeling for the masculinized look about the time *Mata Hari* [1931]
came out. Paris showed little pill-box hats about the time of the
premiere of *Grand Hotel* [1932]. Evening dresses with high necks in
front began so quietly that it is hard to trace the exact birth.' False
eyelashes, originally used only by make-up artists, arrived in England.

Exaggeration continued, but in 1934 the emphasis switched
from the shoulder to the sleeve. By December Schiaparelli had
eclipsed Paris with her use of rayon tulle, which she called
'Cosmic', along with Rhodophane fabric, which looked exactly
like glass. *Vogue* showed some of its uses on models – 'Lest you
think that it is something only a cinema queen might wear.'

RIGHT 'Disciples of Dalí': Cecil Beaton's *Suits on Blocks* of September 1936 gave a new perspective to tailoring, as executed by Robert Piguet and Lucien Lelong.

Hats shrank, hair had uplift. *Vogue* stated the two were still inseparable. 'Every woman has an immoderate passion for hats. She can't have too many – do you remember how young Antonia in *The Constant Nymph* [1933] put eight hats on her trousseau list and no underclothes?' The world's fascination with celebrity was set in stone. An 'incomparable' Marlene Dietrich posed in dresses designed by Travis Banton at Paramount, including a froufrou of black tulle. In the same issue *Vogue* proclaimed, 'The two opposing schools of decoration, the Great Baroque and the Starkly Simple, seem to have met at last.'

Vogue equated fashion design to architecture: 'The era of the dressmaker, all bits and pieces and complicated seaming, gives place to that of the mathematician and architect.' Charles James, a Harrow-educated Anglo-

Monkey-fur melodrama for Marlene Dietrich. Reboux's hat and scarf (Pissot and Pavy)

LEFT Hollywood and Paris ran on parallel lines: Marlene Dietrich's 'monkey fur melodrama' with a Reboux hat, 23 December 1936.

OPPOSITE Elastication makes its debut: Jeanne Paquin's Mummy dresses of 1939 streamlined the figure but allowed the wearer to walk.

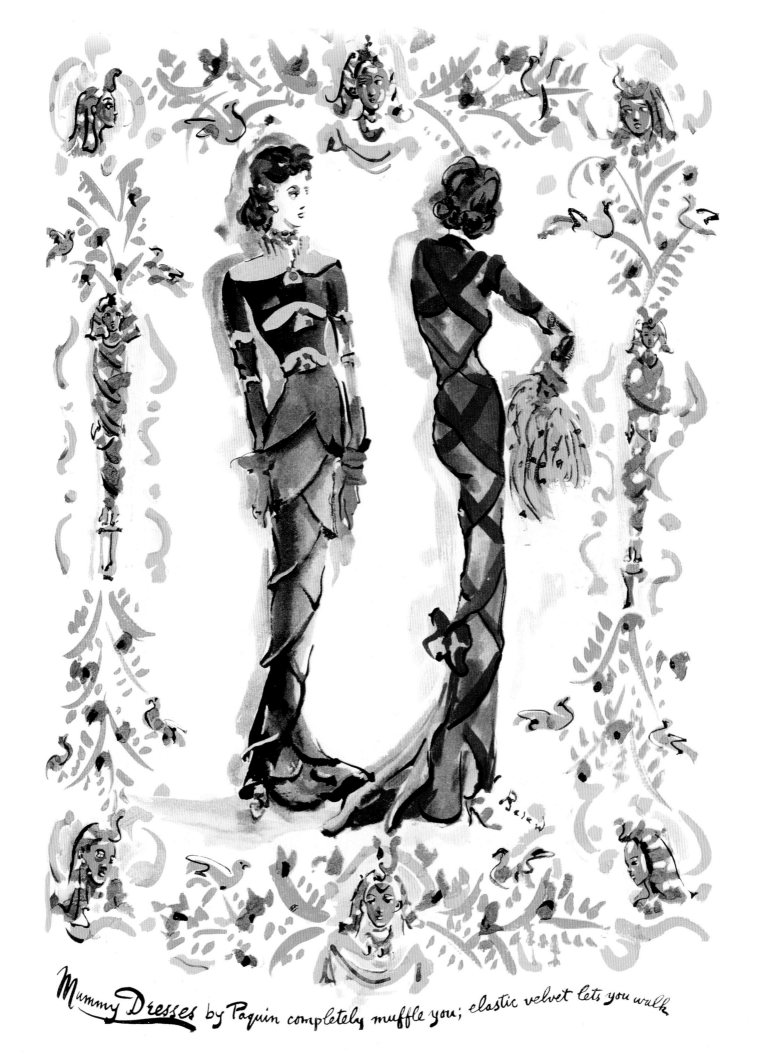

Mummy Dresses by Paquin completely muffle you; elastic velvet lets you walk

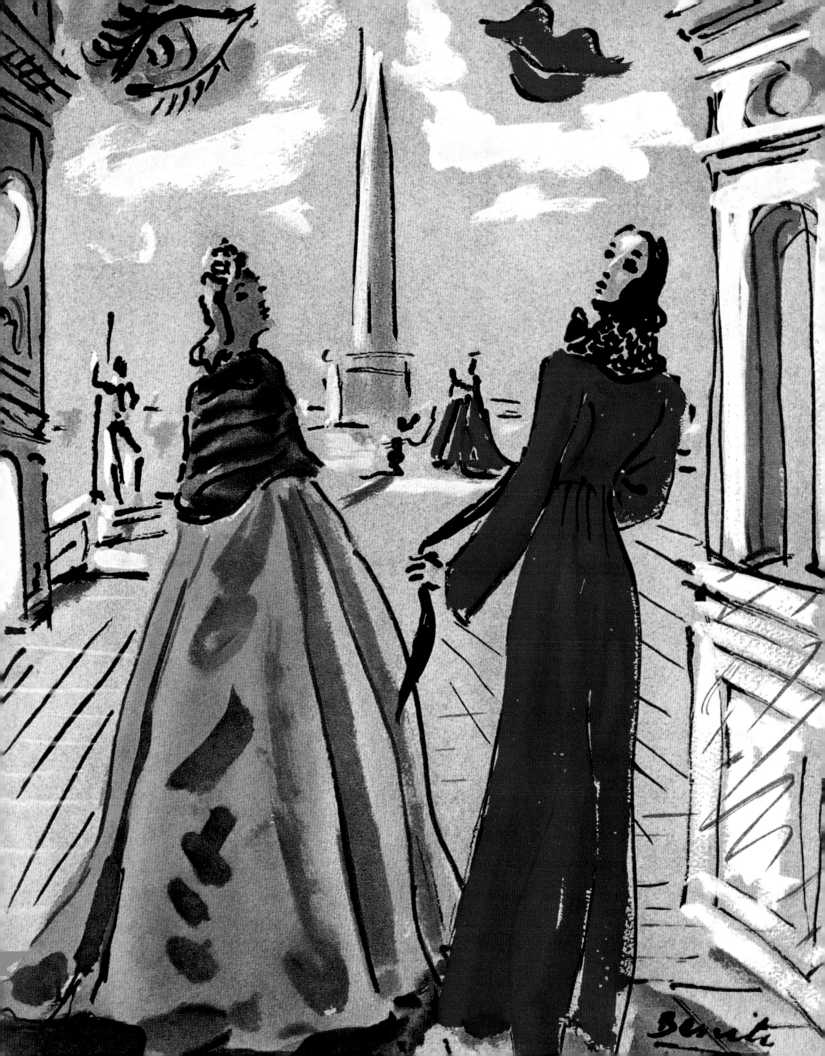

American based in Chicago, was by now a celebrated couturier, making his mark on London. James was an undisputed master of surface austerity and intricate infrastructure; in October 1936 a cavalcade of his capes and coats appeared in Harrods' windows.

Masculine influence filtered through to Paris. The dinner suit was 'the big news in every collection – nothing in fashion is newer'. The surrealist movement influenced fashion shoots. In 1936 dresses by Robert Piguet and Elsa Schiaparelli were seen in a barren landscape – 'Rope, hurtling out of oblivion, surrealist-fashion; spring-coiling over a purple satin dress, incredibly straight, clenched with a metal zip.' On 11 June 1936 London opened its first International Surrealist Exhibition. In January 1937 *Vogue* published a portrait of Salvadore Dalí opposite an explanation of a movement which had, by now, been seen and heard: 'A Surrealist is a man who likes to dress like a fencer, but does not fence; a Surrealist is also a man who likes to wear a diving suit, but does not dive. Mr Dalí recently delivered a speech in London dressed in a diving suit (he nearly smothered to death because someone forgot to open the air-valve).'

Vogue continued to feature film stars in fashion settings. In 1937 Ginger Rogers floated across the pages of *Vogue* in swathes of chiffon. Hollywood designer Gilbert Adrian, working at Metro-Goldwyn-Mayer, described dressing Greta Garbo for *Camille* (1937) and Norma Shearer in *Marie Antoinette* (1938). By the time *Gone with the Wind* (1939) preoccupied the gossip columnists, film fashion had moved from slink fit to crinolines. In March 1937 *Vogue* became critical of the studios' preoccupation with bodice-rippers: 'A curious state of affairs now seems to exist in Hollywood. Everyone has gone into perpetual fancy-dress. There apparently isn't a female star out there who doesn't want to put on pantalettes, do her hair up in curls and a frizz, and go bouncing her hoops in front of the camera. There is such a thing as monotony.'

Surrealist ideals were used to launch an intellectual counter-attack. *Vogue*'s 'Eye View' of April 1937 was written below *Poeme Visible* by Max Ernst: 'This sums up our present state of mind. All eyes straining to probe what the couturiers are inventing to grace this season of seasons.' In July 1938 *Vogue* quoted Albert Einstein's theory of relativity – 'We're abandoning absolute time, too.'

In September 1937 *Vogue* voted Cole Porter's 'I've Got You Under My Skin' as the song of the year and used the phrase 'sex appeal' for the first time. Paris celebrated Ziegfeld Follies' glitter. This was a season of the sequin – 'They flash like a glance from a bright eye and kill their man at ten yards.' The following sex was used to sell the New Look: 'There is a delicious excitement about these new clothes, for in them woman is re-discovering herself, her personality and her sex.'

In March 1938 *Vogue* heralded what it curiously called the 'Feminist movement in Paris' – opposite a wasp-waisted Winterhalter lady. The crinoline had landed. 'Obsolete adjectives come to mind, describing almost obsolete ideals. It is no longer so smart to be boyish. You must be the essence of romance at evening – you wear your satin corset outside your crinoline, pile your hair in a chignon topped with flowers, rustle forth in taffeta with lace petticoats.' *Vogue* cited key influences as the Renaissance, the seventeenth century, the 1880s, schooldays and childhood. On the brink of war, Paris snatched the director's chair – 'Paris backs the bustle', 'The case for slacks', 'Paris says you must have hips'. On 3 September 1939 the Second World War broke out. *Vogue* talked of restraint, common sense, warmth and rationing. Just as it was about to extol the virtues of wasp waists and fragility, Paris, with the brilliance of a seasoned acrobat, did a back flip.

1940–49

Home on leave. Be ready, then, to
greet him. Now if ever, beauty is your duty.
Now, if ever, by that crystal-clear conscience: clothes
that will charm him. Remember – none but the fair
deserve the brave.

The Return of the Soldier, *Vogue*, April 1940

SILK ON ITS LAST LEGS

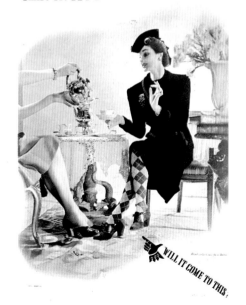

WILL IT COME TO THIS,

With the world at war, London crumbling, and time bombs being dropped a stone's throw from its office, *Vogue* put its faith in fashion: 'It's pulse beats with imperishable vitality. As long as there is desire for change and love of self-expression, a sense of fitness and sense of fantasy – there will be fashion.' Before the outbreak of war, fashion was elitist and escapist. Now, clothes were part of the rallying cry for unity. The industry was frozen, fertile imaginations cut short. Sketchbooks were closed and fashion had metamorphosed into the unlikeliest of symbols: morale booster and government tool.

After decades of free reign and prolonged periods of decadence, the fashion industry had to be creative within the constraints of economic responsibility and social rules. The new words – austerity, rational and utility were delivered in Churchillian fashion; the concept of common sense was new. Women were in uniform and men were taken aback by this. In 1940 in a two-sided argument on the subject of women in uniform, Patrick Balfour talked about the downside as 'a sociological fallacy called feminine emancipation', followed by the ultimate insult: 'Hitler is very probably a woman. In figure, in stridency and in barbarous singleness of purpose, he is the equal of any Fräulein in uniform.'

Women were valiantly clinging to the last bastions of femininity. In 1941 *Vogue* pronounced that silk was on its last legs. Stockings were to be the sacrificial lamb of

LEFT **With 'Silk on its Last Legs',**
***Vogue* visualized the ultimate**
wartime insult: Fair Isle
stockings worn to take tea
at the Ritz, 1941.

OPPOSITE **Actress Valerie**
Hobson, wearing a party
dress by Rahvis, standing in
the burnt remains of *Vogue*'s
studio, November 1941.

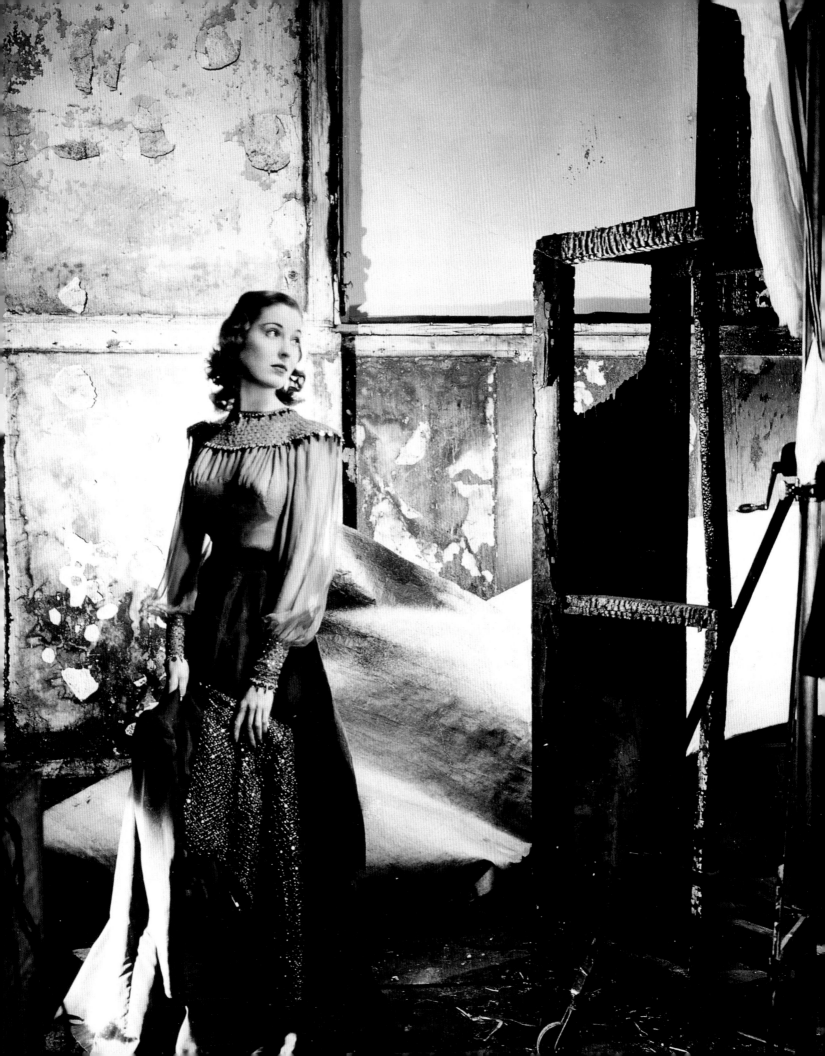

RIGHT **The 'Utility Collection',
featured in October 1942, was
British fashion's answer to
austerity – elegant, feminine
and using the minimum of
hard-wearing fabrics.**

the fashion industry. 'Will it come to this?' said *Vogue*, pointing a
finger at a woman taking tea in a pair of frumpy Fair Isle stockings.
'The ban on silk stockings came as a great shock to feminine pride.
It is a great topic of feminine conversation. "What will we look
like?", "Thick wool legs in the Ritz?", "I can only bear sheer silk,"
"My dear, my ankles."'

While Britain was buckling down to austerity and clothing
coupons, America – alien to belt-tightening – provided the
glamour. *Vogue* trod the fine line between aspiration and reality,
reporting that American women are wearing 'a revolutionary new
silhouette with sloping shoulders … shirt-waist dresses. They
always wore them – they always will … dressed up with jewelled
buttons and a lyrical, hysterical hat.' On 1 June 1941 rationing of
cloth, clothing and footwear was introduced. Clothing requirements
had been reduced to 66 coupons. To add insult to injury, this was
the same quota as margarine.

In 1942 *Vogue* had already coined the phrase 'The New Look'
to describe the current state of mind. 'Dressiness is démodé. It
looks wrong to look wealthy. Understatement has a chic denied
to overemphasis.' Within the financial restraints, there was still
room for creativity. Propaganda prints were designed to get the
message over – 'Dig for Victory', 'Home Guard', 'Happy Landing'
and Vivien Leigh in a '66 coupons' design illustrated with rare
and rationed items. Necessity became the mother of invention.
'Clothes from Chemicals' was a new idea pioneered in America,
as a way of making tough materials which didn't deplete natural
resources – 'Nylon, a versatile chemical product which has
already been proved in hairbrushes, toothbrushes and the best-
wearing stockings in the world, is now being turned into soft,
woolly fleeces. These make coats with almost magic properties.'

In 1941 the British Government was desperately trying to
keep the fashion industry alive. The London Fashion Collection,
representing nine British designers including Norman Hartnell,
Edward Molyneux, Lachasse and Digby Morton toured Buenos
Aires, Montevideo, Rio de Janeiro and São Paulo. By 1942 the
British Government was forced to take direct action closer to
home, and leading designers Hartnell, Molyneux, Morton, Hardy
Amies, Victor Stiebel, Bianca Mosca and Peter Russell put their
heads together to come up with a Utility wardrobe.

As the war progressed, *Vogue*'s tone became increasingly
urgent and dictatorial: 'General Economy Issues his Orders of
the Day', ran next to a figurative collage of zips, stockings and
press studs. Saving paper for re-pulping, using up every scrap
of mending thread, hair pins and buttons, preserving zip
fasteners and re-covering old shoes was recommended.
Austerity extended to beauty treatments, too – 'Diluting just the
last bright drop of nail varnish for just one more application.
Gouging out the last crimson goodness from your lipstick.
Being sparing with face-powder and as cunning with face-cream,
working one tiny dollop into the danger spots under the eyes,
across the brow.'

In October 1942 fashion and politics were firm allies.
Austerity with a glamorous ingredient was called 'Fashionable
Intelligence' by *Vogue*: 'All the designs are, of course, within the
new austerity specification: only so many buttons, this much cuff
and that much skirt … but they are an object lesson in the power
of pure style over mere elegance.' Political implications of 'the
parcel-carrier and the pram-pusher, the government clerk and the
busy clerk' having access to the skills of London's couture elite
was described in socialist terms: 'It is a revolutionary scheme
and a heartening thought. It is, in fact, an outstanding example
of applied democracy.'

Because fabric had to be preserved at all costs, the emphasis
was firmly on accessories. But even here, economies had to be

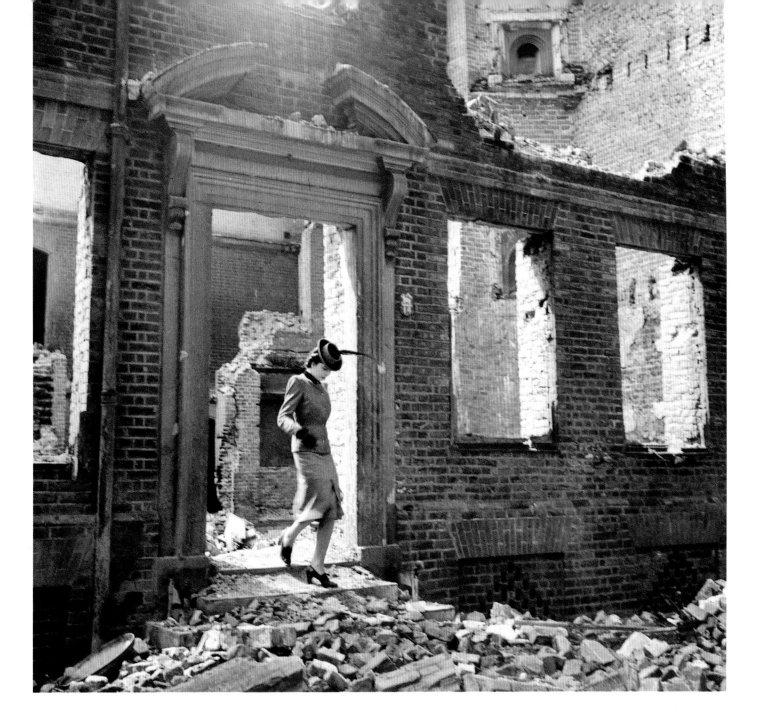

made: 'Milliners must design hats that stay on without the
benefit of elastic'; with straw in short supply, the summer
alternative was a crocheted snood. Wooden-soled shoes save
on the world shortage of leather. Shoulder bags were taking over
– 'Big bags are best: they suit our mood for being self-sufficient.'
With dye in short supply, colour was dull and practical. *Vogue*
even suggested abandoning preconceived ideas about specific
colours – 'You can make your black dress a seven-day-a-week-
dress.' There were many ways of interchange to be considered,
and buying came down to single items.

In September 1943 *Vogue* comprised a 'Portfolio of Wartime
Economies' starting with 'Your One and Only Dress'. Cost-cutting
measures became ever more ingenious as buying was edged out
by recycling. In other words, shop hound makes do. Handbags
were reconditioned with new lining and clasps, hats and clothes
were remodelled, corsets reconditioned, stockings invisibly
mended and shoes dyed.

In December 1943 *Vogue* featured two pin-up girls from
the Ziegfeld Follies. In January 1944 the magazine presented a
panorama of the past – 50 years of significant fashion changes,

'condensed almost to de-hydration point'. As the war neared its conclusion, *Vogue* wondered how the population would react when uniforms were exchanged for civilian dress. In September 1944 it speculated: 'Where is Fashion Going?' Designer Charles Creed predicted that dress restrictions would continue for a long time to come, C Willett Cunnington forecasted a craving for colour after five years of blackout and fashion historian James Laver speculated about a period of wild experiment. Only the British designer, Hardy Amies, had his finger on the button: 'From the scraps of refugee gossip and in illustrations in an odd fashion paper smuggled out, Paris shows us clothes which go just one step further in a perfectly logical sequence: minute waists, full billowing skirts set off by narrow shoulders. I believe in these new clothes – I feel them in my bones.'

When the American troops liberated Paris in 1944, former model and *Vogue* photographer Lee Miller reported from a city that was in raptures. 'Paris has gone mad ... The long, graceful, dignified avenues are crowded with flags and filled with screaming, cheering, pretty people. Everywhere in the streets were the dazzling girls, cycling, crawling up tank turrets. Their silhouette was very queer and fascinating to me after utility and austerity in England. Full floating skirts, tiny waist-lines. The entire gait of the French woman has changed with her footwear. Instead of the bounding buttocks and mincing steps of "pre-war", there is a hot-foot stride, picking up the whole foot at once.'

The following months were a tricky time for *Vogue*. Despite dangling a carrot with descriptions of Parisian chic, British austerity restrictions remained tighter than ever. *Vogue*'s strategy was to put elegance on a piece of elastic, then pull its readers back to reality. 'There is agitation against austerity,' wrote *Vogue* in November 1944. 'America's dress restrictions were only concerned with saving materials. Paris, as an occupied country, has had nothing of the kind. Already we are able to see one another's fashions. One day we shall be able to buy one another's fashions.'

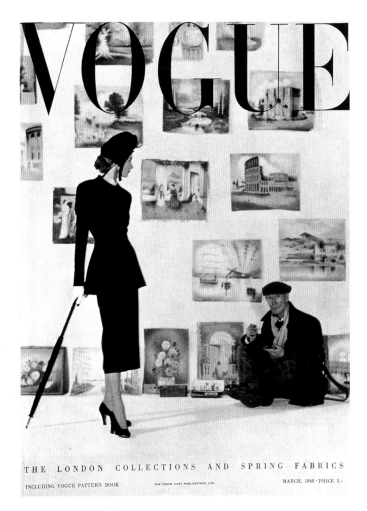

THE LONDON COLLECTIONS AND SPRING FABRICS
INCLUDING VOGUE PATTERN BOOK THE CONDE NAST PUBLICATIONS LTD. MARCH, 1948 · PRICE 3/-

In November 1944 Lee Miller described the first Paris couture collections since 1940 as being, 'simpler than those made under the occupation – plainer and more practical, but rich in ideas'. These included a quilted windbreaker by Marie-Louise Bruyère, Elsa Schiaparelli's fur culottes, Lucien Lelong's cocktail suit, appliquéd with jet-studded red leaves, and Mad Carpentier's apron basque. In December 1944 *Vogue* published its 'Paris Manifesto'. It was an attempt to placate its readers with a message from Lucien Lelong, president of the Chambre Syndicale de la Couture Parisienne, who categorically stated: 'Not more than forty models in any one collection. Not more than half the models to be in woollen materials, and the most important restriction: to limit yardage to 3 yards a dress, 4 yards a suit, 4⅔ yards a coat.'

The question of fashion leadership was hanging in the balance. Britain needed to compete on the world stage if it was to survive. 'It is a vital question,' observed *Vogue* in May 1945, 'for on it hangs great affairs of

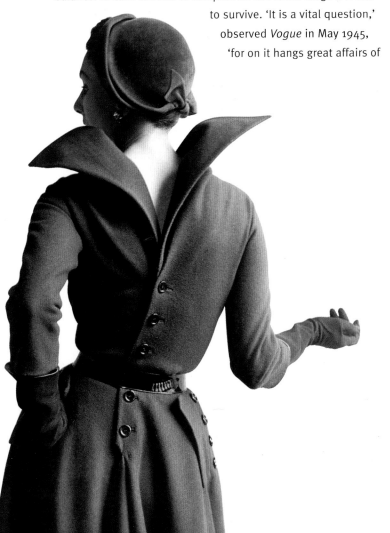

national and international trade, employment and standards of living.' Although British *Vogue* had always actively supported London designers, the war signalled the beginning of an international attitude to fashion. In July *Vogue* printed the first Soviet State Fashion Show report, radioed in from Moscow. *Vogue*'s October 1945 issue was entitled 'Peace and Reconstruction' and had a cloudless sky on the cover. Inside, *Vogue* dovetailed the new demobilization wardrobe and reported on Elsa Schiaparelli's return to Paris when, after a four-year absence, 'the cry, "La patronne, la patronne," ran through the house like a tongue of flame'.

The following year, October 1946, *Vogue* reported that 'Paris revels in femininity' and described the 'Britain Can Make It' exhibition, which had taken place at the Victoria and Albert Museum on 24 September. In January 1947 *Vogue* defined America's new age group, which was to dominate market forces in the 1950s, stating in 'Truth about the Teen-ager': 'They are no less human than their parents and, though their fashions may be cut alike, their philosophies are not.'

In April 1947 *Vogue* witnessed the most extreme shift in fashion since 1910. With his new collection, Christian Dior had

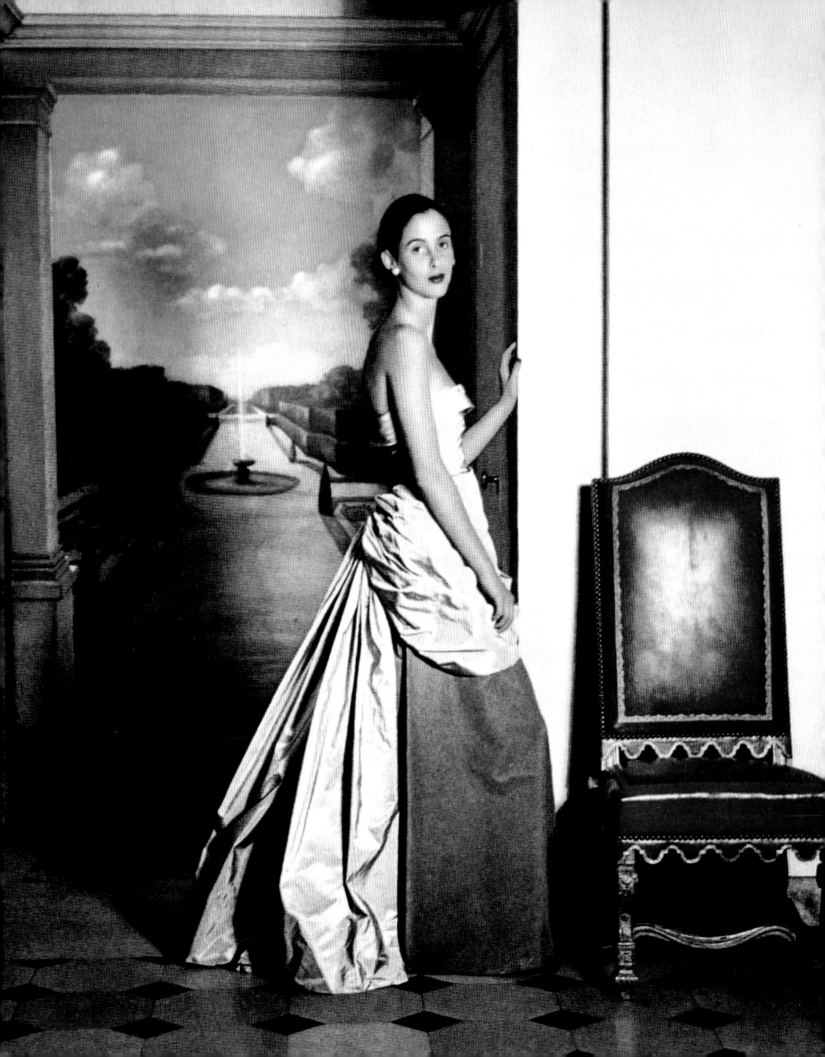

become the new name in Paris. A wit dubbed his collection, 'the Battle of the Marne of the couture'. Pronouncing his ideas as 'fresh and put over with great authority', *Vogue* described the details of his revolutionary New Look – his 'wide waistband and, whittling the waist, the deeply, widely cut bodice'. Cue the hard-hitting punch line: 'Dior uses fabric lavishly in skirts – fifteen yards in a woollen day dress, twenty-five yards in a short taffeta evening dress.'

Launched in an atmosphere of austerity and oppression, the general consensus on the collection was one of moral outrage. *Vogue*, however, unanimously voted it a feat of unparalleled perfection, gasping at the proportional representation of wasp waists, full skirts, narrow shoulders and wide hats. In October of that year, *Vogue* looked even more closely. The sinuous silhouette could not be created with flesh and fabric alone. Dior's corset had a taffeta underbodice with rose ruffles at the breasts and a ruffled hip. Not content with throwing the perfect curve, he had ingeniously designed an understructure of the feminine ideal. The magazine ominously announced, 'There are moments when fashion changes fundamentally. When it is more than a matter of differences in detail. The whole fashion attitude seems to change – the whole structure of the body. This is one of those moments.'

With the hourglass silhouette firmly fixed in female consciousness, fashion entered an experimental phase. Fabric – and copious quantities of it – was flying in all directions. There were back-dipping skirts, uneven hemlines and peplums standing to attention. In October 1948 *Vogue* reported a 'wing-back décolleté of the Dior dress. Huge flapping cuffs like seals' fins'.

The following year, *Vogue* cut to 'the details that spike the Paris collection', outlining the 'gamine haircut, deep décolletages, starched Eton collars on dinner suits. Pockets like croissants. Buttons, buttons, buttons', and endless asymmetry. With the publication of a picture of the Countess Alain de la Falaise wearing Jeanne Paquin's cut velvet and taffeta, the future was assured. *Vogue* wrote: 'There is news of beautifully designed, desirable clothes with the fixed purpose of interesting, of dramatizing a woman.'

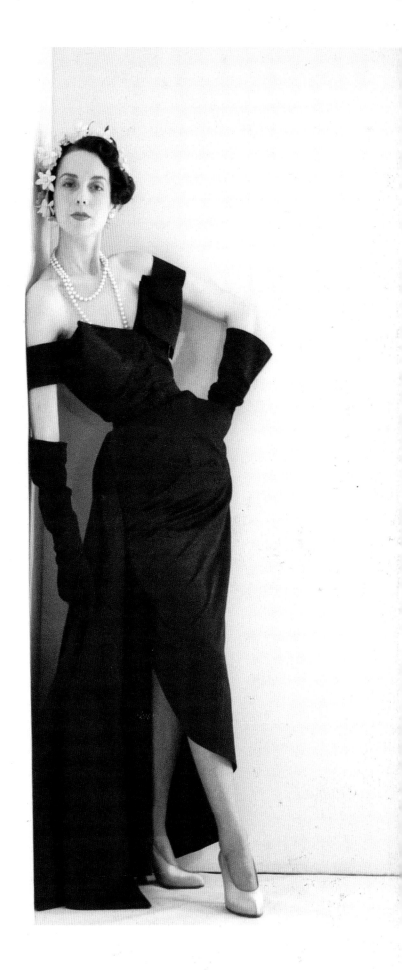

OPPOSITE **Cristobal Balenciaga – the undisputed master of construction. His 'grand ballgown of great dignity' was shot in his salon against a painting of Versailles.**

RIGHT **Christian Dior's sublime, cocktail dress of 1949 featured a nipped-in waist and spiralling skirt – the 1950s look of total elegance and grooming had already evolved.**

1950–59

In accepting an attention from others – a drink, a light for a cigarette – it's young to look pleased, gracious and confident about it. If you hunch forward, it not only adds years, but marks you as a woman to whom such attentions may come seldom. A poised head will make you look confident even when you don't feel it.

Gestures Younger or Older, *Vogue*, November 1957

'This is the new figure,' declared *Vogue*, as it defined the 1950s' body line. 'You see an unexaggerated bosom, a concave middle, a close hipline, a seemingly long leg. See it in the flesh – and in the fabric. If you weren't born with this figure, you can achieve it.' There were new ways to obtain perfect undulations: diet, exercise, massage, posture, brassiere, corset and finally, 'there is the cut of the new fashions themselves, with bulk placed one way or another'.

In January 1950 *Vogue* celebrated a half-century of fashion, not realizing that it had come full circle. Instead of whalebone, there was elastication; propriety had been replaced by poise. Tiny waists and visible curves returned. The elusive beauty was back. The recent past, *Vogue* advised, should be viewed 'with amused tolerance'. Fashion was once more about illusion. *Vogue* asked, 'What is TASTE?' There were two new issues to address: class and age, as defined by dress. The rules were about to change – 'Realism in fashion designing and mass production of clothes now accent personal qualities rather than

LEFT *O Cyril our Waltz*: Antony Armstrong-Jones's dancers defy gravity. Youth revolutionized the dance floor, the wardrobe and the street, November 1959.

OPPOSITE Poise, taste and grooming were the cornerstones of 1950s' fashion. Irving Penn's portrait of elegance sums up the look, *Vogue*, January 1950.

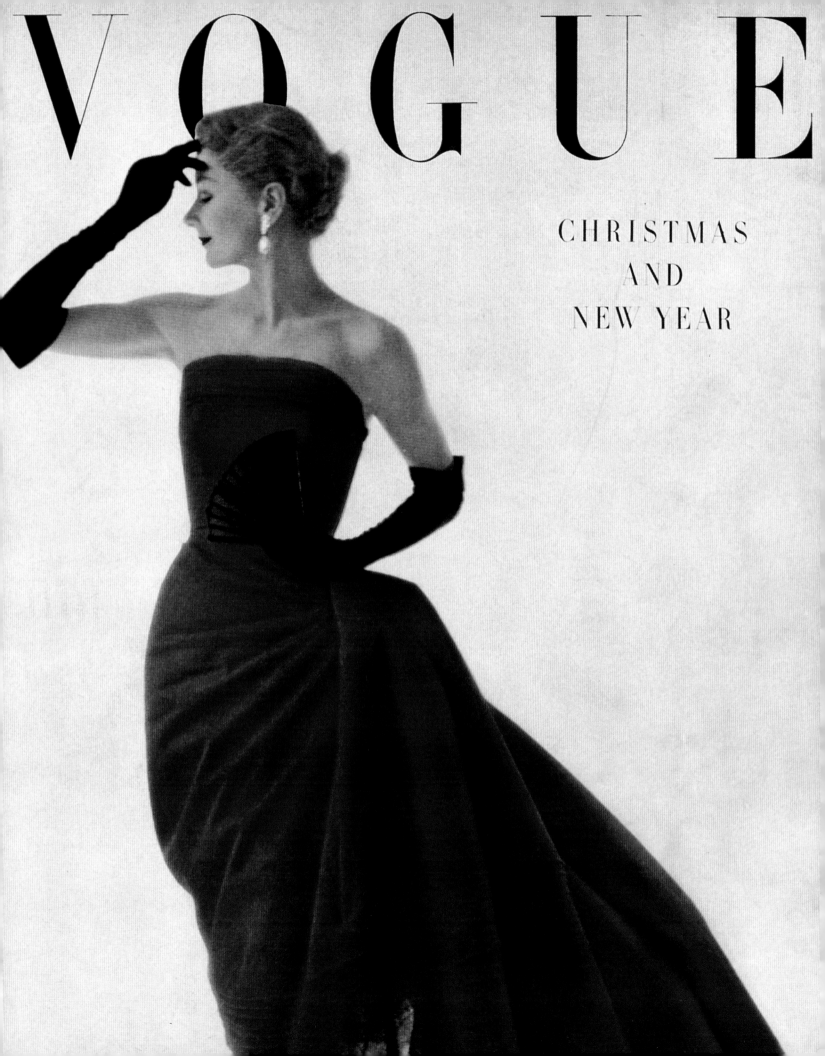

VOGUE

CHRISTMAS
AND
NEW YEAR

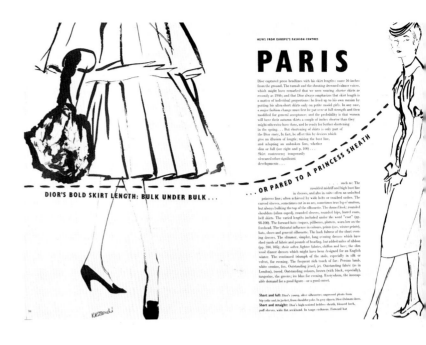

DIOR'S BOLD SKIRT LENGTH: BULK UNDER BULK...

... OR PARED TO A PRINCESS SHEATH

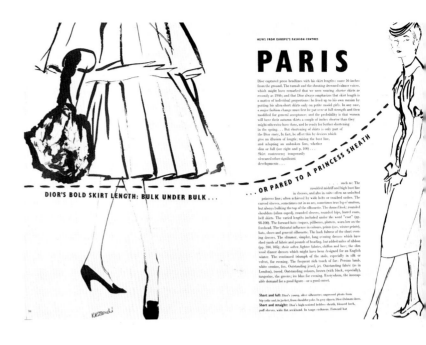

birth and wealth and have made us all sisters under the skin.' Conclusion: clothes would close up the class and age divide.

Age differences, initially acknowledged, started to dissolve. Women no longer aspired to be 30 years old. 'Young As You Are' started in March 1950 and was the first time a series of *Vogue* fashion items had been aimed specifically at the younger reader. By the mid-1950s Mrs Exeter, *Vogue*'s personification of middle-age chic, stood side by side with her teenage counterpart as she was 'invited to parties of many age groups'. Finally, age became a two-way issue in 'Clothes with no Age Tag', where *Vogue* explained: 'The fact that clothes are usually photographed on young, willow-slim models had no more or less significance than the fact that most window-displays are based on elongated plaster-of-Paris ladies with twelve-inch waists and no heads. In each case, the garment shows to its best advantage. That's all.'

The approach to beauty became other-worldly. Eyes were re-defined – wide sweeps of eyeliner flicked out at the corners, precise eyebrows were drawn – and counterpointed by dark lips and porcelain skin. Hair was brushed, coiffed and set into a sleek shape. False eyelashes were essential, mouths remained closed.

In January 1952 *Vogue* suggested additional embellishments to enhance natural coloration: 'pearls adding lustre to the skin, the kindness of dark colours, fresh carnations pinned high on a severe collar'. By the mid-1950s, mystique was dramatically heightened by the addition of a black veil over the face – 'uncompromising, it demands a degree of assurance; and as with all veiling, a master's hand with make-up'. Long, white gloves drew attention and made 'every movement of the hands a *gesture*'.

The arrival of the serene, distant beauty dovetailed precisely with the renaissance of actress Gloria Swanson. At 51 years old, and star of over 60 films, she appeared in *Sunset Boulevard* (1950), which *Vogue* described as, 'a bitter, brilliant film about a silent-screen idol who dreams of a come-back'. At the age of 43, Bette Davis made her first film in England: 'Pastel and pretty, with a tremendous personality, she once put into a film contract "in the party of the first part, I will not be required to wear any of those damned floppy hats."'

Invigorated by the new decade, designers continued their experimental line. In September 1950 Paris focused on the trumpet skirt. The following month, the watchword was 'oblique': Christian Dior's 'oblique' corselet, Edward Molyneux's 'oblique' overskirt, Jacques Fath's 'oblique' fin-flare, and Cristobal Balenciaga's 'oblique' wishbone buttoning on a wool Ottoman suit.

While Paris was enchanted with acute angles, London played safe. 'All to Match', said *Vogue*, reviewing London in September

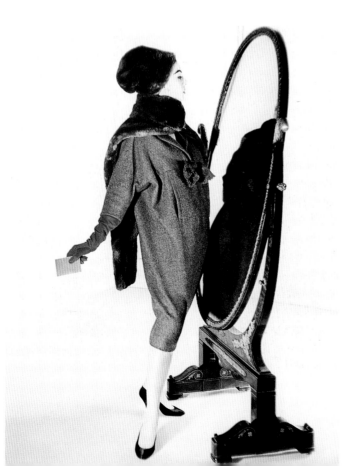

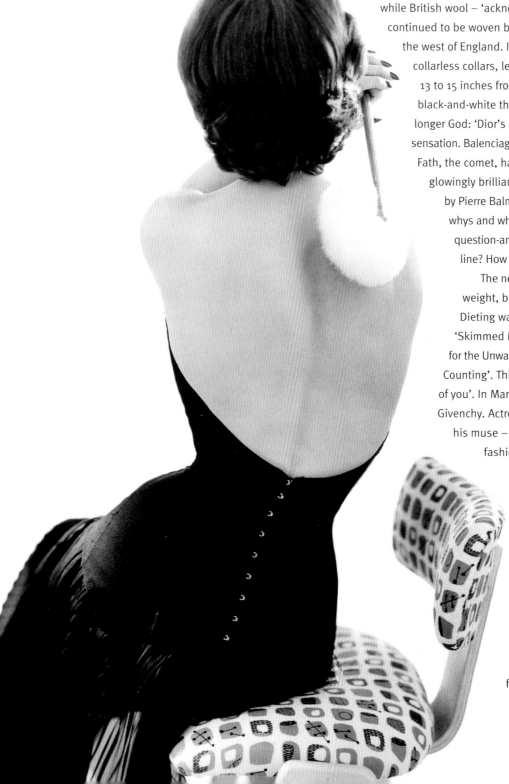

BELOW **The 1950s' shape – 'waist nipper combining corset, bra, petticoat' – all made from the new man-made fibre, nylon. Add graphic print and a powder puff, February 1955.**

1950 and observing: 'Just as a duck demands green peas, so suits like Victor Stiebel's demand a matching velvet blouse and hat.' The juxtapositioning of complementary colour was a recurring theme, and the magazine often provided detachable handbag-sized charts to take shopping. Note *Vogue*'s 'Eye View' of the half-bought dress: 'In one-syllable words, it's not what you wear, but What you Wear with What; and this, with capital letters, is the leading theme.'

At the beginning of the 1950s it was fabric technology, not design talent, that was seen as the future of British fashion. Nylon was produced in a huge new factory in the middle of Monmouthshire, while British wool – 'acknowledged as the best in the world' – continued to be woven by craftsmen in Scotland, Yorkshire and the west of England. In April 1951, in came Chinese jackets, collarless collars, lemon yellow and mauve. Skirts that hung 13 to 15 inches from the ground, natural waistlines and black-and-white themes continued. Christian Dior was no longer God: 'Dior's collection was his best since his first sensation. Balenciaga's equalled his last year's wonder. Fath, the comet, has become a steadier star, and made a glowingly brilliant show.' These top names were joined by Pierre Balmain, Jean Patou and Madame Grès. The whys and wherefores of length were translated into question-and-answer sessions: Where is the waistline? How full is the skirt? What about sleeves?

The new corsetry controlled and redistributed weight, but there was no room for manoeuvre. Dieting was fashionable. *Vogue* featured a 'Skimmed Milk Diet', 'Two-Day Diet', 'Measures for the Unwanted Pounds' and a series on 'Calorie Counting'. This coincided with Dior's 'new shaping of you'. In March 1952 *Vogue* reported the launch of Givenchy. Actress Audrey Hepburn – who later became his muse – was heralded as a combination of 'ultra fashion plate and a ballet dancer.'

In September 1952 *Vogue* noted: 'The little black dress, deceptively simple, is the core of every collection.' By the end of the year, the silhouette had curves at every turn. Sloped shoulders, cowl neckline and a small, hair-concealing hat. Skirts now reached 11 inches from the ground. Designers worked from the inside out, creating corsetry to fill and suppress the seams. *Vogue* told its readers to follow their lead and 'fit the foundation

to the fashion.' Dressing still required strategic thinking of the highest level: 'the sum total, a silhouette that is elegant, body-conscious, adult, becoming'. By January 1953 *Vogue*'s coverline promised 'Fashions for Flattery', featuring inside the new rounded bustline, all-in-one foundation for the moulded torso dress and nip-waisted girdle for the emphasized waist.

Fashion was a jigsaw with specific pieces: the appropriate hat, bag, belt, finishing touch. In April 1952 *Vogue*'s 'What to Wear with What' feature handled clothes in much the same way as interior designers approach decoration. Twenty-five colour schemes were put together to link in with a chart detailing colour-coordinated shoes, handbags, gloves and 'added touches' in the form of earrings, stole or belt. In the new feature, 'More Taste than Money', *Vogue* declared: 'Taste in the truest sense cannot be bought, but it can be acquired. Snobbery is the last thing you can afford.'

Photographer Irving Penn was to play a key role in creating the illusion of absolute assurance. Haughty and unsmiling, hands on hips and one foot in front of the other, Penn's visionary woman was unflustered and in control. Even so, *Vogue* lamented the disappearance of the word serenity: 'Our task is to re-establish in our minds the form and lucidity of the human drama. It is a problem of stillness, of learning how to be still, how to listen. Words are driven out of currency by our self-conscious avoidance of them.'

On 2 June 1953 Queen Elizabeth was crowned in Westminster Abbey. In September *Vogue* returned to the issues of international fashion. The latest centres were Spain, Italy and Dublin, where a new star, Sybil Connolly, presented a collection at Dunsany Castle. In Paris, Dior was again in the eye of the storm, with skirts 16 inches from the ground: 'The tumult and the shouting drowned calmer voices which might have remarked that we were wearing shorter skirts as recently as 1946.' The stalwart London designers remained united in their vision and in March 1956 *Vogue* concluded, 'London is not a city for revolutionaries: in fashion, as in everything else, she shows modernisation, painstaking detail, above all, a deep consideration for people. Here, the couturiers design for their customers, there are no stunts. But that is not to say there is no news.'

Coco Chanel reopened her salon at 31 rue Cambon, Paris, and showed her first post-war collection on 5 February 1954. She was 71. Knowing that her classic style had been relentlessly copied, she finally conceded that imitation was the sincerest form of flattery:

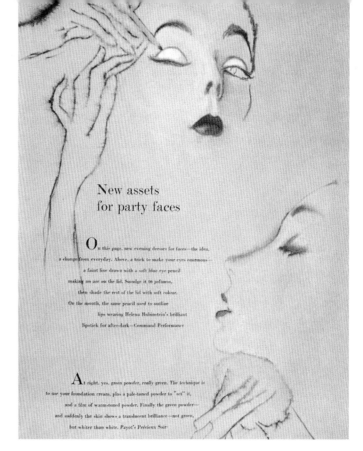

ABOVE **Beauty equals defined lines: on the inner eyelid, around the lips and arching over the brows, with a dusting of powder keeping it all in place, 1955.**

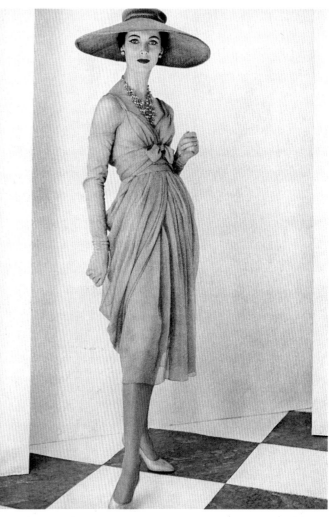

RIGHT **Christian Dior's 'dining out formula' of smoky lilac chiffon, wide hat, elongated gloves and the essential matching shoes, December 1956.**

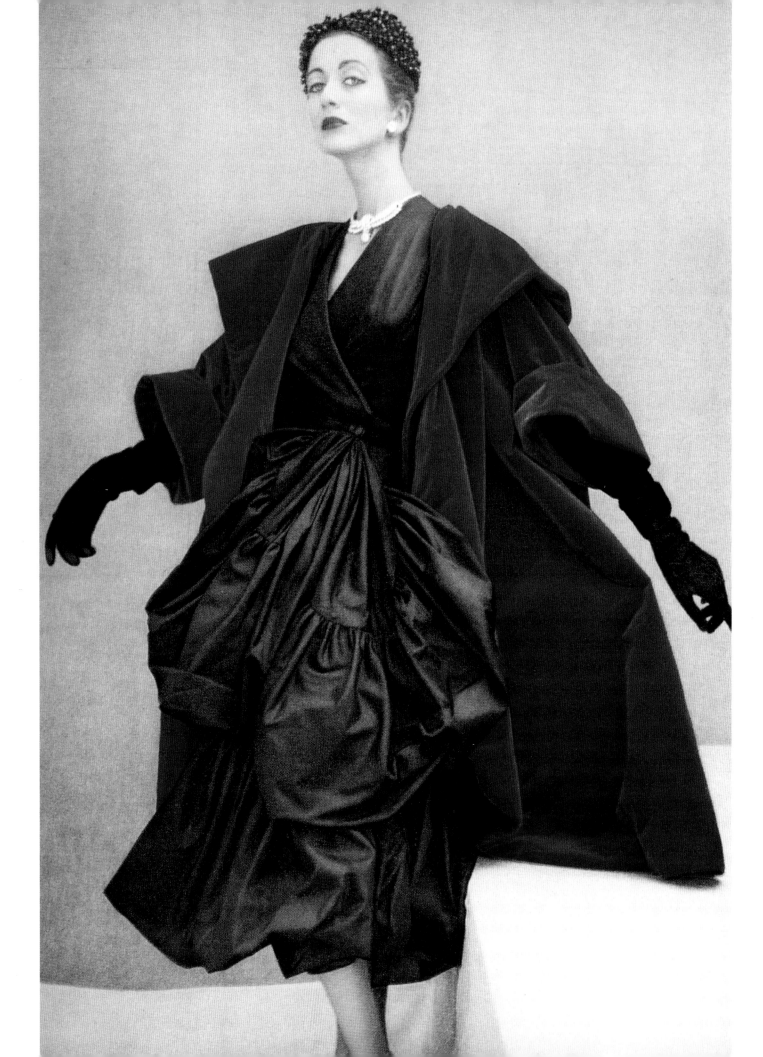

'I am no longer interested in dressing a few hundred women, private clients; I shall dress thousands of women. But a widely repeated fashion, seen everywhere, cheaply produced, must start from luxury. At the top of the pinnacle – le point de depart must be luxe.'

By the mid-1950s synthetic fabrics flooded the market and stockings were 'the sheerest – 12 denier thinness, a new low (we're used to 15) just coming off the nylon machines.' A glossary of new, man-made fibres – each with its own special virtues and 'designed not as a substitute, but to play a particular role in the textile world' – included the specific properties of new mixtures of nylon, Terylene and Orlon.

In September 1956 *Vogue* reported Dior's explosive demi-longeur: 'hailed, laughed at, sighed after, feared, endlessly discussed. Is it a stunt or serious development? Should we, can we, do we want to revert to pre-emancipation femininity in the uncompromisingly emancipated era we live in?' The following April *Vogue* published its first portrait of Christian Dior, describing him as 'a man of the most admirable simplicity, undazzled by ten years of fame'. In December *Vogue* reported his death. The following March Yves Saint Laurent seized the mantle and produced the Trapeze line: 'simply the most important and fully formulated in Paris.'

Space travel was on the horizon. The Futuristic movement, spearheaded by Pierre Cardin, was already underway. In January 1959 *Vogue* described a 'Flying Start to 1959 by comet to New York': 'If you imagine a silver lamé boa constrictor with the curve of a quickly-gulped lunch inside it, this is what the Comet looks like from behind.' The gulf between America and Britain was narrowing. *Vogue*'s tone, which had echoes of the film *Brief Encounter* (1945), was being translated into teenspeak. 'Get With It', readers were told in November 1959, showing partygoers leaping in the air, captioned: '"We've so much in common, Mr Ponsonby-Ponsonby," translation: "Dig! I got the message!"' By December, the 1960s' look was defined in a seminal feature, 'The Teenage Thing'. *Vogue* relayed the opinions of a 17-year-old apprentice hairdresser, schoolboy, waitress and part-time skiffle player, dressed in the 'urban, working class' uniform of winkle-pickers, drainpipes and stilettos. 'What does fashion represent?', asked *Vogue*. 'Decoration? Armour? Disguise? A mood of society? For millions of working teenagers now, clothes like these are the biggest pastime in life: a symbol of independence, and the fraternity-mark of an age-group. Not – repeat not – the sign of a delinquent.'

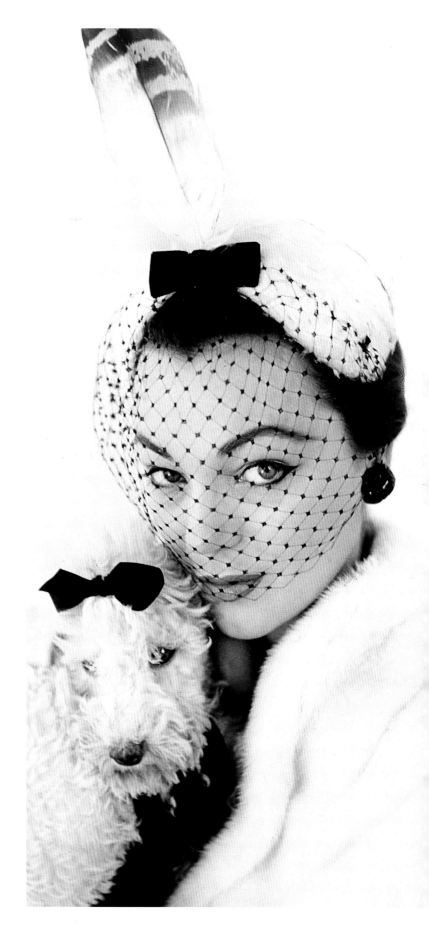

OPPOSITE **Cristobal Balenciaga's melange of mixed proportions and opposing textures – taffeta dress 'with blown-up hem', velvet coat and jet bead toque, 1951.**

RIGHT **Albouy's cavalier white melusine cap, with a black flat velvet bow and a black-and-white feather like a circus pony's plume, 1954.**

1960-69

I may not look like a Board of Trade official. At the risk of sounding like one I would like to say that I am not pessimistic about the future. Our assets are unrivalled. Inside this issue you will see some of Britain's amazing new achievements. Some of them are frivolous. All are wildly exciting. I am one of them.

Vogue cover quote, Jean Shrimpton, 15 September 1964

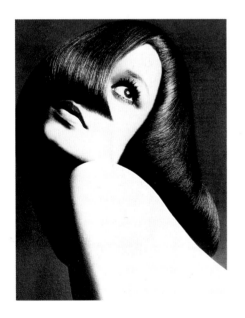

It took three years for the 1960s to start swinging. In 1964 slacking stopped. 'This is no place for the dilettante,' decreed *Vogue* in May of that year. 'In the general social reorganisation of these isles, one fact is clear. A new aristocracy of talent with say, the Beatles at the top and the three Etonian pop groups somewhere near the bottom – however many coronets among their players.' The 1960s instigated the catsuit, the topless swimsuit and the supermodel; with 'the Shrimp' at the beginning, Twiggy in the middle and a startling creature called Penelope Tree at the end. As the 1950s concluded, mods feuded with rockers and the teenager was eyed with fear and trepidation. *Vogue* turned a blind eye. 'Charm and an ingenue look are in tune with 1960's fashion,' said *Vogue* in January, followed by a radical re-think in September: 'Couture Clothes: are they Worth the Money?'

The 1960s turned every preconceived idea on its head. As fashion zoomed into overdrive, everything whirred in reverse. The teenager, previously *persona non grata*, had opinions and pulling power. Make-up turned from haughty to baby looks. Models played gauche, boutiques mixed genders and unisex made an entrance. Second-hand clothes,

LEFT **Vidal Sassoon's 'Rolled Florentine pageboy' haircut swept across the face, circled the brow and exposed one eye, 1969.**

OPPOSITE **Paco Rabanne – overtly unconventional – created a 'kinetic crystal gazing' kite coat, which captured the 1960s' obsession with plastic, 1966.**

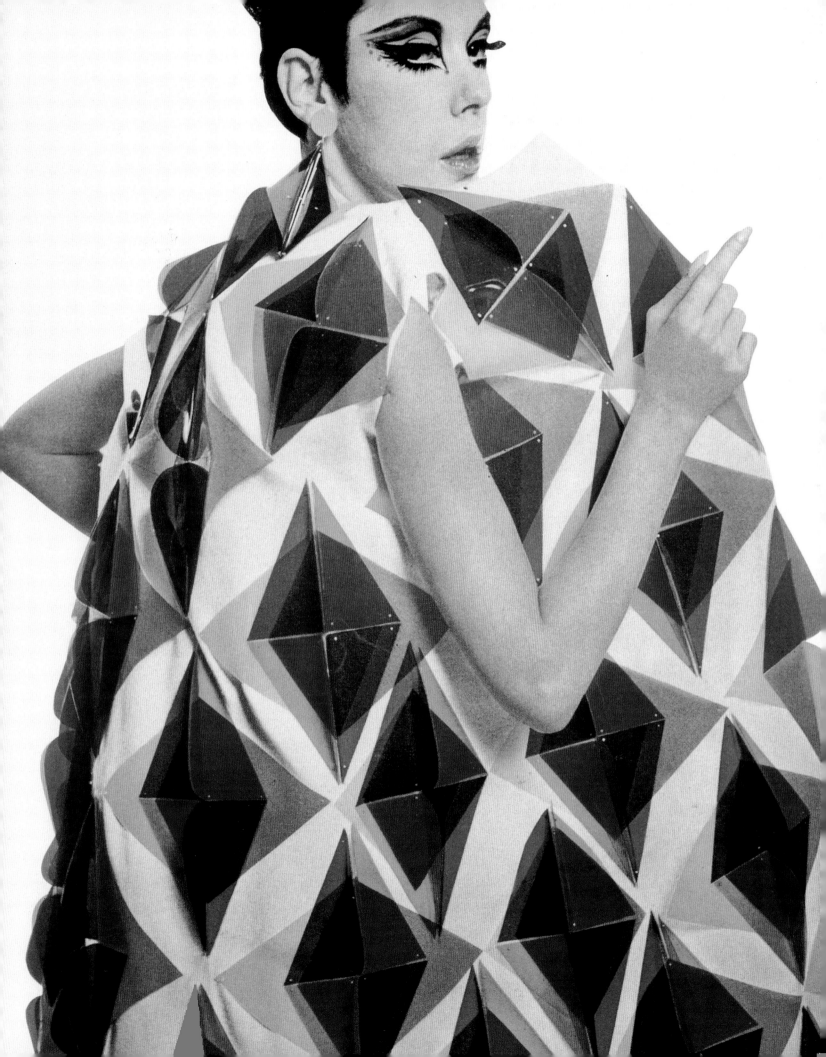

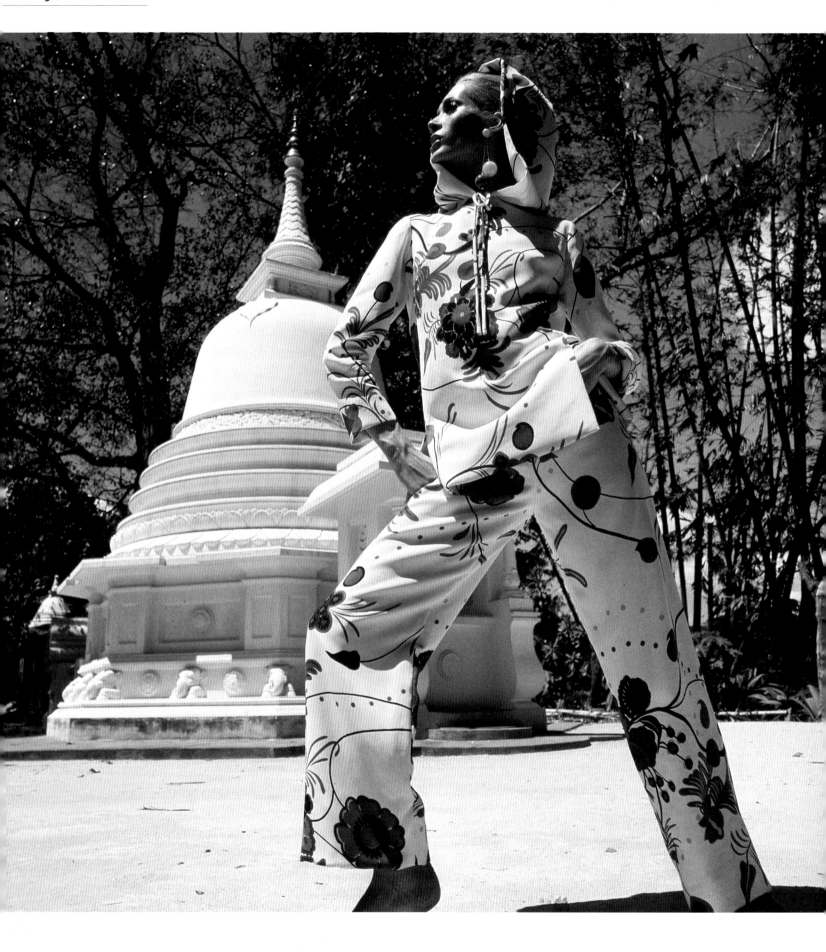

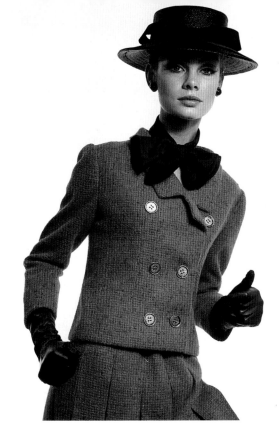

LEFT Jean Shrimpton, photographed by David Bailey in 1964, in Yves Saint Laurent's schoolgirl double-breasted suit in pink lace tweed with flecks of green and blue.

But deafness was feigned. 'You go to those old buffers in Jermyn Street and tell them what's wanted, and they bow and scrape, and it's "Precisely, Sir,"' recalled a Blades' customer in 1964, 'but your suit still has twenty-five inches around the ankles and room for three of you in the seat.'

From 1960 onwards the female erogenous zone moved from demure territory – collarbone, neck and shoulder – to unexplored areas – thighs, arms and stomach. The miniskirt was one of the first fashions to filter through from the street. It was a *Zeitgeist* of mammoth proportions, worn by Mancunian art students,

once associated with charity and poverty, were chic and eclectic. Paris, veering towards a Left-Bank, existentialist look, was called, 'no dictator, but gentle persuader'.

There was a breath of fresh air in the White House, too. Jacqueline Kennedy, who had won American *Vogue*'s Prix de Paris in 1951, instinctively understood the power of clothes as political weapons. Together with designer Oleg Cassini, America's first lady formulated a quiet, meticulously groomed style, which wouldn't upset the moral majority but had youth and vitality on its side. 'She has resolutely eschewed the bun-fights and the honky-tonk of the American political scene,' commented *Vogue* in March 1961, opposite a pencil portrait of the inimitable first lady, 'and is inclined, instead, to the gentler practice of painting, conversation, literature and fashion.'

Fashion direction came from a new angle. Men, traditionally preened into submission by their partners, started dressing up. Even more startling, they had discovered colour. As early as 1961, *Vogue* noted that men had moved from regulation beige to a spectrum of brilliants. 1960s' youth was telling tailors what to do.

OPPOSITE Flower power: Christian Dior's tall crepe trouser suit with a new clarity of line and exotic flower printing – formalized but free. Photographed in Ceylon, May 1966.

RIGHT By 1963 *Vogue* was featuring celebrity fashion shoots. Terence Stamp and Jean Shrimpton in 'Young Ideas High Line' – 'fresh as a baby's first dress' – photographed by Shrimpton's boyfriend, David Bailey.

Andy Warhol
protégée Edie
Sedgewick in New
York, and pushed to
new limits by the mods. It was
picked up by Mary Quant, who marketed
the mini for the masses and produced a collection
of clothes called 'The Ginger Group'. The teenager turned into a
mélange of everything pre-pubescent: *Vogue*'s 'Young Ideas' paired Jean
Shrimpton with Terence Stamp in May 1963: 'The new line is the high line,
fresh as a baby's first dress, but sharp, cool and sophisticated. Ravishing for
anyone young and slim.' In 1966 Twiggy wore a white crepe dress 'with the small
flowers of barely remembered birthday parties'. 'Young Ideas' also ran 'Skipping
Scatterbrained Summer' and, in 1966, 'It's a Small World – a two-sided story about
little girls who like to look grown-up, and big ones who don't.'

Men were turning Wildean, imitating Edwardian and Victorian eras by
wearing frills and furbelows, and allowing their hair to grow below the
collar. Reporting from Paris in March 1964, *Vogue* admitted that fashion
was looking over its shoulder. The incurable romantic was returning:
'The mood throughout is never plain pure nostalgia, never
sentimental, rather totally for the Sixties'. In London, Barbara
Hulanicki opened the first Biba store in Abingdon Road,
Kensington. It was a dimly lit celebration of Art Deco,
which also sold dreamy separates, via mail order, to
Biba wannabees in the provinces.

Couture was becoming passé and irrelevant.
Second lines – now commonly known as diffusion
– were on the increase. As London ignored the
rarefied, Paris embraced the space age.
André Courrèges, who trained at
Balenciaga, approached couture as
an engineer constructs an inter-
planetary craft. His collection
of 1965 was described in
robotic language: 'New
proportions. Click.
New fashion

world. What next? Courrèges-shaped cars. Boats. Buildings. Sounds. What now? Only Courrèges-shaped girls. Like this one. If so, Go!' Hats became helmets. The skirt split in two and began to be known as culottes.

From the early 1960s *Vogue*'s fashion pages were frequented by men, chosen mainly for their intellect and humour – although sometimes a perfectly proportioned jawline would suffice. P J Proby (whose torn trousers cut short his career), Vidal Sassoon, Terence Stamp, Dudley Moore, Warren Beatty and the *Observer* drama critic, Kenneth Tynan all made the pages. Men had a fashion statement to make: Rudolf Nureyev, at 23 years old was heralded as the new Nijinsky; David Hockney, a star from the moment he accepted his Royal College diploma in a gold lamé jacket; Tom Wolfe, whose new novel, with the suitably psychedelic title *The Kandy-Kolored Tangerine-Flake Streamline Baby* (1965), gave the tailoring a literary bent and made journalism cool. Mick Jagger added sexual ambiguity to rock'n'roll: 'When he gets on stage, his striped T-shirt awry, arms, head, body moving, jigging around in an extraordinarily graceful, erotic dance, all the while shaking two phallic-looking rattles, he loses all his sweetness.'

Class barriers broke down. Pre-1960 models were aristocratic decorations with elongated family trees. Then came the beautiful quirks of fate: Jean Shrimpton, discovered by photographer David Bailey; Twiggy, a mesmerizing stick insect, discovered at 16 years old, and

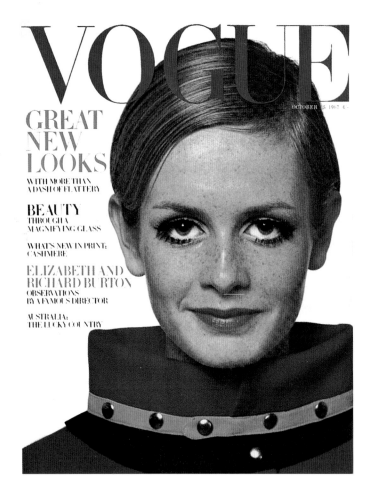

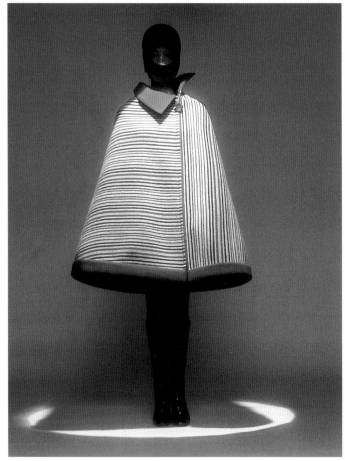

weighing just six and a half stone; exotic Veruschka, often photographed with her body painted, lying in a pool of water; Penelope Tree, 'the new kind of flower child', the absolute antithesis of elusive beauty – whirlpool eyes and flower-stalk legs.

Film continued to influence mainstream fashion. There was the beret and trenchcoat worn by Faye Dunaway in the film *Bonnie and Clyde* (1967) and Mrs Peel's catsuit in *The Avengers* television programme, which sparked off legions of feline imitators. When the musical *Hair* hit Broadway, Marsha Hunt became a star, black was beautiful and whites wore Afro hair for the first time. Rudi Gernreich, California's answer to Courrèges, toyed with topless bathing suits and transparent blouses. By the end of 1964 it had become more and more difficult to shock. Encouraging innovation, *Vogue* advised: 'Look prepared for the next century'. 1966 saw the

ABOVE LEFT The inimitable Twiggy – alias Lesley Hornby – eternally photogenic, wearing Emmanuelle Khanh's silver-studded felt culotte suit, October 1967.

RIGHT The photographic shoot entitled 'The Fool at Apple', which was featured in January 1968, showed the beginning of ethnic blending on the fashion pages.

OPPOSITE, TOP RIGHT **Pierre Cardin's 'graphic new cape shape' with an asymmetrical collar and zipped at one side, worn with tight, high boots and a helmet with a vinyl mask, 1967.**

RIGHT **Strangely beautiful Penelope Tree wears a white linen outfit by Ossie Clark, accessorized with a chiffon scarf by Bernard Nevill and a Louis Vuitton suitcase.**

rise of futurist Paco Rabanne and the invention of Le Smoking jacket by Yves Saint Laurent, who told *Vogue* that he would love to find a pill that took the place of eating. In 1965 Andy Warhol, who stunned the world with his stacked Brillo soap pads and silk-screen prints of Marilyn Monroe, told *Vogue* that he was into fashion cloning and named Courrèges as his favourite designer. 'Everyone should look the same,' said Warhol, doing a perfect impersonation of an alien from outer space. They should be 'dressed in silver. Silver doesn't look like anything. It merges into everything. Costumes should be worn during the day with lots of make-up.'

Artifice increased with the space race. Before man landed on the moon, the unwritten rule, which said plastic was for picnics, metal for cutlery and paper for printing on, was thrown out of the window. Dresses were made from every conceivable material – from paper to plastic discs, leather to PVC – all cut along babydoll lines. There were obvious hairpieces and outrageous eyelashes, and hair was cut at obtuse angles, courtesy of London's most experimental coiffeurs, Leonard and Vidal Sassoon. Hairdressers, models and photographers – normally on the periphery of the industry – were the new VIPs. It was the defining moment when the world realized celebrities had less mystique, but more fascination than royalty.

In England, an art school revolution was underway, pioneered by Professor Janey Ironside at the Royal College of Art in London. The new wave of hot British talent included Ossie Clark, who graduated with first-class honours in 1965, and was photographed, hands held behind his head, wearing an op art quilted silk coat and skirt. 'I want to dress frilly people ... in colours that confuse the eye,' he said. When he married textile designer Celia Birtwell in 1966 the two became twin talents, combining Birtwell's beautiful textiles and Clark's extraordinary eye for powerful sexuality. Underwear was virtually invisible. Bras – often two triangles of sheer fabric, held together by a few strips of elastic – were now so tiny they could be folded into a breast pocket. There was no visible means of support because it wasn't needed: the 1960s' chest was flat.

In the Summer of Love, 1967, Paco Rabanne's paper dresses sold at La Gaminerie on the Left Bank in Paris. Woodstock was having a hallucinogenic moment and Jimmy Hendrix said

purple was the colour of the universe. The Lord Chamberlain relinquished his powers and nudity was permitted on stage for the first time. In fashion historian James Laver's 'Instant Guide to Undress', he asked: 'Where do you go from nearly nothing?' *Vogue* presented a cultural melting pot in September 1969 entitled 'AFRODIZZYACTION', a fashion shoot which combined Clark pants, Birtwell prints, Nigerian jewellery, porcelain skin and Afro wigs by Leonard. In October 1969 *Vogue*'s 'Memo From New York' said: 'AND THE WORD IS – FANTASY. How else would we earth beings have ever gotten to the moon ... October 1969, this IS the fantasy moment.' Ziggy Stardust and the Spiders from Mars were waiting around the corner.

1970–79

Style is independent of fashion. Those who have style can indeed accept or ignore fashion. For them fashion is not something to be followed, it is rather something to be set, to select from or totally reject. Style is spontaneous, inborn. It is the gloriously deliberate, unpremeditated but divine gift of the few.

Spotlight on Style, *Vogue*, 1 September 1976

Pre-empting the moment when punk clashed with the Queen's Silver Jubilee, *Vogue* used the A-word. 'You'll be wearing a positive anarchy of costume both cleverer and simpler than anything you've worn in your life,' said *Vogue* in its first directive of the 1970s. 'You are one of a kind, unique in fashion. Forget rules – you make them, you break them.' Anarchy arrived after a process of wild experimentation, the shock of glam rock, the rise of platforms, the plummeting of skirts, and the ultimate role reversal: men wearing make-up. The 1970s opened with a celebration of decoration and ended in a sinuous body line. Anarchy simmered under the surface, exploding mid-way, with a flash of perpendicular hair, safety pins and bondage trousers. By January 1970 one thing was clear: the spacesuit was not going to take off.

In the summer of 1970 the miniskirt reached the point of no return. Crotch-skimming started to look tired and out of date. 'The long skirt is here – and the first *Vogue* with not a short skirt in sight, and more leg than ever,' announced *Vogue* in its 'Eye View of A Nice Sense of Proportion' in August: 'Jean Muir's new collection says it all.' The Muir midi had

LEFT **Seventies' style: white straw hat and halterneck with electric striped chevrons above a blue ribbed waistband – Sheridan Barnett, 1972.**

OPPOSITE **A mixture of the extraordinary, the Oriental and the Kabuki theatre – worn with outrageous platform boots – Kansai Yamamoto, 1971.**

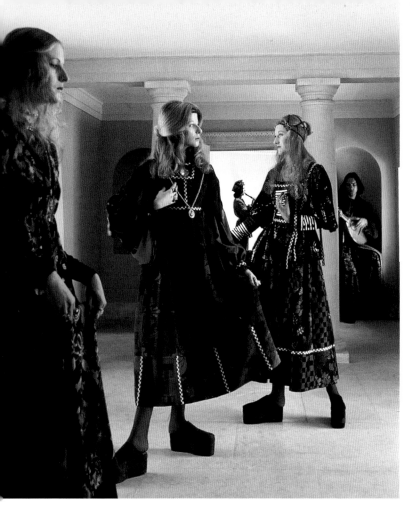

Rhodes, who studied textiles at the Royal College of Art in the 1960s, started to produce her own unmistakably flamboyant clothes, which took pattern as a starting point.

The fusion between fashion and rock music, which started in the 1960s, was cemented in the 1970s. Ossie Clark was making jumpsuits for Mick Jagger. Anthony Price, who made his *Vogue* debut in October 1971 as 'an ex-RCA [Royal College of Art] revolutionary, a designer of quite some force', became responsible for styling and designing clothes for Roxy Music and dressed Gayla Mitchell for the back view of Lou Reed's 1972 album, *Transformer*. *Vogue* photographed David Bowie and Twiggy together – a shot which ended up on the cover of Bowie's *Pin Ups* album in 1973.

Orientalism was the new preoccupation. Kansai Yamamoto showed his first London collection in 1971, with *Vogue* raving

fluidity, breezed just above the calf and came to a halt 3 inches below the knee. Meanwhile, Ossie Clark staged a 'fashion happening' at Chelsea Town Hall – 'more a spring dance than a show' – with music by Steve Miller, Juicy Lucy and Hot Rats. The models wore Celia Birtwell prints, wild hair, sparkling green eye shadow and carmine lipstick.

Under the editorship of Beatrix Miller, British *Vogue* nurtured British designers, spotting and promoting talent from the Royal College of Art in London. The new breed of designer was part-textile and part-fashion designer, with the ability to switch between preparing a silk-screen and sewing revers. Bill Gibb's creations were wearable works of art, complete one-offs that were beyond a seasonal timescale. Gibb worked with a team of knitters, weavers, painters and embroiderers. 'They've added tassels and ribbons, enamelled buttons, reptile bands, Russian braid, painted, printed and embroidered patterns and pictures, made every design a collector's item,' observed *Vogue*. From 1971 onwards Zandra

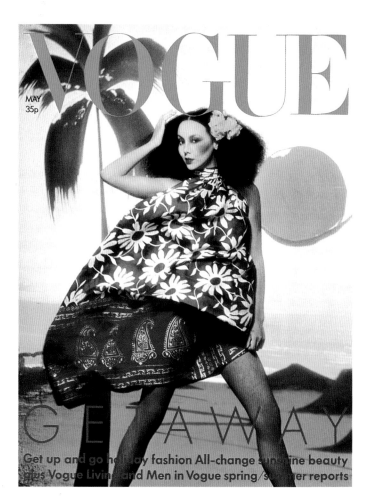

VOGUE

MAY 35p

GETAWAY

Get up and go holiday fashion All-change sunshine beauty plus Vogue Living and Men in Vogue spring/summer reports

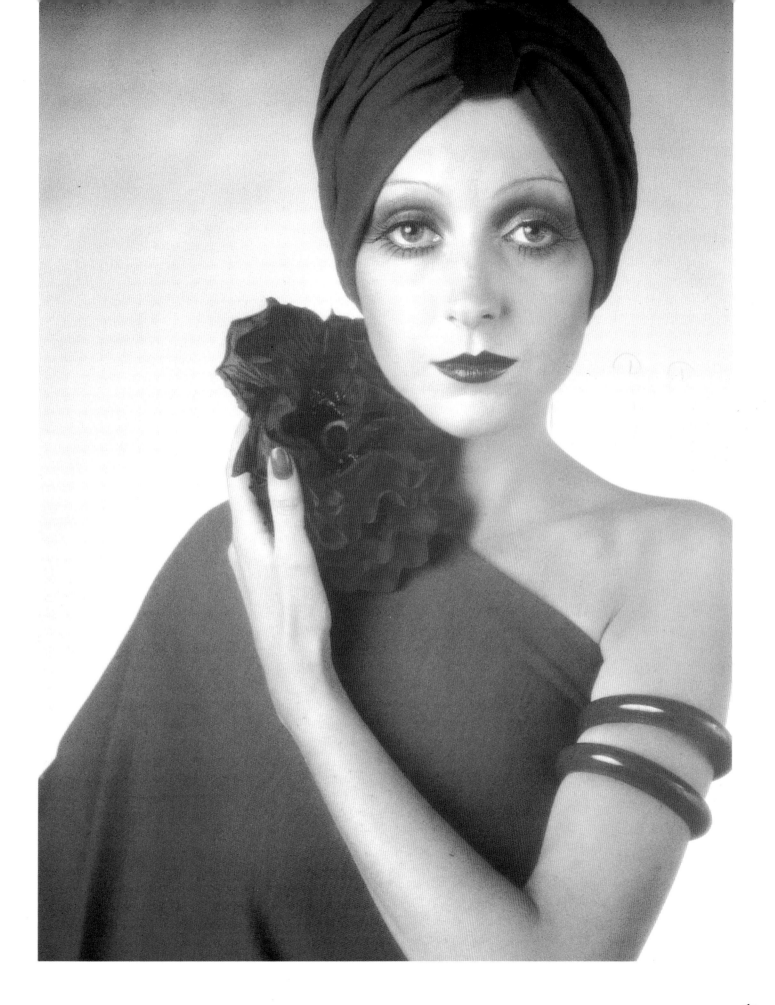

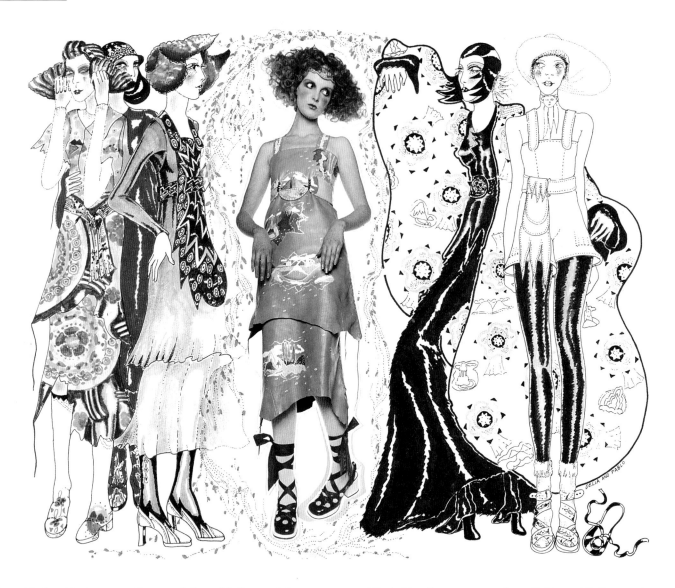

about his theatrical powers. Commercialism didn't come into it: 'Kansai Yamamoto's extraordinary evening clothes, pure theatre. Kabuki theatre. The face knitted into the playsuit and emblazoned over miles of cape.' Yoko Ono, avant-garde artist and wife of John Lennon, arrived in England in 1966 with a performance, *Cut Piece*, where she sat on stage while her clothes were deconstructed by the audience. Polly Devlin describes the chemistry in an interview for *Vogue* in 1971: 'Yoko, in antique white satin, and Art Deco shoes, plastic, exotic, beautiful. John kissed the shoe, rearranged her hair. "Why did you do that?" she said, suddenly querulous.' In February 1972 *Vogue*'s spotlight was on China. In June *Vogue* said: 'Go East! Collect flowers of Japanese culture.' The model Veruschka, who photographer Richard Avedon voted the most beautiful woman in the world, 'sits at a dressing table with her tea and honey, naked, oblivious to hairdressers, fashion editors and assistants, making up her face with a Japanese paintbrush'.

Ethnic blending was everywhere. Pablo and Delia, a curious couple who met at art school in Buenos Aires – 'looking like creatures of Bavarian fantasy, made to live in Mad Ludwig's castles' – had a vision of an exotic world inhabited by 'caricature people'. Their underground fashion statement included hand-painted, rainbow-coloured shoes and bags depicting imaginary landscapes. Thea Porter's exotic Middle Eastern upbringing translated itself into beautiful coats of brocade, silk, embroidery and crushed velvet. In October 1971 *Vogue*'s 'Eye View' presented 'The Dress you can't Date' – sugar pink, silk, wasp-waisted, with optional eras of 1937, 1938, 1948 and 1971.

Post-Woodstock, America was on a nostalgia trip. Ralph Lauren learnt his trade in retail and was one of the first fashion designers to understand the importance of sartorial storytelling, building a brand around an image. The lifestyle concept arrived. In 1973, while concentrating on menswear, Lauren designed Robert Redford's wardrobe for *The Great Gatsby* (1974). Four years later

he styled Diane Keaton – playing a flaky, androgynously dressed thirtysomething – in Woody Allen's *Annie Hall* (1977). Lauren's subsequent collections capitalized on reworking America's heritage in a modern context.

By the mid-1970s New York buzzed with a coterie of world-class designers, who were talking an international language. Calvin Klein, already anticipating the onset of the designer decade, concocted controversial advertising images with photographer Helmut Newton and built the foundations of a business that would reach an annual turnover of $500 million by 1980. Manhattan was the centre of social activity, with club Studio 54 the celebrity magnet. Halston, a great American minimalist, held court in the VIP room and had a list of socialite clients as long as his arm: Liza Minelli, Bianca Jagger and Marisa Berenson (great grand-daughter of Elsa Schiaparelli), all invariably dressed in his glamorous, understated gowns. In an

interview before he hit the big time in September 1972, *Vogue* noted: 'Halston rarely uses the word design, he prefers the word make. He insists it's the same thing.' Bianca Jagger, one of Halston's star clients, although possessing a degree in politics, was famous for being famous – 'When she says she is the only person who has become a star without having done a thing, you tend to agree.'

In Britain, the political climate was changing. In 1975 *Vogue* pre-empted Margaret Thatcher's rise to prime minister, showing her feminine side before she was re-packaged for the camera: 'She wears a lot of jewellery – real, but discreet. A surprisingly frivolous dress: flower-printed on black chiffon. It was cut tight in the bodice with long narrow sleeves.' *Vogue* reflected on fashion in the past tense in its December 1975 issue: 'Seventy-five, the hinge of the decade, when we start to realise what we look like. Oh, those loon-pants and smocks! Clothes that looked best with a high wind blowing through them, free-form clothes hinting only vaguely and almost depreciatingly at the earthly reality of limbs beneath them.' Two years on, the body was taking shape, but clothes were still essentially voluminous. *Vogue* told readers to, 'Think: Big. Think: Body Space. Learn to move inside clothes like mobile homes. Everything's made for a new race of healthy people. Do you belong?'

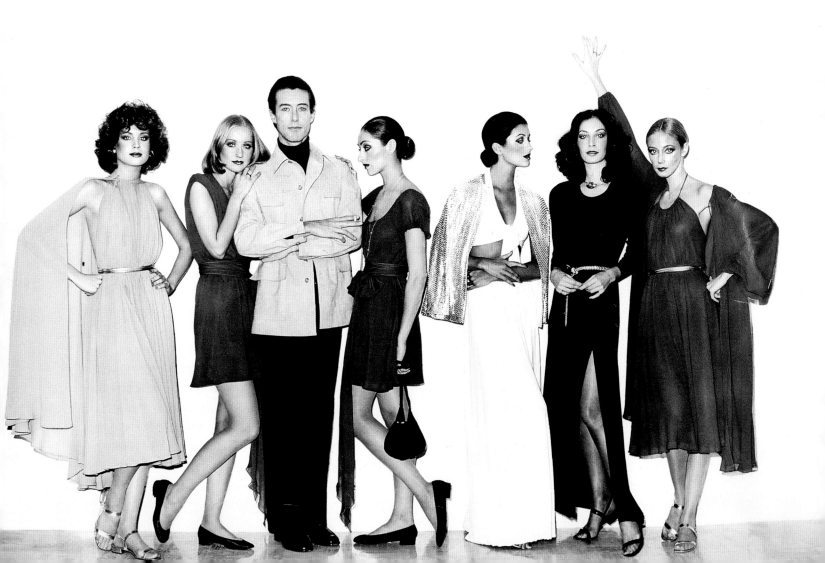

LEFT **Punk equalled safety pins, chains, slashes and the ultimate two-fingered salute to the Establishment. Zandra Rhodes' 1977 version was called 'Conceptual Chic'.**

Fashion's sublime paradox occured in the spring of 1977. Britain celebrated the Queen's Silver Jubilee, punk ran riot and *Vogue* assessed the importance of royal fashion. The Firm was about to change: 'Queen Elizabeth II, her dressmakers and milliners agree, regards fashion as a duty, though one of the least tiresome of her duties. So might anyone who spends about 172 hours a year being fitted for clothes and hats.' There was also an incisive prediction by *Vogue*'s Georgina Howell: 'The Queen is probably the last British monarch who will play by the rules.'

Punk was the product of disaffected youth, whose bondage trousers, ripped T-shirts and upstanding fluorescent hair were a rude salute to conformity. The most controversial statement of the twentieth century was invented by Vivienne Westwood, a former schoolteacher from Tintwistle in Derbyshire and her partner Malcolm McClaren, who had worked with the New York Dolls and now 'mis-managed' the Sex Pistols. Together, they took London's King's Road by storm, opening a succession of shops including Sex, Let It Rock and Seditionaries. They secured their place in history by committing the ultimate act of rebellion: producing an image of the Queen with a safety pin through her nose. The sense of political unease was tangible. *Vogue* asked: 'Is this the last Labour government?'

In December *Vogue* remembered Jubilee year and in the same issue featured the Queen wearing a pink Hardy Amies silk crepe dress and Frederick Fox bell hat. 'What we do know is that she never looked better or more relaxed with colours a shade brighter, and hats more dashing.' However, this was followed by a pictorial record of punk. Propriety and subversiveness could and would exist side by side: '1977, the year hair stood on end with fluorescent dyes, the year of war paint ... Punks deliberately seek to create a style which looks cheap, scruffy and trashy. A lot of time and money may go towards creating an appearance that resembles that of a tramp who has slept in his clothes and hasn't combed his hair for years.'

1978 became the year of cults and computers. *Vogue* analysed the former, and was fascinated with the latter. 'You can have a conversation with them,' said *Vogue* in its assessment of the computer revolution, while defining the biggest growth industry as cult-spotting: 'Sociologists tell us they no longer really talk of culture among themselves but of media feedback. Many cults today have a paranoid edge to them. The Punk cult, for instance, gains its

aggressive thrust from the aimless ranks of those who are young, sullen and often workless.' Punk, in its raw form, had nothing in common with regular incomes and couture salons. Zandra Rhodes took the paraphernalia – safety pins, rips, zips, spikes of fluorescent colour, eliminated the anarchy and diluted them into a collection she called 'Conceptual Chic'. 'Awful colours, aren't they?' commented Rhodes in 1978. 'When I can't decide what colours I'll have for my new collection, I try and think of what colour really grates. Now I love cheap, punky lilac. Some colours just have more of an edge to them.'

Punk made uniformity redundant. Style – an obsession that peaked in the 1980s – was the elusive quality that everyone wanted. The question was how to acquire it without looking contrived. In 1976 *Vogue* put the 'Spotlight on Style', pointing out that 'Style is what everybody would like to think they have but very few do. Style has nothing to do with youth ... or age ... or sex. It has nothing to do with class or colour ... or money. Though richer, as Fanny Brice once remarked, is better.' The indefinable was due for a makeover: 'Style is badly in need of

redefinition. It's that quirk of the human psyche which hopefully makes every millionth Chinese wear his Mao suit in a way that 999,999 had never thought of.'

The body, no longer hidden beneath the voluminous shapes of the 1970s, was fashionable – a supple body became the ultimate accessory. *Vogue* featured a 'superfit leotard', 'roller disco beading', 'summer's great little stretch'. In 1979 collections focused on 'The BODY in fashion': 'Hot line equals bodyline – a wide-shouldered, waisted, long-legged look.' The Lycra revolution made skintight stretch a reality and body-consciousness possible – a plus when dancing to 'Boogie Wonderland'. *Vogue* said: 'DISCO – the music that made audience stars – is now international, not only as a sound, but as a word and world in itself ... While the public wants to perform, disco will continue to be their stage.'

Vogue viewed 'The 70s through the Looking Glass': 'This was the decade of onion dressing. We were into crypto stripping and there were moments of peek-a-boo.' Punk – aggressive, subversive and a complete shock to the system – was frequenting London's King's Road. In a club called The Blitz, a new style which involved piracy and pillaging, was being formed, cue: the New Romantics.

RIGHT **1970s' disco, with its flashing lights and feverish sounds, demanded a silky jersey playsuit which would allow the wearer to dance and glow at the same time.**

1980-89

For the New York teenager, the European or Japanese housewife, British fashion means pop videos on MTV and splashy Di and Fergie cover stories. To the world at large, our style is that which is worn by youth as its class extremes: British fashion in international markets *is* Rock 'n' Royalty.

Rock & Royalty, *Vogue*, August 1987

Britain's new ambassador for fashion had an aristocratic lineage, endless legs, and the combined charisma of Elizabeth I and Mary Queen of Scots. At 19 years old, Lady Diana Spencer possessed a shy smile and a firm grip on the public imagination – key ingredients, which made her the most photographed woman in the world. In May 1981 *Vogue* dedicated its 'Eye View' not to the minutiae of the collections, but to the new royal arrival: 'Five foot ten and long-legged like her mother, it is rather as if a charming young giraffe had wondered into the royal enclosure.'

The decade which worshipped status symbols and courted conspicuous dressing was rooted in romantic fantasy. Royalty and soap opera lived in parallel universes. In style and content, the line between television screen and tabloid newspaper became blurred. The twin obsessions of the 1980s were *Dynasty* and Diana, both bonded by the upwardly mobile shoulder pad. By 1980 punk burnt itself out and *Vogue* entered the decade with a series of exclamation marks on its cover: 'STARS! MORE! SUCCESS! WIN!'

LEFT **The woman whose face launched a thousand looks: Lady Diana Spencer, photographed by Lord Snowdon in February 1981, before her engagement was announced.**

OPPOSITE **Big hair and a self-assured stare – only the shoulder pads are missing. Herb Ritt's seminal 1988 fashion shoot was one of the most powerful of the decade.**

VOGUE

DEC
£2·20

MODERN LEGENDS

LEFT The ultimate arrival suit: in 1982 Giorgio Armani's immaculate tailoring and quiet confidence was the complete opposite to conspicous consumption.

Vogue pre-empted the royal engagement in its 'Portrait Portfolio' by Snowdon in February 1981. It was the first official sitting of the then 19-year-old Lady Diana Spencer – 'youngest daughter of the Earl Spencer and the Hon. Mrs Peter Shand Kydd' – dressed in a cream organdie and lace dress by Gina Fratini, and also photographed in a pale pink chiffon blouse by Emanuel. In the same issue *Vogue* turned its spotlight onto America's new First Lady, Nancy Reagan: 'A character briefing, run through a computer, would read something like this: 5 foot 4 inches, articulate, intelligent, immaculately groomed ... likes colour (especially red), designer fashion (especially Galanos and Adolfo).' On the Reagan way of life: 'Our style won't be the Carters' way or the Nixons' or

By 1980 Vivienne Westwood had abandoned bondage trousers and was experimenting with radical cutting. She dissected pirates, pillaged ideas from the past and opened a shop called World's End on London's King's Road, where the clock outside whirred backwards. The Japanese were already thinking along the same lines: Issey Miyake, forefather of intellectual dressing, joined by Rei Kawakubo and Yohji Yamamoto, took a more refined approach to origami pattern cutting. Japanese designers defied shopping logic by putting minute quantities of origami clothes in expansive areas of prime retail space.

Bruce Weber, who had worked on Ralph Lauren's advertising campaigns, pioneered the idea of a fashion shoot as stylish newsreel, seducing the customer with a mix of nostalgia, beauty and wide, open spaces. In January 1981 Weber was on the Santa Fe trail, shooting swimsuits in the Rio Grande, and re-creating the pioneering spirit at the TeePee Village on the Ghost Ranch Abiquiu.

OPPOSITE **'Beguia on The Bounty': Vivienne Westwood's pirate look 'in castaway cottons', which instigated New Romanticism, sold at World's End, London, 1981.**

RIGHT **Karl Lagerfeld arrived at Chanel in 1983 and brought with him a fresh perspective on the founder's original idea. The signature suit remained.**

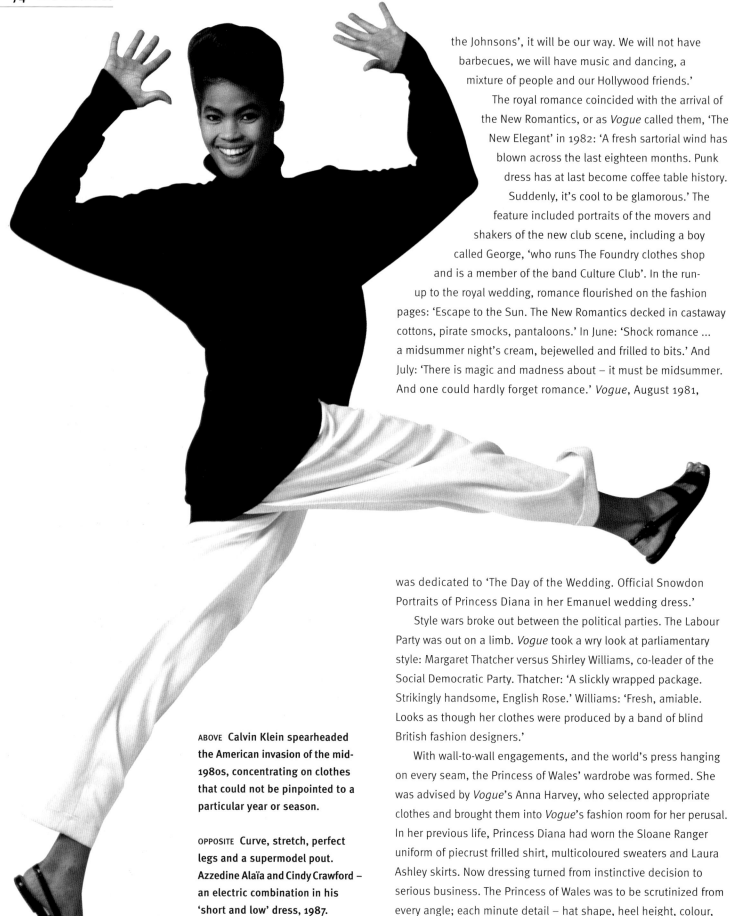

the Johnsons', it will be our way. We will not have barbecues, we will have music and dancing, a mixture of people and our Hollywood friends.'

The royal romance coincided with the arrival of the New Romantics, or as *Vogue* called them, 'The New Elegant' in 1982: 'A fresh sartorial wind has blown across the last eighteen months. Punk dress has at last become coffee table history. Suddenly, it's cool to be glamorous.' The feature included portraits of the movers and shakers of the new club scene, including a boy called George, 'who runs The Foundry clothes shop and is a member of the band Culture Club'. In the run-up to the royal wedding, romance flourished on the fashion pages: 'Escape to the Sun. The New Romantics decked in castaway cottons, pirate smocks, pantaloons.' In June: 'Shock romance ... a midsummer night's cream, bejewelled and frilled to bits.' And July: 'There is magic and madness about – it must be midsummer. And one could hardly forget romance.' *Vogue*, August 1981,

ABOVE **Calvin Klein spearheaded the American invasion of the mid-1980s, concentrating on clothes that could not be pinpointed to a particular year or season.**

OPPOSITE **Curve, stretch, perfect legs and a supermodel pout. Azzedine Alaïa and Cindy Crawford – an electric combination in his 'short and low' dress, 1987.**

was dedicated to 'The Day of the Wedding. Official Snowdon Portraits of Princess Diana in her Emanuel wedding dress.'

Style wars broke out between the political parties. The Labour Party was out on a limb. *Vogue* took a wry look at parliamentary style: Margaret Thatcher versus Shirley Williams, co-leader of the Social Democratic Party. Thatcher: 'A slickly wrapped package. Strikingly handsome, English Rose.' Williams: 'Fresh, amiable. Looks as though her clothes were produced by a band of blind British fashion designers.'

With wall-to-wall engagements, and the world's press hanging on every seam, the Princess of Wales' wardrobe was formed. She was advised by *Vogue*'s Anna Harvey, who selected appropriate clothes and brought them into *Vogue*'s fashion room for her perusal. In her previous life, Princess Diana had worn the Sloane Ranger uniform of piecrust frilled shirt, multicoloured sweaters and Laura Ashley skirts. Now dressing turned from instinctive decision to serious business. The Princess of Wales was to be scrutinized from every angle; each minute detail – hat shape, heel height, colour,

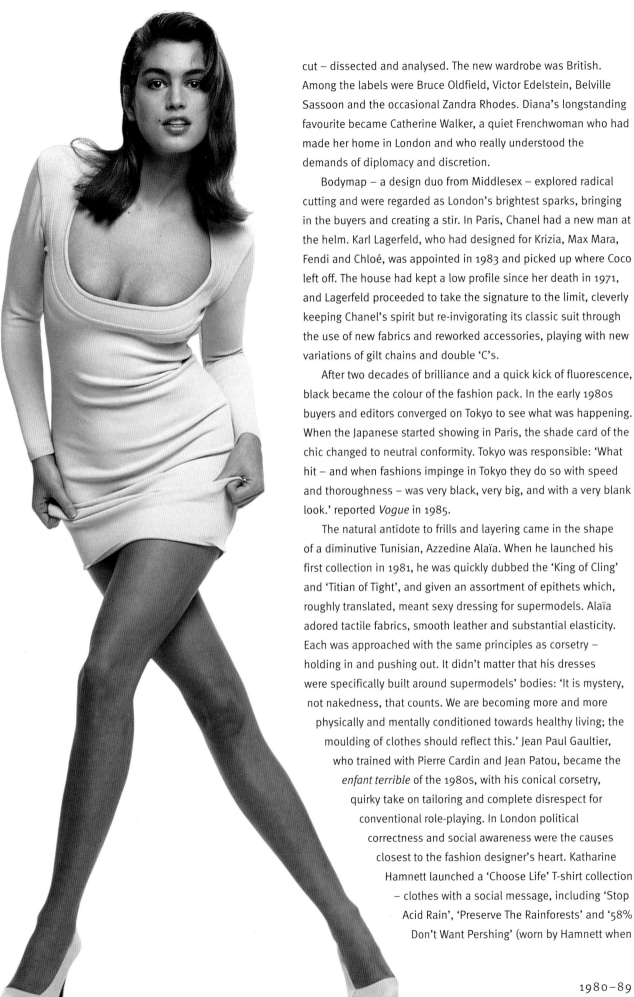

cut – dissected and analysed. The new wardrobe was British. Among the labels were Bruce Oldfield, Victor Edelstein, Belville Sassoon and the occasional Zandra Rhodes. Diana's longstanding favourite became Catherine Walker, a quiet Frenchwoman who had made her home in London and who really understood the demands of diplomacy and discretion.

Bodymap – a design duo from Middlesex – explored radical cutting and were regarded as London's brightest sparks, bringing in the buyers and creating a stir. In Paris, Chanel had a new man at the helm. Karl Lagerfeld, who had designed for Krizia, Max Mara, Fendi and Chloé, was appointed in 1983 and picked up where Coco left off. The house had kept a low profile since her death in 1971, and Lagerfeld proceeded to take the signature to the limit, cleverly keeping Chanel's spirit but re-invigorating its classic suit through the use of new fabrics and reworked accessories, playing with new variations of gilt chains and double 'C's.

After two decades of brilliance and a quick kick of fluorescence, black became the colour of the fashion pack. In the early 1980s buyers and editors converged on Tokyo to see what was happening. When the Japanese started showing in Paris, the shade card of the chic changed to neutral conformity. Tokyo was responsible: 'What hit – and when fashions impinge in Tokyo they do so with speed and thoroughness – was very black, very big, and with a very blank look.' reported *Vogue* in 1985.

The natural antidote to frills and layering came in the shape of a diminutive Tunisian, Azzedine Alaïa. When he launched his first collection in 1981, he was quickly dubbed the 'King of Cling' and 'Titian of Tight', and given an assortment of epithets which, roughly translated, meant sexy dressing for supermodels. Alaïa adored tactile fabrics, smooth leather and substantial elasticity. Each was approached with the same principles as corsetry – holding in and pushing out. It didn't matter that his dresses were specifically built around supermodels' bodies: 'It is mystery, not nakedness, that counts. We are becoming more and more physically and mentally conditioned towards healthy living; the moulding of clothes should reflect this.' Jean Paul Gaultier, who trained with Pierre Cardin and Jean Patou, became the *enfant terrible* of the 1980s, with his conical corsetry, quirky take on tailoring and complete disrespect for conventional role-playing. In London political correctness and social awareness were the causes closest to the fashion designer's heart. Katharine Hamnett launched a 'Choose Life' T-shirt collection – clothes with a social message, including 'Stop Acid Rain', 'Preserve The Rainforests' and '58% Don't Want Pershing' (worn by Hamnett when

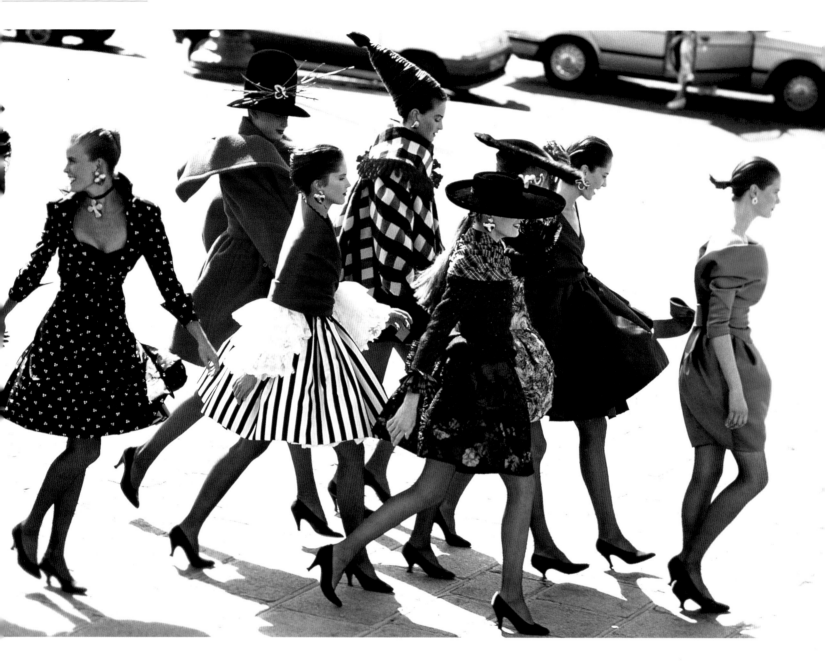

she met the prime minister at Downing Street in 1984). Two years later, designers banded together to form 'Fashion Aid', a benefit at the Royal Albert Hall in London.

John Galliano graduated from London's Central Saint Martins College of Art and Design in 1984 with a first-class honours degree, a collection called 'Les Incroyables', and a line-up of models whose expressions implied they were facing the guillotine. It was not until 1988 that he was on his way to becoming that rarest of breeds: a British designer with world appeal. 'To be international,' he told *Vogue*, 'is to appeal to everyone.'

Mid-way through the decade, American designers were talking concept, sensing the *Zeitgeist* and formulating collections which were flexible in more ways than one. The working wardrobe

required effective subliminal messages. The power suit, the short skirt, the heel – which said sexy but could also walk the length and breadth of the boardroom – all required a dress code that wouldn't cause alarm in the office, the bank and the stock exchange. In September 1985 Donna Karan showed her first solo collection since working as principal designer at Anne Klein. Karan's mantra was women with curves and busy lives to lead – 'clothes that would travel, interchange and impress'. Her basis was the wool jersey body suit, to which a tubular skirt, elasticated sarong or wool wrap was added, then simple pieces of 24-carat plate jewellery by Robert Lee Morris were added or subtracted: 'Everything she needs to refine or elaborate her look is contained within the collection.'

OPPOSITE Christian Lacroix
introduced the puffball skirt
and 'spurred everyone on to
new heights of lively, short and
seductive' at his debut in 1987.

RIGHT Turning fashion upside
down and throwing the rule book
out of the window. Rei Kawakubo's
'body bunch and random elastic'
at Comme des Garçons, 1984.

The new consumer bought Calvin Klein underwear with his signature woven into the elastic waistband. A Versace or Armani outfit could be spotted from 500 yards by the new designer literate. Gianni Versace – glitzy, glamorous and the epitome of Italian excess – presented his first collection in 1978, and by 1985 he had built, on one line alone, 70 Versace boutiques throughout the world. Giorgio Armani symbolized Milan's other side: subtle tailoring, soft shoulders, and a look that became the corporate uniform for the world's financial whiz kids. In 1987 the puffball skirt blew in and out of fashion and Christian Lacroix, a 36-year-old from Arles, France, had left Jean Patou to open his own couture house. Lacroix's lush cartwheel hats, coloured silks, froufrou skirts and seemingly irreverent approach to the reverential traditions of Parisian couture was a persuasive message for the younger customer. The following year, Diana, Princess of Wales and Sarah, Duchess of York held court to their individual sets of designers. *Vogue* cited 'Rock and Royalty: Fashion's most powerful influences' and in January 1988 switched to parliamentary matters: 'Dressing for political life is serious business; stakes are high and traps await the unwary.'

Twelve years before the dawn of the twentieth century, *Vogue* detected a disparity between designers. Some looked forward, others back; Calvin Klein, Donna Karan, Versace and Armani occupied the middle ground. Among the historians were Romeo Gigli, John Galliano and Christian Lacroix, who said, 'Every one of my dresses possesses a detail that can be connected with something historic, something from a past culture. We don't invent anything.' In the minimalist camp were Comme des Garçons, Yohji Yamamoto and Geoffrey Beene, who predicted, 'There will be a backlash against overdressing and ostentation. Economic conditions will change things, clothes will have to work for life. I don't like to look backwards – it's not fun, it's not challenging, and it's been done before.' Both designers were right. Soap opera style changed from a symphony of shoulder pads to a workable wardrobe, which appeared – even if it had an Armani label inside – to intertwine with real life. *Thirtysomething* was soothing escapism for baby-boomers, who walked around in crumpled chinos and expressed angst about their relationships. Said *Vogue*'s 'Eye View' for winter 1989: 'The first clothes we shall wear in the nineties are designed to caress the senses and soothe the spirit. The hard style of the work ethic has modulated into a new sense of the importance of balance and well-being. From eighties office clone to the nineties woman of feeling – the new psychology starts here.'

Over Christmas 1989 *Vogue* reported the death of Diana Vreeland, the legendary editor of American *Vogue*, whose favourite directive was, 'astound me'. Karl Lagerfeld photographed Princess Caroline of Monaco, *Vogue* featured Diana, Princess of Wales at Highgrove with her children and picked the Mona Lisa as 'the most desirable pin-up in the world'. There was an analysis of glamour by British *Vogue*'s editor, Alexandra Shulman: 'The glamorous should not be like anyone else: Elizabeth Taylor should not have a weight problem, the royal family should not have dull, domestic spats. If glamour is a projection by the observer, whether based on envy or desire, it can always be withdrawn. Exposure and enigma are an irresistible mix.'

1990-99

Parisians do not have nightmares about being run over, rushed to hospital and caught out wearing holey grey knickers. It couldn't happen. Firstly, Parisians never leave the house in anything less than a perfect state of attire. Secondly, they do not possess holey grey knickers. Their reasoning? You wear grey knickers, your man has an affair.

French Polish, *Vogue*, May 1998

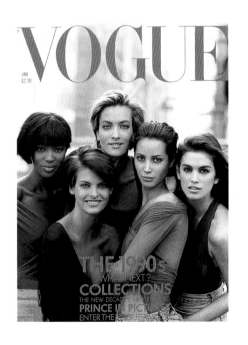

Five women who won the genetic lottery appeared on *Vogue*'s first cover of 1990. Naomi Campbell, Linda Evangelista, Tatjana Patitz, Christy Turlington and Cindy Crawford all smiled in Giorgio di Sant'Angelo stretch, faded jeans and invisible make-up. The supermodels had superseded movie-star celebrity. They were lusted after for their looks, admired for their power and revered in the 'greed is good' 1980s for refusing to get out of bed for less than $10,000 a day.

The 1990s became the decade of the mixed message. In the space of ten years, the power shoulder was exterminated, accessories escalated, the classic cardigan hit the office, big hair was cut to the quick, matt glamour disappeared, slip-dresses came out of the closet, and just when supermodels were hitting their stride, their fascination expired.

Baby-boomers had reached a point where laughter lines and middle age were staring them in the face. *Vogue* talked about 'Real Life Fashion', with older role models arriving on cue. Isabella Rossellini signed another contract with Lancôme at the age of 39. Lauren Hutton, who had joined the Eileen Ford agency in 1966, was, by October 1991,

LEFT The supermodel was a 1980s' phenomena, which reached its zenith in 1990 when five of its most famous faces posed for Peter Lindbergh.

OPPOSITE Experimental shapes for a new millennium: Givenchy, under the direction of Alexander McQueen, has introduced 'sexy structure', April 1998.

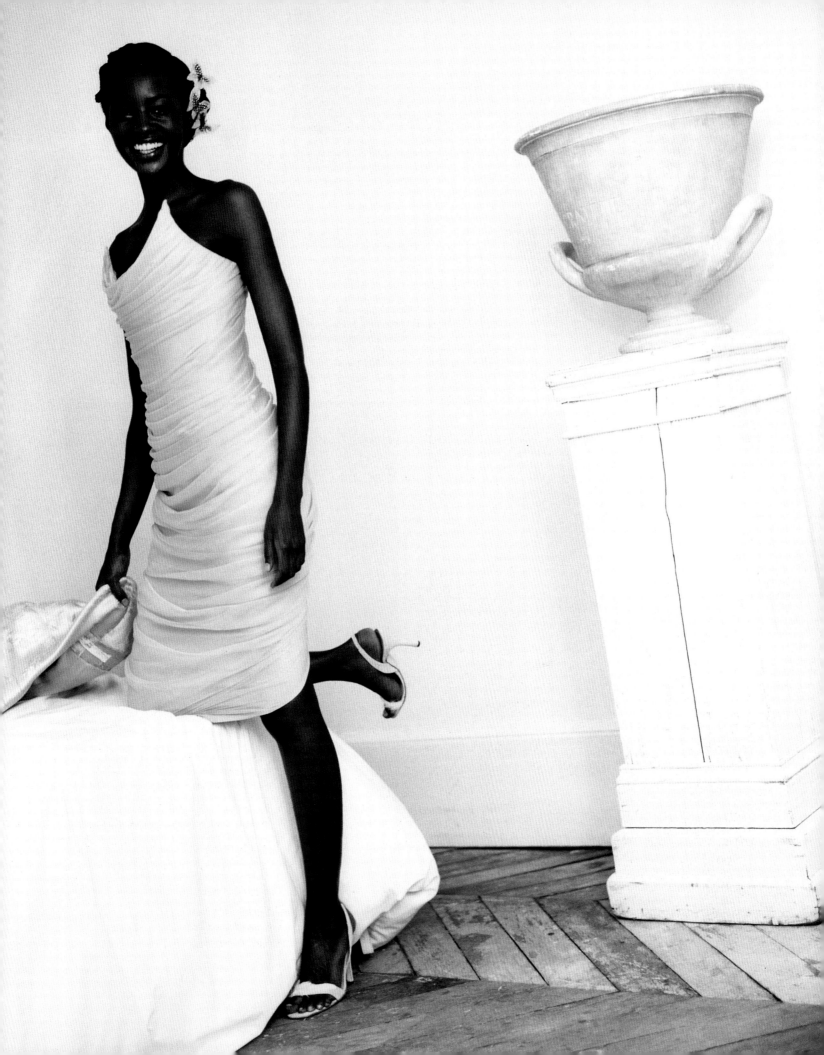

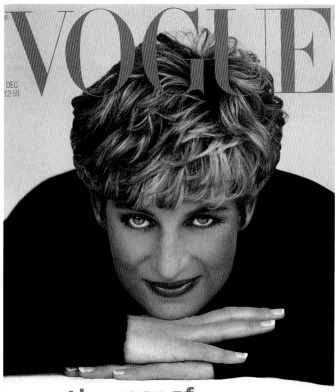

Skirt'. What seemed an impossibility at the end of the 1980s was now set in stone: 'In Britain, the verdict is in on the long skirt. We like it.' By August the long skirt had gone global: 'Autumn 1992 is the season of the quiet revolution. By unanimous international vote, long skirts and trousers are already *faits accomplis*. The change starts with a fixed idea of elegant, elongated line from which everything else flows.'

The 1990s fashion designer no longer created clothes with complementary cosmetics and scent; customers wanted to buy into a lifestyle. Calvin Klein, whose perfumes – Obsession in 1984 and Eternity in 1987 – had captured the mood of the moment was ready to 'Escape'. Interviewed in his East Hampton retreat with his wife Kelly in November 1991, he said: 'There's going to be a big change in the nineties and it's only just beginning. The eighties were a very conservative period, sexually and in so many ways. There's a restructuring of

almost 48 years old and working with hip photographer Steven Meisel. 'One of the nicest things about Steven is the way he encouraged me to be my age,' said Hutton. 'He didn't want me to look pert, or this or that ... he wanted me to look as I felt at that time, which of course means I can feel fifteen one day and a hundred-and-fifty another – and of course look it!'

As fashion became fixated with the here and now, there were two major fashion flashbacks. Just as the 1970s had resurrected the 1920s and 1930s, so the 1990s reinvigorated the 1960s and 1970s with flares (later called bootlegs) and platform shoes. In spring 1990 stretch leggings replaced tailored trousers, with Pucci print versions the must-have of the moment.

By 1992 the power suit had been given the last rites and in July of that year *Vogue* sounded the death knell when it said, 'RIP The Short

ABOVE **Diana, Princess of Wales was** *Vogue***'s cover girl in December 1991 for the first time since her marriage – wearing a black polo neck, with a new tousled haircut.**

RIGHT **The Versace dress from the spring/summer 1994 collection, which made actress Elizabeth Hurley's career and put a new slant on safety pins.**

priorities. It's less about flash and more about people in the streets, the environment. People are becoming more real.' In September 1994 Ralph Lauren, photographed at his 250-acre estate in Bedford, New York, became past master of retail seduction: 'I like faded and old, you know, I *like* shabby. It's not a mania for Englishness, it's a matter of ... integrity.'

British *Vogue* celebrated its seventy-fifth anniversary in June 1991, with Linda Evangelista, Christy Turlington and Cindy Crawford on the front cover. In December the cover girl was Diana, Princess of Wales, photographed by Patrick Demarchelier and sporting a new, short haircut, courtesy of Sam McKnight. She wore a plain black sweater, her chin resting on her hands. The royal divorce meant that the former HRH was free to dress as she pleased. Protocol no longer mattered. Valentino, Chanel, Lacroix and Versace were all sported as the newly single princess started to show the hallmarks of someone starting afresh: lower necklines, shorter skirts and – now that she was no longer concerned about towering over her husband – higher heels.

London was on the brink of a fashion renaissance not seen since the 1960s. Alexander McQueen graduated from Central Saint Martins College of Art and Design in 1992 and his work appeared for the first time in British *Vogue* in November of that year, worn by *Vogue* stylist Isabella Blow. McQueen's opening gambit – bumster trousers – divided the press. Although fans said they were the best thing since sliced bread, the critics pointed out that bumsters – low-slung trousers which left little to the imagination – were par for the course on building sites. The following year, grunge – a sub-culture which started in Seattle, USA – spawned a new kind of fashion shoot and a different way of posing. Kate Moss captured the look in *Vogue*'s first grunge shoot in 1993, photographed in a sparse flat with a suitably vacant expression.

When Elizabeth Hurley arrived at the premiere of the film *Four Weddings and a Funeral* (1994), her curves held in place by Versace's silk crepe and a series of safety pins, notoriety and a lucrative Estée Lauder contract followed. In 1998 the memory had transcended into fashion history: 'Her arrival in "that" Versace dress has the same kind of significance in tabloid folklore that the Nativity does to Christians: the moment at which a star was born.' *Vogue*'s Christmas 1993 issue featured two new models and paved the way for the modern aristocratic muse: Honor Fraser,

RIGHT **Kate Moss, complete with fairy lights, wore a Liza Bruce vest and translucent G-string to star in *Vogue*'s first grunge shoot, June 1993.**

photographed at the family seat in Inverness-shire, and Stella Tennant, in a dilapidated part of Spitalfields, east London, sporting a ring through her nose. However, Cindy Crawford faced a far more pressing dilemma than which designer to wear: she was getting older. With a fashion consensus that was saying young, gauche and skinny, Cindy Crawford was curvy, womanly and nudging 30. 'She recently turned down the idea for a Cindy Doll, complete with mole, which would have made her a ton of money,' reported *Vogue*. 'I'd get too much shit for doing that. In my mind, I kept seeing the promotional picture of me holding a doll dressed in exactly the same clothes I was wearing. That picture would speak a thousand words – and they're not the thousand words I want spoken.'

In 1990 Marc Bohan, ex-Dior designer, was asked to take over at Norman Hartnell in London. Then, in November 1995, John Galliano made history as the first British designer to be appointed

head of a French couture house when he went to Givenchy. Two years later he was head-hunted by Dior and presented his first collection in January 1997. It was a pivotal moment for Paris couture and the fulfilment of a delicious dream for Galliano. When Gianfranco Ferre left a vacant space at Christian Dior, musical chairs commenced: Galliano went to Dior, Alexander McQueen went to Givenchy and Stella McCartney took over at Chloé. Then the Americans landed: Michael Kors was appointed at Céline and Narciso Rodriguez – a virtual unknown until he designed Carolyn Bessette Kennedy's wedding dress in 1996 – took over the helm at Loewe. Marc Jacobs moved to Louis Vuitton and Alber Elbaz, a protégé of Geoffrey Beene, went to Guy Laroche and later to Yves Saint Laurent, overseeing the ready-to-wear collection while the maestro concentrated on couture.

Just as the four fashion capitals achieved equal footing, they were joined by a fifth: in Belgium, Dries Van Noten, Martin Margiela and Ann Demeulemeester comprised a new brand of fashion intelligentsia, which was on a par with the Japanese. *Vogue* took a wry look at the breed: 'While still at kindergarten in Antwerp, the Belgian designer had a strong vocational calling. But ten years and three Patti Smith albums later, she discovered that you don't have to be a Carmelite nun to wear groovy black clothes. Designers, too, can credibly go the Goth route.'

Designer logos no longer shouted conspicuous consumption, but whispered subliminal messages. The Gucci snaffle, the Hermès bag, the small but perfectly

formed Prada triangle in silver and black were all 1990s' symbols for chic and hip, understood only by those who knew the precise code. Martin Margiela headed Hermès; Tom Ford gave Gucci a new lease of life. Even though the designers were high profile, it was the brand and not the individual that was gaining momentum.

As the millennium drew closer, *Vogue* traced the disappearance of the Chanel button and the death of the personal trainer. The 'in' accessory was a more accessible way of giving potential customers a piece of the action. During the 1990s, style switched seasonally, from Prada's nylon bag to Fendi's baguette. Eventually, the designer bag wasn't held in the hand but, instead, hugged the body. London produced designers who were being taken very seriously. Hussein Chalayan, who veered more towards fine art than fashion, was one of the few British designers to focus on minimalism, designing cashmere for TSE in New York and dressing Icelandic singer-songwriter Björk: 'Fashion is so transient now. I'm trying to give my work constant development – both conceptually and aesthetically. Sex has always sold fashion, and I'm just tired of it.'

The sudden, tragic death of Diana, Princess of Wales was marked with a tribute by *Vogue*'s Anna Harvey in October 1997: 'It is said she was more beautiful in the flesh. Once, on a visit to *Vogue*, the art department, who'd been quite cynical about her, were agog. She had sparkle. It was simply magnetic and, in the end, it transcended her clothes.'

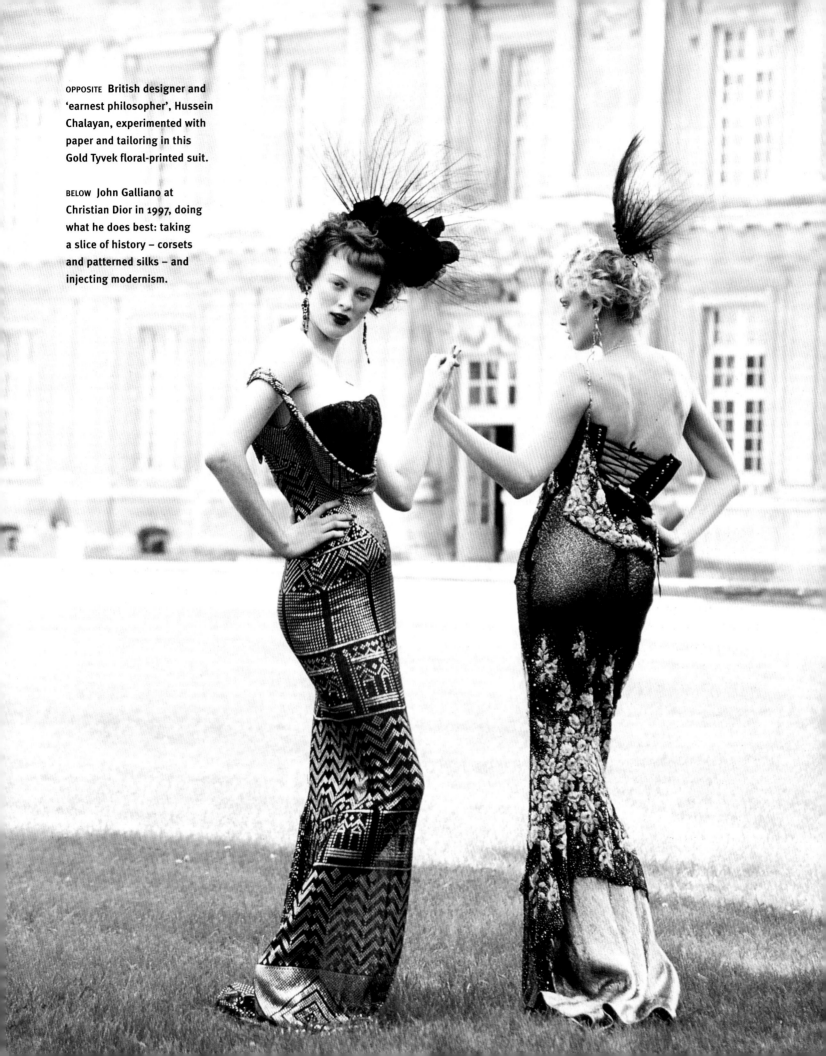

OPPOSITE **British designer and 'earnest philosopher', Hussein Chalayan, experimented with paper and tailoring in this Gold Tyvek floral-printed suit.**

BELOW **John Galliano at Christian Dior in 1997, doing what he does best: taking a slice of history – corsets and patterned silks – and injecting modernism.**

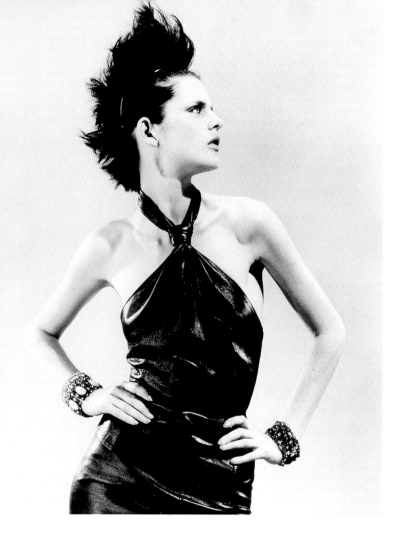

The fashion show became a new form of performance art. Alexander McQueen was becoming just as famous for theatrics as his avant-garde attitude to cutting. 'Alexander said he wanted the paint guns to look like snakes rearing up to attack,' *Vogue* reported of his show that simulated urban carnage with burning cars. 'When people started rioting to get in, I remember running backstage and thinking, "Well, Alexander's famous now."'

Author Helen Fielding, alias Bridget Jones, scored a double whammy when she tapped into one of the most important social changes of the century and added 'singleton' and 'smug marrieds' into the general vocabulary. 'The office for National Statistics predicts that by the Year 2000, a quarter of all women will be single.' For the woman with an escalating disposable income and a tenuous grasp on her emotions, retail therapy was a soother of senses; a tangible form of spiritual uplift, a new kind of designer deliverance.

At the first couture collection after the death of her brother Gianni in 1997, Donatella talked about diluting the full-on Versace glamour and concentrating on more refined designs: 'That's what people really wear. I want to make clothes that can be worn all the time but are still extraordinary.' Women began searching for something more meaningful than designer labels and desirable logos: antique clothes with a sense of history. *Vogue* wrote, 'As we head towards 2000, fashion is travelling back in time to the *fin de siècle*, when femininity held sway and the emphasis was on soft sensuality.' In 1999 *Vogue* focused on 'Fashion's New Medicis' – designers who were moving into the art world. When Gucci sponsored the exhibition 'The Work of Charles and Ray Eames' at London's Design Museum in 1998–9, the museum's director said: 'Let's face it, more people have heard of Gucci than the Eameses.' Discussing his collaboration with artist Jenny Holzer, Helmut Lang told *Vogue* that he wanted to develop a perfume that 'would smell of the human body – like clothes that had been worn but were still fresh'.

RIGHT **Eclectic antique clothing, or collections which gave that sensation, ran parallel to purism at Dries Van Noten's autumn/ winter 1998 collection.**

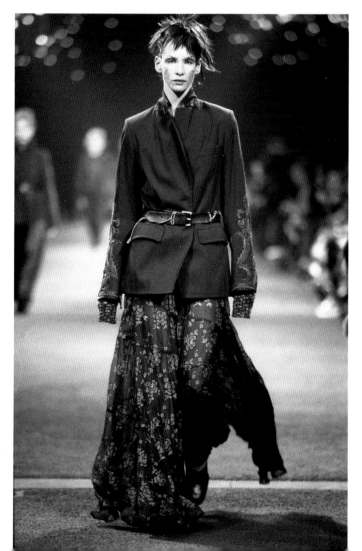

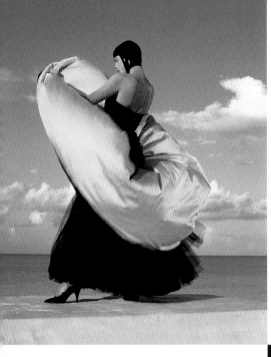

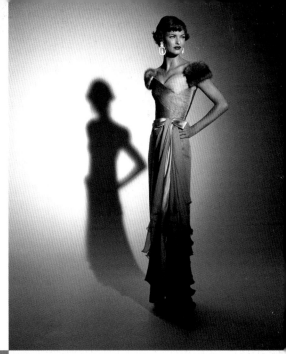

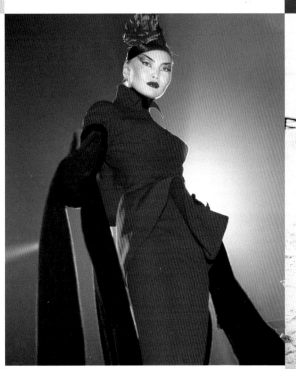

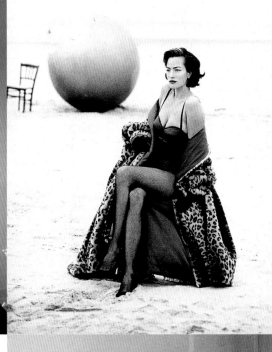

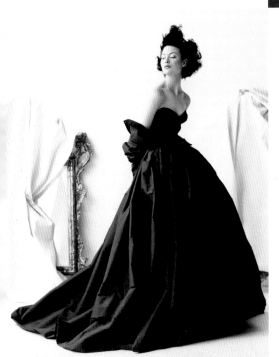

the designers

ADOLFO

BORN: CARDENAS, CUBA, 1933

'Since Nancy Reagan, one of Adolfo's biggest fans, has become first lady, the crush to get a front-row seat became an upmanship scene,' reported American *Vogue* in 1981. Designer to New York's socially significant, Adolfo's first client was Gloria Vanderbilt and his most famous was former first lady, Nancy Reagan, for whom he made a red wool inauguration coat and matching braided toque.

When Adolfo closed his New York salon in April 1993, it signalled the end of an era, which began in 1948 when Adolfo F Sardina arrived in New York from Cuba. Like Halston, Adolfo initially trained as a milliner, before working first at Bergdorf Goodman and then at Emme. In 1967 he established his own ready-to-wear business. The Adolfo look was never experimental, rather a quiet classic style – with shades of Chanel – which enabled the wearer to glide effortlessly through social situations.

ADRIAN, Gilbert

BORN: NAUGATUCK, CONNECTICUT, USA, 1903
DIED: LOS ANGELES, CALIFORNIA, USA, 1959

'Twelve hundred costumes, five thousand wigs and fripperies for two poodles were Adrian's pre-occupation during the filming of *Marie Antionette*,' noted *Vogue* in 1938. The most prolific costume designer of Hollywood's heyday, Gilbert Adrian's square 'coathanger' shoulders and elongated silhouette captured the audiences and knocked Paris off kilter. Adrian designed for every Hollywood beauty, including Jean Harlow in *Dinner at Eight* (1933), Joan Crawford in *Letty Lyndon* (1932) and Katharine Hepburn in *The Philadelphia Story* (1940). His first film costumes were for Rudolph Valentino in *The Eagle* in 1925.

Adrian – born Adrian Adolph Greenburg – had creativity in his genes: his father ran a millinery business, his mother was an artist, his uncle a theatrical designer. In 1921 he enrolled at Parson's School of Design in New York to study fashion and was transferred to Paris, where he met Irving Berlin.

He returned to New York, designing for Berlin's *Music Box Reviews*, before moving to Paramount to work with the film producer and director Cecil B de Mille.

In 1941 he formed Adrian Limited, a ready-to-wear business based in Beverly Hills, and showed his first collection the following year. He launched two complementary fragrances, Saint and Sinner, in 1946 and opened a boutique in New York in 1948. After suffering a heart attack, he retired with his wife, actress Janet Gaynor, to recuperate in Brazil. In 1959 Adrian died, having returned to his first love, designing costumes for the Lerner and Loewe production, *Camelot*.

AGNÈS B

BORN: VERSAILLES, FRANCE, 1943

Eclectic, young and with the simplicity of a school uniform, the Agnès B label has branches in London, Tokyo, Los Angeles and Amsterdam. Her first customer was actress Dominique Sandra.

In the mid-1970s, having worked as a fashion editor and assistant to designer Dorothée Bis, Agnès B designed her own collection and opened a boutique in 1976. Agnès B also designs specifically for teenagers and children, and produced a maternity collection: fitting for a woman who at 43 had four children and one grandchild. 'I always make things I would wear,' she told *Vogue* in 1986. 'I love white, I love black, and I love finding new colours. I think people like my clothes because they can be neutral.'

AGNÈS, Madame

BORN: FRANCE, LATE 1800S
(ACTIVE: 1910–40)

Agnès hats, named after their maker, appeared regularly in *Vogue* in the 1920s and 1930s. She could turn her hand to the occasional incredible concoction, but mostly Madame Agnès made chic cloches, swirling felts and variations on a beret that had been popularized by Marlene Dietrich. During the 1920s millinery was a fine art which became an occupation of the chic, and Madame Agnès, photographed by *Vogue* in 1925 wearing a futurist dress and angular earrings – both heavily influenced by the Cubists – was a prime example.

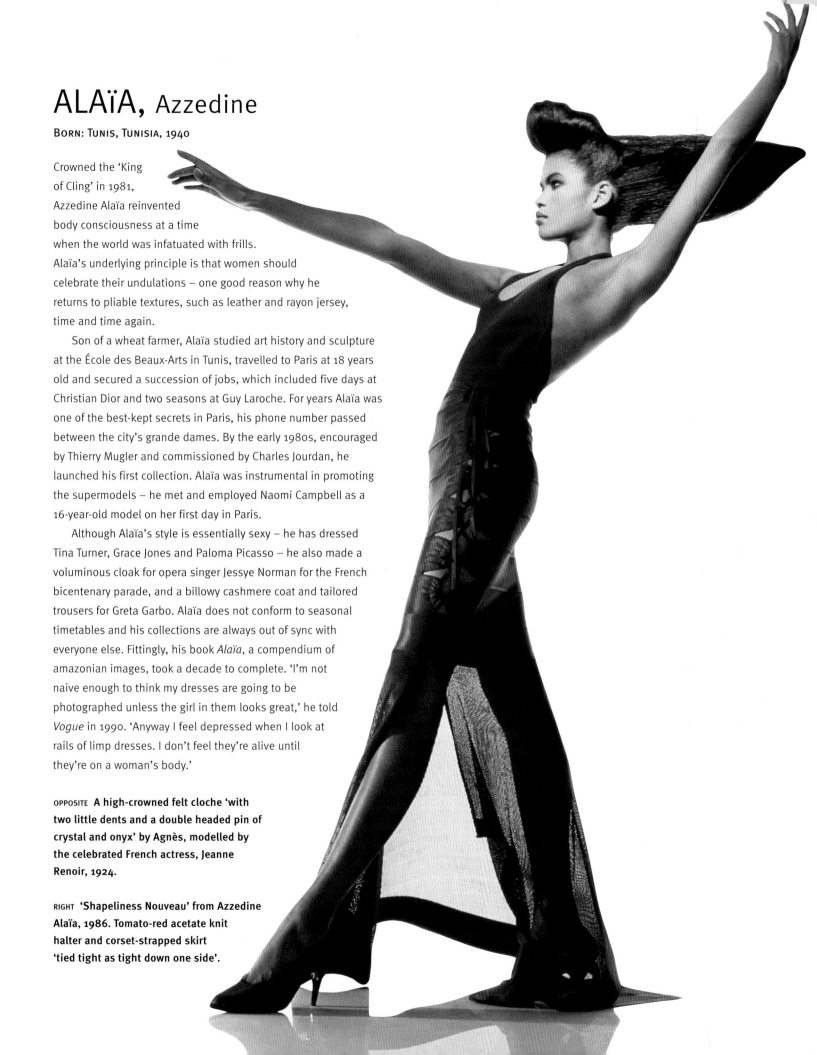

ALAïA, Azzedine

BORN: TUNIS, TUNISIA, 1940

Crowned the 'King
of Cling' in 1981,
Azzedine Alaïa reinvented
body consciousness at a time
when the world was infatuated with frills.
Alaïa's underlying principle is that women should
celebrate their undulations – one good reason why he
returns to pliable textures, such as leather and rayon jersey,
time and time again.

Son of a wheat farmer, Alaïa studied art history and sculpture
at the École des Beaux-Arts in Tunis, travelled to Paris at 18 years
old and secured a succession of jobs, which included five days at
Christian Dior and two seasons at Guy Laroche. For years Alaïa was
one of the best-kept secrets in Paris, his phone number passed
between the city's grande dames. By the early 1980s, encouraged
by Thierry Mugler and commissioned by Charles Jourdan, he
launched his first collection. Alaïa was instrumental in promoting
the supermodels – he met and employed Naomi Campbell as a
16-year-old model on her first day in Paris.

Although Alaïa's style is essentially sexy – he has dressed
Tina Turner, Grace Jones and Paloma Picasso – he also made a
voluminous cloak for opera singer Jessye Norman for the French
bicentenary parade, and a billowy cashmere coat and tailored
trousers for Greta Garbo. Alaïa does not conform to seasonal
timetables and his collections are always out of sync with
everyone else. Fittingly, his book *Alaïa*, a compendium of
amazonian images, took a decade to complete. 'I'm not
naive enough to think my dresses are going to be
photographed unless the girl in them looks great,' he told
Vogue in 1990. 'Anyway I feel depressed when I look at
rails of limp dresses. I don't feel they're alive until
they're on a woman's body.'

OPPOSITE **A high-crowned felt cloche 'with
two little dents and a double headed pin of
crystal and onyx' by Agnès, modelled by
the celebrated French actress, Jeanne
Renoir, 1924.**

RIGHT **'Shapeliness Nouveau' from Azzedine
Alaïa, 1986. Tomato-red acetate knit
halter and corset-strapped skirt
'tied tight as tight down one side'.**

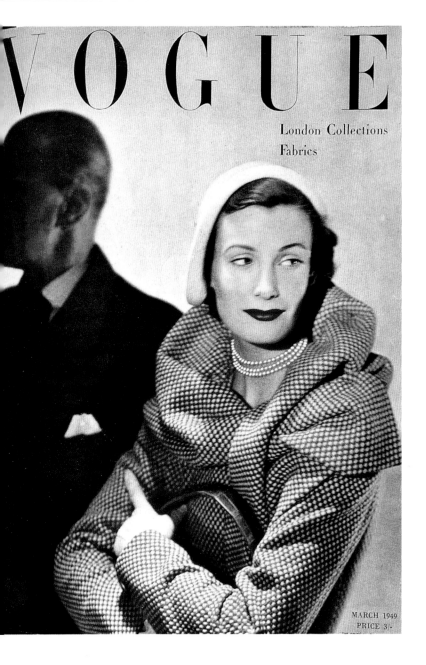

LEFT **Hardy Amies' first *Vogue*
cover, March 1949, photographed
by Norman Parkinson, shows
an Amies shawl-collared jacket
with ubiquitous pearls and
Agmar cloche.**

OPPOSITE **Giorgio Armani's
sequinned 'sunbeaded'
sarong dress with shoestring
shoulder straps, worn by
supermodel Claudia
Schiffer in 1991.**

AMIES, Sir Hardy

BORN: LONDON, ENGLAND, 1909

England's most distinguished designer has become something
of an *enfant terrible* in his old age, frequently consulted by style
pundits for his outspoken opinions on everything from modern
manners to the minutiae of old-fashioned roses (his favourite is
a subtly striped variety called *Rosa* 'Mundi').

Hardy Amies was educated at Brentwood. His father was a
London County Council surveyor, his mother a *vendeuse* at a court
dressmaker called Miss Gray Limited. In 1934 he became head
designer at Lachasse, taking over from Digby Morton. During the

Second World War, Amies, who was fluent in French and German,
joined the Intelligence Corps, working for the Special Operations
Executive as head of the Belgium section, organizing the dropping
of Resistance workers during the occupation. In 1945 he opened
his house at 14 Savile Row, London, a property formerly owned by
restoration playwright, Richard Brinsley Sheridan. He presented his
own-name collection the following year. Hardy Amies has been the
Queen's dressmaker since 1950, when Princess Elizabeth, as she
was then, made her first royal tour of Canada. He has made clothes
for every royal tour since, his *pièce de résistance* being the pink
dress the Queen wore in Jubilee year.

Described by *Vogue* in 1960 as 'a brisk, dynamic man with
a finger in innumerable pies', Hardy Amies has always been a
vigorous promoter of his own business. In the early 1960s he
frequently travelled to America and Australia on promotional
tours. By 1964 he was head of a successful business, which
included couture, a boutique and a ready-to-wear collection,
and had a turnover of £15 million in menswear and £750,000
in womenswear. He owns a flat in London's Kensington and
a converted Victorian school in Gloucestershire.

Amies has witnessed a very significant fashion revolution of
the twentieth century and has made a valuable contribution to
British fashion: first to the Government's wartime utility scheme,
which made Britain count on the world stage, and secondly,
incisively predicting the onset of the New Look. The house is now
run by design director Jon Moore, and menswear by Ian Garlant;
but, at 90 years of age, Sir Hardy still works a three-day week.

Hardy Amies was awarded a CVO in 1977 and in 1989
a KCVO – a non-political knighthood awarded only to those
who work closely with the Queen. He has published two
autobiographies, *Just So Far*, in 1954, and *Still Here*, 30 years
later. A decade after that he wrote *The Englishman's Suit* –
a wry look at sartorial propriety. Speaking about style to *Vogue*
in 1984 he said, 'The greatest enemy of style is gentility because
style is honesty.' At his spring/summer 1999 couture show,
Sir Hardy, immaculately dressed and sitting at the back of the
salon, instructed the audience to savour the moment. 'Why
don't you clap?' he said loudly while the models were mid-twirl,
'It's a *marvellous* outfit.'

ARMANI, Giorgio

BORN: PIACENZA, ITALY, 1934

'In Italy, fashion is logical, rational and wearable,' observed Giorgio Armani in 1986. 'I do not allow myself the luxury of waiting for inspiration. The birth of a new collection is a drama, of course. But in the end I sit down alone at a sheet of white paper, and design.' Architect of the soft shoulder and fluid suit, Giorgio Armani is the undisputed king of Italian tailoring, revered by his contemporaries and customers alike.

Having studied medicine at the University of Bologna, Armani left in 1953 to serve in the Italian army. In 1954 he was employed as a window-display designer and stylist, and eventually became menswear buyer for La Rinascente department store chain. He designed menswear for Nino Cerruti from 1960–70, followed by five years of freelance work, culminating in the launch of his own menswear collection, instigated by his close friend and business partner Sergio Galeotti in 1975.

Armani spent almost 20 years analysing fashion from different angles – and it shows. He sees clothes in the round and the fashion industry as a complete entity, its quiet evolution rather than earth-moving revolution. He isn't into trickery. He sells. He delivers. No wonder Armani is the biggest-selling European designer in the USA. Myths and legends surround the designer with his white hair, permanent tan and calm veneer, but the picture

BELOW **Armani's ultimate designer arrival suit: pale grey and cream wool plaid with shoulder pads, 'very Katharine Hepburn', 1987.**

emerges of a perfectionist who dictates the precise distance between hangers, allows his cats to eat from starched white napkins, and only handles credit cards, never cash. His staff say he resembles Rodin's *Thinker* while designing.

During the designer decade, Armani was the symbol of success among the stockbrokers and financial whiz kids around the world – a quiet, assured label which spoke a thousand words about salary levels and business hierarchy. The recipient of numerous awards, Armani's accolades include the Grand Ufficiale dell'Ordine al Merito della Republica – the highest government award – and a doctorate from the Royal College of Art. His doctorate for design excellence put him on a par with architect Sir Norman Foster and David Lynch, director of *Twin Peaks* (1989).

Armani always has a strong presence at the Oscars and has dressed the A-list of screen stars including Jodie Foster, Anjelica Huston, Michelle Pfeiffer and Robert de Niro. He made clothes for *The Untouchables* (1987) and *American Gigolo* (1980). The director Martin Scorsese made a 26-minute documentary film about Armani's collection, called *Made in Milan*, which was launched at the Venice film festival in September 1990. Armani now has a Los Angeles representative to coordinate celebrity clients but in 1987 he protested, 'Please don't call me a celebrity designer. I like designing for people who work, so that includes actors and actresses, but as people who work, not as stars.'

ASHLEY, Laura

BORN: MERTHYR TYDFIL, WALES, 1925
DIED: COVENTRY, ENGLAND, 1985

Advocate of the piecrust frill and full-blown ballgown, Laura Ashley began her business by silk-screen printing textiles on her kitchen table. Together with her husband, Bernard, Ashley started selling scarves to John Lewis. Laura Ashley Limited was established in 1968 when the couple opened their first outlet in Pelham Street, Kensington. The design ethos – puffed sleeves, smocks and voluminous dresses with patch pockets – were available in a variety of pretty cotton prints, including stripes, spots and floral sprigs. At its height – during the 1960s, 1970s and 1980s – there were Laura Ashley shops in Paris, Geneva, New York and San Francisco. By 1989 Laura Ashley sold lawn fabrics, printed cottons and linens, and won the Queen's Award for Export Achievement in 1977. Laura Ashley turned down an OBE because her husband wasn't offered one too, but Buckingham Palace made amends in 1987 and gave him a knighthood. As a consequence of boardroom shuffles and shifting fashion tastes, the company's

philosophy started to waver after Laura Ashley's death. Today, Laura Ashley remains a strong presence on the high street, but the designs are less English rose and more international high-flyer. Taffeta ballgowns rub shoulders with anonymous tunics, but the traditional ethos is still apparent – with cotton summer dresses evoking thoughts of garden parties, and cable-knit sweaters prompting memories of long weekends spent in the country.

AUGUSTABERNARD

FOUNDED BY AUGUSTA BERNARD IN 1919

'The new silhouette slides in like a fish', observed *Vogue* in its 'Turning Points towards a New Mode' in 1933. 'Augustabernard was the magician who first called it to life. This silhouette is vertical, but well formed; it makes a woman look extremely tall, but at the same time rounded. No extreme bulk, but the natural, normal curves of the figure.'

Augustabernard opened in 1919 – its founder linking her Christian and surname together to form the name. She became famous for her bias cutting, slim silhouettes and ability to excel in flattery. Her designs were spare and intricate in construction; like Madeleine Vionnet, Augustabernard was a technical wizard. Unfortunately, during the depression of the 1930s, her clients started to tighten their belts and Augustabernard, sadly, slid out of business as a result.

BAKST, Léon

BORN: ST PETERSBURG, RUSSIA, 1866
DIED: PARIS, FRANCE, 1924

A fine artist turned costume designer, Léon Bakst was best known for his work with the Ballets Russes, where his exotic use of colour and extraordinary patterns had a profound influence on fashion. His costume designs – drawn mainly on Greek and Egyptian lines – often combined inverted triangles and vertical lines. Bakst gave lectures on the aesthetic principles of dress during the 1920s. He analysed the slim silhouette for *Vogue*, showing how the positioning of graphic pattern could destroy or enhance a silhouette, and stressed the importance of having a beautiful body. 'Like a magnificent dog or horse – forgive, Mesdames, this comparison since it is in your praise – the woman who possesses beautiful articulation is a woman of race: sick or well, she always bears the mark of physical perfection.'

ABOVE **A deep, smoke-grey satin sheath from Augustabernard for 'modern sirens who lend such enchantement to the drawing-room', 1934.**

BALENCIAGA, Cristobal

BORN: GUETARIA, SPAIN, 1895
DIED: JAVEA, SPAIN, 1972

In *Vogue*, 1962: 'There is one brief, pithy Spanish word, *cursi*, that Balenciaga uses to describe what he hates most in fashion: vulgarity and bad taste. Of these he has never, ever, been guilty.' Cristobal Balenciaga is the undisputed designer's designer. Revered and admired by couturiers past and present, including a coterie of all-time greats: Madeleine Vionnet, Hubert de Givenchy, Christian Dior and Coco Chanel. André Courrèges and Emanuel Ungaro were lucky enough to have worked with him on a one-to-one basis. Givenchy, for whom Balenciaga was a mentor, described him to *Vogue* in 1991 as 'Gracious, elegant, religious, simple, talented.'

Balenciaga's colour palette was, like his clothes, very carefully edited. 'His colours are of Spain', commented *Vogue* in 1962, 'deep, thick black, accented with white; brilliant reds; turquoise; yellow; warm, cinnamon browns; and whether he knows it or not, Goya is always looking over his shoulder.' The immaculate quality of his collections prompted *Vogue* to observe that what Balenciaga designed in 1938 would always transcend time. 'He has a complete and utter disregard for public opinion, caring not a fig whether Press or customers like his collection, and because he follows no ideas or trends but his own, everyone follows him.'

Balenciaga was the son of a fisherman and seamstress. One of his mother's clients, the Marquesa de Casa Torres, apprenticed him to a tailor at 13 years old. At 24 he opened his own house, dressing ladies of the court of Alphonse XIII. Balenciaga went bankrupt in 1931, reopened in Madrid and Barcelona, and travelled to Paris, via London, six years later. In the latter part of his career, Balenciaga was asked to lend his name to an American tie line. He felt licensing was a form of prostitution. Givenchy recalled, 'He was indeed of another era. When commissioned to design Air France uniforms he wanted to personally do the fittings for 3,000 stewardesses.'

Unlike Dior, who made a statement which changed the course of twentieth-century fashion, Balenciaga created the most enduring examples of perfection. In 1962 *Vogue* observed that Balenciaga was 'an implicit believer in the golden rule of fashion – that the essence of chic is elimination. It follows that he has the most elegant clientele in the world.' Six years later – a year before man landed on the moon – Balenciaga closed the doors to his business, claiming there was no one left for him to dress. When customers asked where they should go, 73-year-old Balenciaga pointed them in the direction of Givenchy, whose salon was situated across the street.

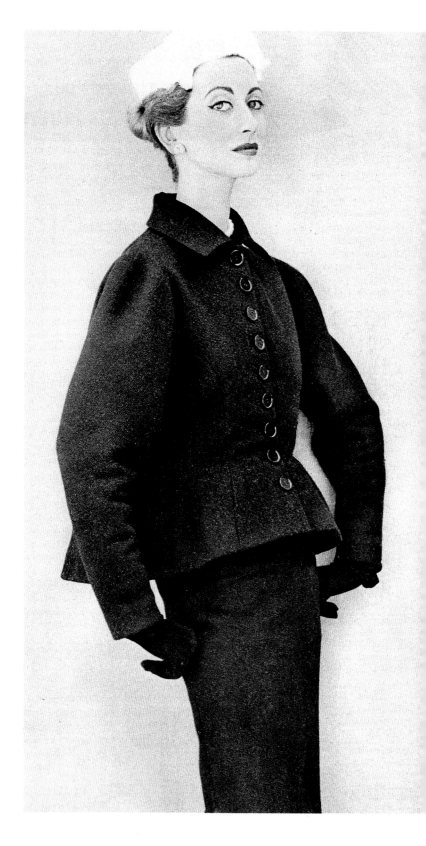

OPPOSITE **The 'revolutionary late-day variation on a suit-plus-stole theme', 1952 – a black suit, white stole and cyclamen ribbon.**

ABOVE **Balenciaga's structured suit of immaculate proportions: 'fitted front, loose back line' in black wool ottoman, September 1951.**

BALMAIN, Pierre

BORN: ST-JEAN-DE-MAURIENNE, FRANCE, 1914
DIED: PARIS, FRANCE, 1982

A mover rather than a shaker, Pierre Balmain launched his career by working with three of fashion's greats before branching out on his own. He began freelance drawing for Robert Piguet and then spent five years with Edward Molyneux before moving on to Lucien Lelong, where he sketched alongside a young designer called Christian Dior. Balmain's own Parisian house opened on 12 October 1945. His *pièce de résistance* was an embroidered white brocade dinner dress worth 120,000 francs.

Although Balmain's grandfather had owned a drapery business, financial difficulties prompted his mother to suggest that Pierre become a naval surgeon. He ignored her advice and instead, wrote to Piguet, Lelong, Jeanne Lanvin and Molyneux. The latter gave Balmain his first job.

On his own, Balmain's clients included the Duchess of Windsor, the Duchess of Kent, Sophia Loren and the Queen of Siam. Since his death in 1982, many designers have taken over the Balmain mantle: first Erik Mortensen, then Alistair Blair. In November 1992 Hervé Pierre was replaced by Oscar de la Renta.

In his biography, *My Years and Seasons* published in 1964, Balmain reflected, 'Business turnover may grow, personnel change, publicity [become] more blatant, but a couture house seldom escapes from the category in which it is initially placed. I was lucky that my first show earned me a high rating.'

BANTON, Travis

BORN: WACO, TEXAS, USA, 1894
DIED: LOS ANGELES, CALIFORNIA, USA, 1958

Travis Banton was considered – along with Gilbert Adrian – one of the most important figures in Hollywood. Having attended the New York School of Fine and Applied Arts, he worked for Lucile Duff Gordon, who was then one of the most famous couturiers in the world. Banton's big break came in 1924, when he was commissioned to design the costumes for Leatrice Joy and the cast of *A Dressmaker in Paris*.

During his time as chief designer at Paramount, from 1927–38, Banton created costumes for Tallulah Bankhead, Marlene Dietrich, and Claudette Colbert's 1935 appearance in *Cleopatra*. His trademark was bias cutting and body consciousness. When his contract expired with Paramount, he switched to Twentieth-Century Fox, then Universal Studios.

BATES, John

BORN: DINNINGTON, ENGLAND, 1935

'I admire the way Americans care, but it shows a little and it shouldn't,' said John Bates in *Vogue*'s 'Designer Series' in 1976, 'they're best when they're wearing the least make-up and their hair shines like they invented shampoo.'

One of the brightest stars of British fashion during the 1970s, Bates had a French training at Herbert Sidon of Sloane Street in London; he then moved to Jean Varon in 1958 and formed his own label in 1972. Bates had a meticulous attention to detail, piecing together the complete look from millinery to custom-made stockings. He made his name by dressing Diana Rigg for *The Avengers* television series; her first outfit – a fight-scene suit with a black stripe across the bustline – was commissioned and made within three days.

Bates's business went bankrupt in 1980 and, faced with an uncertain future in the rag trade, otherwise known as the 'Calcutta run, which you do if you want to feel instantly depressed', he moved to Wales in 1989, where he lives in a cottage with views over the estuary, designing for larger ladies and perfecting his life-drawing technique.

LEFT **Balmain's Tibetan jacket, from his *Jolie Madame* collection of 1957, with sweeping sleeves and inner cuffs of leopardskin 'to match the helmet hat'.**

OPPOSITE **Kingsize djellaba super-cover by John Bates, in black wool crepe; striped, bound, panelled in flowers of embroidered ultraviolet silk, 1972.**

BEENE, Geoffrey

BORN: HAYNESVILLE, LOUISIANA, USA, 1927

A resolute modernist and designer's designer who works in a mixture of mediums, Geoffrey Beene is a quiet thinker with a soft southern accent, who calls his clothes 'liquid geometry'. Beene claims he did not leave but 'fled' Haynesville to study medicine at Tulane University in New Orleans and Los Angeles from 1943–6. He decided to switch to fashion after being mesmerized by Gilbert Adrian's designs for Joan Crawford in *Humoresque* (1946). Beene worked in the display department of the I Magnin store in Los Angeles and studied at Traphagan School of Fashion in New York before moving to Paris, where he studied at L'Académie Julian with a tailor who had worked with Edward Molyneux. In 1951 Beene left Paris, working with the designer Teal Traina before launching Geoffrey Beene Inc. in 1963.

Geoffrey Beene has always defied convention: in 1966 he was putting grey flannel and wool jersey into eveningwear, predicting jumpsuits would be the future of fashion and making sequinned sportswear. He launched Beenebag, one of America's first diffusion lines, in 1971. In 1976 he was the first American designer to show in Milan, prompting *L'Uomo Vogue* to issue a warning: 'Look out Italian designers. This is the future.' Beene was famously made *persona non grata* by buyer's bible *Women's Wear Daily* in 1967 – allegedly because he wouldn't give advance details of the wedding dress he had designed for Lynda Bird Johnson. 'I felt my allegiance was to the President,' he told *Vogue* in 1987. The ensuing feud lasted for decades. This would have been commercial suicide for most designers, but not for Beene, who survived with a hard-core clientele and a sense of humour: 'I've been called a lot of things other than Mr Beene, believe me.'

With eight Coty Awards under his belt, Beene has been both employer and mentor to some of the most talented American designers, including Gene Mayer, Alber Elbaz and Issey Miyake – Japan's forefather of aesthetic dressing. His talents are not confined to fashion. Beene also designs furniture, shoes and accessories, and has cultivated a collection of over 2,000 orchids. Despite being on the board of the American Ballet Theatre, he had never designed dance costumes until he was commissioned by Twyla Tharp Company for the 1999 dance work *Diabelli*.

Beene is one of fashion's thinkers, a revolutionary, a fabric technologist, who lives a solitary existence with two dachshunds. He hates looking back. 'The future of fashion is performance,' Beene told *Life*. 'Clothes will be packable, versatile and practically weightless. I said about 10 years ago that the major change in fashion will come about when the chemist meets with the artist.'

OPPOSITE **Master minimalist Beene's navy and white spotted evening dress in silk jersey with long bias-cut skirt, 1992.**

ABOVE **Cream corded and black embroidered lace come together in Beene's diagonal edge-to-edge scalloped evening dress, 1986.**

BENETTON

FOUNDED BY LUCIANO, GIULIANA, GILBERTO AND CARLO BENETTON
IN 1965

The Italian knitwear company, Benetton, caused a stir by producing
a series of shocking advertising campaigns directed by its creative
director, Oliviero Toscani. Scenes splashed across billboards and
magazines included an AIDS patient on his deathbed, and another
of a baby complete with umbilical cord. Benetton claimed they
were promoting social awareness, but critics pointed out that
photojournalism had nothing to do with selling sweaters. Whatever
the moral standpoint, Benetton have sustained a high profile and
are one of the best-known Italian companies in the world.

BERARDI, Antonio

BORN: GRANTHAM, ENGLAND, 1968

Rising star Antonio Berardi told *Vogue* in 1997, 'My work is a mix of my
British and Sicilian roots: an art school mentality combined with the
inspiration I take from the strength of the women in my family.' Berardi,
whose Sicilian parents owned an ice cream business, graduated from
London's Central Saint Martins College of Art and Design in 1994, already
showing signs of pulling power: his show featured hats by Philip Treacy
and shoes by Manolo Blahnik; hairdresser Sam McKnight and make-up
artist Mary Greenwell gave their services free of charge. In December
1996 Berardi signed up with Italian manufacturers Givuesse and in 1999
he showed for the first time in Italy. His collection, 'Never Mind the
Borgias', contained punk and Renaissance references, his *pièce de
résistance* a jacket constructed from 200 zips. Later that year he made
matching purple outfits for the wedding of Victoria Adams (Posh Spice)
to Manchester United star David Beckham – and their baby Brooklyn.

BIAGIOTTI, Laura

BORN: ROME, ITALY, 1943

With designs that are quiet, clean and spare, in classic fabrics and
neutral colours, Laura Biagiotti has forged a reputation for understated
Italian clothing that needs no concepts or gimmicks to sell it. Biagiotti
studied literature and archaeology before returning to the family's
ready-to-wear company in 1962. She worked with Roberto Cappuci
and freelanced with a host of other Italian designers before founding
her own label. Italian in thinking but international in attitude, the
Laura Biagiotti label sells as far afield as Thailand, China and Moscow.

BIBA

FOUNDED BY BARBARA HULANICKI
BORN: WARSAW, POLAND, 1936

Barbara Hulanicki's biography, *From A to Biba* (1983), is
dedicated 'To All Optimists, Fatalists and Dreamers', a fitting
introduction to a story of extraordinary vision and retail
invention, which captured the imagination of a generation.
Biba was the parting shot of the 1960s: the seminal moment
of shopping without cynicism.

Biba's creator, Barbara Hulanicki, started as a fashion artist and
began Biba's Postal Boutique in the early 1960s. Her first dress –
a gingham shift with matching headscarf – sold via the *Daily Mirror*
for 25 shillings. The first Biba shop, formerly a small chemist's in
Abingdon Road, Kensington, London, was opened in 1964. A series
of publicity coups followed: Cathy McGowan, the hip presenter of
the pop programme *Ready Steady Go*, wore a Biba smock dress on
television, and Biba provided the wardrobe for the film *Darling*
(1965), staring Julie Christie. Biba moved to bigger premises on
Kensington High Street in 1969, and Hulanicki's ultimate dream came
true in 1973 when the label took over the magnificent Derry and Toms
department store – a huge Art Deco space with original fittings.

ABOVE 'Twiggy – plain Twiba –
wearing Biba, that is' in 1973,
showing off Biba's china doll
foundation and femme fatale
look to its best advantage.

OPPOSITE **Twiggy in the entrance
to Biba's extravagant changing
rooms, wearing Biba's great
spot trenchcoat with matching
fake leopard pillbox hat, 1973.**

Hulanicki's attention to detail knew no bounds: Biba was an oasis of gorgeousness, where customers could buy tins of beans and feather boas, black and plum lipsticks, each with Biba's logo of lacquered black and swirling gold. A mesmerizing monument to Art Deco and Art Nouveau, the interior was described by *Vogue* in 1973 as 'a palace of apricot marble, coloured counters and fake leopardskin walls. Six floors of 1930 fantasy.' Although visually stunning, the venture was commercially unsound, the store too huge, the lighting too dark. Biba became a financial nightmare and a shoplifters' paradise. Declared bankrupt in 1976, Hulanicki moved to Brazil and then to Miami Beach, Florida, where she has turned her talent to designing hotels.

BIKKEMBERGS, Dirk

BORN: FLAMERSHEIM, GERMANY, 1962

Part of the Belgian contingent that gained prominence during the early 1990s, Dirk Bikkembergs first became famous for his footwear, with his functional, hard-wearing shoes.

Bikkembergs studied fashion at the Royal Academy of Arts in Antwerp, and worked as a freelance designer for a variety of companies before launching his own line in 1985. His first menswear collection was shown in 1988, followed by womenswear five years later.

BIRTWELL, Celia

BORN: BURY, ENGLAND, 1941

Depicted in countless canvases and drawings by David Hockney, Celia Birtwell is a talented textile designer and superb colourist, most famous for her electric collaborations with her late ex-husband, Ossie Clark. Both are immortalized in London's Tate Gallery's most popular portrait, *Mr and Mrs Clark and Percy*, painted by Hockney in 1970.

Celia – then a beatnik in winkle-picker shoes – met Ossie Clark via Mo McDermott in Manchester. She had been attending Salford Art School since the age of 13, eventually teaching cake decoration. Celia travelled south to London in 1962. She never went back.

Most famous for her extraordinary prints on silk chiffon, which she produced during her marriage to Ossie Clark, she now has her own shop in London's Westbourne Park Road and has a fabric collection called 'Celia's Stripes' to be launched by Zoffany in the millennium. Speaking in 1994 of her partnership with Ossie Clark, she said, 'We were marvellous together. A very peculiar, strange mix that was pretty powerful.'

BLAHNIK, Manolo

BORN: SANTA CRUZ, CANARY ISLANDS, 1942

'If God had wanted women to wear flat shoes, he wouldn't have created Manolo Blahnik,' wrote *Vogue* editor Alexandra Shulman in July 1994. An Englishman with branches in New York and a home in Bath, Blahnik is a master shoemaker in a world of plummeting standards. Like most great designers, he follows his own line. He has a distinct aversion to platforms and predominantly uses silk and satin. 'Quality in everything is paramount,' he told *Vogue* in 1990.

Of Czech and Spanish parentage, Blahnik studied law, literature and Renaissance art at university in Geneva before moving to London in 1970. On showing his portfolio to *Vogue*, the then editor Diana Vreeland suggested that he concentrate on shoe

designs, a proposal that played an instrumental part in his rise. He opened his first shop and called it Zapata, before reverting to his own name.

Blahnik's shoes are collected, cosseted and often regarded as being so exquisitely beautiful that they are put on display as works of art. He has been commissioned many times to design shoes for the collections of John Galliano, Isaac Mizrahi, Todd Oldham, Bill Blass and Alexander McQueen, among others. Lucy Ferry, wife of rock star Bryan, told *Vogue* in 1990, 'I bought my first pair in 1976 when I was sixteen and I've been buying them ever since. Other shoemakers don't have his imagination, or the incredible detail – such teeny weeny buckles, they're all perfect.'

BLASS, Bill

BORN: FORT WAYNE, INDIANA, USA, 1922

Bill Blass possesses the three key ingredients of a successful American designer: a good eye for design, a shrewd business brain and a personality that charms the birds off the trees. His talent for licensing is legendary: Blassport sportswear was launched in 1972 and his signature perfume in 1978; other products include swimwear, jeans, bedlinen and shoes.

Blass came to New York when he was 17 years old and spent a brief spell as a sketch artist before becoming a sergeant in the army. He designed at Anna Miller and Company, New York, and then moved on to·Seventh Avenue's Maurice Retner, where he was so successful that his was one of the first American designer's names to appear on the label. On Retner's retirement, Blass became the owner and in 1973 Bill Blass Limited was born.

Blass has won countless awards including the Coty American Fashion Critics' Award, which he has won three times, and the Gentlemen's Quarterly Award in 1981. On 25 May 1999 he received the first Lifetime Achievement Award from the Fashion Institute of Technology. He holds three Honorary Doctorate degrees and was one of the founder members of the Council of Fashion Designers of America (CFDA). President Reagan appointed Blass to the President's Committee on the Arts and Humanities in 1987. In January 1994 he contributed $10 million to the New York Public Library, which now has a public reading room in his name.

OPPOSITE **The maestro of the high heel, Manolo Blahnik, switches to flat thong sandals in 1999, made from a mix of diamanté and silver leather.**

RIGHT **Bill Blass's 'brilliant stem of cyclamen and yellow silk crepe' of 1986, with a sweeping skirt and a bodice cut to resemble a bolero.**

BODYMAP

FOUNDED BY DAVID HOLAH AND STEVIE STEWART IN 1982

'Young designers are re-drawing the hemline, any line, and not always with a ruler,' said *Vogue* in its assessment of the new cotton softwear in 1984. Bodymap were a breath of fresh air in the early 1980s, mixing stretch forms, ribbing and graphic patterns by textile designer Hilde Smith.

Holah and Stewart met at Middlesex Polytechnic, progressed to a stall in Camden Market and graduated with first-class honours. Heavily influenced by the Japanese avant-garde and Vivienne Westwood, their 1984 show, with its bare breasts and skullcaps, prompted the *Daily News Record* to question whether it was 'an outrageous pretension or merely a pretentious outrage'. The press went crazy. Buyers bought in droves. Bodymap held a 'Survival in the Fashion World' party in 1989. Unfortunately, what it really needed was a creative accountant and sympathetic backer – the business folded in 1991.

BOHAN, Marc

BORN: PARIS, FRANCE, 1926

'Marc Bohan is small, dark and quicksilver, and a most sophisticated man as befitting the artistic director of Christian Dior, the house that spells the ultimate in luxury for perhaps the greatest number of people in the world,' said *Vogue* in 'The Perfectionists' in 1974.

Bohan has a meticulous design pedigree: he worked at Jean Patou in 1945, Robert Piquet in 1946 and Edward Molyneux in 1950, returning to Patou in 1953 as designer of the haute couture collections. In 1958 Bohan spent time in America, familiarizing himself with Seventh Avenue. He prepared and designed the Christian Dior London collections in 1958, and in September 1960 he travelled to England to create their ready-to-wear collections. In 1960, on his appointment as artistic director at Christian Dior,

Bohan returned to Paris, where he continued to produce immaculate collections for Dior until 1989. In 1990 Bohan was persuaded to return to London to Hartnell, which had been floundering since its founder's death. Although Bohan's collections were well received, financial difficulties and lack of licensing income meant Hartnell had to close. On his appointment at Hartnell, Bohan recalled Molyneux's advice, which he had adhered to all his life: 'Amuse yourself with sketches, not with dresses.'

BOUÉ SŒURS, House of

FOUNDED BY SYLVIE AND JEANNE BOUÉ IN 1899

'Two fairy aprons float upon the skirt in front and back ... Add sparkle, and faint motion.' *Vogue*'s lyrical description of Boué Sœurs dresses captured the ethereal quality of one of the most distinctive signatures of the century. Boué Sœurs – two sisters who had a common love of embellishment – crossed the line between lingerie and outerwear. Using theatrical, iridescent fabrics with light-reflective surfaces, silver and gold lace trimming, ribbons, translucent fabrics and pale colours, Boué Sœurs made dresses with a wistful quality. Frequent visitors to America, Boué Sœurs, like Callot Sœurs, had a loyal transatlantic following. By the 1930s, when fashion fell out with surface effects, the Boué Sœurs ceased to exist.

BRUCE, Liza

BORN: NEW YORK, NEW YORK, USA, 1955

Liza Bruce built her business on stretch fabric and quickly became known as the 'Queen of Lycra', producing swimsuits of the neon-coloured variety, aerodynamic lines and cut-outs. With no formal training and a foray into the restaurant business, Bruce progressed from swimsuits into catsuits and curvy dresses. Interviewed by *Vogue* in 1990 she said, 'Posture is central to looking youthful and, as clothes become more streamlined, good posture will become even more important.'

BURBERRY

FOUNDED BY THOMAS BURBERRY IN 1856

An inventor and fabric technologist, who predicted the advent of sportswear and steered its course, Thomas Burberry opened his shop in Basingstoke, Hampshire, in 1856 when he was 21 years old. In 1888 he took out a patent for improved materials and was making waterproof garments by the turn of the century.

In 1901 Burberry designed clothes for the new leisured classes, sportswear and the utility raincoat – the famous Burberry check originated in Edinburgh in 1924, but became hot property in the 1960s. He also designed a new service uniform for British officers and Sir Ernest Shackleton's Outrig suit, worn on the British Everest Expedition of 1924.

The classic Burberry trenchcoat is recognized all over the world and has appeared many times on film including *Torn Curtain* (1966), *Kramer Versus Kramer* (1979), *Wall Street* (1987), *Dick Tracy* (1990) and *The Pink Panther Strikes Again* (1976), during the filming of which Peter Sellers always had two on set. Marcello Mastroianni used the classic trench in all his films during the 1950s and 1960s. Celebrity wearers included Grace Kelly, Ingrid Bergman and Jacques Tati.

Backed by an advertising campaign photographed by Mario Testino, the Burberry flagship store, at 18–22 Haymarket, London, has recently been beautifully revamped under the direction of Rose Marie Bravo, formerly of Manhattan's Saks Fifth Avenue, who was appointed worldwide chief executive of Burberry in October 1997. The following February Roberto Menichetti, who previously worked for both Claude Montana and Jil Sander, was appointed creative director.

BURROWS, Stephen

BORN: NEWARK, NEW JERSEY, USA, 1943

Best known for his use of colour, Stephen Burrows' career has fluctuated as many times as his styles. He studied at New York's Fashion Institute of Technology and spent two years working in New York's fashion industry. Picked up and promoted relentlessly by Henri Bendel department store in the 1970s, he was given his own in-store boutique called Stephen Burrows' World. Frequently in and out of fashion, Burrows' clothes have a wide appeal and have been worn by Debbie Harry of Blondie and Diana Ross.

BYBLOS

FOUNDED IN 1973

A company which previously employed Gianni Versace and Guy Paulin as its in-house designers, Byblos has been directed since 1981 by Keith Varty and Alan Cleaver. Known as the 'Byblos boys', Varty and Cleaver are both English designers who totally understand the Italian sensibility. 'A company like Byblos simply doesn't exist in England,' they told *Vogue* in 1990. 'We don't have a budget – nobody questions how much we spend on fabrics. Coming to Italy opened our eyes to the importance of quality. The British have a whole different sense of priorities. In Italy, designers are treated like pop stars.' Richard Tyler has been designing for Byblos since he was made design director in 1996.

OPPOSITE **Riding on the wave unconventional cutting, Bodymap's pattern, stretch and a fish fin skirt: textiles by Hilde Smith, 1986.**

ABOVE **Still wowing the raincoat devotees, Burberry 1999-style. Knee-length mac with functional detail, but made in silk, by Burberry Prorsum.**

CACHAREL, Jean

BORN: NÎMES, FRANCE, 1932

Originally a men's tailor, Jean Cacharel switched to womenswear when he became a pattern cutter and stylist at Jean Jourdan of Paris. He founded his own business at the turn of the 1960s, perfectly capturing the downturn of couture and upward mobility of ready to wear. Cacharel sealed his fame when he collaborated with Liberty of London during the mid-1960s, revamping their traditional prints and making them relevant to a hipper, younger clientele. The Cacharel label consequently became synonymous with sporty, easy shapes, adding childrenswear, jeans and menswear in 1994, and two phenomenally successful fragrances – Anais Anais and Lou Lou. Jean Cacharel received an Export Trade Oscar in 1969.

CALLOT SŒURS, House of

FOUNDED BY SISTERS GERBER, BERTRAND AND CHANTERELLE IN 1895

Exotic and breathtakingly beautiful dresses bearing the Callot Sœurs label still astound. Like their creators, they have an air of mystique. 'A curious situation controls the house of Callot. Its gowns are known wherever smart gowns are worn, yet the women who govern the house are almost mythical. It would be a mockery to apply the word "fashionable" to these women: they would despise it. They never go out at all,' said *Vogue* in 1915. Previously in business separately, the reclusive Callot sisters decided to pool their resources, eventually moving to the avenue Matignon, Paris, employing 1,500 workers and supplying a huge American market. The Callot Sœurs were world authorities on antique lace and were often called upon for advice by French and foreign museums. *Vogue* imbued the sisters with a legendary sense of mystery: 'Silently, working away with their shears and thread, they weave

LEFT 'A graceful arrangement of floating red tulle edged with black chantilly' by Callot Sœurs, worn by Miss Elsie de Wolfe at a dance given by Madame Hyde, 1920.

clothes that bring them millions, and from their workroom, into which no stranger penetrates, they govern the destiny of continents they have not seen.'

CAPELLINO, Ally

BORN: HAMPTON COURT, ENGLAND, 1956

Modern, easy and eternally wearable, Ally Capellino's brand of English simplicity has worldwide appeal. Alison Lloyd – the designer behind the Ally Capellino label – graduated from Middlesex Polytechnic in fashion and textiles in 1978, and worked at the Courtauld Institute in London before forming her own company selling accessories, millinery and jewellery in 1979. She established the Ally Capellino label the following year. In addition to producing collections, being involved in Crafts Council projects and design consultancy work, Ally lectures at the Royal College of Art and Central Saint Martins College of Art and Design in London, passing on her expertise to stars of the future.

CAPUCCI, Roberto

BORN: ROME, ITALY, 1929

An expert in sculptural shape and circular form, Roberto Capucci was one of the first post-Second World War Italian couturiers to enjoy international fame. In 1961 *Vogue* described Capucci's crisp, abbreviated shift: 'Nothing more than stark, elegant shapes with hems cropped daringly short – designed to make women look outrageously young yet *mondaine*.'

After spending a decade designing in Rome, Capucci moved to Paris with the backing of a Florentine businessman and opened his own salon on rue Cambon. He returned to Rome six years later to resume his experimentalism and open another salon on Via Gregoriana. Capucci's designs are not just about his use of fabric; he has also incorporated ribbons, pebbles and quilting to enhance his organic forms.

CARDIN, Pierre

BORN: SAN ANDREA DA BARBARA, ITALY, 1922

In 1974 *Vogue*'s assessment of Pierre Cardin was as a 'ferbrile, anguished, original, the air quaking about him as he hurtles from place to place, project to project.' The cover of *Forbes* magazine 15 years later was emblazoned with the words, 'Pierre Cardin: Why am I bad if I sell a frying pan?' For Pierre Cardin, read: paradox. Visionary designer and unashamed licencee.

Cardin's career began as a tailor's cutter in Vichy, France. He opened his own business in 1950, with his first haute couture collection in 1953 and a boutique the following year. Cardin personified the forward-thinking 1960s with his preoccupation with science fiction: jumpsuits and plastic discs; helmets instead of hats. With a marketing strategy years ahead of its time, Cardin extended the tentacles of his empire into new territory, pre-empting the mass-market explosion of the 1960s. In 1956 he was the first European designer to establish himself in Japan, and in 1981 he was the first to open a showroom in China. He has been saying since the 1960s that he would like to have the first boutique on the moon.

With 840 licences in 125 countries, the world-famous Cardin name has appeared on a variety of products – from furniture to private jets, chocolates to nuts. Cardin told *Vogue* in 1990, 'After those, of course, they all sneered and said I'd be doing sardine tins next, and I said why not? It's all part of the creative process.'

ABOVE **Space-age 'cosmos' creations by Pierre Cardin. Models pose – 1966-style – in front of Cardin's L'Espace.**

CARNEGIE, Hattie

BORN: VIENNA, AUSTRIA, 1889
DIED: NEW YORK, NEW YORK, USA, 1956

The first American designer to make the psychological leap between design and lifestyle, Hattie Carnegie was a retail phenomena who imported Paris couture into America – sometimes diluting the styles under the Hattie Carnegie Originals label. The Carnegie headquarters on East 49th Street stocked jewellery, cosmetics, sportswear – even antiques and Carnegie chocolates.

Carnegie's forceful and opinionated nature was legendary. She was an astute businesswoman with a sharp commercial brain, who began her career as a trainee milliner and runner at Macy's. In 1909 she opened a hat and dress shop on East 10th Street. Carnegie specialized in the complete look – advising and providing everything from gloves to cosmetics. After her death in 1956, the company carried on, but when fashion swung in favour of the adolescent, the Carnegie business – inextricably linked with its creator – went to the wall.

CASHIN, Bonnie

BORN: OAKLAND, CALIFORNIA, USA, 1915

Years ahead of her time, Bonnie Cashin was both an innovator and experimentalist. In the mid-1930s she became costume designer for Manhattan's Roxy Theatre, where she learnt the principles of movement and shape. Spotted by sportswear supremo Louis Adler, Cashin designed for his company, Adler and Adler, for over a decade. In 1953 she reverted to the freelance lifestyle. While the silhouette of the 1950s dictated cinched waists and tight fits, Cashin stayed true to her principles of modernity and purity. Her timeless shapes, based on triangles, rectangles and squares, formed the foundation of American fashion in the twentieth century.

CASSINI, Oleg

BORN: PARIS, FRANCE, 1913

A renowned Casanova and professional charmer, Oleg Cassini is a Russian count who is famous for three things: his pencilled moustache, his engagement to Grace Kelly and the official wardrobe he designed for the century's most elegant first lady, Jacqueline Kennedy.

Cassini trained at Jean Patou in Paris, before moving to New York in 1936, where he was employed by various manufacturers on Seventh Avenue. In 1940 he moved to Los Angeles, where he became a Hollywood costume designer under Edith Head. He also dated a number of starlets, before deciding to settle down with actress Gene Tierney. By 1950, Cassini was back on Seventh Avenue – where his name became synonymous with glamorous sheath dresses, knitted jackets and cocktail dresses. In 1961 Cassini was appointed Jacqueline Kennedy's official dressmaker and formulated her wardrobe during her White House years – from a wool coat with removable collar of Russian sable to the A-line dress at the Pre-Inaugural Gala, which Cassini described in 1991 as 'audacious, studied simplicity'.

In 1961 Cassini made a leopardskin fur coat for Jacqueline Kennedy. Almost 40 years later, he attempted to redress the balance with a fake fur collection called 'Evolutionary Furs'. Cassini told *The Sunday Times* in 1999, 'Fashion is not couture anymore. It is show business.' At 86 years old, Cassini's pencilled moustache was still intact.

ABOVE 'Mrs Kennedy's New Evening Choices' – an ankle-length evening dress of green silk jersey created by Oleg Cassini in 1961 for America's first lady.

OPPOSITE Bonnie Cashin's 'high voltage coat and dress'. A shocking-red kidskin coat, ruffled in racoon and lined in fleece, photographed by Helmut Newton, 1966.

CASTELBAJAC, Jean-Charles de

BORN: CASABLANCA, MOROCCO, 1949

With his flair for architectural shapes and clear blocks of colour, Jean-Charles de Castelbajac has always been associated with streamlined design. He formed a ready-to-wear fashion company with his mother and freelanced for various companies from Max Mara to Levi Strauss. In 1970 he launched his own label and his collections have been exhibited in Paris, Austria and Belgium. In addition, Castelbajac has designed for film and stage, including the pop group Talking Heads. In 1979 he began designing furniture and interiors. For two years he designed the collections of André Courrèges, the 1960s' designer who epitomized futurism.

CAVANAGH, John

BORN: IRELAND, 1914

A former assistant to Edward Molyneux and, briefly, Pierre Balmain, John Cavanagh opened his London salon in 1952. *Vogue* summed up his style with a description of his customers: 'His clients move with the times in an establishment world: their kind of life ranges from the country weekend to jet propelled globetrotting.' He is a member of the Incorporated Society of London Fashion Designers, together with London luminaries Norman Hartnell, Digby Morton and Lachasse. Cavanagh designed the wedding dresses for both the Duchess of Kent and Princess Alexandra.

CÉLINE

FOUNDED IN 1973

Céline is a French luxury brand which was founded in 1973 but did not make its mark until two years later when the first Céline boutiques opened around the world: starting with Monte Carlo, Geneva and Hong Kong, followed by London, Toronto and Beverly Hills. Sponsoring the French Open and America's Cup in the 1980s raised Céline's profile.

OPPOSITE **One of Hussein Chalayan's early pieces, 1994: a modern zip-up 'paper' jacket with elongated collar – 'unrippable and washable.'**

In 1997 Michael Kors was appointed chief ready-to-wear designer. The first collection was a resounding success – a sea of calm, quiet colours – and, although Kors had produced the show in double-quick time, he remained – like the clothes – cool, calm and collected. Kors now holds the position of creative director.

CERRUTI, Nino

BORN: BIELLA, ITALY, 1930

Probably most famous for his menswear, Nino Cerruti took over his family's textile business at 20 years old and produced his own line in 1957. His early collections were considered avant-garde and revolutionary. Later, he became a consummate businessman, paring down and refining his designs for the mass-market. He started his career creating hip menswear, progressed into knitwear, unisex in 1967 and womenswear in 1976. Like Giorgio Armani, Cerruti rarely wavers from his principles, preferring clean, restrained tailoring.

CHALAYAN, Hussein

BORN: NICOSIA, CYPRUS, 1970

More fine artist than fashion designer, Hussein Chalayan has broken the mould of British fashion by being a quiet minimalist as opposed to rebel without a cause. He is the only British designer to compete intellectually with Comme des Garçons.

Chalayan graduated from Central Saint Martins College of Art and Design in London in 1993 with a first-class honours degree and final collection entitled 'The Tangent Flows'. Armed with an envelope of metal filings and fabric buried in his back garden, his unconventional approach brought a commission from the equally unconventional Icelandic singer, Björk.

An intense thinker, who isn't part of the fashion circuit, Chalayan's main concession to commercialism is a capsule high street collection and a contract with New York cashmere company, TSE. His experimental ideas – the wooden corset, the moulded dress with armrest – are counterpointed by his pliable paper clothes. His designs – best analysed in depth and from all sides – suit the art installation approach: he has exhibited in Paris, Prague and at London's Science Museum. Awarded British Designer of the Year in March 1999, it is a pity Chalayan cannot experiment with shape and form to his heart's content. He is currently constructing a plastic mechanical dress with designer Paul Topen, which will feature in London's Millennium Dome.

CHANEL, Gabrielle 'Coco'

BORN: SAUMUR, FRANCE, 1883
DIED: PARIS, FRANCE, 1971

'Chanel is the fascinating paradox,' said *Vogue* in 1957, 'the couturier who takes no account of fashion, who pursues her own faultlessly elegant line in the quiet confidence that fashion will come back to her – and sure enough it always does.' The most influential designer of the twentieth century was a non-conformist with a classical streak. Coco Chanel designed the definitive women's suit, wore masculine clothes, sported a cropped haircut and flaunted a suntan when it was considered to be an emblem of the working classes. In 1916 she outraged the fashion industry by using jersey at a time when it was strictly associated with underwear. 'This designer made jersey what it is today – we hope she's satisfied,' snapped *Vogue* in 1917. 'It's almost as much part of our lives as blue serge is.' Modernity and comfort came naturally to Chanel. This was the key reason why the classic Chanel suit – collarless, simply cut, trimmed with braid and with a discreet chain sewn into the hem – has transcended every single movement of the twentieth century. 'Men make dresses in which one can't move,' she observed. 'They tell you very calmly that dresses aren't made for action.' Coco Chanel had a disappointing love life and brittle personality. She continually criticized her contemporaries: dismissing Elsa Schiaparelli as a dressmaker, accusing Christian Dior of dressing women like armchairs, and giving Cristobal Balenciaga the ultimate backhanded compliment in admiring his design, but questioning his ability to cut.

The first Chanel shop opened in Paris in 1914; by 1930 annual turnover totalled 120 million francs. When war broke out,

Chanel's salon on rue Cambon closed and she went into exile. When the salon reopened in 1954, Chanel was interviewed by *Vogue*. Now almost 70 years old, she was in a defiant mood: 'Look at today's dresses: strapless evening dresses cutting across a woman's front like this. Nothing is uglier for a woman; boned horrors, that's what they are.' On plagiarism: 'I have always been copied by others. If a fashion isn't taken up and worn by everybody, it's not a fashion but an eccentricity, a fancy dress.'

By 1969 Chanel had appeared consistently in *Vogue* for over 50 years. Her place in history was secured. Already a legend, she was immortalized on Broadway in Alan Jay Lerner's musical *Coco*, which centred on Chanel's 1953–4 comeback; the lead role was played by Katharine Hepburn and the costumes were by Cecil Beaton, who received a coveted Tony Award for them. In her twilight years, Chanel lived a solitary existence, residing at the Ritz hotel in Paris.

The Chanel label found its natural successor, Karl Lagerfeld, in 1983. Lagerfeld's singular ability to astound, exploit and amuse – often all at the same time – took Chanel to the limit. His arrival coincided perfectly with the mood of the moment: a decade when conspicuous consumption and designer labels became the new religion.

LEFT **'This year's Chanel suit' – in 1957 – 'widely-ribbed navy blue jersey, fastening high with brass buttons, skirt features Chanel's new side pleat.'**

OPPOSITE **The Chanel suit, 1995 – collarless, trimmed in navy, and worn with a side zip miniskirt and sailor hat, modelled by Stella Tennant.**

RIGHT **'Deep iris blue on white with flowers whirling straight from Tannhauser', a dramatic, exotic design from Chloé, 1967.**

CHÉRUIT, Madeleine

FOUNDED BY MADELEINE CHÉRUIT IN 1900

Madeleine Chéruit was described in *Vogue* in 1915 as 'a Louis XVI woman because she has the daintiness, the extravagant tastes, the exquisite charm, and the art of those French ladies who went gaily through the pre-revolution epoch.' The house, designed by the architect Pierre Bullet and built in the early eighteenth century, extended from the place Vendôme to the rue des Petits-Champs. By 1915 the house of Chéruit was the property of Mesdames Wormser and Boulanger, who, *Vogue* observed in 1915, 'keep the house to its original type but bring much originality to it'. Apart from gowns, Chéruit was famous for its evening wraps, work in fur, children's clothes, lingerie, blouses and trousseaus.

CHLOÉ

FOUNDED BY GABY AGHION AND JACQUES LANOIR IN 1952

The Chloé philosophy of embodying young, forward-thinking design has always been reflected by the designers in Chloé's employ – Karl Lagerfeld, who worked at the company for almost 20 years, from 1965–83, again joining the company briefly in 1992; Martine Sitbon from 1987–91 before the appointment of Central Saint Martins College of Art and Design graduate, Stella McCartney. Her appointment, almost straight out of college, prompted shouts of nepotism. McCartney has proved she can deliver: the shows have been well received, sales figures are up and the Chloé look has a new, fresh perspective.

CHOO, Jimmy

BORN: PENANG, MALAYSIA, 1961

A relative newcomer to London's footwear fraternity – who established himself within the space of a decade – Jimmy Choo has shod a variety of the rich and famous. His clients included Diana, Princess of Wales, who had countless pairs of his high heels and flat pumps in her wardrobe.

Choo has gained a higher profile since the appointment of Tamara Yeardye, professional It Girl and managing director of the

company, who has helped his name become known on both sides of the Atlantic. Today, Jimmy Choo has branches in London, New York, Beverly Hills and Las Vegas. The first menswear collection was launched in February 1999.

CLAIBORNE, Liz

BORN: BRUSSELS, BELGIUM, 1929

Based on accessibility, versatility and quality, the Liz Claiborne label is revered and admired in corporate circles. The sheer size is astounding. Liz Claiborne studied fine art in Belgium and Nice, before finding her way into the fashion industry via illustration and a spell on New York's Seventh Avenue, eventually forming her own company in 1976.

Claiborne's success is built on divisions and a design appeal that has caught the imagination of the American public.

CLARK, Ossie

Born: Liverpool, England, 1942
Died: London, England, 1996

A genius cutter and constructor of clothes, Ossie Clark was the 1960s' wunderkind with all the essential ingredients: good looks, an extraordinary eye, an enormous ego and a talent to amuse. His bons mots littered the fashion pages of the 1960s and 1970s. The little black dress he christened 'a history of nice times'.

Ossie's ambiguous sexuality and instinctive feel for the female anatomy was at the core of his unique talent. He remains one of the few male fashion designers of the century who instinctively understood how women's bodies actually worked. 'His clothes were never vulgar,' said his ex-wife, textile designer Celia Birtwell, who he dressed during her two pregnancies with their sons Albert and George, 'I think he had respect for women. They were his goddesses.'

Ossie Clark was the product of a poor working-class family – the youngest of six children, who were evacuated to Oswaldtwistle during the Second World War. Encouraged by a schoolteacher who brought in glossy magazines, Ossie studied building, geometry and construction at Warrington Technical College, and in 1957 attended the Regional College of Art in Manchester. An outstanding talent, he secured a scholarship at London's Royal College of Art and emerged in 1965 with a first-class honours degree and a full page in *Vogue*. His final college collection featured graphic fabric, acquired during a drive across America with David Hockney in the summer of 1964.

A collaboration with Alice Pollock of Quorum in Chelsea's Radnor Walk catapulted Ossie Clark onto centre stage. Soon he was at the epicentre of the swinging sixties – friends included Patrick Procktor, David Hockney and Jimi Hendrix. Cecil Beaton attended his shows – along with London's glitterati. In 1966 Ossie married Celia Birtwell, who he met while she was teaching at Salford School of Art.

The magical meeting of Celia's textiles and Ossie's cutting created some of the most beautiful dresses of the decade – with plunging necklines, flowing sleeves and ethereal silhouettes. This was sensual perfection for the beautiful people. 'Ossie Clark's collection was a fantasy of the finest silks, cut velvet and dotted chiffon,' reported *Vogue* in 1971. 'The French were amazed and amused by the crazy glamour of Gala Mitchell, Ossie's London girl.'

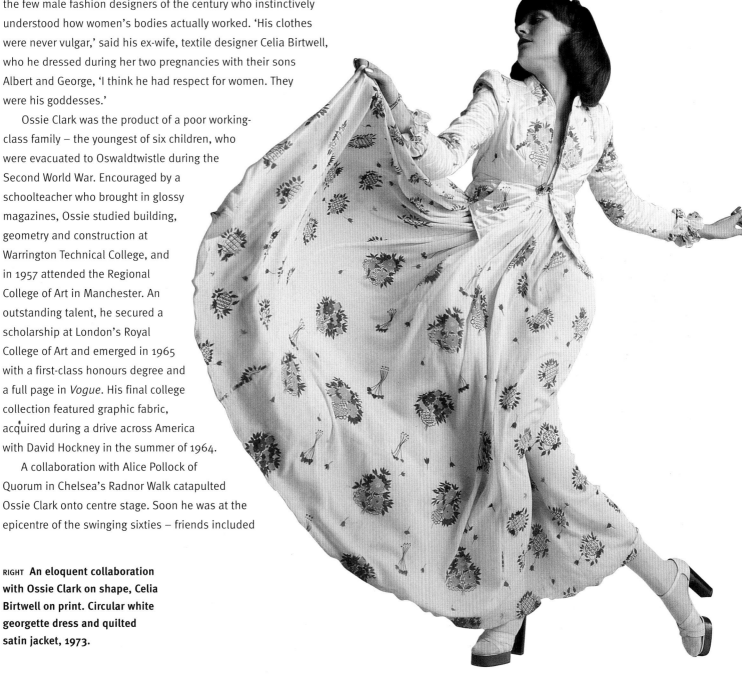

RIGHT An eloquent collaboration with Ossie Clark on shape, Celia Birtwell on print. Circular white georgette dress and quilted satin jacket, 1973.

The 1970s were not easy for Clark: there were a series of comebacks, divorce from Celia in 1973 and legal wranglings in the bankruptcy courts. By the 1990s he had dropped out of the industry; he became a Buddhist and made occasional one-offs for private clients. Despite his premature demise, and tragic death at the age of 54, Clark's legacy of extraordinary dresses remains. 'I don't care how much anything costs as long as it's beautiful,' he told *The Sunday Times* in 1970. A heartfelt sentiment which characterizes many of the century's most brilliantly talented designers.

CLEMENTS RIBEIRO

FOUNDED BY SUZANNE CLEMENTS AND INACIA RIBEIRO IN 1993
SUZANNE CLEMENTS, BORN: EPSOM, ENGLAND, 1969
INACIA RIBEIRO, BORN: ITAPECERICA, BRAZIL, 1964

'Minimal dressing had become so uniform, we felt that romantic and feminine was the only way to go,' said Inacia Ribeiro, summing up his collection in 1997. The couple, who met while they were students at Central Saint Martins College of Art and Design in London, graduated with first-class honours in 1991 and married a year later. They worked as design consultants in Brazil before forming their own company in 1993. Clements Ribeiro are part of the new wave of British designers who mix colour, form and fabric in what they call an 'irreverent take on traditional elegance'. Their influences range from urban gypsies and faded opulence to Elizabethan tailoring and textures, and the colours of the sea.

CLERGERIE, Robert

BORN: PARIS, FRANCE, 1934

Clergerie shoes are synonymous with luxury, quality, and a constant attention to detail. They appeared in the film *Indecent Proposal* (1993) as part of the accoutrements of a millionaire's working wardrobe. Robert Clergerie is a fervent believer in simplicity: 'Black is practical. It continues,' he said in 1992. 'You mustn't confuse people with reality. It mixes them up.'

In 1992 he was awarded a design award from the Fashion Footwear Association of New York and opened a new store in Manhattan's SoHo. Father of three, fluent in English, and able to talk eloquently about the shape of shoes to come, Clergerie launched an exhibition of his life's work in Paris in March 1995, which travelled to New York and Hong Kong, and finished at the Shoe Museum in the shoemaking capital of Romans, France.

COLONNA, Jean

BORN: ORAN, ALGERIA, 1955

Jean Colonna learnt his craft at Balmain before launching his own label in 1985. It was not until fashion entered its deconstruction period in the early 1990s that Colonna found his métier. His look is simple without being dull, interesting yet not too extreme. Colonna is not precious about design: he regularly uses inexpensive fabrics and raw methods of finishing.

OPPOSITE Ossie Clark's 'last word in long coats', 1976: made from mist-pink Harris tweed, wasp-waisted, the silhouette stretched to the ankles.

RIGHT Elegantly distressed slip in silk chiffon, interspersed with diamanté pieces in Clements Ribeiro's 1998 'seabed' dress.

COMME DES GARÇONS

FOUNDED BY REI KAWAKUBO IN 1973
BORN: TOKYO, JAPAN, 1942

In 1981 there were four fashion capitals – Paris, London, Milan and New York – Tokyo was about to become the fifth. Comme des Garçons' mantra was monochrome colours, random elastication and a quest to turn conventional pattern cutting on its head. 'Red is Black' declared its founder, Rei Kawakubo. The shade, which for a century had been associated with mourning, was about to become the uniform of the fashionable.

Daughter of a university lecturer, Rei Kawakubo studied fine art at Keio University, Tokyo, and then went on to work for the advertising department of a chemical company. Disillusioned, she progressed to styling – an unusual occupation at the time. Comme des Garçons was established in 1973; two years later Kawakubo showed in Tokyo, and opened her first shop a year after that. But it was not until she showed in Paris in 1981 that the full force of the Japanese influence filtered through. What the audience saw was a shock to the system: random ruching, irregular hems, asymmetric seams and crinkled surfaces. *Vogue* called it 'oblique chic'.

Like her contemporaries, Issey Miyake and Yohji Yamamoto, Rei Kawakubo is an intellectual designer for whom fashion is a fine art. Her clothes require a different thought level, her pieces destroy pre-conceived ideas. The Comme des Garçons' concept sticks to the same principles: minimalist display and perplexing cuts. Often the uninitiated cannot understand where Kawakubo is coming from: sometimes shapeless and complicated, complex and baffling, a Comme des Garçons collection exposes the inner workings of a lapel, leaves edges unfinished and reduces a sweater to an unintelligible mass of boiled wool. In the autumn/winter 1996 collection, Kawakubo experimented with padded humps. The end product – nicknamed Quasimodo by the tabloid press for obvious reasons – had removable pads positioned in a variety of places. Her biannual magazine *Six* (from sixth sense), with its esoteric photographs and references to Zen, will probably one day be the subject of Freudian analysis.

Despite its unorthodox associations, Comme des Garçons has populist appeal: there are more than 300 outlets in 33 countries worldwide. Rei Kawakubo was the first to use 'real' people as catwalk models, including Hollywood stars Dennis Hopper, Matt Dillon, John Malkovich and John Hurt. Wearer of austere expressions and giver of few interviews, Kawakubo said, in *Rei Kawakubo and Comme des Garçons* (1990), 'What I do is concerned with the long term, and yet fashion is cyclical. It is a paradox, but it doesn't bother me. It's always exciting to do a new collection.'

ABOVE **Comme des Garçons' angular jacket of 1986 'with maverick swagged peplum', in Venetian striped polyester satin.**

OPPOSITE **A series of stripes, any which way but straight, highlight the complexity of cut in a Comme des Garçons suit, 1996.**

CONNOLLY, Sybil

BORN: SWANSEA, WALES, 1921
DIED: DUBLIN, IRELAND, 1998

When Dublin staged its first international dress show in the autumn of 1953 at Dunsany Castle, Sybil Connolly, the most famous name in Irish fashion, was the star. Born in Wales but with an Irish father, Connolly served an apprenticeship at Bradleys the dressmakers in 1938, where she attended fittings for the ailing Queen Mary, and moved to Dublin when she was 17 years old. A superb self-publicist, Connolly made it onto the cover of *Life*, dressed a series of aristocratic figures and became a friend of Jacqueline Kennedy. The Connolly style mixed American shapes and Irish content – simple linens, Donegal tweeds and Aran wool. When Jacqueline Kennedy visited Ireland in July 1967, she visited Connolly and wore one of her linen pieces in an official White House portrait.

Sybil Connolly established herself in a mansion in Merrion Square, Dublin, eventually paring down her business to cater only for a coterie of loyal clients, while writing books on Irish homes and gardens, and designing crystal and pottery for Tiffany & Co.

CONRAN, Jasper

BORN: LONDON, ENGLAND, 1959

Descended from a family of creatives and high achievers, Jasper Conran trained at Parson's School of Design in New York and then worked briefly at Fiorucci, Wallis and a clothing manufacturer in Barnsley, England. With the aid of a bank loan, he founded his own business in 1979, initially working from his father's Regent's Park house. In 1982 *Vogue* was calling Jasper Conran a 'British superlative'. At 26 years of age, he won the British Designer of the Year Award and had a turnover of £2.5 million. In 1991 he was nominated by *Tatler* as Mary Quant's tip for the top 'because he makes clothes women want to wear'.

Jasper Conran is one of the few designers who can switch from menswear to womenswear, from commercial, wearable clothes to watchable theatrical costumes. He rarely confuses the two. Conran has designed many times for the theatre including The Scottish Ballet's production of *Sleeping Beauty*, *My Fair Lady* directed by Simon Callow, and Jean Anouilh's *The Rehearsal*, for which he won a Laurence Olivier Award in 1990. His bridesmaids' dresses for the wedding of Lady Sarah Armstrong-Jones stand out as some of the most stunning ever produced.

COPPERWHEAT BLUNDELL

FOUNDED BY LEE COPPERWHEAT AND PAMELA BLUNDELL IN 1992

The Copperwheat Blundell partnership has a firm foundation built on solid experience from both sides. Lee Copperwheat studied tailoring at Tresham College in Northampton, at the London College of Fashion and at Aquascutum. Pamela Blundell trained at Southampton University, won the Smirnoff Best Young Designer fashion award in 1987, designed with John Flett and was commissioned to design a capsule collection for Liberty.

In 1997 Copperwheat Blundell launched CB OUTLINE, a collection which includes modern fabrics and has a sporty appeal. In the same year, they presented their first catwalk show in Japan. Their design experience is diverse, ranging from uniforms for Marco Pierre White's *Titanic* restaurant to clients including Cameron Diaz and The Corrs.

COURRÈGES, André

BORN: PAU, FRANCE, 1923

One of many designers of the 1960s who claims to have invented the mini, André Courrèges was mesmerized by space travel. In the years before the first man landed on the moon, Courrèges went crazy: silver trousers, moon boots, white plastic sunglasses – with slits echoing the shape of the eyelashes. The Courrèges look was clean, streamlined, and always looking to the future – white on white, silver on silver, sequins with moon boots, and space helmets accessorizing everything from shift dresses to trousersuits. Naturally, Andy Warhol was a fan.

Having originally trained as an air force pilot, Courrèges later enrolled at a training college for the clothing industry in Paris. In 1947 he worked as a designer at Jeanne Laufrie, and in 1951 for Cristobal Balenciaga. Balenciaga became Courrèges' mentor, making a loan available to enable him to set up a business with his partner Coqueline Barrière in 1961.

Courrèges showed his first mini in 1964, with *Vogue* declaring his version the shortest in Paris. Shortly afterwards, he announced that his designs were being plagiarized and suspended giving shows until 1967, but continued to design for private customers. In 1968 Courrèges built his own futuristic factory in Pau – a suitably semi-transparent structure with glass

LEFT Courrèges' view of fashion in the year 2000: 'she is constantly ascending, she's tied to the cosmos, hence, her spacesuit'.

CRAHAY, Jules-François

BORN: LIÈGE, BELGIUM, 1917
DIED: MONTE CARLO, MONACO, 1988

Son of a couturière, Jules-François Crahay began his career early. At 13 years old he was already working as an illustrator at his mother's couture house. In 1934 Crahay moved to Paris to study couture and then returned to join his mother's establishment, where he helped dress Belgium's high society for two years. During the Second World War he was captured and imprisoned for four years. Crahay then joined Nina Ricci – his 1959 collection was rapturously received – and defected to Jeanne Lanvin in 1963, succeeding Antonio del Castillo and directing the collections for 20 years. 'I have no use for afternoon clothes,' he once remarked, 'fashion leaps from the little morning suit to the evening gown.'

walls. Two collections were produced by Jean-Charles de Castelbajac in 1994. Still looking to the future, in 1997 André Courrèges launched his perfume 2020.

COX, Patrick

BORN: EDMONTON, ALBERTA, CANADA, 1963

Most famous for his Wannabe loafer, which enjoyed phenomenal success in the early 1990s, Patrick Cox has now changed tack from concentrating solely on shoes to accessories and clothing.

Cox emigrated from Canada to England in 1983 to attend Cordwainers College, London – the only establishment to specialize specifically in shoe design. While still a student, he worked with Vivienne Westwood on her autumn/winter 1984 collection. In 1985 Cox set up his own company – which commissions for British designers including John Galliano – where he continued for six seasons. Since then, he has produced collections for Anna Sui, Katharine Hamnett and, in 1990, Lanvin's prêt-à-porter collection. In 1991 Patrick Cox opened his first shop in London, selling antiques alongside his bestselling loafer.

CREED, Charles Southey

BORN: PARIS, FRANCE, 1909
DIED: LONDON, ENGLAND, 1966

Son of Henry Creed of Paris – who claimed to be the first tailor to introduce tweeds into women's suits – Charles Creed was one of the movers and shakers of British fashion in the 1940s. 'He was pre-destined to design exquisite clothes,' said *Vogue* in 1946. 'Like any artist he seeks perfection, in his case it is tailored perfection.'

Educated in France, England and Germany, Creed joined his father's business – established by his ancestors in 1710 – before settling in London. At 17 years old, he travelled to Vienna to study tailoring and design. In 1941 he produced utility designs and, after the Second World War, opened his own London house. He married Patricia Cunningham, a fashion editor at *Vogue*, in 1948.

Charles Creed was in possession of one of the finest collections of lead soldiers and porcelains of the Napoleonic era. In his autobiography, *Maid to Measure* (1961), he claims to have invented the concept of boutiques in 1939 and concludes, 'I have grown older and grey and rather bald in the pursuit of my profession and the opposite sex – and I still cannot think of a better way to spend one's time.'

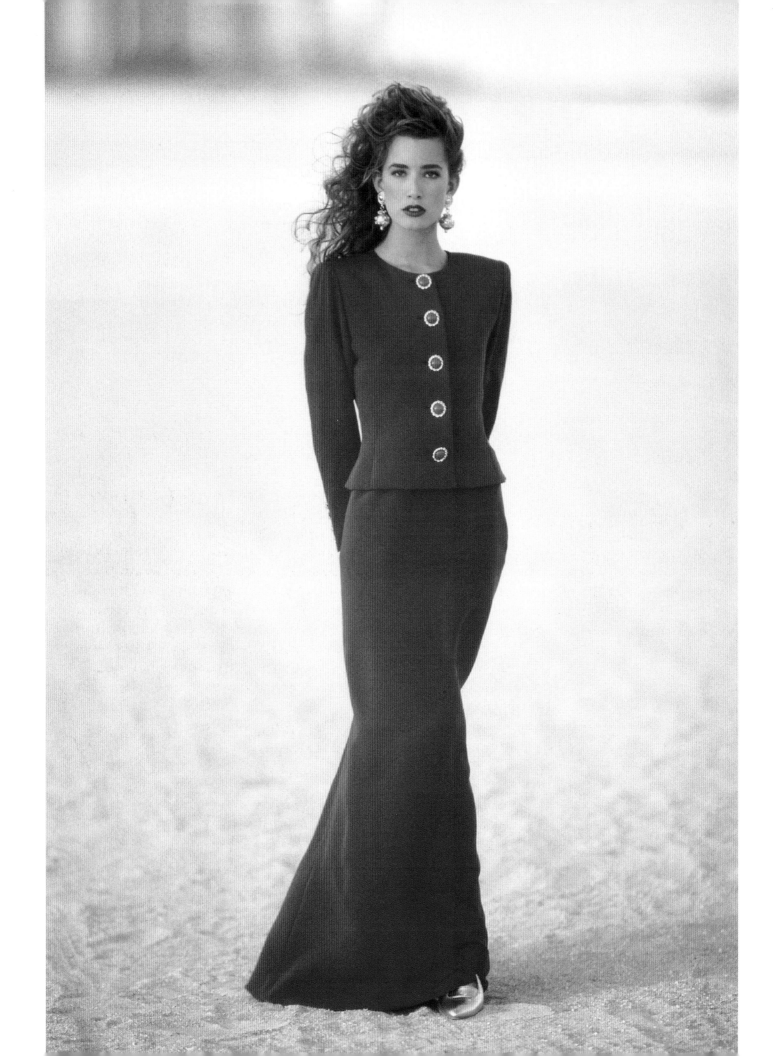

DACHÉ, Lilly

BORN: BÉGLES, FRANCE, 1907
DIED: LOUVECIENNES, FRANCE, 1989

The personification of the American Dream, Lilly Daché was a French immigrant who, within the space of a decade, became an enduring household name for chic millinery.

Having learnt her craft at Reboux in Paris, Daché defected to New York in 1924, becoming a millinery sales assistant at Macy's department store. She then worked at The Bonnet Shop, before buying the business and opening additional outlets in Chicago and Florida. At the height of her fame, Daché was collaborating with Hollywood costume designer Travis Banton. Her speciality, turbans draped directly onto the head, enabled her to swathe fabric around some of Tinsel Town's starriest crowns, including Carole Lombard, Betty Grable, Lorette Young and Marlene Dietrich. Daché was also famous for close-fitting, brimmed cloche hats, snoods and caps. Her autobiography, *Talking Through My Hats*, was published in 1946; in the late 1950s, she employed Halston as an assistant.

DE LA RENTA, Oscar

BORN: SANTO DOMINGO, DOMINICAN REPUBLIC, 1932

Colourful and sociable, Oscar de la Renta studied art in Spain, worked for Cristobal Balenciaga and was then employed as an assistant to Antonio del Castillo at Lanvin. He cites Coco Chanel and Balenciaga as the major talents of the century.

In 1967 de la Renta married the editor-in-chief of French *Vogue*, Françoise de la Languade. He later married New York socialite, Annette Reed, in 1989. De la Renta lives in Connecticut, but also owns an opulent apartment in New York and a luxurious retreat in La Romana in the Dominican Republic. Famous for his opulent evening wear, which is both vibrant and tasteful, his clients list is a roll call of America's socially significant – Liza Minelli, Nancy Reagan, Joan Collins, Ivana Trump, Jacqueline Onassis and Fay Dunaway – and his friends include Dr Henry Kissinger and television presenter Barbara Walters.

OPPOSITE **Oscar de la Renta on top form: fitted sunset-orange jacket in silk crepe with gilt-edged buttons, over a matching full-skirted dress, 1989.**

De la Renta is well known for his services to charity: he set up a children's home, Casa de Niños, in his native Dominican Republic – and adopted one of their children, Moises, at 8 months old.

Although de la Renta's signature is flamboyance and colour, he has survived major swings in fashion. In 1991, at 58 years of age and with annual sales of $350 million, de la Renta showed his collection for the first time in an attempt to broaden his client base – it was also the first time an American designer had shown in Paris. The public relations exercise paid off: two years later, in 1993, he was appointed designer to Pierre Balmain – making him the first American designer to head a Parisian couture house. His career had, at last, come full circle.

DE LISI, Ben

BORN: BROOKLYN, NEW YORK, USA, 1955

Winner of British Fashion's Glamour Award two years running, Ben de Lisi was born in Brooklyn, raised in Long Island and graduated from the Pratt Institute, New York, in 1977. He worked briefly for Bloomingdales while he was still at college, designed a range of T-shirts which he sold to Saks Fifth Avenue, and spent four years with a young designer called Penelope before launching his own menswear line called 'Benedetto' – his full Christian name.

In 1982 de Lisi opened a French restaurant, Ciboure, in London's Belgravia. He designed a capsule collection of ten pieces using job lot fabric – cut on tables above the restaurant – and made them up himself between sittings. He pounded the pavement and ended up with £30,000 worth of orders. De Lisi excels at swimwear and eveningwear – in December 1998 he opened his first shop in Belgravia's Elizabeth Street.

DE PRÉMONVILLE, Myrène

BORN: HENDAYE, FRANCE, 1949

Known for her use of colour and fastidious tailoring with a slight theatrical bent, Myrène De Prémonville was described by *Vogue* in 1987 as 'the new discovery of the past two seasons … her collection neither based on a lifestyle, nor a customer, but the creative urge of someone who has worked half her life in fashion.'

Working exclusively with French fabrics and French manufacturers, De Prémonville's clothes – including dresses for day and evening, and knits – blend a youthful spirit of innovation with conservative Gallic chic.

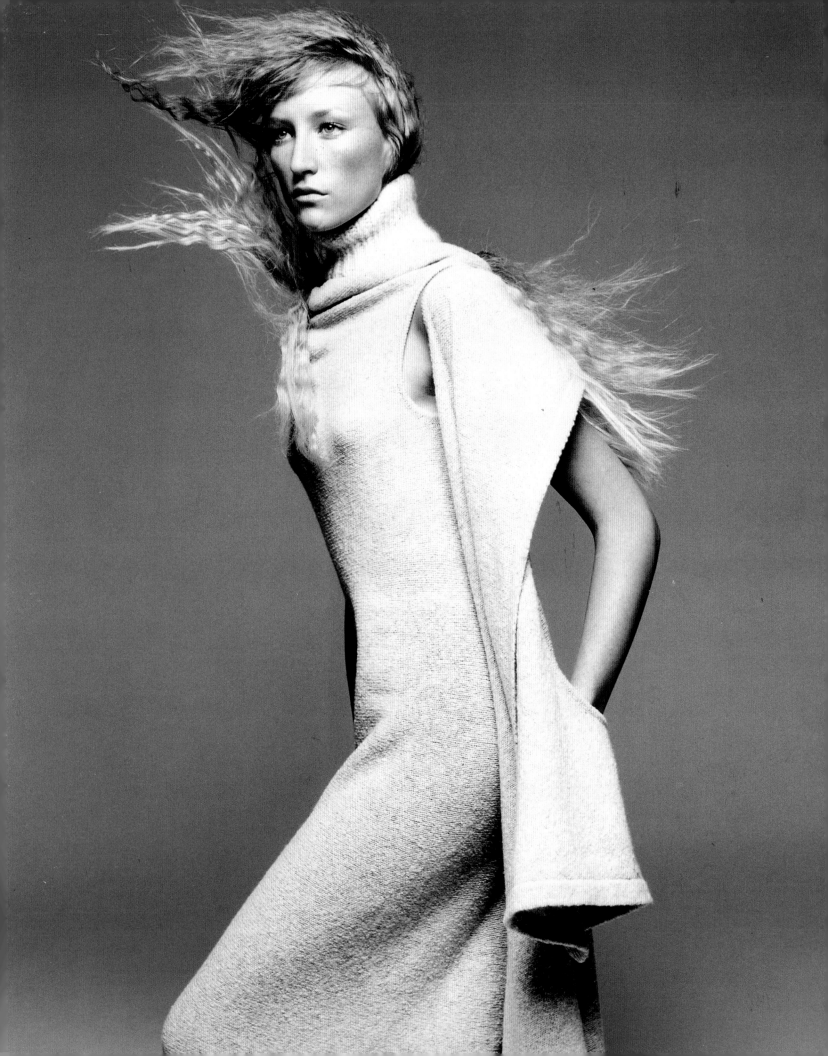

DELAUNAY, Sonia

BORN: ODESSA, UKRAINE, 1885
DIED: PARIS, FRANCE, 1979

Painter, textile designer and supreme colourist, Sonia Delaunay's dresses epitomize the meaning of modernity. Abstract and angular, her designs contain the juxtaposition of geometric shapes and squares and developed out of Cubism. Delaunay's designs were worn by Nancy Cunard, Gloria Swanson and a host of French film stars and international artists. She delivered a lecture at the Sorbonne in Paris in 1926 called 'The Influence of Painting on Fashion Design'. An amazing 94 years old when she died, Delaunay left a rich seam of work and dresses, which look as if they were designed yesterday.

DEMEULEMEESTER, Ann

BORN: KORTRIJK, BELGIUM, 1959

Ann Demeulemeester is a member of a group of experimental designers who emerged from Belgium in the mid-1980s. Termed deconstructivists, they achieved recognition by creating raw, elemental, non-traditional clothes. Demeulemeester designs with a close attention to detail and prefers to concentrate on pairing unusual fabrics, rather than focusing on colour and ornament. Although she is a meticulous planner, her clothes always look uncontrived. Her style is a melting pot of punk, gothic and Japanese; long coats and dresses in draped fabrics have become her signature, together with halter-neck vests and trousers and skirts which expose the hip bone. Often contradictory, Demeulemeester combines unconventional cutting and tailoring with distressed fabrics and crucifixes, and always mixes the austere with the avant-garde.

Demeulemeester studied fashion design at the Royal Academy of Fine Arts in Antwerp and worked freelance before launching her own line in 1985. She showed her first collection in a Parisian art gallery and opened her Paris showroom in 1992. In 1996 she produced her first menswear line. Her celebrity clients include Madonna and Courtney Love.

OPPOSITE Demeulemeester deconstructs the knit: a cream merino wool cape dress with detachable polo neck collar, 1998.

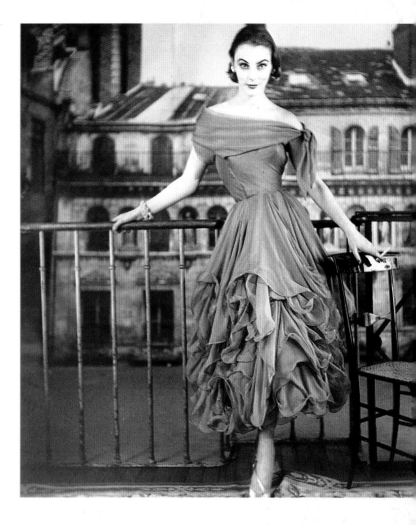

ABOVE **Flounced, smoky mauve skirt, caught up unevenly in tiers like curls of smoke on one of Dessès's many chiffon dresses, 1953.**

DESSÈS, Jean

BORN: ALEXANDRIA, EGYPT, 1904
DIED: ATHENS, GREECE, 1970

In 1950 *Vogue* described Jean Dessès, an Egyptian-born Greek, as daring and influential. 'Dessès creates with a hand that is dashing and unafraid. The inspired results: flattering décolletages; clothes with easy and young movement of line.' A couturier who came to prominence in post-war Paris, Dessès had become so famous by the turn of the 1950s that he created the 'Jean Dessès American Collection', a range that was designed and sold directly through wholesalers. He was acclaimed as one of *Vogue*'s 'Names in the News', 'hailed and applauded by American store buyers, recognised and respected by your customers.'

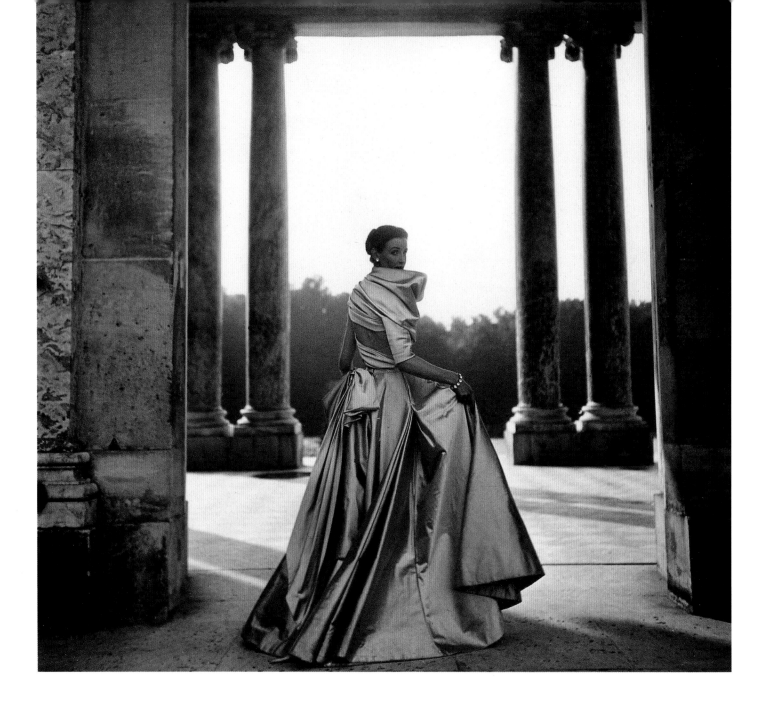

DIOR, Christian

BORN: GRANVILLE, FRANCE, 1905
DIED: MONTECATINI, ITALY, 1957

Christian Dior was responsible for the pivotal point in twentieth-century fashion. His New Look shook the world, brought women back to life and became fashion's most powerful political statement. Dior studied political science at École des Sciences Politiques in Paris from 1920–25. He served in the French army and worked as an art dealer, illustrator and designer at Piguet and Lelong before launching his curvaceous controversy on an unsuspecting world in December 1946. Heralded an overnight sensation, Dior was, in fact, 41 years old.

Dior's New Look was equal parts fashion and social revolution. It was a female seducer with explosive elements: excessive fabric in a period of austerity; a return to femininity after wartime suppression; a taste of glamour after years of drab. Although sketches smuggled out of Paris during the war were predicting a return to undulation, it was Dior who delivered. 'The prime need of fashion is to please and attract,' he mused in his memoirs, *Dior by Dior* (1957). 'Uniformity is the mother of boredom.'

Dior – whose preferred places for sketching were the bed or bath – dominated *Vogue*'s collection reports for a decade. 'His ideas were fresh and put over with great authority,' wrote *Vogue* in 1947. 'His clothes were beautifully made, essentially Parisian, deeply feminine ...' Like Balenciaga, Dior's prime concern

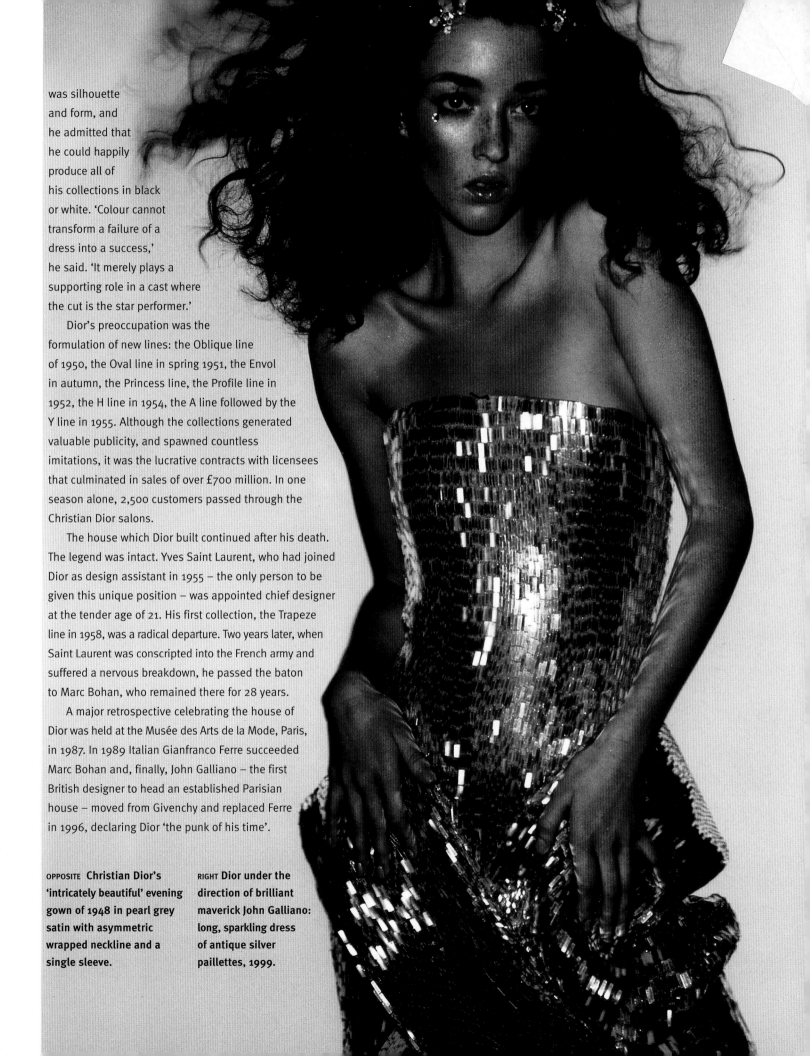

was silhouette
and form, and
he admitted that
he could happily
produce all of
his collections in black
or white. 'Colour cannot
transform a failure of a
dress into a success,'
he said. 'It merely plays a
supporting role in a cast where
the cut is the star performer.'

Dior's preoccupation was the
formulation of new lines: the Oblique line
of 1950, the Oval line in spring 1951, the Envol
in autumn, the Princess line, the Profile line in
1952, the H line in 1954, the A line followed by the
Y line in 1955. Although the collections generated
valuable publicity, and spawned countless
imitations, it was the lucrative contracts with licensees
that culminated in sales of over £700 million. In one
season alone, 2,500 customers passed through the
Christian Dior salons.

The house which Dior built continued after his death.
The legend was intact. Yves Saint Laurent, who had joined
Dior as design assistant in 1955 – the only person to be
given this unique position – was appointed chief designer
at the tender age of 21. His first collection, the Trapeze
line in 1958, was a radical departure. Two years later, when
Saint Laurent was conscripted into the French army and
suffered a nervous breakdown, he passed the baton
to Marc Bohan, who remained there for 28 years.

A major retrospective celebrating the house of
Dior was held at the Musée des Arts de la Mode, Paris,
in 1987. In 1989 Italian Gianfranco Ferre succeeded
Marc Bohan and, finally, John Galliano – the first
British designer to head an established Parisian
house – moved from Givenchy and replaced Ferre
in 1996, declaring Dior 'the punk of his time'.

OPPOSITE **Christian Dior's
'intricately beautiful' evening
gown of 1948 in pearl grey
satin with asymmetric
wrapped neckline and a
single sleeve.**

RIGHT **Dior under the
direction of brilliant
maverick John Galliano:
long, sparkling dress
of antique silver
paillettes, 1999.**

DŒUILLET, House of

FOUNDED BY GEORGES DŒUILLET IN 1900

One of the most-featured labels in *Vogue*'s early years, the house of Dœuillet was known for its attention to detail, rather than for directional design.

Having worked as a manager at Callot Sœurs – who specialized in fine lace and delicate touches – Georges Dœuillet branched out on his own. He situated his house in one of the royal mansions on the place Vendôme in Paris, where he forged a reputation for exquisite evening wear. In 1914 he was made president of the French Syndicate of Dressmakers and was described in *Vogue* as 'not pronounced in his personality, but his wonderful head for business and his saneness make him a bulwark for many of the other couturiers'. In 1929 Dœuillet merged with the house of Doucet.

DOLCE & GABBANA

FOUNDED BY DOMENICO DOLCE AND STEFANO GABBANA IN 1985

Dolce & Gabbana put sex into Sicily. They swept away the preconceived ideas of widows and vendettas and reinvented it with seduction and shades of Sophia Loren. Dolce & Gabbana are experts in mixed metaphors of flyaway beading, corsetry and cleavage, often accessorized by curled locks and a sweep of 1950s-style eyeliner. Launched in 1985, their early collections concentrated on corsetry, the promotion of cotton/Lycra underwear as outerwear. In 1993 the duo designed costumes for Madonna's Girlie Show. By 1997 they were Hollywood hotshots, dressing the stars for a variety of awards. 'The show is only fantasy,' said Stefano, underplaying their reputation in 1997, 'it's not even that representative of what we do. People think Dolce: glamour, curves, sexy. But we also do suits, cardigans, skirts – clothes women can wear to work.'

DOUCET, Jacques

BORN: PARIS, FRANCE, 1853
DIED: PARIS, FRANCE, 1929

'Next to Poiret, Doucet is the most amazing personality among the men in the dressmaking world of Paris,' commented *Vogue* in 1914. 'He is often called the most elegant man in Paris.' The celebrated house of Doucet was established in 1816 by the

ABOVE **Dolce & Gabbana's 'movie star glamour' of 1991: fake leopardskin coat with deep shawl collar; scarlet silk corset with black stitching.**

grandmother of Jacques Doucet. The building – a house already renowned for making fine lingerie – was situated on boulevard Saint-Martin. Maison Doucet later relocated to rue de la Paix. In 1877 it began making gowns and costumes.

Jacques Doucet was a patron of the arts, an authority on French eighteenth-century history, with an instinct for the grand occasion – he collaborated on countless theatrical productions, owned a hotel and, it is said, invested six million francs in rare books. *Vogue* assessed his collections as embodying 'a gracious elegance and a fineness of workmanship which could not be surpassed'. In 1932, after a merger with Dœuillet, the house closed.

DUFF GORDON, Lucile

BORN: LONDON, ENGLAND, 1862
DIED: LONDON, ENGLAND, 1935

A single mother in an era when divorce was associated with disgrace, Lucile Duff Gordon had a colourful personal life, a high profile and a 21-inch waist in 1899. Married at 18, she was divorced by her mid-twenties with a 5-year-old daughter, Esme. In 1900 she met and married Sir Cosmo Duff Gordon, whose social connections invariably helped her client list.

Lucile, as she was known, advocated the elimination of the corset, a return to Grecian lines, and put colour into hair years before punk. Although Paul Poiret pioneered the new silhouette, Lucile promoted the Empire line. She broke into the American market, made theatrical designs and met Emmeline Pankhurst when she was advocating votes for women. Sister to novelist Elinor Glyn and pioneer of her time, Lady Duff Gordon came to the conclusion that women should be seen but not heard. In her autobiography, *Discretions and Indiscretions*, published in 1932, she writes, 'I do not think that, on the whole, it is good for a woman with a temperament. It is much better for her to be a vegetable, and certainly much safer, but I never had a choice.'

RIGHT AND BELOW **Lucile's 'exotic, Oriental frocks' of 1917 reveal bare flesh, ankles, arms, a flash of cleavage and gold lace trousers.**

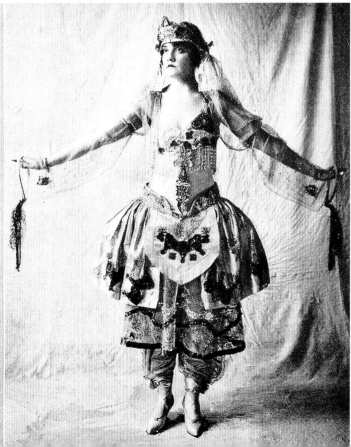

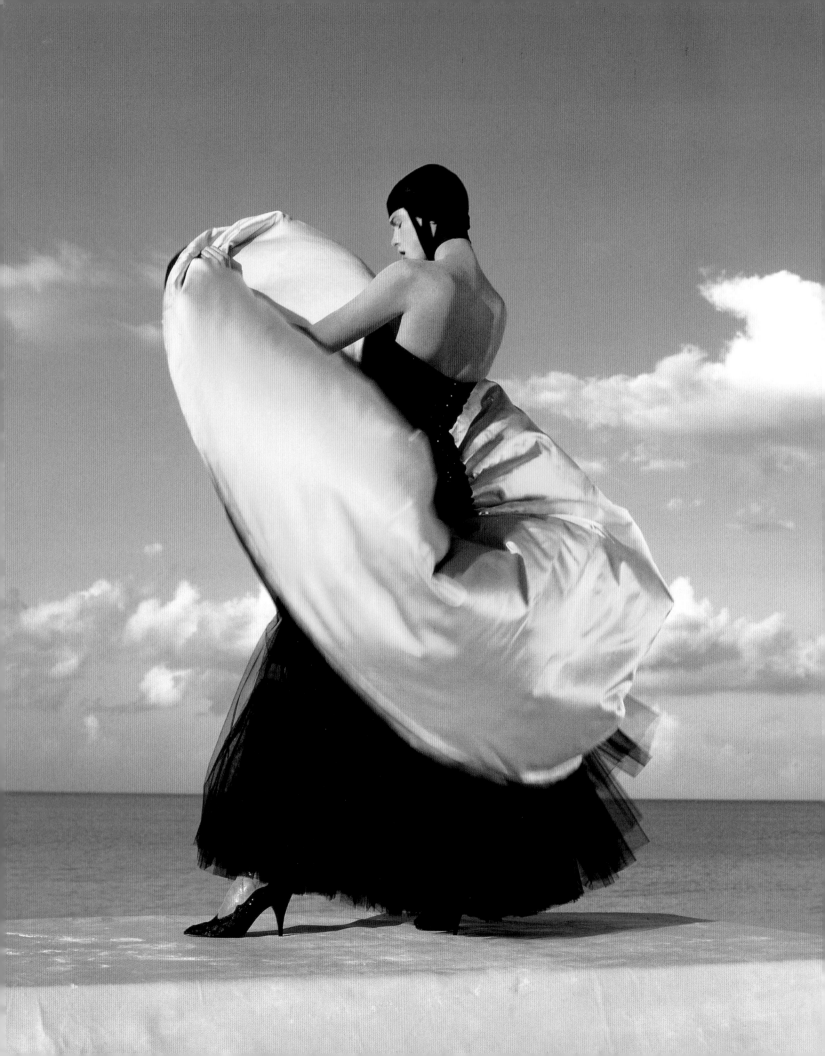

EDELSTEIN, Victor

BORN: LONDON, ENGLAND, 1947

'She likes body-conscious clothes, and why not? She's got a fabulous figure,' said British couturier Victor Edelstein of his most famous client in 1987. Edelstein will forever be associated with the bare-shouldered velvet dress he made for Diana, Princess of Wales, which she wore while dancing with John Travolta at President Reagan's White House State Dinner in 1985. At the Christie's auction in 1997 it eclipsed every other gown, selling at the record price of $222,500.

Descended from a line of dressmakers – both his father and grandfather were in the business – Edelstein trained at Alexon and a Paris couture boutique. In 1967, after several dismissals for being too dreamy, he worked for Barbara Hulanicki at Biba for three years. Then, after a period of self-employment, he became assistant designer at the London couture branch of Christian Dior. He married art dealer Annamaria in 1973 and started his own ready-to-wear business in 1978. In 1982 he decided to concentrate solely on couture.

At 46 years old, Edelstein hung up his scissors and decided to retire. His reasons were both financial and psychological: as he told the *Evening Standard* in 1993, 'I've spent eleven years being polite and constantly watching what I say. I look at something that's tight and instead of saying "We'll let that out", I have to say "We'll ease that over the hips."' Currently painting landscapes in Venice, treading on eggshells is no longer one of his concerns.

ELBAZ, Alber

BORN: CASABLANCA, MOROCCO, 1961

The first designer to direct Yves Saint Laurent's Rive Gauche line, Alber Elbaz is an Israeli-American with a fantastic sense of proportion and healthy sense of humour. Elbaz trained with America's foremost minimalist, Geoffrey Beene, for seven years before being offered an opportunity he couldn't refuse. He first designed at Guy Laroche and presented his first collection at the Carrousel du Louvre in Paris on 13 March 1991. On 2 November 1998 Alber Elbaz joined Yves Saint Laurent as artistic director for women's ready to wear, leaving the maestro to concentrate on couture.

OPPOSITE Victor Edelstein's wild side: silk grosgrain bustier and golden yellow duchesse satin skirt over a black tulle petticoat, 1986.

ELLIS, Perry

BORN: PORTSMOUTH, VIRGINIA, USA, 1940
DIED: NEW YORK, NEW YORK, USA, 1986

Perry Ellis designed sportswear in the true sense of the word. Clean lines, crisp fabrics – clothes that crossed the border between lounging and activity. Ellis knew all about the ins and outs of sportswear, having started his career as a sportswear buyer for Miller & Rhoads, a Virginian department store, later taking up a position of designer. He had degrees in both business and retailing, and his diverse experience culminated in an astute understanding of commercial design.

Ellis formed his own label, Perry Ellis International, in 1978. His easy-to-wear slouch look – consisting of loose trousers, layered tunics and oversized sweaters – became his signature menswear and sportswear line in conjunction with Levi Strauss. Elected president of the Council of Fashion Designers of America in 1984, he said, 'My clothes are friendly – like people you've known for a long time, but who continue to surprise you. Clothes must do the same.'

RIGHT Loose tailoring, long lines and 'Chaplin bags' in Perry Ellis's Burren tweed suits, here drawn by Ellis himself.

LEFT A hint of things to come: this early Emanuel taffeta 'wedding crinoline' appeared in June 1981, one month before the royal wedding dress.

ENGLISH ECCENTRICS
FOUNDED BY HELEN DAVID IN 1983

Having trained at London's Camberwell School of Art and Central Saint Martins College of Art and Design, Helen David – founder of English Eccentrics – is known for her print, colour and quirky textiles, which mix the baroque with aesthetically pleasing shapes. Not limited to accessories, the English Eccentrics label also encompasses shirts, often with a Pucci-esque feel.

ESTRADA, Angel
BORN: BARCELONA, SPAIN, 1957
DIED: NEW YORK, NEW YORK, USA, 1989

A talented designer, who had a flair for combining sculptural shapes with fluid effects, Angel Estrada secured a *Vogue* front cover – a satin bustier with luggage zip – within his first year of business in November 1986.

Estrada's family relocated from Spain to New York when he was 3 years old. After studying briefly at Parson's School of Design, New York, he worked as a hair and make-up artist and then, in 1985, formed his own label, which he kept afloat without outside finance. After Estrada's death at the age of 31, the business was taken over by his sister Virginia, an artist and sculptor, who had collaborated with her brother on his collections.

ETTEDGUI, Joseph
BORN: CASABLANCA, MOROCCO, 1936

Son of a French-Moroccan furniture retailer, Joseph Ettedgui emigrated to London in the late 1950s and trained to be a hairdresser. During the 1960s he began travelling to Paris to see the ready-to-wear collections. There, he met Kenzo, whose brightly-coloured sweaters he started to sell in the reception area of his King's Road salon. Before long, the clothes had eclipsed the hairdressing, and Joseph's first shop was established below the salon in the early 1970s.

EMANUEL,
David and Elizabeth

DAVID EMANUEL, BORN: BRIDGEND, WALES, 1952
ELIZABETH WEINER, BORN: LONDON, ENGLAND, 1953

The couple who have now gone their separate ways will forever be remembered as the designers behind the wedding dress of Diana, Princess of Wales. Unveiled on 31 July 1981, the most important royal wedding dress of the decade was made from pure silk taffeta overlaid with lace, mother-of-pearl sequins and pearls, with a double-flounce collar and 7.6-metre (25-foot) detachable train. A matching pochette and an umbrella were designed in the event of rain.

Already married when they entered the Royal College of Art in London, the Emanuels graduated in 1978 and launched their Mayfair boutique. They perfectly captured the mood of the moment – a mix of New Romantics and royal wedding fever. The then Lady Diana Spencer wore an Emanuel blouse for her first sitting for British *Vogue*. The Emanuels have since concentrated on their individual careers.

Joseph has continued his winning-formula own label alongside international names – from Azzedine Alaïa to Helmut Lang, with John Galliano, Katharine Hamnett and a host of others in-between. In 1993 he moved into menswear, then furniture design and cafes – Joe's and L'Express – and one restaurant, Joe's Cafe. His shops, designed by architects Eva Jiricna and David Chipperfield, are appropriately modernistic – using steel, white and concrete colours as a background for the collections. He also has branches in Paris, Cannes and New York. As he told the *Observer* in 1987, 'Once a place becomes a meeting point, you get the business.'

FARHI, Nicole

BORN: NICE, FRANCE, 1946

Unpretentious clothes with nothing to prove are at the core of Nicole Farhi's philosophy. After studying fashion in Paris, Farhi freelanced at Agnès B and Jean-Charles de Castelbajac. She moved to Britain in 1973 and worked for French Connection with Stephen Marks. A decade later she formed her own label, and launched a menswear collection in 1989. Her flagship store on London's Sloane Street opened in October 1998. Like Joseph, she has expanded her business to include a restaurant – in her case Nicole's – situated beneath her Bond Street store. Farhi opened her first New York branch in 1999.

FATH, Jacques

BORN: LAFITTE, FRANCE, 1912
DIED: PARIS, FRANCE, 1954

Jacques Fath was the darling of the Parisian social scene, his name spoken in the same sentence as Cristobal Balenciaga and Christian Dior. Fath's style, however, was less breathtaking and more a celebration of the female form. Described by *Vogue* in the 1950s as 'a comet', Fath shot to fame after the Second World War, in the wake of the fashion revolution caused by Dior's New Look: women dressed according to the Paris directive and the press were, once again, frequenting the front row.

Fath had dressmaking in his blood – his great-grandmother was dressmaker to Empress Eugénie – but he started his career as a book-keeper. He showed his first collection in 1937, but it was in the post-war era of renewed optimism and femininity that he made his mark. While Balenciaga and Dior concentrated on sculpture and the invention of new proportions, Fath focused on undulating lines and elegant juxtaposition of colours.

'Persian lamb is dyed blue to trim a blue suit,' said *Vogue* in its collection report of September 1956. 'Fath carries the idea still further with green, red and purple.' During his short, sharp career, Fath made a lasting impression. A retrospective of his work was held in Paris in 1993.

FENDI

FOUNDED BY ADELE CASAGRANDE IN 1918

One of the largest and most important of the Italian fashion dynasties, Fendi began as a leather and fur workshop over a century ago. Its founder, Adele Casagrande, who married Eduardo Fendi in 1925, changed the company's name after the death of her father in 1954.

Although Fendi is inextricably linked with fur, the label is also known for its other lines – namely ready to wear and accessories. During the 30 years that Karl Lagerfeld has been associated with Fendi – he has designed their collections since 1965 – he has redirected the label from an anonymous luxury brand into a high-profile house with elitist connotations. Like the unmistakable Chanel logo, Fendi's logo is world-famous.

Over the past century fur has fallen in and out of favour with alarming regularity. Despite shifting tastes and phases of political correctness, Fendi has remained immovable, although customers in the late 1990s showed more interest in Fendi's chic accessories – the baguette bag was a phenomenal bestseller – than in making huge investments buying fur.

FÉRAUD, Louis

BORN: ARLES, FRANCE, 1921

Chic suits and sophisticated French tailoring are the signatures of Louis Féraud. Glamorous and wearable, his clothes appeal to groomed thirtysomethings and women of a 'certain age': his clothes were worn by Joan Collins during her *Dynasty* and *Dallas* periods, but have also been worn by Brigitte Bardot, Catherine Deneuve and Kim Novak.

Féraud served as a lieutenant in the French Resistance, and opened his first couture boutique in Cannes in 1955, which was patronized by movie stars. He became a costume designer before moving to Paris 20 years later. In 1984 he won the coveted Golden Thimble Award. An accomplished artist with a sensitive palette, he has held many exhibitions and is also an author – *L'Été du Pingouin* was published in 1975.

LEFT
The perfectly proportioned shoe from Ferragamo, featuring his gloved suede arch of 1952: 'it's all new, the colour, the shape, the spool heel.'

FERRE, Gianfranco

BORN: LEGNANO, ITALY, 1944

Famously compared with Frank Lloyd Wright, Gianfranco Ferre has a rotund physique and aesthetic sensibility. His grandfather designed bicycles and his father was the owner of two factories. Ferre originally trained as an architect at Milan Polytechnic, graduating in 1969. His favourite architectural triumphs include the Institut du Monde Arabe in Paris and the Torre Velasca in Milan. Ferre's first official show was presented in a restaurant in Via San Murillo, Milan, in 1974. Four years later came his first collection, 'Gianfranco Ferre Donna', followed by a menswear line in 1982.

A doer rather than a talker, since 1983 Ferre has been a professor at the Domus Academy in Milan and financed the restoration of sixteenth-century frescoes. His intellectual approach and sensitivity to form and outline produces powerful designs – such as his voluminous organza shirts – as well as immaculate tailoring. In 1989, Ferre was appointed artistic director at Christian Dior, and his first collection – which he was told he had nine weeks to complete – occured in the same year. With Grace Jones and Princess Michael of Kent in the front row, Ferre's first show for Dior was dedicated to Cecil Beaton's Ascot scene in *My Fair Lady* (1964), and featured Ferre's speciality – huge bows. It was described by *Vogue* as 'a matter of Dior discipline and Ferre flourish'. He was awarded Paris fashion's highest accolade, the Golden Thimble, on the final day of the collections.

Ferre continued with his own collection, and his career after leaving Dior in 1996 has included diffusion lines Ferre Sport, Ferre Jeans, Ferre Studio and Studio 000.1, as well as an experimental line, GIEFFEFFE.

FERRAGAMO, Salvatore

BORN: BONITO, ITALY, 1898
DIED: FIUMETTO, ITALY, 1960

Salvatore Ferragamo's supremacy in making innovative shoe shapes was a product of his apprenticeship with a craftsman in his native Italy. In 1923 he emigrated to America and opened a shoe shop in Santa Barbara, California, making couture shoes. His client list included Audrey Hepburn, Sophia Loren, the Duchess of Windsor and Eva Perón. He also worked with producer and director Cecil B De Mille. Ferragamo was a perfectionist and innovator. He worked with unusual materials – Cellophane, raffia, lace and crystal, as well as fish skin and sea leopard – and instigated new shapes, including the platform shoe, an ancient Chinese idea which he relaunched in 1938. Between 1927 and 1960 he produced 20,000 designs, and published his biography, *Shoemaker of Dreams* in 1957. He didn't care that his style was relentlessly plagiarized – Ferragamo was the original: 'Elegance and comfort are not incompatible, and whoever maintains the contrary simply doesn't know what he is talking about.'

OPPOSITE
Gianfranco Ferre's voluminous flair: silk blouse with huge organza collar and hat by Marina Killery. Modelled by the 'unutterably glamorous' Linda Evangelista, 1991.

FERRETTI, Alberta

BORN: RICCIONE, ITALY, 1950

That rarest of breeds – clever designer and top flight manufacturer – Alberta Ferretti is one of the most powerful women in Italian fashion. Owner of Aeffe, a high-tech computerized manufacturing complex near Rimini, Ferretti trained at her mother's small atelier before opening her first shop in Cattolica at 18 years old, selling Armani, Krizia and Versace. She switched from selling to designing, and today heads one of the most technologically advanced factories, which has produced collections for Franco Moschino, Rifat Ozbek, Narciso Rodriguez and Jean Paul Gaultier, while producing her own name lines. 'One of my principles is there's no such thing as "It's impossible"', she told *Vogue* in 1992, 'I always try.'

FIORUCCI, Elio

FOUNDED BY ELIO FIORUCCI IN 1962
BORN: MILAN, ITALY, 1935

In the same way that Biba made black lipstick beautiful, Fiorucci made the 1950s fashionable. An inspired retailer, after inheriting his father's footwear business, Elio Fiorucci started to stock hip 1960s' designers (the British contingent included Ossie Clark). Fiorucci was aimed specifically at the youth market, taking inspiration from the 1950s' plastic shoes, bags and jeans – a reversal of roles: American classics with Italian marketing. Colourful and airbrushed, the advertising had a Vargas-Girl slant, with glamorous starlets featured on posters. Fiorucci claims that it was the first company in Italy to show bare breasts in an advertising campaign. Italy went berserk at one particular circular car sticker they produced. 'Fiorucci is fashion. Fiorucci is flash. Fiorucci stores are the best free show in town,' said *The Fiorucci Book* (1981), 'but the difference is all that sex and irony.'

FLETT, John

BORN: CRAWLEY, ENGLAND, 1963
DIED: FLORENCE, ITALY, 1991

John Flett began his career as the star of his year at Central Saint Martins College of Art and Design in London, from where he graduated in 1985. Like John Galliano, Flett had a talent for unconventional cutting. His first collection caught *Vogue*'s attention and was bought by Joseph and Bloomingdales; he added menswear and diffusion lines to his repertoire in 1986.

In 1989 Flett moved to Paris, working with Claude Montana on his first couture collection for Lanvin. When that didn't work out, he was employed by designer Enrico Coveri in Florence. He was on the verge of signing another deal with the Italian fashion house Zuccoli, when he died tragically young, never fulfilling his early promise like his friend, John Galliano.

FLYTE OSTELL

FOUNDED BY ELLIS FLYTE AND RICHARD OSTELL IN 1991

Both Ellis Flyte and Richard Ostell had survived fashion's school of hard knocks – bankruptcy, backers and being flavour of the month – before joining forces in 1991. Ostell is a superb minimalist designer and Flyte has a flair for theatrical designs; together, they were regarded as the English equivalent to Zoran. Ostell had worked with Romeo Gigli; Flyte in theatre, costume and television.

The Flyte Ostell look – drawstring trousers, fluid tunics, silks and satins – was lauded by the pundits but relentlessly plagiarized. The business folded and they now work separately as consultant designers. As they commented at the time, 'It seems to be what people want. The cut is right, the design is right, the time is right.'

FOALE & TUFFIN

FOUNDED BY MARION FOALE AND SALLY TUFFIN IN 1961

Pioneers of the 1960s, Marion Foale and Sally Tuffin – both graduates of the Royal College of Art in London – started their business from a bedsit in London's Gloucester Road. In 1963 their cottage industry moved to Carnaby Street, which at the time was dotted with haberdasheries and dry-cleaners. Their customers included Jane Asher, Julie Christie and Cilla Black. Foale & Tuffin toured America together with Mary Quant and a contingent of go-go girls. Their first *Vogue* coverage came via an article by Lady Rendlesham.

In 1971 the Piscean partnership reached its natural conclusion and the two designers went their own way professionally. Since 1981 Marion Foale hand-knits in her thatched cottage in the Warwickshire countryside and sells to Barneys New York, Bergdorf Goodman and Harrods. Her ex-partner and long-standing friend, Sally Tuffin, designs ceramics for Dennis China Works in Somerset.

FORD, Tom

Born: Austin, Texas, USA, 1962

The Texan with the Midas touch, Tom Ford has done what every financier dreams about: taken an established label and made it relevant for a new generation. The Gucci phenomenon is the success story that has swept both the fashion industry and the stock market off its feet. Through the canny creation of seasonal must-have icons – in addition to sexy, sophisticated advertising – Ford gives us a perfect example of fashion items which foster huge public demand, and then burn out in time for the next 'big thing'.

Tom Ford moved to Santa Fe, New Mexico, when he was 13 years old. He initially aspired to be an actor and spent six years in Los Angeles. In the late 1970s he arrived in New York, where he frequented the infamous nightclub Studio 54 and studied interior design at Parson's School of Design. He decided to concentrate on fashion instead and ended up as a senior designer at Cathy Hardwick's studio on Seventh Avenue. Two years later Ford had moved to Perry Ellis as design director of Women's America Division. In 1990 he relocated again – this time to Milan, where he worked for Dawn Mello at Gucci, eventually taking over from her when she moved back to New York in 1994 to head up department store, Bergdorf Goodman.

In 1992 Ford designed his first menswear collection. The tide turned in his favour in March 1995. Celebrity backing and advertising campaigns, photographed by Mario Testino, followed. Famous for photographing the world's most beautiful women, Testino presented Ford's overtly sexy designs in a dramatic, deeply glamorous, light.

Ford's fashion inspiration came from his grandmother: 'She was an Auntie Mame character,' Ford told American *Vogue* in 1999, 'with six husbands and a closet full of Courrèges pantsuits, coral bangles and I Dream of Jeannie falls.' Still harbouring a secret desire to tread the boards, Ford has a Hollywood agent who vets scripts for him. Ford works on instinct. In 1999, when Gucci was under threat from a takeover, Ford made a multi-million dollar decision for a new investor over lunch. 'What can I say?' he told *Vanity Fair* later, 'I'm a Virgo.'

RIGHT **Taking Gucci to its natural conclusion, Tom Ford designs the ultimate funnel neck coat for winter 1999, tied at the waist with a leather thong.**

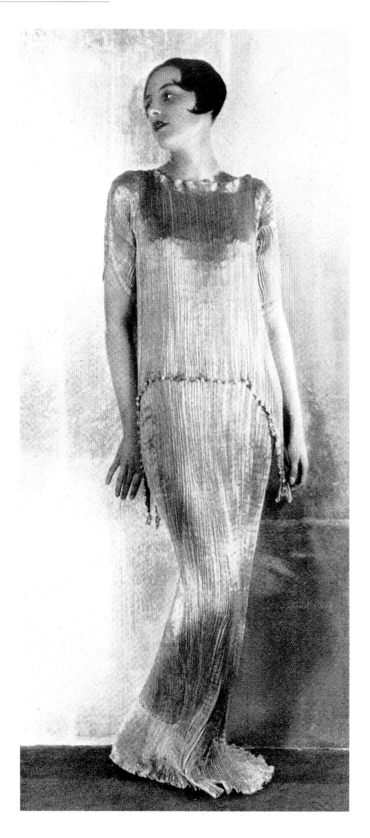

FORTUNY, Mariano

BORN: GRANADA, SPAIN, 1871
DIED: VENICE, ITALY, 1949

Mariano Fortuny was a visionary, Renaissance man and creator of revolutionary fabrics. His Delphos gown, devised in 1907 and patented two years later, was a masterpiece of fabric and form: a free-flowing revelation in a period of restriction, made from a tube of pleated silk. In one stroke of genius, Fortuny embodied the principles of the aesthetic and rational dress movements, whose supporters relentlessly campaigned for the abolition of torturous corsetry. His dresses were drawn on Greek lines, suspended from the shoulder and later decorated with Venetian glass beads. 'This invention is related to a type of garment derived from the Classical robe,' stated Fortuny's original patent description, 'but its design is so shaped and arranged that it can be worn and adjusted with ease and comfort.'

Son of a distinguished Spanish painter, Fortuny came to Venice when his mother, Cecilia de Madrazo, moved to the seventeenth-century Palazzo Martinengo after his father's death. Fortuny was a natural-born textile designer, producing Knossos printed scarves from 1906, opening a showroom for the sale of textiles and clothing in Venice and establishing his own factory for printing fabrics in 1919. Fortuny's talents were not limited to his most famous invention: he developed techniques of printing and over-painting on velvets and cottons, photographed stunning panoramic views of Venice and even invented a new kind of photographic paper. In all, he was an incredible sculptor, artist, stage designer, scientist and chemist – refining and reinventing everything he touched, from theatrical sets to lighting.

The most sensitive colourist of the twentieth century, Fortuny often dipped lengths of silk several times to achieve the precise tone. His perfectionism knew no bounds. Together with the standard Delphos design, Fortuny also patented his pleating methods: the intricacies remain a mystery, but in layman's terms this involved a complicated and arduous process of running the irregular, horizontal folds of silk between copper plates and ceramic tubes.

The Fortuny Museum, in the Palazzo Pesaro, Venice, stands as a monument to Italy's most notable fashion genius. Timeless and modern in the truest sense of the word, Fortuny designs were featured in *Vogue* in 1927 and again almost 50 years on – its advocates spanned half a century, from Isadora Duncan to Julie Christie. Unlike most wearable antiques, original Fortuny's have not disintegrated with time. Still mesmerizing and stunning in the flesh, Fortuny gowns are worn, collected and lusted after – an amazing feat after almost a century in circulation.

ABOVE **Fortuny's masterpiece of 1927: a tea gown in perpendicular, finely pleated satin, with opalescent beads on the hem.**

OPPOSITE **Julie Christie in Venice, wearing a Fortuny gown borrowed from ardent collector and artist, Mrs Liselotte Hohs Manera, 1973.**

FOX, Frederick

BORN: URANA, AUSTRALIA, 1931

Frederick Fox, England's most distinguished milliner, is an Australian who spent his childhood on a farm in New South Wales. During the Second World War, he created new hats by cutting up old ones and reconstructing them. At 17 years old he moved to Sydney, where he visited other milliners – first Henriette Lamotte, who pointed him in the direction of a Mrs Normoyle. Nine months later he moved to Phyl Clarkson, where he stayed for ten years. He travelled to London via Paris and secured a job with Otto Lucas. It was, by his own admission, a tough learning curve: 'I was 26, looked 15 and was in charge of a table of 40 women old enough to be my mother.' He moved on to Mitzi Lorenz, then to Langée in Brook Street, London, which he took over in 1964, and then moved to his present premises in Bond Street.

Fox began making hats to complement the Queen's wardrobe, designed by Hardy Amies, in 1968. His first five hats were for a tour of Chile and Argentina. He received his royal warrant in 1974 as Milliner to HM The Queen and was awarded an LVO in the Queen's 1999 birthday honours list. At one time he hatted eight royal ladies – including Queen Elizabeth the Queen Mother, Princess Alice and Diana, Princess of Wales.

Fox's talent is not limited to creating hats for Ascot, chic weddings and royal tours. He has worked with Red or Dead, and designed the white leather crash helmets that appeared in Stanley Kubrik's classic film *2001, A Space Odyssey* (1968).

FRATINI, Gina

BORN: KOBE, JAPAN, 1934

One of the key instigators of the 1960s romantic movement, Gina Fratini had Irish parentage but was raised in Japan. Her father, the Honourable Somerset Butler, was twin brother of the Earl of Carrick. In 1947 Fratini attended the Royal College of Art in London and then joined the Katherine Dunham dance group, assisting the costume and set designer, John Platt. She also designed clothes independently, and continued to produce private commissions after she married jazz guitarist David Goldberg in 1954.

In 1965, on marrying Renato Fratini, she established her own business, which continued successfully until 1989. Before Marc Bohan joined Hartnell in 1990, Gina Fratini was a guest designer there: 'It was the first time I could just create without thinking of the business. It was wonderful. What a treat and a joy it was just to design.'

OPPOSITE **Bella Freud's 'weird, wonderful, mismatched colours': canary wool twill jacket, Neapolitan merino wool leggings and leather platforms, 1992.**

FREUD, Bella

BORN: LONDON, ENGLAND, 1961

Bella Freud – daughter of artist Lucien and sister of novelist Esther – designs clothes like those she wears: schoolgirl coats and lean shapes. Her logo, drawn by her father Lucien, depicts his whippet, Pluto.

Freud worked as an assistant in Vivienne Westwood's Seditionaries shop in London's King's Road before going to Rome to study design at the Accademia di Costuma di Moda. On her return in 1984 she worked with Westwood on the 'Mini-Crini' collection and became her assistant until she set up her own collection of 30 pieces in 1989. Her first show was in 1993.

Bella Freud had a bohemian childhood, and the year spent in Morocco with her mother and sister was immortalized in Esther's novel, *Hideous Kinky* (1992). She has been captured on canvas many times. Freud's father – who critics regard as the greatest living artist – often slips into the shows unnoticed.

GALANOS, James

BORN: PHILADELPHIA, PENNSYLVANIA, USA, 1924

When James Galanos retired in 1998, after 47 years in business, the former first lady, Nancy Reagan, paid him a resounding tribute in American *Vogue*: 'No one makes clothes like he does – his workmanship, his choice of fabric. I have often said you could wear a Galanos dress inside out and no one would know, because it would be so beautifully made.'

The maker of the former first lady's inaugural gowns – two for the governorship and two for the presidency – began his illustrious career as assistant to Hattie Carnegie. His early work included a stint as an illustrator for Columbia Pictures and assistant to Robert Piguet in Paris before returning to New York to work with designer Davidow. He started his own company, Galanos Originals, in 1951.

Galanos is known for successfully producing ready-to-wear clothes with couture touches – silk linings, embroidery and beadwork. He has been the subject of many exhibitions, including one celebrating a quarter of a century in business.

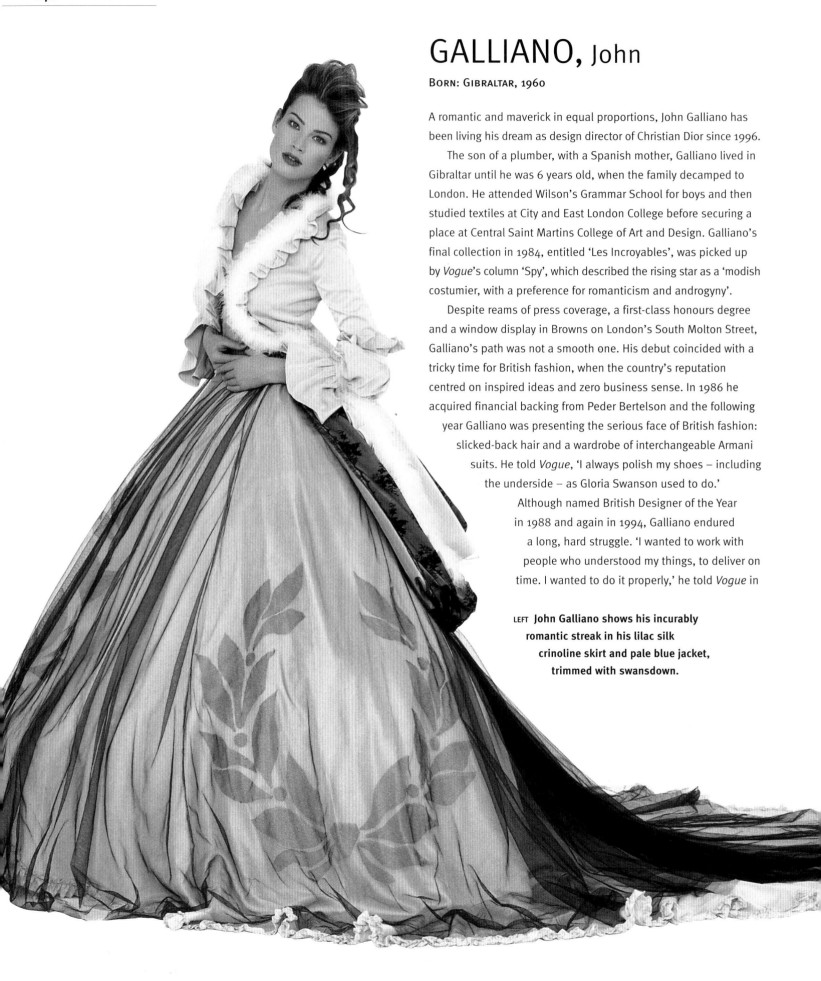

GALLIANO, John

BORN: GIBRALTAR, 1960

A romantic and maverick in equal proportions, John Galliano has been living his dream as design director of Christian Dior since 1996.

The son of a plumber, with a Spanish mother, Galliano lived in Gibraltar until he was 6 years old, when the family decamped to London. He attended Wilson's Grammar School for boys and then studied textiles at City and East London College before securing a place at Central Saint Martins College of Art and Design. Galliano's final collection in 1984, entitled 'Les Incroyables', was picked up by *Vogue*'s column 'Spy', which described the rising star as a 'modish costumier, with a preference for romanticism and androgyny'.

Despite reams of press coverage, a first-class honours degree and a window display in Browns on London's South Molton Street, Galliano's path was not a smooth one. His debut coincided with a tricky time for British fashion, when the country's reputation centred on inspired ideas and zero business sense. In 1986 he acquired financial backing from Peder Bertelson and the following year Galliano was presenting the serious face of British fashion: slicked-back hair and a wardrobe of interchangeable Armani suits. He told *Vogue*, 'I always polish my shoes – including the underside – as Gloria Swanson used to do.'

Although named British Designer of the Year in 1988 and again in 1994, Galliano endured a long, hard struggle. 'I wanted to work with people who understood my things, to deliver on time. I wanted to do it properly,' he told *Vogue* in

LEFT **John Galliano shows his incurably romantic streak in his lilac silk crinoline skirt and pale blue jacket, trimmed with swansdown.**

1988. International success was elusive, backers came and went, and Galliano often produced collections while sleeping on friends' floors. When financial constraints dictated a new direction, Galliano brought out a cheaper line – Galliano's Girl in 1991, followed by Galliano Genes. Despite his aptitude for diffusion lines, he remained a couturier at heart, often fingering toiles by Balenciaga and Charles James in the vaults of London's Victoria and Albert Museum.

Galliano's pursuit of recognition was relentless. He moved to Paris in 1994, and two years later made a resounding impression with an impeccable collection inspired by the opera *Madame Butterfly*. In one fell swoop, Galliano underlined the purity and modernity of the kimono.

After months of feverish speculation, on 11 July 1995, Galliano was appointed the successor to Hubert de Givenchy – and made history as the first British designer to be appointed head of an established French house. On 14 October 1996 John Galliano was appointed design director of Christian Dior, his debut unveiled on 20 January 1997.

Galliano is first and foremost a romantic. He is also a historian, an explorer, and a person who is unashamedly in love with fabric and form. Some say his heart rules his head. No one questions his talent. Galliano remains a fabulously inventive designer with a healthy respect for the house built by the legendary Christian Dior.

RIGHT **'First smash your specs': Galliano's radical ensemble of 1985 with 'rolluppable' back, sleeves to the knees and mismatched buttoning.**

GAULTIER, Jean Paul

BORN: ARCUEIL, FRANCE, 1952

The description 'enfant terrible' has followed Jean Paul Gaultier (the son of two accountants) around for over 20 years. Now nudging 50 years old, Gaultier does 60 daily press-ups and sports cropped peroxide-blond hair.

Gaultier's career commenced on his eighteenth birthday when he was employed as a sketcher at Pierre Cardin. A year later he moved to Esterel, then to Jean Patou, where he worked for two years – first with Michael Gomez, then Angelo Tarlazzi – before returning to Cardin, based in the fashion backwater of Manila in the Philippines. Gaultier returned to Paris in 1976 and began making electronic jewellery with his partner, Francis Menuge, and in 1978 presented his first fashion collection without success. 'I was a joke for three years,' he told the Sunday Express in 1987, 'And in France to be a joke is not funny.' He hit his stride in the mid-1980s, generating reams of newspaper copy with his catwalk escapades, conical corsetry and skirts for men. The latter, he claimed at the time, resulted in sales of 3,000 skirts worldwide. Vogue described an early collection as 'a motley fusion of punk pilferings, slattern sophistication and B-movie anecdotes'. His finest hour was dressing Madonna in a mix of satin corsetry and black bondage for her Blonde Ambition tour of 1990.

No one could accuse Gaultier of being a one-trick pony. He successfully produces both mens- and womenswear, diffusion and couture. Gaultier has run the gamut from fetishistic fabrics – rubber and PVC – to conventional wools and cotton/Lycra. His first fur collection was unveiled in 1998. He has worked several times with choreographer Régine Chopinot, dressed countless pop stars and even released his own album of house music, How to do that?, with Tony Mansfield, in 1989. His cinematic costume credits include City of the Lost Children (1995) by Caro and Jeunet, Luc Besson's The Fifth Element (1997) and, the one which was probably most suited to his style, Peter Greenaway's 1989 celebration of decadence, The Cook, the Thief, his Wife and her Lover. Gaultier's autobiography, A Nous Deux la Mode, published in 1990, was suitably kitsch in content and cover, with Gaultier posing in a nautical striped T- shirt, surrounded by flowers. In 1999 he was the first French fashion designer to go on-line.

A self-confessed Anglophile, who is more likely to be found rummaging in Camden market than admiring historical exhibits, Gaultier co-hosted Eurotrash, a saucy tabloid television show, during the 1990s. He appeared weekly, invariably wearing a kilt and a wide grin, and played up his French accent for all it was worth.

In 1997 Gaultier's first couture collection revealed a host of hidden attributes – restraint for one – and received favourable

reviews. In one of his earliest Vogue appearances he said, 'My affinities are with the young and unorthodox, so I create costumes that break rules, go over the top if you like ...' Irony is still his speciality. Long may his quirkiness continue.

ABOVE **Gaultier's infamous conical corset of 1983. The cups became more elongated and outrageous as the decade progressed.**

OPPOSITE **The subdued side of Gaultier: flounced chiffon petti-coats, metallic silk, garlands of flowers and 1950s' quiffs, 1995.**

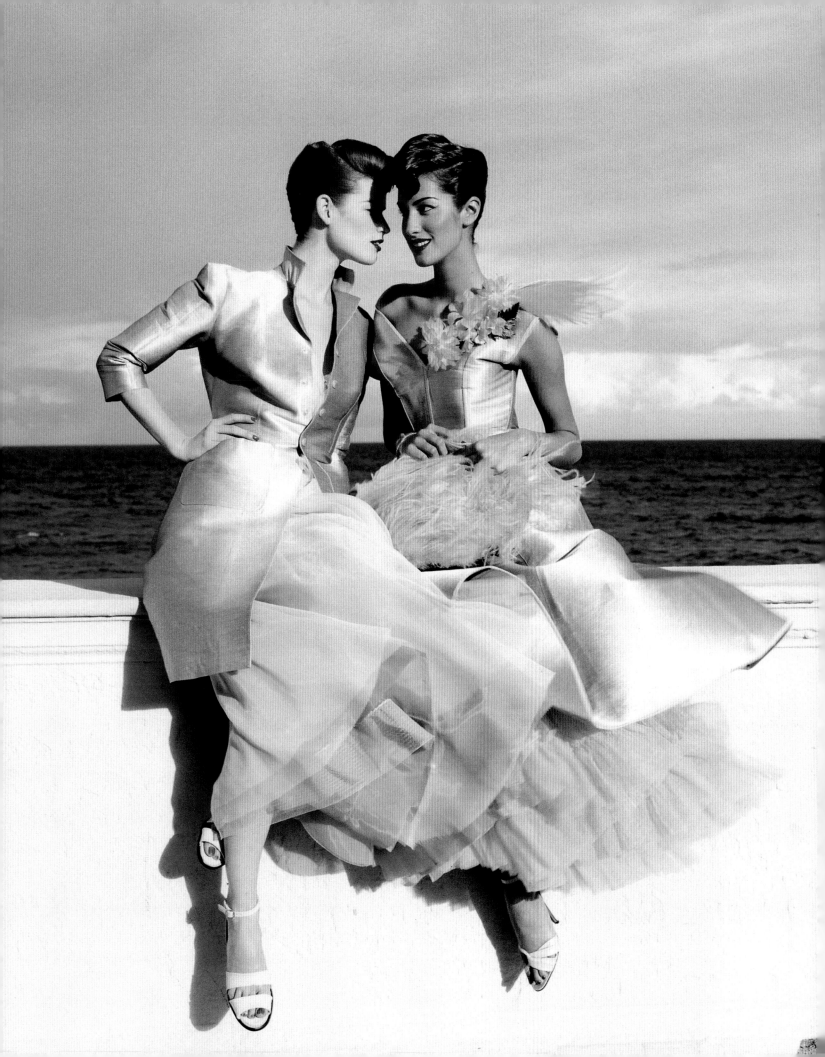

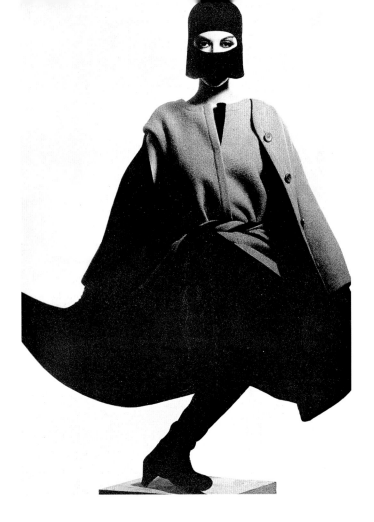

GHOST

FOUNDED BY TANYA SARNE IN 1984

Languid lines, flowing shapes and the absence of any sharp edges are the signatures of the Ghost label. Founded by Tanya Sarne, Ghost is a commercial and design success because it fulfils the criteria of modern design for comfort and fluidity by using practical fabrics which rarely crease and adapt to varying shapes and sizes. Launched in the era of the outrageously large shoulder pad, Ghost is a collection with mass appeal – a worldwide bestseller, with 80 per cent of its custom divided between the USA, Japan, Europe, Australia and the Middle East. The company was awarded the British Apparel Export Award in 1992. In 1999 Ghost decided to swap London Fashion Week for a show in New York.

GIBB, Bill

BORN: FRASERBURGH, SCOTLAND, 1943
DIED: LONDON, ENGLAND, 1988

The creator of some of the century's most mind-blowing dresses, Bill Gibb's celtic sensibility, love of craftsmanship and extraordinary colour sense made him a star in the truest sense of the word. 'It would be hard to imagine anyone less pompous than Bill Gibb,' said *Vogue* in 1977 on the eve of his ten-year retrospective at the Albert Hall in London. 'He wears a broad smile, a long floppy scarf and strange knit bobble hat. Who else would have laughed when Elizabeth Taylor wore one of his dresses back to front on television?'

Son of a New Pisligo farmer, Gibb switched from farming to fashion with the greatest of ease. He studied at the Royal College of Art in London in 1966, but left to do his own thing after just a year. Gibb then joined the shop Baccarat as a freelance designer, later working in collaboration with knitwear designer, Kaffe Fassett. A typical Bill Gibb creation had a simple shape and fantastical surface – a gorgeous entity which employed his team of knitters, weavers, embroiderers and printers. At the height of his career, Gibb's clients included Eartha Kitt, Tina Chow, Twiggy and the Empress of Iran. 'Everywhere I move I take four things with me,'

GERNREICH, Rudi

BORN: VIENNA, AUSTRIA, 1922
DIED: LOS ANGELES, CALIFORNIA, USA, 1985

The dancer turned designer, who many regard as America's answer to Pierre Cardin, Rudi Gernreich was a 1960s' experimentalist, most famous for the topless swimsuit, which he launched in 1964.

Gernreich's career followed a natural path. He studied at Los Angles City College, later becoming a dancer and costume designer with the Lester Horton Dance Company. He designed freelance for a variety of markets, including swimwear, shoes and knitwear before opening his own showroom on Seventh Avenue in New York, which straddled two lines of knitwear and experimental ideas.

It was Gernreich's infamous breast-exposing swimsuit that spread his notoriety and secured his place in fashion history. Like the French futurists of the 1960s, Gernreich was experimenting with plastics and vinyl fabrics, exploring the idea of unisex clothes and inventions with self-explanatory titles: namely the No-Bra Bra and Pubikini. His model and muse Peggy Moffitt, who modelled the topless swimsuit, had a suitably startling look which dovetailed with Gernreich's vision of the future.

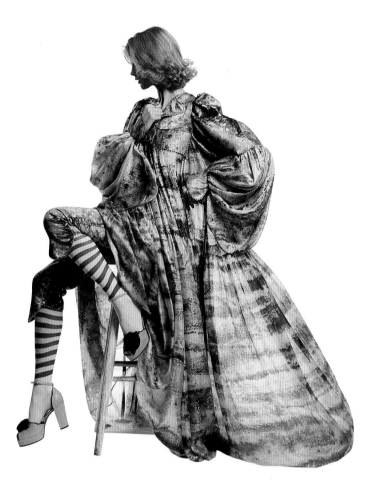

of a store in Bologna asked Gigli to design. He moved to New York in 1978 and designed a collection for Piero Dimitri.

With sloping shoulders, beautiful colours, opulent fabrics and flat pumps, Gigli reintroduced the Renaissance woman just at the point when big shoulders were beginning to fall out of favour.

Gigli set up his own label in 1983, but it was not until his fourth season, in March 1986 – following a show of elongated knitwear and languid lines – that he was heralded 'a quiet new talent' by *The New York Times*. In March 1989 Gigli decided to show in Paris for the first time. Backed by Zamasport, his autumn/winter Byzantine collection was rapturously received by the international buyers. He launched the perfume, Romeo, later that year and rode the crest of rave reviews. A diffusion line and G Gigli was on the horizon, but behind the scenes Gigli was facing a business fracas involving two former business partners. This dispute did not reach a settlement until May 1991, when Gigli regained control.

he said, 'two chemist chests, a 1930s' porcelain head, and my collection of bees.' Bill Gibb, sensitive, original and self-effacing, was most suited to a period which appreciated craft and worshipped surface texture. His dresses – perfect expressions of hippiedom – were sadly out of sync with the late 1970s, while his talent was probably best summed up by Beatrix Miller, former editor of British *Vogue*, who commented in his obituary in 1988. 'Perhaps he never found his métier, and it is cruel that fashion decreed he never would. Theatre, ballet, opera might have given him the scope he needed.'

GIGLI, Romeo

BORN: CASTELBOLOGNESE, ITALY, 1949

'When I'm working on a collection I'm not thinking,' said Romeo Gigli of his divine inspiration in 1989, 'it's a spontaneous, chemical thing.'

Both Gigli's father and grandfather were antiquarian book dealers and he spent his childhood surrounded by his father's collection of 20,000 books from the fifteenth and sixteenth centuries. Gigli originally trained as an architect and spent four years living on the Balearic island of Ibiza before moving to Milan. In 1972 the owner

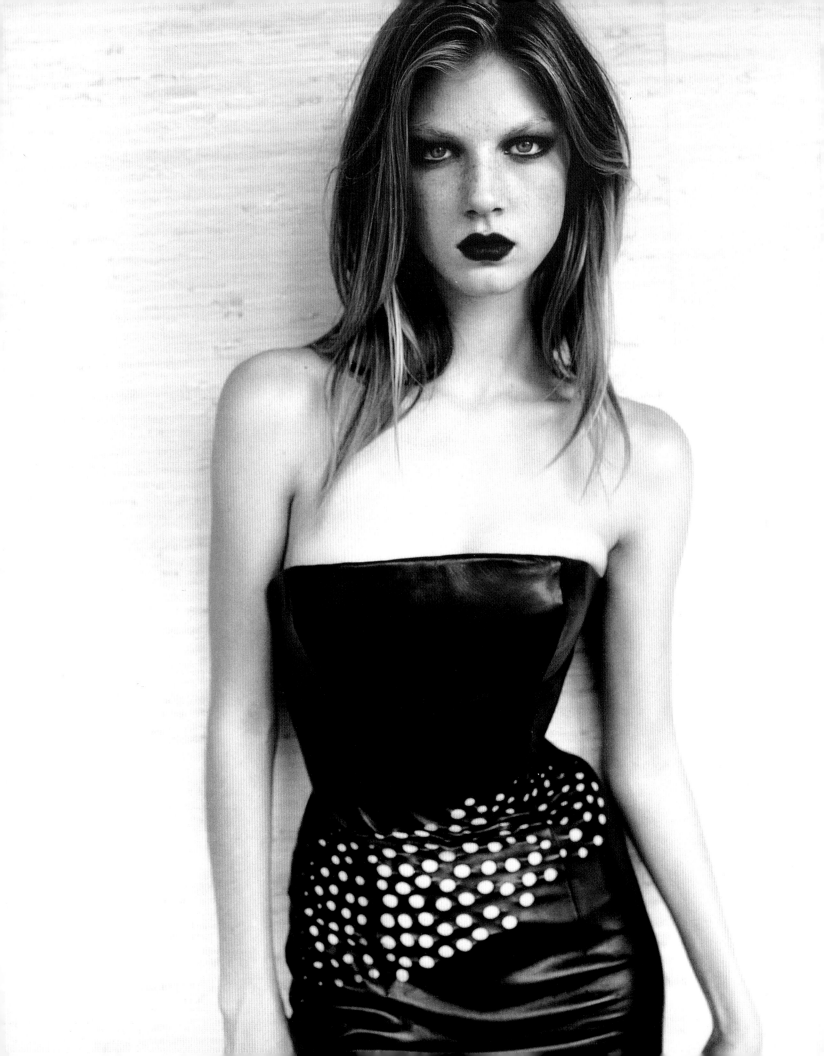

GIVENCHY, Hubert de

BORN: BEAUVAIS, FRANCE, 1927

Hubert de Givenchy's quest for perfection was a direct consequence of his friendship with Cristobal Balenciaga. For 40 years he wore his mentor's white coat at the end of each show. 'Monsieur Balenciaga gave it to me,' he told *Vogue* in 1991. 'It is like a talisman, a protection, a second skin.' Givenchy's 1952 philosophy on economy was years ahead of its time: 'All a woman needs to be chic are a raincoat, two suits, a pair of trousers and a cashmere sweater.' His own suits are made by Huntsman of Savile Row, London.

Having studied at College Félix Faure in Beauvais and then at the École Nationale Supérieure des Beaux Arts in Paris, Givenchy worked with Jacques Fath, Robert Piguet, Lucien Lelong and at Elsa Schiaparelli before opening his own house on 2 February 1952 on the rue Alfred de Vigny at the age of 25. *Vogue* described him as, 'One of the most newsworthy happenings this spring. The applause at his premiere was loud, unqualified, and long.' First-day sales totalled seven million francs.

By 1963 Balenciaga and Givenchy were being talked about in the same breath. 'Between them, Balenciaga and Givenchy innovate and predict, with an equal profundity of perfection and clear-sighted boldness that needs no excessive extravagance to be understood,' wrote *Vogue*. A decade later, Givenchy was enjoying the fruits of his labour; *Vogue* described his impeccable apartment, hung with a Picasso: 'The setting is superb but then so is Givenchy. The beautiful blue Miró hangs high like a patch of rippling June sky above a drawing room that is so luxe, so polished, so civilised, so burnished, that it practically turns over and purrs when you look at it.'

Givenchy's close relationship with his clients crossed the line between discreet couturier and close friend: Jacqueline Kennedy, who he dressed in ivory satin for a party in Versailles in 1961; the Duchess of Windsor, for whom he made a black dress and coat for her husband's funeral in 1972 in 48 hours; Audrey Hepburn, who Givenchy dressed for almost 40 years after they met at the time he was presenting his first collection. When Givenchy celebrated 40 years in fashion in October 1991 with an exhibition at the Palais Galliéra (Musée de la Mode et du Costume, Paris), naturally it was Hepburn, who had been transformed from gamine film star to ambassador for the United Nations Children's Fund (UNICEF), who inaugurated it.

Givenchy sold his house to LVMH (Louis Vuitton Moët Hennessy) in 1988, after 36 years of being his own boss. With his retirement imminent, the man who Marc Bohan called 'the aristocrat of the couture', told the *Independent*, 'I hope someone exciting and new will replace me. It's important that an established hand is not imprinted on the house – we have to look forward.' John Galliano was appointed Givenchy's successor in 1995, followed by Alexander McQueen in 1996.

OPPOSITE Alexander McQueen's direction for Givenchy, 1997, creates a tiny waist and uses leather to devastating effect in his minidress with boned bodice.

ABOVE The perfect little black dress, with discreet buttons, bows and furbelows, by Givenchy, the man who made Audrey Hepburn an icon of elegance.

GODLEY, Georgina

BORN: LONDON, ENGLAND, 1955

Georgina Godley's design career was short and sharp, her clothes sculptural and memorable. Godley originally trained as a fine artist at Brighton Polytechnic, moving on to Chelsea School of Art, London. She worked as a restorer and illustrator, and made clothes and sculptures via private commissions before joining forces with fellow student, Scott Crolla, in 1981. They opened Crolla – a menswear shop which specialized in opulent suits. By 1987 Godley was doing her own thing: 'I do believe in a reappraisal of sexual roles,' she told *Vogue* in 1987. 'But we're different and please let's accept it.' Godley is now teaching womenswear at the Royal College of Art in London.

GREER, Howard

BORN: NEBRASKA, USA, 1896
DIED: CALIFORNIA, USA, 1974

Author of *Designing Male*, published in 1951, which told of the trials and tribulations of dressing some of Hollywood's most enduring stars, Howard Greer began his career in the New York branch of Lucile. During the First World War he was stationed in France and gained employment with Paul Poiret and Edward Molyneux. On his return to America, in 1923, he began designing for Paramount and opened his own salon in 1927, using his expertise to re-create his cinematic touches in a realistic setting.

GRÈS, Madame

BORN: PARIS, FRANCE, 1903
DIED: SOUTH OF FRANCE, FRANCE, 1993

'Grès: the supreme dressmaker at the top of her form. Completely modern – sexy, romantic without a trace of nostalgia … a feeling for splendour and mystery. Her cuts are dreams of invention … cloth made to move like the extension of a gesture,' observed American *Vogue* in 1964 of the couturier's couturière. Madame Grès trained as a sculptor, studying painting and sculpture in Paris, and served a three-month apprenticeship with the designer Premet in 1930. She worked under the name 'Alix' until 1942 when she adopted her husband's name – he was called Serge Czerefkov, but signed himself Grès. Madame Grès opened her couture house in 1934, which initially consisted of three rooms on rue de Miromesnil, but she soon moved to a three-storey building on avenue Matignon. It was called the

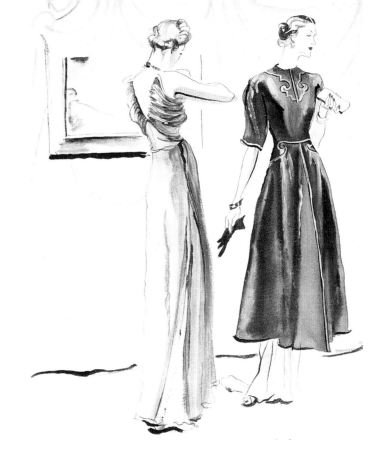

house Alix, on the suggestion of her financial backers. When war broke out in 1940 Madame Grès left Paris. She told *Vogue* in 1984, 'During the war I was in the mountains, the Pyrenees, and I made my own dummies with hay, a bit of wood and a tin. I bought fabric from the market and carried on draping clothes.' After the war she re-established herself as Madame Grès instead of her tradename, Alix, and continued to design along the same lines, taking inspiration from Grecian drapes.

In 1966 *Vogue* recorded a memorable meeting between Madame Grès and Barbra Streisand for a photoshoot with Richard Avedon. 'Grès arrives and a remarkable romantic confrontation it turns out to be: a meeting of two arts, generations, and continents; one epitomizes France, the other all we think of as American. Madame Grès, elegant, luminous, composed, Streisand, fluid, flamboyant and posed; one in classic sweater, skirt, turban and pearls, the other in a huge flowing poncho, a white nunnish coif, looking as though she had been designed by Le Corbusier.'

Notoriously secretive, her death was concealed from the public until the following year, when an exhibition dedicated to her design was held at the Metropolitan Museum of Art, New York. Cecil Beaton once commented: 'She made a Greek dress in a way no Greek could ever have imagined and turned her customers into moving sculptures.'

ABOVE **Madame Grès's slip dress in shirred chiffon and silver-braided, flared metallic coat which 'shoots you straight into the news'.**

OPPOSITE **Pale rose mousseline 'just caught the shoulders', by Madame Grès, the doyenne of draping, cutting and simplicity, 1975.**

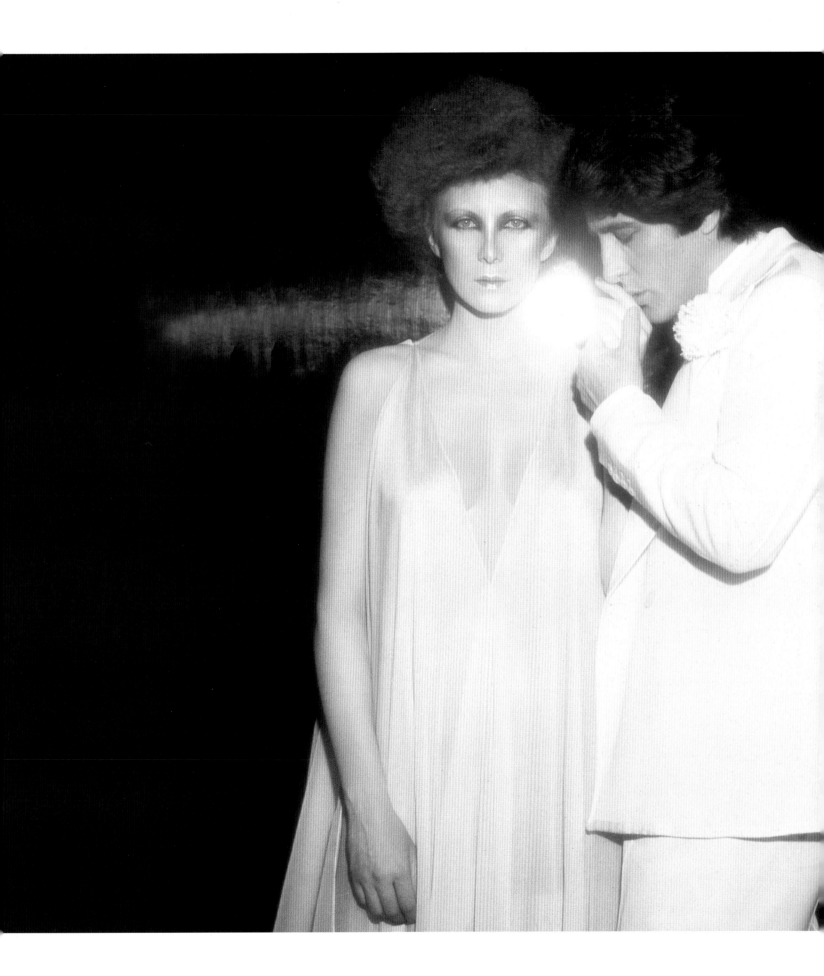

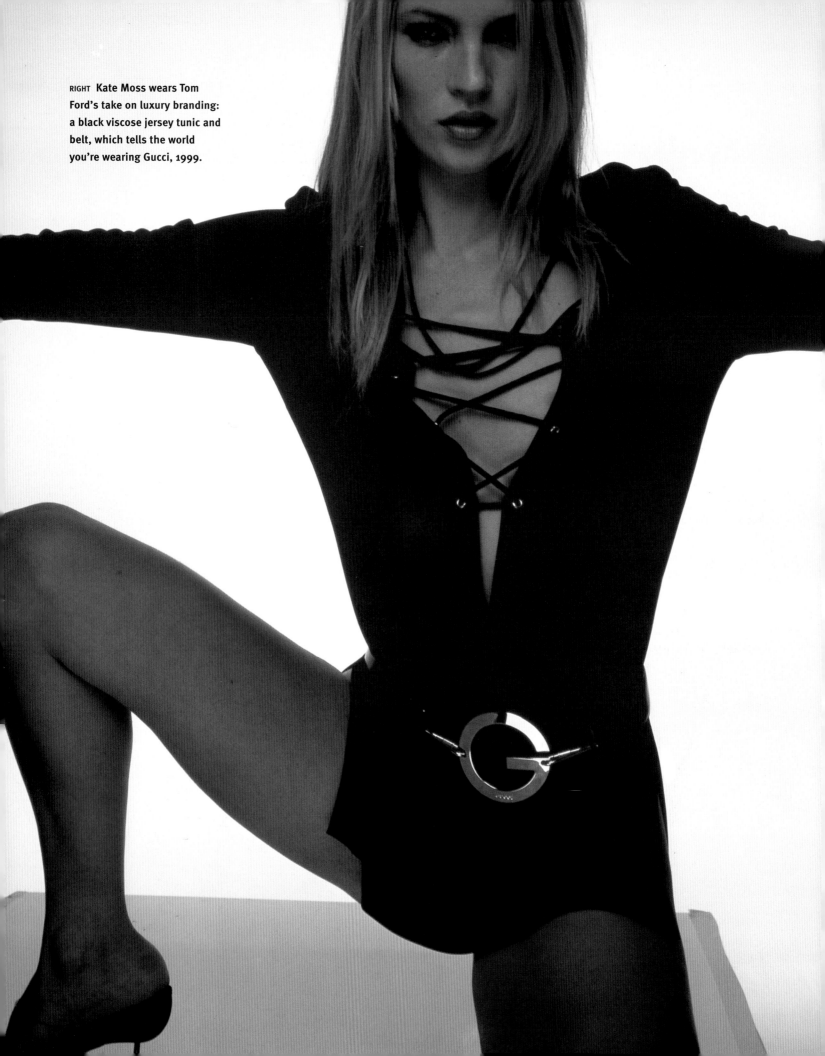

RIGHT Kate Moss wears Tom Ford's take on luxury branding: a black viscose jersey tunic and belt, which tells the world you're wearing Gucci, 1999.

GRIFFE, Jacques

BORN: CARCASSONNE, FRANCE, 1917

One of the few designers to have worked at the house of Vionnet, the undisputed queen of perfect cutting, Jacques Griffe, first learnt how to sew and construct clothes under the instruction of his mother. He later trained with a tailor and worked in a couture house before joining Vionnet in 1936. After the Second World War he assisted Edward Molyneux and eventually opened his own house with the encouragement of Vionnet. Despite his earlier training in the art of couture, Griffe could adapt to the mass market and he opened a boutique and also designed a ready-to-wear range, both of which were commercial successes. Nan Kempner, American socialite and front-row fixture, wore a Jacques Griffe dress for her coming out. Later on, she incorporated it into her wedding dress.

GUCCI, Guccio

BORN: FLORENCE, ITALY, 1881
DIED: MILAN, ITALY, 1953

Gucci was originally a leather goods company founded by Guccio Gucci in Florence in 1922. Gucci, who worked as the maître d' at the Savoy in London from 1915 before returning to Florence, knew the importance of service and good quality. He invented the signature interlocking Gs and the red and green trim. In recent years the Gucci label has enjoyed a renaissance of gargantuan proportions. The design director, Tom Ford, appointed in 1994, has pulled off what every financier dreams of: reinvigorating an established house while retaining its identity.

In 1989, following the trend for established houses to be injected with new life, Dawn Mello, who had been president of Bergdorf Goodman for 15 years, took up an offer to move to Italy to become creative director of the label that had gone to sleep and was in desperate need of re-merchandizing. Mello kick-started the Gucci rebirth in 1992. Bestsellers included reinterpretations of the classics of the 1960s: loafers, bamboo bag and leather wallet with hand-shaped silver clasp. Mello rejoined Bergdorf Goodman in 1994 and her ready-to-wear designer, a Texan called Tom Ford, took Gucci from sleepy status-symbol to celebrity must-have. He has a hands-on approach with everything from handbags to his shops' interiors.

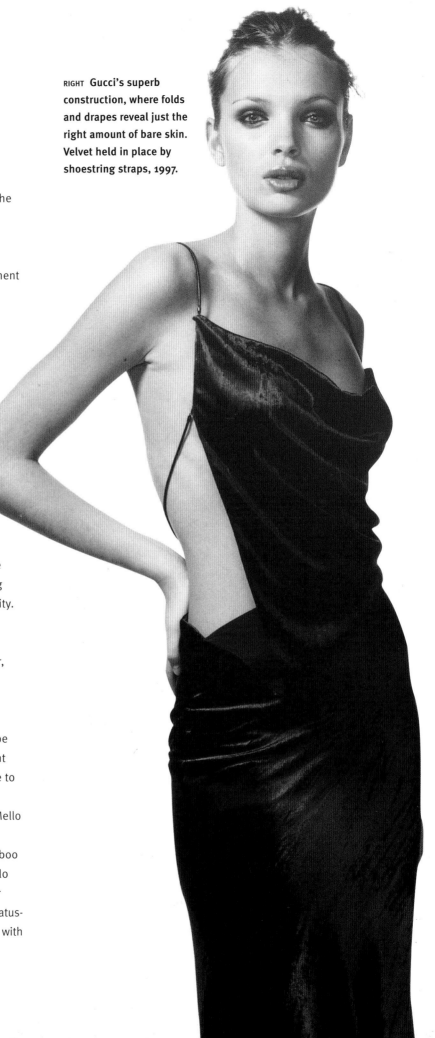

RIGHT **Gucci's superb construction, where folds and drapes reveal just the right amount of bare skin. Velvet held in place by shoestring straps, 1997.**

HALSTON, Roy Frowick

Born: Des Moines, Iowa, USA, 1932
Died: San Francisco, California, USA, 1990

Roy Halston was New York's most visible party animal during the 1970s and one of the key players in Andy Warhol's infamous diaries. He was a born socialite, fabulous designer and a public relations' dream, who knew the power of the celebrity endorsement. His favourite phrase: 'You're only as good as the people you dress.'

Roy Halston Frowick (as he was christened) arrived in New York in 1958 to assist the milliner Lilly Daché, having already worked in Chicago as a milliner. In the early 1960s, he left Daché to work for Bergdorf Goodman. 'I liked hats,' Halston told *Vogue* in 1972. 'Bergdorf had the biggest millinery business in the world. We had the Who's Who of the world coming to us, from Balenciaga to Givenchy.' Halston was attributed with making Jacqueline Kennedy's first pillbox hat.

On 2 December 1968 Halston opened his salon. Custom quickly followed: avid admirers included Babe Paley, Ali MacGraw and Liza Minelli. By 1973 he had won four Coty Awards and business was booming, reaching almost $30 million retail. He was so famous that he had his own one-off show, *Dinner with Halston*, and in January 1978 he moved his operation to the Olympic Tower, a minimalist palace with panoramic views across Manhattan. In 1983 Halston made the fatal mistake of selling his name. By

autumn 1984 his Olympic Tower showroom was being sold, and he was working from home. 'Where did Halston go so wrong when he sold his name?' wrote Warhol in his diary entry for 25 November 1984. 'What should he have done that he didn't? That's what I want to know. And I want to know it from him.'

BERRY BERENSON

HALSTON

LEFT Halston, 'star designer USA', four times winner of the Coty Award, drawn by Antonio, 1973. Above, Berry Berenson wears his 'easy, rich' suit.

RIGHT The 'New American Look' from Halston in 1973: hand-painted batik stripes on chiffon pyjamas modelled by Berry Berenson, sister of Marissa.

HAMNETT, Katharine

BORN: GRAVESEND, ENGLAND, 1948

'The only way you can change the system is from within,' said Katharine Hamnett in *Vogue* in 1987. 'The next era of conquest is to go into the boardroom wearing a smarter suit than the chairman.' Hamnett is a diplomat's daughter, who was educated at the genteel Cheltenham Ladies College and spent the swinging sixties at the centre of fashion activity, Central Saint Martins College of Art and Design. She was co-founder of Tuttabanken Sportswear in 1970, and when the business folded she designed freelance in New York, Paris, Rome and London, finally founding Katharine Hamnett Limited in 1979 with a £500 loan. She survived bankruptcy and fashion fracas to branch into menswear in 1982.

Her style was always sportswear – jumpsuits made from parachute silk, for example – but it was fashion with a political slant which made her name. In 1983 Hamnett launched her 'Choose Life' T-shirt collection, which was a milestone in the cross-fertilization of fashion and politics. Already a staunch supporter of the Greenham Common women and environmental issues, Hamnett was photographed meeting the prime minister, Margaret Thatcher, at a Downing Street reception in her '58% don't want Pershing' T-shirt. This was a seminal moment in British fashion and the ultimate photo opportunity, resulting in the image of the decade. Other slogans included 'Stop Killing Whales', 'Education Not Missiles', 'Stop Acid Rain', 'Preserve the Rain Forest' and 'Worldwide Nuclear Ban Now', which were all printed in huge capital letters on white T-shirts – a clever ploy to encourage copyists – the British profits from which went towards stopping child abuse. The following year, she received the British Designer of the Year Award and in 1988 the British Knitting and Clothing Export Council Award for Export. In October 1990 she made her Paris debut and launched Hamnett Active and the environmental Green Cotton campaign at the same time.

Katharine Hamnett is a designer with conviction and a company that has an annual turnover of £100 million and

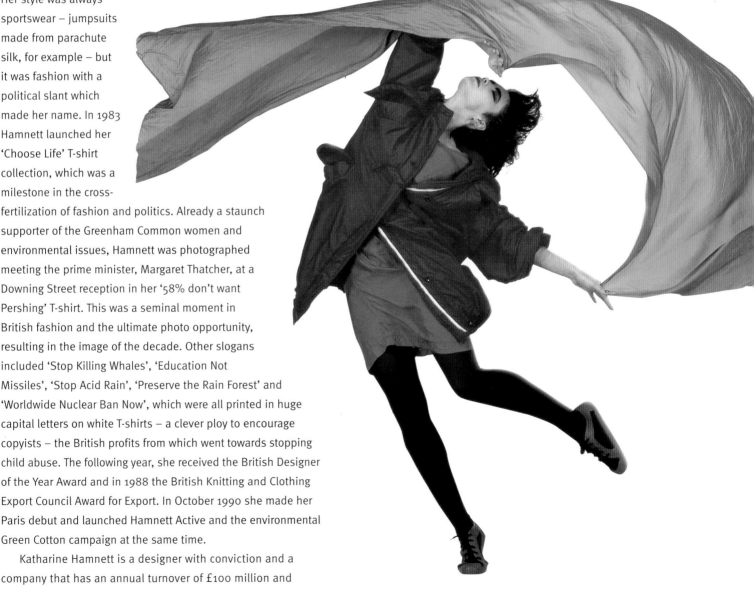

BELOW '**No message, but brilliant silks', courtesy of Katharine Hamnett – flying colours, tight-waisted dress, scarlet anorak and wind-blown green scarf.**

17 licences. In 1992 she wore a 'Vote Tactically' T-shirt and told the *Independent*, 'It's time we got the broom out and swept the cupboard clean: the Tories have actually wrecked the country from top to bottom.' By 1998, disillusioned with New Labour, she defected to the Conservatives and produced a T-shirt that read 'Say No to Euro'.

HARTNELL, Sir Norman

BORN: HONITON, ENGLAND, 1901
DIED: WINDSOR, ENGLAND, 1979

In 1939 *Vogue* made the following assessment of royal couturier Norman Hartnell: 'He discovered the lost arts of femininity, and in the arid angularity of the 'twenties, he launched a new, de luxe woman, poised, svelte and soignée: subtle rather than snappy.'

Romanticism was Hartnell's signature, and was perfectly suited to Cecil Beaton's Winterhalter-inspired images of the Windsors surrounded by garlands of flowers and an air of mystique. Hartnell's distinguished career started at Magdalene College, Cambridge, where his costumes and posters for the amateur dramatic societies received favourable reviews and caught the imagination of Lady Diana Duff-Cooper, who persuaded him to exchange academia for the more insecure world of haute couture. He took a job for £3 per week with the court dressmaker Madame Desirée and was sacked three months later. Undeterred, in 1923 he opened his own dressmaking studio at 10 Bruton Street, London, with his sister, three workgirls, a sewing machine and £300 capital from his father. He took his collection to Paris in 1927.

Appointed dressmaker to Queen Elizabeth in 1937, Hartnell excelled at grand occasions – he designed the gown worn by the Queen Mother for the portrait by Cecil Beaton (opposite) and two royal wedding dresses. The first, for Princess Elizabeth in 1947, was embroidered with 10,000 seed pearls and diamonds and was described by *Vogue* as 'ivory satin, starred with Botticelli-like delicacy and richness with pearl and crystal roses, wheat, orange blossom'. The second, for Princess Margaret's wedding to the then photographer Tony Armstrong Jones in 1960, was probably the most beautiful royal wedding dress ever made, a masterpiece in white silk organza, which silenced the critics who said Hartnell's forte was glitz. He designed the Queen's historic white satin coronation dress of 1952, which was embroidered with emblems of Great Britain and the Commonwealth, including a Welsh leek and a Canadian maple leaf. 'It is not sensible to be too sensible in fashion, nor is it smart to be too smart,' he commented in 1964. Royals apart, Hartnell's clientele included Merle Oberon, Marlene Dietrich, Evelyn Laye and Gertrude Lawrence. In 1977 Hartnell was awarded Knight Commander of the Royal Victorian Order – the first time a couturier had been honoured with the Queen's personal gift of knighthood. He was responsible for the wardrobe of Queen Elizabeth the Queen Mother for over half a century.

In 1987, eight years after the death of its founder, the house was acquired by former Moss Bros chief executive, Manny Silverman, who initially brought in British designer Murray Arbeid and, later, Victor Edelstein. In June 1990 Silverman persuaded Marc Bohan, ex-head of Dior for 28 years, to move to Hartnell. His first Hartnell collection was unveiled in January 1991 to great acclaim. Unfortunately, even the seasoned skills and considerable talent of Bohan could not save Hartnell and its salon in Bruton Street, closed in November 1992.

HEAD, Edith

BORN: LOS ANGELES, CALIFORNIA, USA, 1907
DIED: LOS ANGELES, CALIFORNIA, USA, 1981

Meticulous, bilingual and mesmeric, Edith Head was a prolific and revered designer, who became the first female to run a costume department in the history of Hollywood.

An only child who spent her early years in Mexico, Head eventually moved back to Los Angeles to study at the University of California, and then took an MA at Stanford University, where she specialized in languages. She taught Spanish at the Hollywood School for Girls and began studying life drawing and sculpture in the evenings.

Her illustrious career started in 1923 at Paramount Studios when she became assistant to Howard Greer and then to his successor Travis Banton. In 1938 Banton left to become freelance and Head was appointed the first female head of a studio. In 1967 she became chief designer at Universal Studios. Head studied cinema from all angles, analysing the script, the stars and the action, and meticulously researching the period in which the films were set. She frequently working on several films – both historical and contemporary – simultaneously.

Highlights of her career included dressing Clara Bow, Mae West, Veronica Lake and Shirley Temple. She designed the famous sarong for Dorothy Lamour in *The Jungle Princess* (1936) and dressed Charles Laughton as Nero in *The Sign of the Cross* (1932). Edith Head collected eight Oscars, including one for her costumes for Gloria Swanson in *Sunset Boulevard* and another for *All About Eve*, both in 1950. Speaking after the Second World War she said, 'I honestly don't mind when people say to me, "Remember the fantastic clothes you used to design?" After all, it was the fabulous era, and the movies were very young.'

OPPOSITE **The Queen Mother – 100 years old in the year 2000 – poses for Cecil Beaton 'in unaccustomed black' velvet dress by Norman Hartnell, 1949.**

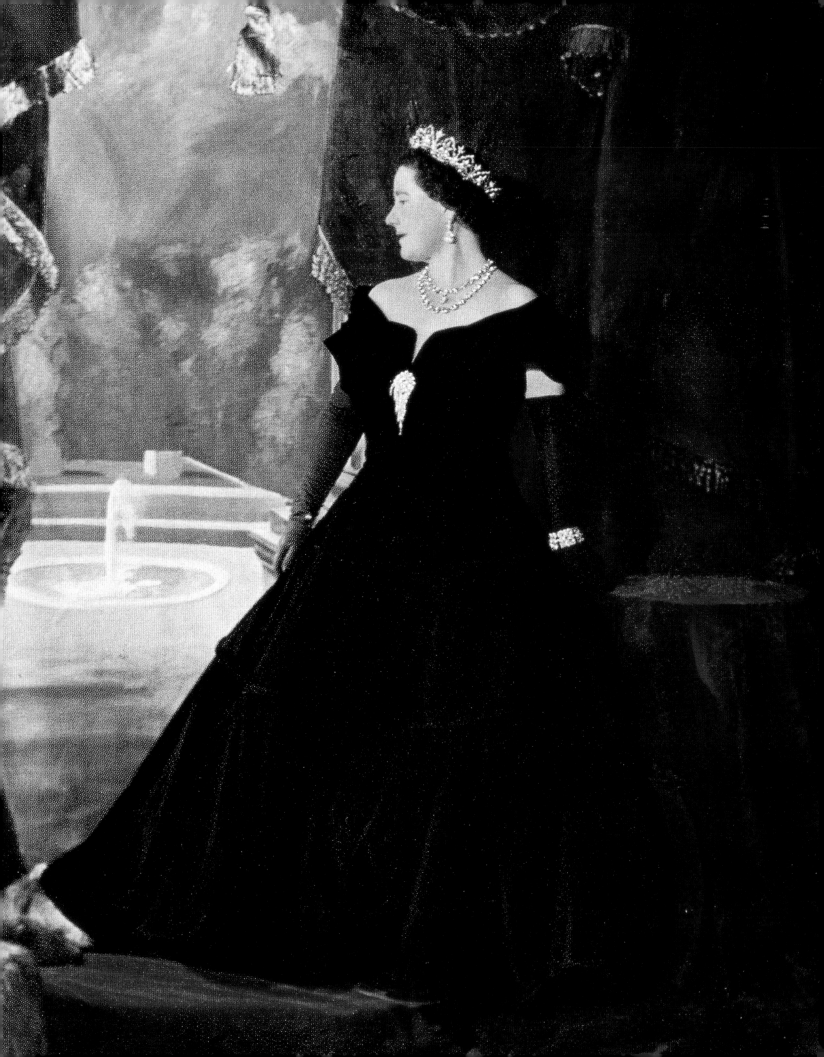

HEIM, Jacques

BORN: PARIS, FRANCE, 1899
DIED: PARIS, FRANCE, 1967

In the 1920s Jacques Heim managed his parents' fur fashion house and started a couture branch before opening his own couture house in 1930. Heim is considered more of a marketer than a designer, who was able to adapt and survive in a fickle business for almost 40 years. He launched a diffusion line in 1950 and was elected president of the Chambre Syndicale de la Couture Parisienne in 1958. Heim held the position until 1962, when he upset his fellow designers by disclosing their collections to the American press before the agreed date. His business closed two years after his death in 1969.

HERMÈS

FOUNDED BY THIERRY HERMÈS IN 1837

Thierry Hermès established himself as a master craftsman with a workshop in rue Basse du Rampart, Paris, making harnesses to sell to the carriage-makers of the Champs Elysées. Saddlery was added in 1879 and the business moved to 24 Faubourg-Saint-Honoré, where the flagship shop still stands. Thierry's grandsons, Adolphe and Emile-Maurice, spread the Hermès name wordwide, supplying the Imperial Court of Russia and clients in South America. After the First World War and the demise of the horse-drawn carriage, Hermès made small leather goods – wallets, handbags and luggage. In 1922 Emile-Maurice bought his brother's share of the business and the building. Leather goods were soon followed by clothing, costume jewellery, diaries and silk squares printed with original designs, the first of which appeared in 1937. In the late 1950s a fragrance division was launched.

In 1988 Claude Brouet was appointed design director and was responsible for the renaissance of the revamped Kelly bag – named after Princess Grace of Monaco – a cult handbag of the 1950s. Martin Margiela was appointed to design the ready-to-wear collection in 1997.

HILFIGER, Tommy

BORN: ELMIRA, NEW YORK, USA, 1952

The Tommy Hilfiger Corporation was founded in New York in 1992 and it is a label that appeals to young and old. In the best traditions of American design, where business, design and marketing are mutually compatible, Hilfiger is an unashamed marketing magnate, who knows his customers and what they want – relaxed, comfortable sportswear. He expanded his line in 1994 with tailoring.

HOWELL, Margaret

BORN: REIGATE, ENGLAND, 1946

'Quality is like coffee. Once you've tried the real thing, you can't go back to instant,' said Margaret Howell. Quality is the cornerstone of her business and her collections always centre on the eternals: white shirt, trenchcoat and classic trousers. She is one of the few female designers with flair for designing both mens- and womenswear, and she also designs household, gardening and children's merchandise.

Howell studied fine art at Goldsmith's College, University of London, and began designing accessories. She developed her first clothing collection in 1970 and opened her flagship shop during the 1980s. Howell was nominated Designer of the Year by *Vogue*'s editor Grace Coddington. Her clothes are displayed in the Costume Museum in Bath and in the Victoria and Albert Museum in London.

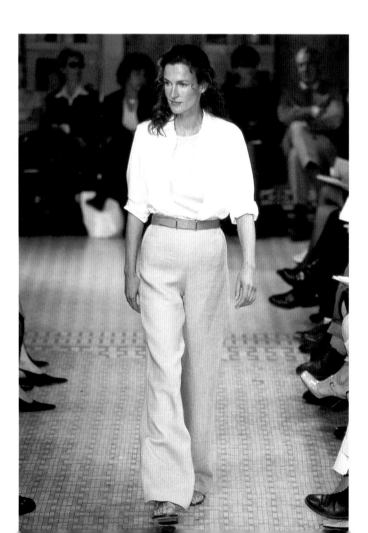

LEFT **Hermès, plain and simple under the precise direction of Martin Margiela, is taking luxury into the millennium.**

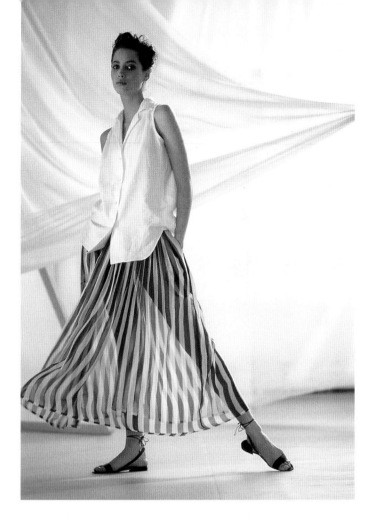

JACOBS, Marc

BORN: NEW YORK, NEW YORK, USA, 1964

One of America's most celebrated young guns, Marc Jacobs has risen – in the space of 15 years – from Parson's graduate to design director of the revered luxury goods line, Louis Vuitton. Jacobs graduated from Parson's School of Design in New York and won the Perry Ellis Golden Thimble Award in 1984. He started his own company – which lasted for two years – before taking up a post at Perry Ellis, following in the footsteps of one of America's foremost sportswear designers. In 1994, Jacobs formulated his own line, which still continues to receive rave reviews for its simplicity and modernity. He was announced designer at Louis Vuitton in 1997 and told American *Vogue* of his plans: 'What I have in mind are things that are deluxe but that you can also throw into a bag and escape town with, because Louis Vuitton has its heritage in travel.'

JACKSON, Betty

BORN: BACUP, ENGLAND, 1949

After graduating from the Royal College of Art, London, Betty Jackson began her career via the Quorum design studio. She set up her own business in 1981 with her husband, David Cohan, who is also a director of the company. Jackson was awarded an MBE in 1987 and opened her first retail outlet after a decade in business in September 1991 in London's Brompton Cross. She has never had a backer.

Jackson's style is fluid and easy; she achieves a thoughtful balance between fashion and comfort, and her uncomplicated shapes often incorporate printed textiles and tactile fabrics such as suede, muslin jersey, silk georgette and hand-beaded silk. Her oversized shirts, which hide a multitude of sins, are always the first pieces to sell out. Jackson's clothes are sold in Europe, the USA and the Middle and Far East. She also produces BJ accessories and BJ knits, and has been a consultant on womenswear for high street chain, Marks and Spencer. Customers range from British comediennes to serious thespians. She admires strong women, 'like Lauren Bacall', she told *Vogue* in 1991, 'Bold and casual. I've never liked prettiness much.'

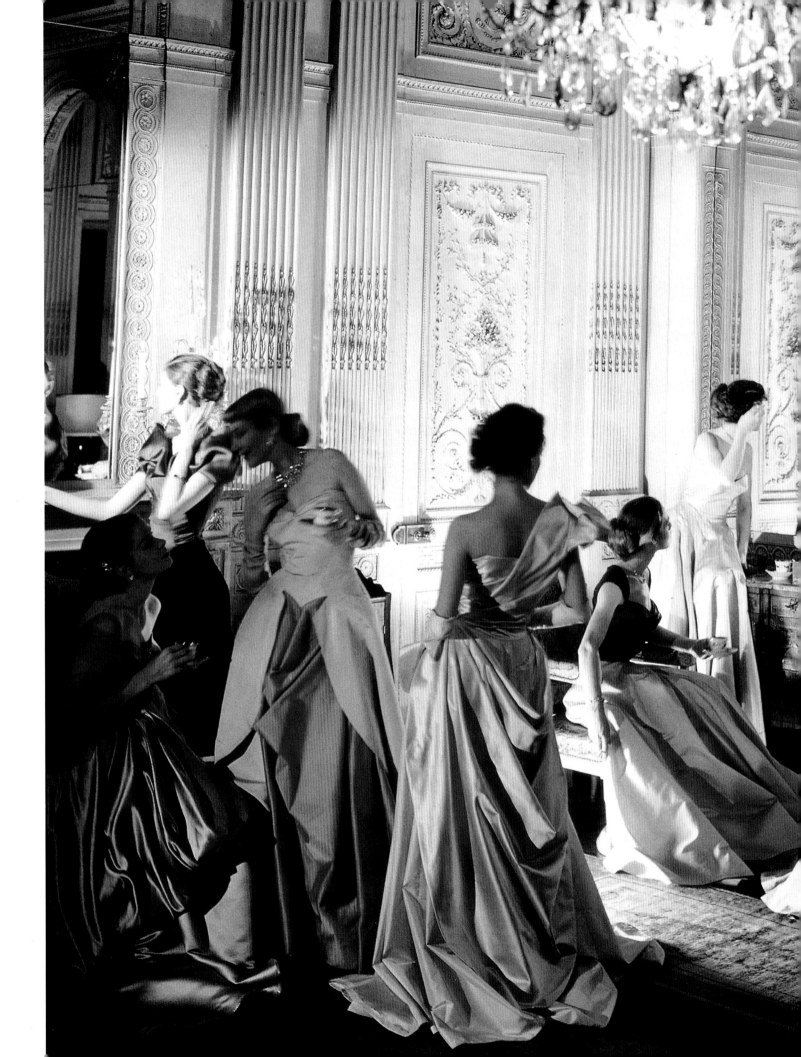

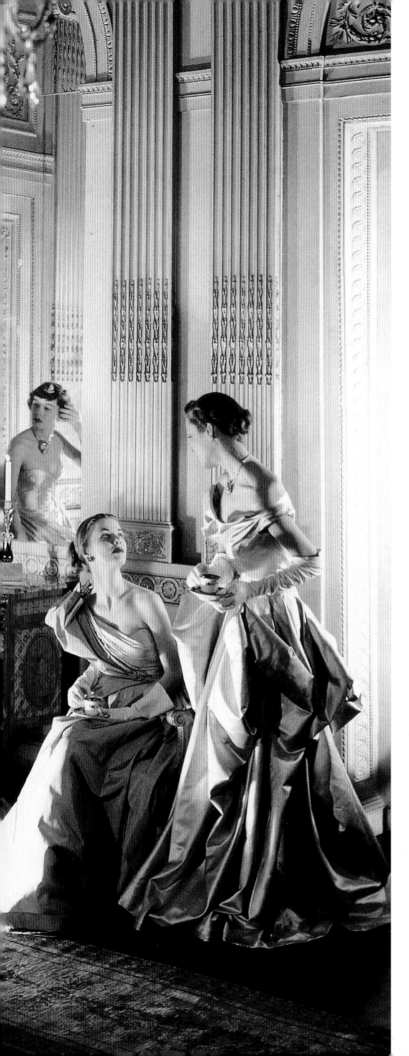

JAMES, Charles

BORN: SANDHURST, ENGLAND, 1906
DIED: NEW YORK, NEW YORK, USA, 1978

Charles James was a structural genius, a maker of the most complex dresses of the century; a man who would spend years on a single sleeve, months on a seam. As a result, his life was a series of aesthetic crises and cash-flow problems.

James's father was an English military officer, his mother was from Chicago. He was educated at Harrow in England, but was expelled. His family sent him back to Chicago to work in the architectural department of a utilities concern, but this was short-lived – as was a job on the *Chicago Herald Examiner*. In 1926, with no formal training but a talent for construction, he opened a hat shop on North State Street called Charles Boucheron; in 1928 he moved to New York where he again opened a millinery shop.

In 1930 James crossed the Atlantic and established a house in Bruton Street, London; the name E Haweis James was taken from his father's two middle names. Bankruptcy followed but undeterred, James opened another business in the same street and began showing in London and Paris. Already selling to some of America's most important department stores – including Lord & Taylor and Bergdorf Goodman – he returned to New York and opened Charles James Inc. at 63 East 57th Street in 1940. From 1943–5 he collaborated with beauty expert Elizabeth Arden, showing couture designs in her salon.

James looked upon all his dresses as works of art. Season after season he reworked original designs – the components of which were interchangeable so that he had an almost unlimited fount of ideas on which to gain inspiration from.

James's business life became a succession of bankruptcy and lawsuits. Although he established a licensing company and manufactured, he found it virtually impossible to adapt to mass-production and was only happy in the environment of personalized couture. By the 1970s he was living in the Chelsea Hotel and a new generation of designers had rediscovered his talent. Halston sought him out and employed him within his studio, but the professional collaboration was a disaster. Eventually, as with all James's associations, it ended in tears.

LEFT **Cecil Beaton's seminal shot of mind-blowing construction by James, 1948: 'master of colour, cut, fold, and exceptional cloths.'**

LEFT 'Sharp, white fluorescent jacket, with silver buttons all the way,' 1966. From Betsey Johnson, former 1960s' swinger, now flower child.

OPPOSITE 'The Hots', 1988: Stephen Jones's parti-coloured check, fine straw pork pie hat, perched precariously on the side of the head.

JONES, Stephen

BORN: WEST KIRBY, ENGLAND, 1957

Having graduated from London's Central Saint Martins College of Art and Design at a pivotal time in British fashion – post-punk and pre-New Romantics – milliner Stephen Jones designed a collection for Fiorucci before opening his first salon in Covent Garden, London, in September 1980.

Educated at Liverpool College in 1975, he completed his art foundation course at High Wycombe School of Art. His collections have included miniature Christmas trees and swirling meringues, and reflected mood swings from 'Norma Desmond Lives' (1992) to 'Murder by Millinery' (1997).

Jones has designed for many international names including Jean Paul Gaultier, John Galliano, Thierry Mugler, Zandra Rhodes, Claude Montana and Vivienne Westwood. His hats have been worn by a host of celebrities – from Madonna to U2. He designed hats for Disney's *101 Dalmations* (1996) and Steven Spielberg's *Jurassic Park* (1993).

Temporarily eclipsed by the arrival of Philip Treacy at the turn of the 1990s, Jones continues to create innovative and outlandish hats and also has licences for gloves, scarves and eyewear, in addition to Jonesgirl for Stephen Jones Japan. He has produced a collection of asymmetric shapes specifically to celebrate the Millennium on New Year's Eve, and is credited with helping to revive the art of millinery during the latter part of the twentieth century.

JOHNSON, Betsey

BORN: WETHERSFIELD, CONNECTICUT, USA, 1942

At the same time that Mary Quant was causing a stir in London, Betsey Johnson was creating a Carnaby Street situation in New York, gaining a reputation as a radical young designer, selling a clear vinyl dress with paste-your-own star motifs.

She studied at the Pratt Institute, New York, and originally intended to become a dancer. Her first boutique was called Betsey, Bunky and Nini. An advocate of flower power, she married John Cale of the Velvet Underground.

Betsey Johnson has been a colourful fixture on the New York scene for 20 years, often doing a cartwheel down the catwalk – not bad for a woman pushing 60. She showed her first London collection in 1998. Her daughter, Lulu, a more restrained blonde, designs the Betsey Johnson Ultra collection.

JOURDAN, Charles

FOUNDED BY CHARLES JOURDAN IN 1920

The Charles Jourdan label – founded in Romans, France, in 1920 – has always been able to swing according to the way fashion is going. In the 1950s Jourdan created the high beechwood heel, the 1960s produced the patent leather pump with circular heel, rounded toe and daisy on the front, and in the 1970s the ubiquitous platforms appeared. These were shown to their best advantage in advertising campaigns shot by photographer Guy Bourdin.

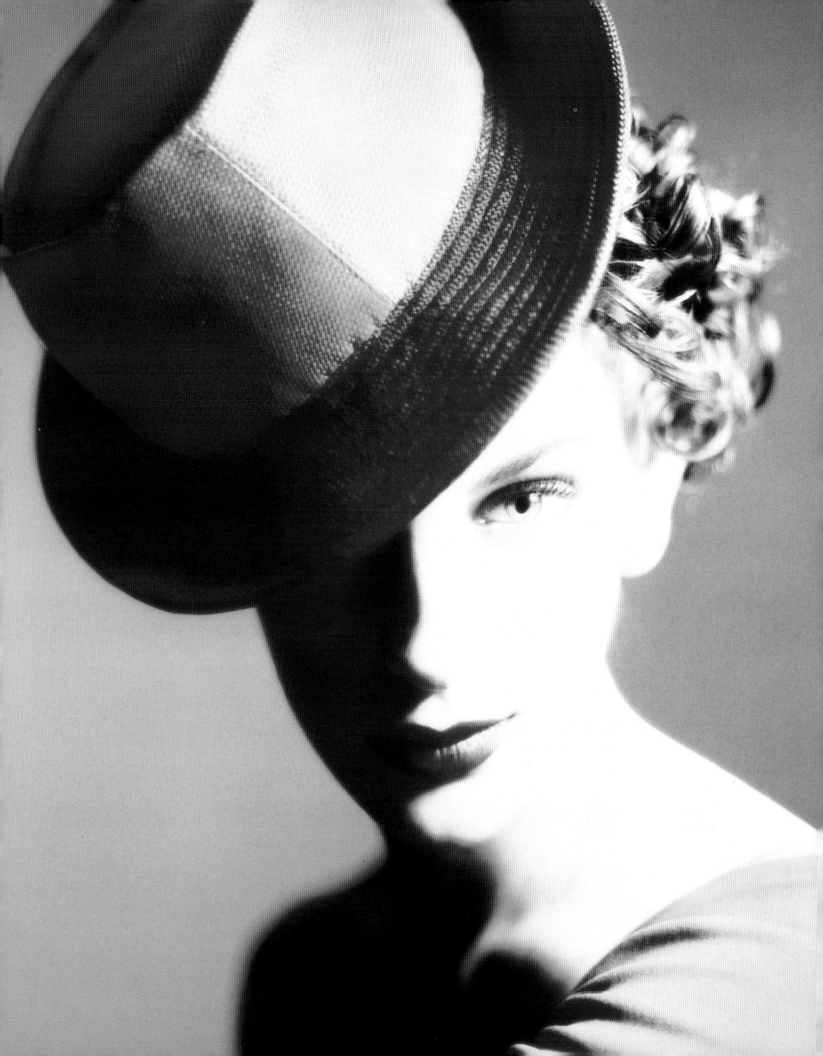

KAMALI, Norma

BORN: NEW YORK, NEW YORK, USA, 1945

A native New Yorker, whose flagship store stands in Madison Avenue, Norma Kamali successfully mixes modernism with nostalgia. She has won two CFDA Awards for video innovation and designed costumes for the Twyla Tharp Company and for the Emerald City sequence in Sidney Lumet's *The Wiz* (1978). Kamali left New York's Fashion Institute of Technology in 1964 with a degree in fashion illustration. Four years later she opened her own shop at 229 East 53rd Street. Her first designs were typical of the late 1960s, combining appliquéd leather, lizard and snakeskin. She pared down her designs as the 1970s progressed, making clothes from silk parachutes as early as 1974, and her famous sleeping-bag coat the following year. Her shop OMO (On My Own) opened in 1978 after her divorce.

KARAN, Donna

BORN: LONG ISLAND, NEW YORK, USA, 1948

Donna Karan built her business on three things: a stretch body, a sarong skirt and precise pieces of bold jewellery. She added neutral colours, a measure of stretch and assembled a philosophy which was alien to social X-Rays. As she told *Vogue* in July 1987, 'I am a woman with a rounded figure. I'm not a model size 8. I won't design clothes that can't be worn by a woman who is a size 12 or 14.'

Karan started her career as assistant to Anne Klein in 1967, but it was almost 20 years later, in 1985, when she formed her own company. When Karan acknowledged the existence of hips and curves and said, 'I'm dealing with the fallibility of a woman's body', she struck a chord with half the population on the planet.

Like all successful American designers, Donna Karan was backed by powerful advertising campaigns – the most memorable showing a Karan-suited woman being sworn in as president of America. Donna Karan lives the life she sells: Seventh Avenue during the day; East Hampton at weekends; a family and husband; and running an empire. Karan's spring 1993 press release underlined the link between imagination and reality: 'Like her ads, Karan starts the day on the telephone in her car. And from there it's anyone's guess. She could be dashing to a fitting, meeting with her retailers, brainstorming with her ad agency ... or showing her collection to the ladies from *Vogue*.'

Like the analyst who soothes the mind, Karan shoots inspirational one-liners – instant relief to those who aren't ecstatic about their natural outline. Her thoughts on black: 'It goes day-into-evening. It packs. It's city friendly. And you never have to worry about how to dress the leg.' And to the stressed-out executive with ample thighs: 'Once I figure it out for me, I can figure it out for you.' In 1992 she assured readers of American *Vogue*, 'Right now I'm having a catastrophe over legs.'

Karan is not only consumer sensitive, offering an oasis of calm for the bodily challenged, she also knows about the feeling of fabric on skin and loves natural fabrics – her body cream was, appropriately, called Cashmere. Karan doesn't just do stretch, comfort and clever psychology. During her reign on Seventh Avenue she put women into pinstripe suits and brought out a sportier range, DKNY. From the tip of her slingbacks to the sweep of her wrap, Karan keeps to her seasonal mantra: 'Layer. Subtract. Add. Delete.'

LEFT **Donna Karan's formula for the rounded figure, 1987, in jersey, neutral colours and body-conscious stretch, with the ubiquitous, generous wrap.**

OPPOSITE **All that glitters: Donna Karan's weighty gold sequinned sarong, accessorized with pure lilies, Grecian pillars and bare breasts, 1985.**

KELLY, Patrick

BORN: VICKSBURG, MISSISSIPPI, USA, 1954
DIED: PARIS, FRANCE, 1990

Huge buttons, abbreviated hemlines and a talent for trompe l'oeil marked Patrick Kelly out as a natural New Yorker in Paris. His colourful clothes were a product of his Mississippi childhood and his long-held fascination with antique clothes. He so impressed his French compatriots that he became the first American designer to be elected to the Chambre Syndicale de la Couture Parisienne.

Kelly studied history at Jackson State University in Mississippi and fashion at Parson's School of Design in New York, but he learnt his trade on the shop floor; this included a stint at a Rive Gauche boutique and a foray into antique clothing. In 1980 Kelly moved to Paris, where he became a freelance costume designer for Le Palais Club. Sadly, Kelly's promising career was cut short by his untimely death.

KENZO

BORN: HYOGO, JAPAN, 1939

A brilliant mix of colour, texture and attention to detail, Kenzo's style regularly crosses the design spectrum: menswear, womenswear, and also costume. He has even been a film director.

Kenzo – full name Kenzo Takada – studied at the Bunka College of Fashion in Tokyo, and worked briefly there before relocating to Paris to work as a freelance designer in 1965. In 1970 he opened his first boutique, Jungle Jap, which immediately attracted customers including models and trendsetters. Money was tight to start off with, and Kenzo's first autumn/winter collection was made entirely of cotton, much of it quilted.

A tireless innovator, Kenzo's lively combination of textures and patterns has spawned a dozen imitators. The Kenzo label was first introduced to London by Joseph Ettedgui, who sold his sweaters in his hairdressing salon, and later in his shops. Unlike his compatriots, Kenzo does not dabble in radical cutting or intellectual dressing, but produces young, wearable collections that are easily understood and worn endlessly.

LEFT **Kenzo's colourful, crisp, and cleverly abbreviated kimono top ties above a bare midriff. Worn with a sarong-style skirt, 1976.**

KEOGH, Lainey

BORN: OLD TOWN, IRELAND, 1957

Creator of the most amazingly organic knitwear, Lainey Keogh spent her childhood living on a farm as part of a family of ten, watching the Irish countryside go by: 'We ate, slept, and lived our lives in tune with the seasons.'

Keogh studied microbiology and was discovered by retailer Marianne Gunn O'Connor while she was knitting in the corner of Bewley's coffee house in Dublin. Her first collection had the buyers in raptures and her first show, in February 1997, was unveiled to great acclaim.

Keogh works mostly with cashmere and, more recently, with crystal. Her pieces are predominantly handmade by expert Irish knitters. 'We do a lot of things through human endeavour,' says the maker of lyrical knits, 'but we are dipping into technology in the millennium.'

KERRIGAN, Daryl

BORN: DUBLIN, IRELAND, 1964

One of the few Irish designers to take New York by storm, Daryl Kerrigan – or Daryl K as she is known to her younger customers – has captured the market in hip, cool sportswear with a SoHo slant.

Kerrigan studied at the National College of Art and Design in Dublin and arrived in New York at the age of 22. She originally worked on costume design in the film industry, most famously dressing Joe Pesci in *My Cousin Vinny* (1992). With her earnings from that project, she opened her own shop in 1992. Kerrigan quickly established herself as a designer who could appeal to the American market, but she was also able to think both laterally and internationally. Her look is East Village elite, with a healthy slice of sportswear. In 1996 she won the CFDA Perry Ellis Award for Womenswear.

KHANH, Emmanuelle

BORN: PARIS, FRANCE, 1937

'The Emmanuelle Khanh cult has spread like wildfire,' wrote *Vogue* in 1964. 'Her gentle, feminine shapes and her curvy tailoring have been copied everywhere.' An ex-model, who showed Givenchy and Balenciaga dresses off to their best advantage during the late 1950s, Emmanuelle Khanh switched to the other side of the fashion business in 1962. She was at the forefront of the French revolution in favour of ready to wear, and is credited with starting the young fashion movement in France.

Khanh's clothes had a hippie feel to them. She first became known for The Droop, a slim, clinging dress which contrasted with the structured clothes of the time. Signature details included Romanian embroidery coupled with denim and chenille, and she also featured dangling cufflink fastenings and half-moon moneybag pockets. Her silhouettes were always refined, flattering and utterly French.

With a great ability to combine colour, detail and commercial acumen, Khanh worked with Cacharel and Dorothée Bis before pursuing a freelance career in the late 1970s.

KLEIN, Anne

BORN: BROOKLYN, NEW YORK, USA, 1923
DIED: NEW YORK, NEW YORK, USA, 1974

Taking her cue from Claire McCardell, Anne Klein epitomized American simplicity. She was one of the first designers to celebrate sportswear as the most workable way to accommodate the typical American woman's lifestyle, using cool fabrics, clean lines and sportswear shapes.

Klein was 15 when she got her first job on Seventh Avenue; the next year she joined Varden Petites and in 1948 she set up her own company with her husband. Given her training, it was natural that she should first fill gaps in the market, and she became known for taking junior-size clothes out of little-girl cuteness and into adult sophistication. In the mid-1960s Klein had already sensed a sea change in women's attitudes towards work, and designed her collections accordingly. She was one of the first designers to have shop floor space dedicated solely to her label – a store within a store – and was the winner of many awards – from Coty American Fashion Critics' Award to an award from the National Cotton Council.

After Klein's death in 1974, the firm continued under Donna Karan, a former design assistant. When Karan left to form her own company in 1985, the label was headed by Louis Dell'Olio, followed by Richard Tyler in 1993.

OPPOSITE **Extraordinary knitwear from Ireland's inventor, Lainey Keogh. Here, her Venus dress is worn with a cashmere coat from Clements Ribeiro, 1998.**

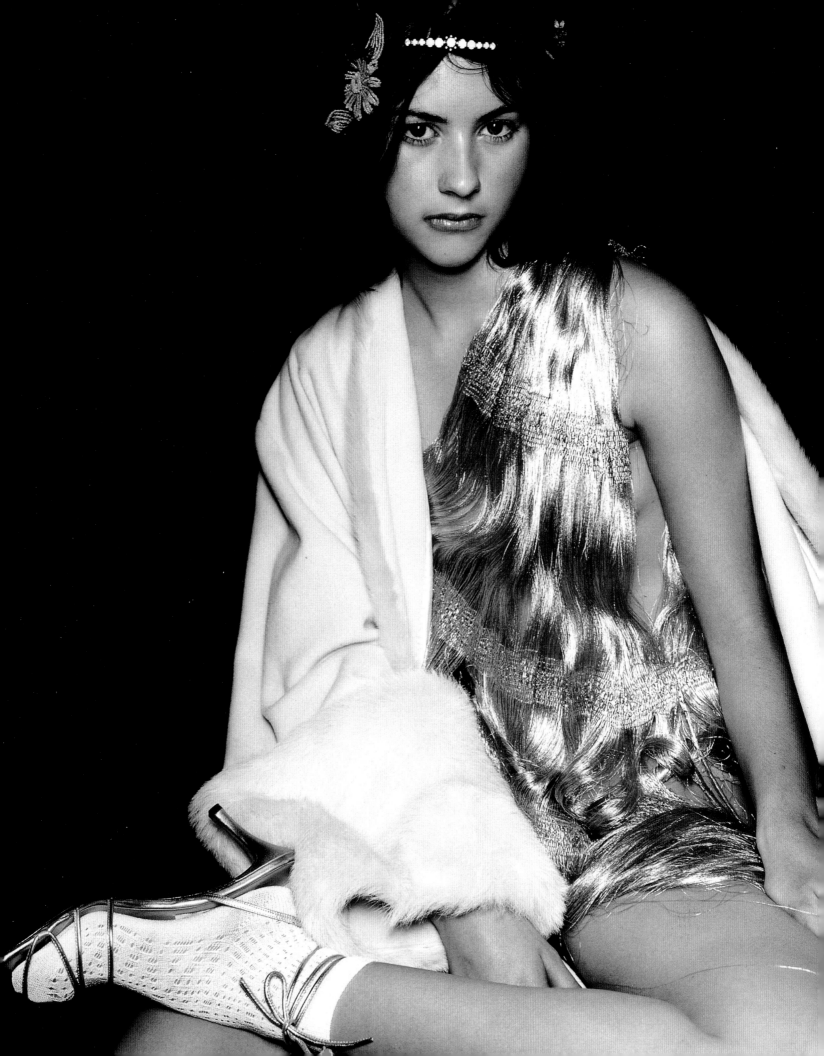

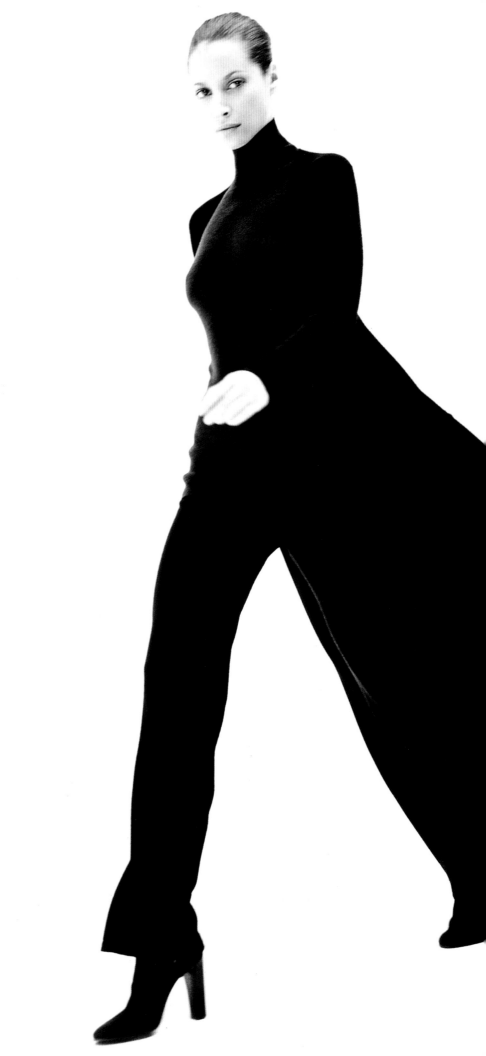

KLEIN, Calvin

BORN: NEW YORK, NEW YORK, USA, 1942

Tapping into the *Zeitgeist* comes naturally to Calvin Klein; some say he directs it. From being at the centre of 1970s disco to the quiet refinement of Long Island's Hamptons, Klein has steered, redesigned and refined the international image of classic American fashion. He frequented the New York nightclub Studio 54 when it was hot; launched designer jeans in the 1970s; reinvented men's underwear in the late 1980s; brought out two fragrances – Obsession and Eternity – one after the other in the 1990s; and was the first designer to pick up on the widespread appeal of supermodel Kate Moss.

Calvin Klein's style has always pivoted on simple, all-American principles of wearable purity: white shirt, classic jeans, camel coat, perfect T-shirt, cable-knit sweater. These are the fashion eternals, which Calvin Klein knows will last into the next century.

Brought up in the Bronx, Klein was educated at the Fashion Institute of Technology in New York, before starting his own business in 1968 with his business partner Barry Schwartz. By the 1970s Klein was enjoying the kind of success his competitors would kill for. His sales zoomed into the outer stratosphere when he employed a teenage Brooke Shields for an advertising campaign; she was shown lying across a billboard wearing blue jeans with the seductive byline, 'Nothing comes between me and my Calvin's'.

No one understood, predicted and rode the designer-obsessed 1980s better than Calvin Klein. Cleverly, no one switched tack more quickly when the 1990s started gliding towards nurturing and nest-building. Klein replaced his minimalist interior for soft cushions and sofas, traded in his batchelor lifestyle for marriage and bought his new wife, Kelly, a gold and diamond eternity ring which once belonged to the Duchess of Windsor.

Like all American designers, Klein's life and design are a single entity. He understood the power of the older woman in the early 1990s, as well as that of the grungy waif. In 1993 he scored a double whammy when he was voted both Mens- and Womenswear Designer of the Year. The common denominator has always been classic Americanism: glossy hair, clear skin,

OPPOSITE 'C is for Christy in Calvin': Klein's clean and totally modern silhouette, 1996 – turtleneck sweater, aubergine cardigan and knitted trousers.

effortless beauty. Naturally, it was Klein who employed the epitome of Calvin Klein's vision, Carolyn Bessette Kennedy, as his PR.

An American marketing genius without compare, Klein understands that the new radicals can do what they want. Shock expires. Reality sells. Everyone wants to be able to sit down, stand up, and put their hands on a perfect American classic every once in a while.

BELOW **Palest *café au lait* cashmere polo neck sweater and deep brown suede trousers, tailored like jodhpurs, 1989.**

KRIZIA

FOUNDED BY MARIUCCIA MANDELLI IN 1954

With Mariuccia Mandelli at the helm, Krizia is one of Italy's most successful and best-known labels. Originally a teacher, Mandelli started making her own clothes, designed a series of separates, and by the mid-1950s was sufficiently established to launch an exhibition of her work. Krizia's design has always mixed the fantastical with the colourful. In the best tradition of Italian fashion, it combines both brilliant texture with wit. Knitwear is a speciality.

LACHASSE, House of

FOUNDED IN 1928

England's oldest couture establishment has survived war, economic fluctuation and every significant trend – from the flapper to deconstruction. Lachasse still has a hard-core client base who remain loyal to the kind of British tailoring in which the house excels – immaculate cutting, fine fabrics, and nothing too radical. An emulator rather than an instigator of fashion, Lachasse remains a resolute favourite with the British aristocracy who could tell the world a thing or two about good taste.

Lachasse has employed many of the most important British designers during its reign: Digby Morton, Hardy Amies and, during the 1950s, Michael Donellan, who in 1953 was photographed by *Vogue* as part of the Incorporated Society of London Fashion Designers. During the 1980s, Japanese designer Yuki worked upstairs, draping his beautiful evening gowns in a small room above the Lachasse workrooms. Lachasse is still synonymous with the best of British tailoring and is currently under the direction of Peter Lewis-Crown.

KORS, Michael

BORN: NEW YORK, NEW YORK, USA, 1959

Michael Kors is one of the industry's great communicators. He loves doing trunk shows, explaining looks, meeting clients and expressing his opinions. Kors speaks for every American designer when he says, 'designing simple is the hardest thing in the world'.

Encouraged by his mother, an ex-Revlon model, Kors studied fashion design at the Fashion Institute of Technology in New York at the age of 18, while working as a sales assistant at Lothar's boutique on 57th Street. He quickly progressed from knowing what sold to designing his own range. The success of the collection made Kors form his own label in 1981 and he received DuPont's first American Original Award two years later. In 1995 he launched a diffusion line called Kors. He moved to Céline in late 1997, producing a successful collection in just four months, and is now creative director there.

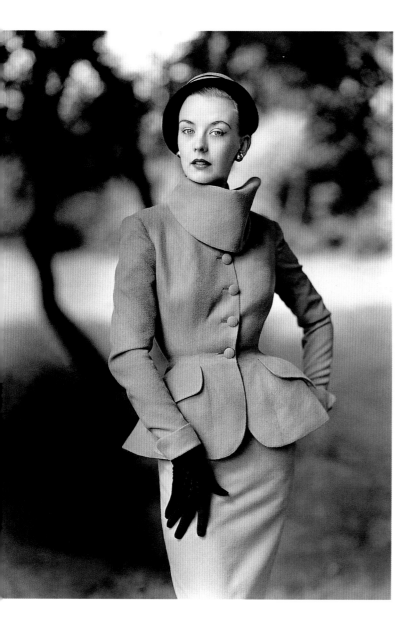

LACROIX, Christian

BORN: ARLES, FRANCE, 1951

Credited with putting a new spin on couture, and new faces in the front row, Christian Lacroix's debut in October 1987 provoked a unanimous reaction: *Vogue* talked about his irreverent spirit, while *The Sunday Times* magazine showed a photograph of 36-year-old Lacroix taking his bow with his finale bride, exclaiming on its cover: 'Vive Lacroix! There's been nothing like it for 25 years.'

Lacroix, saviour of eloquent colour and mouthwatering embroidery, studied art history and museum studies at the Sorbonne and the École du Louvre in Paris before working as an illustrator at Hermès and assistant to Guy Paulin. He spent five years at Jean Patou as chief designer of haute couture before opening his own house in 1987. The reaction verged on the orgasmic: the press were in raptures over his use of froufrou, textural mix and wonderful flair for theatricality. Lacroix scored a double whammy: he blew the cobwebs away from Paris couture and brought in the puffball skirt at the same time. Lacroix's influences – from the Queen of Arles to royal ruffles, Picasso and Cecil Beaton – reflect his love of decoration. He has designed bullfighting costumes for the world's most famous matadors. His style is full-blown rose rather than full-on sexuality. Romantic and beautiful, Lacroix's collections are examples of what occurs when a supreme colourist meets couture technique.

BELOW Lacroix's ultra-sensitive palette in lilac, rosewood and copper: boned corset, silk bustier and a splash of white silk pansies.

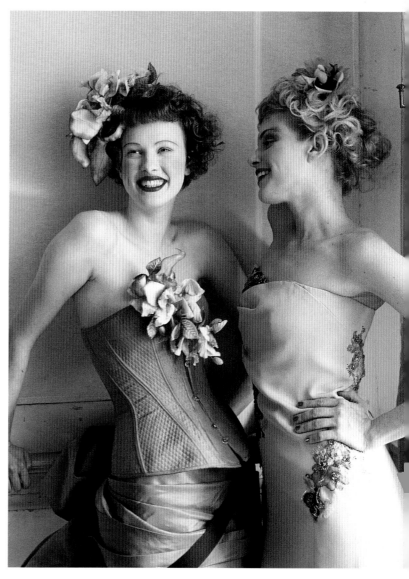

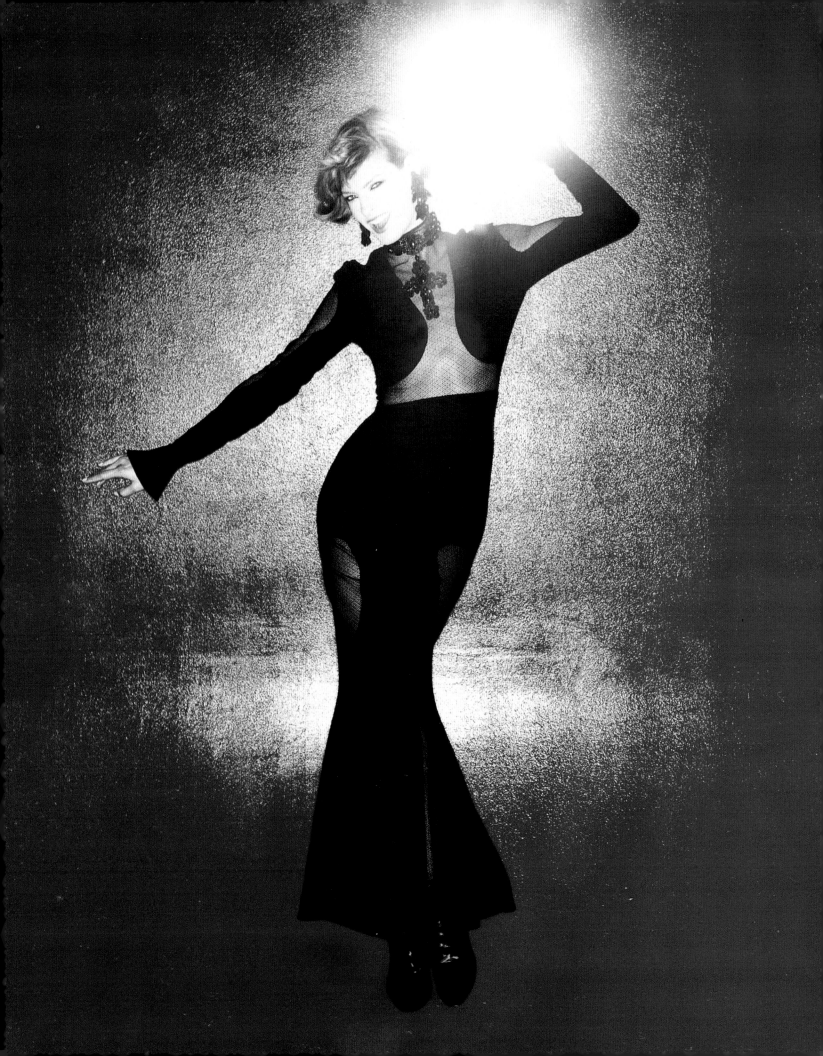

LAGERFELD, Karl

Born: Hamburg, Germany, 1938

Prolific and perceptive, Karl Lagerfeld is the designer who made Chanel a phenomenon of the 1980s and, in turn, the most significant signature of the century. No other designer could have handled it better.

When Lagerfeld arrived at Chanel in 1983 he was clearly on a roll: reinventing the Chanel suit with endless permutations, positioning the camelia on a plain white vest, putting the double 'C' insignia on motorcycle boots. He cleverly added a sporty feel, branding the puffa jacket, leggings and haversacks with the Chanel signature and thus capturing a new generation of customers.

No-one has more experience in different markets than Lagerfeld, who worked at Balmain, Patou, Chloé, Krizia, and many others. He knows how to handle fur, has a flair for irony and is also a clever fabric experimentalist: his work with the Linton Tweed mill in Carlisle included mixing Lurex with stretch and tweed with raffia. A modernist who detests museums but whose homes are reminiscent of the court of Louis XV, Lagerfeld switches styles from collection to collection in the same way that actors change character. In 1973 he told *Vogue* that 'movies are the only expression of modern thinking'. In 1983 Karl Lagerfeld made it into the most sought-after signature on the planet, becoming head designer at Chanel. Having previously worked at Chloé since the early 1960s, he returned briefly in 1993, replacing designer Martine Sitbon.

Lagerfeld's legendary fan, which has created an eclipse over his lips for years and acted as protective shield, is just one of his perennial trademarks, along with his sleek ponytail. His high-profile personality made him a natural target to hang tags on: he was called Darling Dictator, King Karl and Kaiser Karl, and was slammed as a mercenary and control freak by his competitors. Lagerfeld prefers a subtler summing-up, describing himself as an 'intelligent opportunist'.

Designing apart, Lagerfeld is an accomplished photographer and illustrator, who drew a beautiful version of *The Emperor's New Clothes*. His four lines, Chanel, Fendi, Karl Lagerfeld and

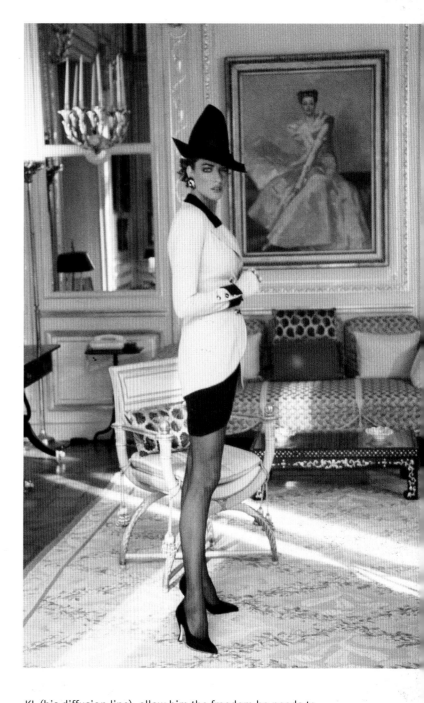

KL (his diffusion line), allow him the freedom he needs to dip into the delights of both mass-market and couture, and fly in the face of the politically correct with his extraordinary inventions using animal fur. Like Coco Chanel, Lagerfeld has a healthy attitude to plagiarism: if it's being copied, it must be good.

Still sporting his aristocratic hairdo, and with the attention span of a gnat, Lagerfeld lives on a diet of adrenaline. 'Stress? Don't name it and you don't get it,' he told American *Vogue* in 1988. 'You can say I'm a professional dilettante. What I enjoy about the job is the job.'

OPPOSITE **Caught in a flash: Lagerfeld's 'transition vamp' dress, 1993, made from lace and crepe, revealing and concealing in one fell swoop.**

ABOVE **The ultimate in gorgeousness by Karl Lagerfeld for Chanel couture – long, lean jacket, skirt slashed to the hip, topped by a Tyrolean hat, 1990.**

LANG, Helmut

BORN: VIENNA, AUSTRIA, 1956

One of the Belgian contingent of designers who put deconstruction into the fashion vocabulary, Helmut Lang established his own fashion studio in 1977. Despite having no formal training himself, he has lectured at the University of Applied Arts in Vienna.

Brought up by his grandmother in an area of mountainous tranquillity, Lang developed a taste for clean lines and linear constructions. Economy, unobtrusiveness, and a penchant for inexpensive fabrics mean that what appears to be simple is, in fact, a subtle mix of varying textures. His designs are clean and sharp – the complete antithesis of grunge. A natural futurist, he shunned the conventional catwalk show for an instinctive 'happening' on the internet.

Lang is typical of the new breed of Belgian designer: low key, anonymous and detached. A man of few words rather than master of the sound bite, he is someone who could slip into a hip restaurant without causing a ripple of swivelling heads – and his clothes are designed along the same principles. Helmut Lang – the anonymous entity with a universal label. That's the way he likes it.

LANVIN, Jeanne

BORN: BRITTANY, FRANCE, 1867
DIED: PARIS, FRANCE, 1946

Lanvin is one of the oldest established houses in Paris. Its founder, Jeanne Lanvin, served her apprenticeship as a seamstress and became a milliner, working initially from a small apartment. By 1915 Lanvin had become a byword for femininity and simplicity – and her success had made her rich. She had a house at Le Vésinet, close to Versailles and Paris, and 'was of the French designers who has made a large fortune through governing the output of styles for the young girl,' commented *Vogue* in 1915. 'She has never departed from her first conviction that modified Grecian lines are the best for the youthful figure.'

Lanvin was one of the century's first minimalists, and although she was an accomplished art collector, she did not draw direct inspiration from her paintings. Her designs relied on the use of a combination of graphic patterning, clear colours, precise positioning of details and a mix of appliqué and embroidery. Lanvin's clientele included European royalty, noted aesthetes, novelists and Hollywood stars Marlene Dietrich and Mary Pickford.

After Jeanne Lanvin's death, the house was directed by her daughter, Countess Jean de Polignac, during the 1950s, followed by Antonio del Castillo, Jules-François Crahay and, briefly, Claude Montana.

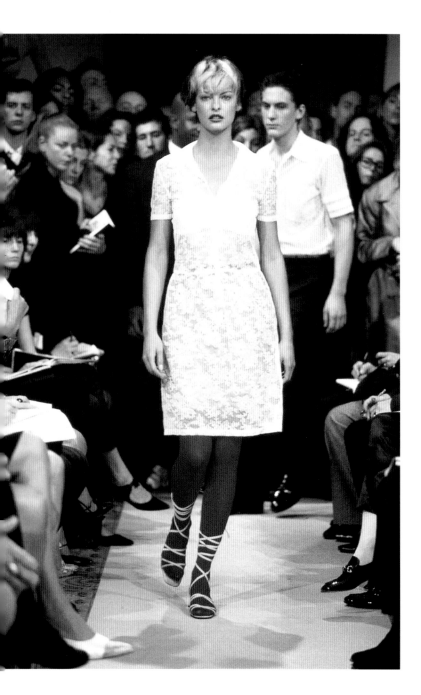

LEFT **A short, sharp exercise in how to re-work pure lace to phenomenal effect from Helmut Lang, summer 1996.**

LAROCHE, Guy

BORN: BORDEAUX, FRANCE, 1923
DIED: PARIS, FRANCE, 1989

When Guy Laroche burst onto the fashion scene during the mid-1950s *Vogue* commented, 'His collection puts a young kick into the traditional elegance and maturity of Paris.' By 1960 he was a mover and shaker who, together with Madame Grès, Jacques Heim, Jean Dessès, Maggy Rouff and Nina Ricci, had formed the Association des Maisons Françaises de Couture-en-Gros, a sure-fire indication that couture was, at last, being replaced by more accessible lines.

Having worked first as a milliner, and then in New York on Seventh Avenue, Laroche returned to Paris and found employment with Jean Dessès for eight years, and was talked about in the same breath as Pierre Cardin and Nina Ricci as one of the instigators of the Left-Bank look in *Vogue*'s feature, 'Half Time Score' of September 1960. 'The cloche and bob look, evocative, but new and now prevails ... narrow side-wrapped coats and suits, snuggled fur collars; head-hugging clothes; a curved slick of hair on the cheek.'

His successful apprenticeship with Dessès enabled Laroche to open his own house in 1957, where his masterful cutting and tailoring solidified his name. His early work was influenced by the architectural cutting of Cristobal Balenciaga, but he later gave this austere formality a new freshness, attracting custom from younger women. During the 1960s Laroche diversified his couture business, moving into ready to wear and specializing in reversible coats, traditional patterns and his trademark – the loose, waistless sheath. His most significant contribution at this time was for lending an almost girlish attitude to formal clothes. In the 1970s his trouser suit – a symbol for liberated women – became a wardrobe staple for women everywhere.

At the time of his death in 1989, Laroche had an extensive empire producing both couture and ready to wear. Michael Klein became couture designer in 1993, with Jean Pierre Marty in charge of ready to wear. In 1998 Laroche employed Alber Elbaz, who moved to Yves Saint Laurent's Rive Gauche line later the same year.

LAPIDUS, Ted

BORN: PARIS, FRANCE, 1929

Son of a Russian tailor, Ted Lapidus forfeited his training in engineering to transfer his talents to fashion design. His early years were spent studying in Tokyo.

He moved to Paris in the early 1950s to open his own establishment concentrating on designing on a one-to-one basis, while exploring the possibilities of mass manufacture. He designed his clothes as a technician, concentrating his attentions as much on precision-cutting as on the design of a garment. During the 1960s he produced a safari jacket which became extremely popular. With a rounded view of the fashion industry, Lapidus has successfully kept pace with advances in both tailoring techniques and fabric technology.

LAUREN, Ralph

BORN: NEW YORK, NEW YORK, USA, 1939

Ralph Lauren is the master of marketing, maestro of the seductive image, and probably the only designer who can take a period of history or slice of culture and make it totally relevant today. Lauren has taken a foray into the 1920s, a trip to Indian territory, and a safari in Africa. His greatest feat is selling Englishness to the British. His stores, which take inspiration from *Brideshead Revisited* and *The Great Gatsby*, appeal to the Ivy League graduate and low-key aristocrat. Lauren's greatest strength is his aptitude for being totally international in thinking. His shop interiors reflect stately homes: wall-to-wall mahogany, family portraits in silver frames, Navaho wraps slung nonchalantly over a sofa.

Lauren studied business science and served in the American army. He learnt all about the ins and outs of trading by doing it the hard way: selling ties. Lauren has no qualms about telling the world how he became head of a multi-million dollar empire from the shop floor. For this reason alone, he looks at the whole package rather than pondering for hours over a single outline. His flair is for themes and stories rather than seamlines and silhouettes. Lauren's advertising campaigns, shot by photographer Bruce Weber, feature Ivy League men and all-American beauties intermingling with wilting roses, thoroughbred horses and the odd wire-haired terrier. Sometimes Lauren appears himself. For him, fashion is a film set; his ultimate customer, the person who hasn't tried too hard. What he is trying to convey, he told American *Vogue* in 1992, is 'The heritage, a sense of heritage ... atmospheres of what people are and what they are doing as opposed to a Thing.'

The Lauren empire was formed in 1967 when he created his first Polo tie collection. He began with menswear and made his name by dressing Robert Redford in *The Great Gatsby* (1974); he reiterated his feel for nostalgic elegance when he dressed Diane Keaton in *Annie Hall* (1977). Lauren has won countless awards, culminating in a Lifetime Achievement Award in February 1992 from the Council of Fashion Designers of America.

Lauren's flagship store, a beautifully restored former Rhinelander mansion on Madison Avenue in New York, is an elegant combination of gentleman's club, stately sitting room and safari retreat. The shop, kitted out with polished mahogany furniture, oil paintings, lived-in leather sofas and low lighting, is the ultimate scene-setter for the look. The clothes seem to be almost incidental. Although he is the most financially successful fashion designer of modern times, Lauren admitted to *Vogue* in 1992: 'I never learned fashion, I was never a fashion person. I was a guy looking at a girl.'

ABOVE **Ralph Lauren's 'ladies man', 1992, in a lean pinstripe suit with bowler hat, silk tie and fob chain.**

OPPOSITE **Cindy Crawford in Lauren's black cashmere halterneck sheath dress, clinging to every curve, 1995.**

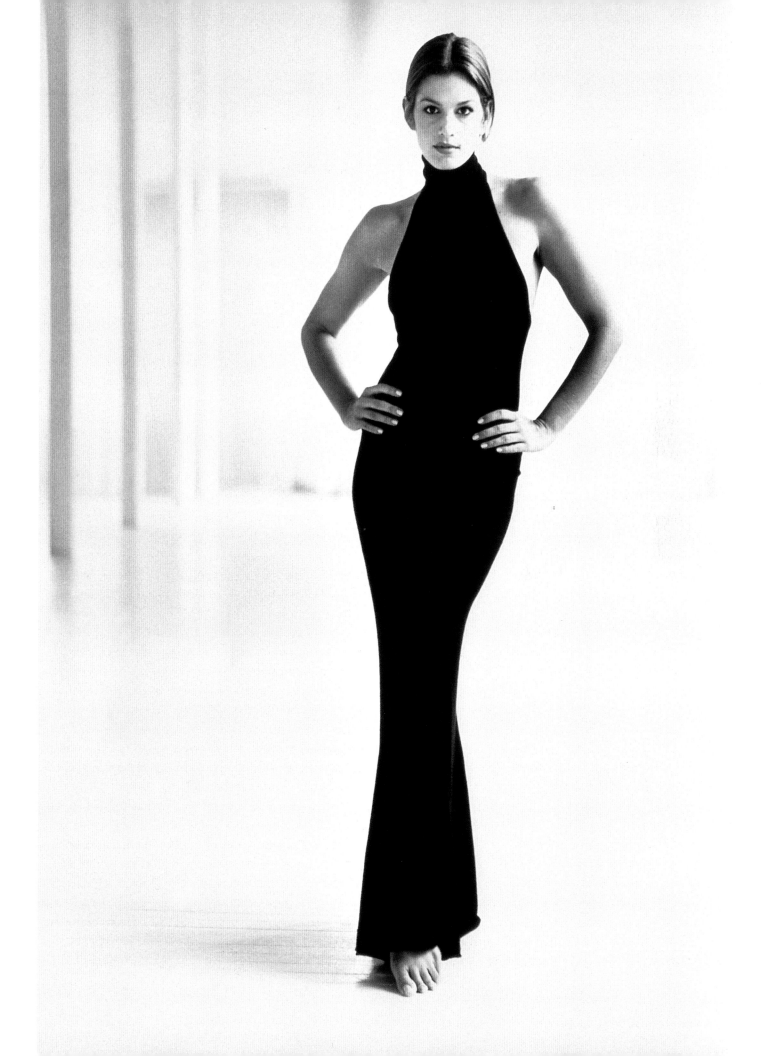

RIGHT **Lelong's 'Watteau-ish' coat of many colours from 1938, with grey panels back and front: 'sobering, flaring, daring.'**

LÉGER, Hervé

BORN: BAPAUME, FRANCE, 1957

Taking his cue from Azzedine Alaïa, Hervé Léger took the stretch, body-conscious look – which was pushed to the limit by Alaïa in the 1980s – and re-worked it for the 1990s. Léger worked at Fendi, Chanel, Lanvin, Chloé and for shoemaker Charles Jourdan before launching his own label in 1993. His clothes are instilled with the knowledge of shape and form he gathered from working at so many different fashion houses.

Léger's look takes the principles of underwear and employs them in curvaceous, clinging forms for outerwear. The comparisons with Alaïa are obvious, but Léger takes a different tack, using strips of fabric like lengths of elastic, which act as a corset. For Hervé Léger read: elasticated couture which clings to the body and helps the female form to undulate in all the right places.

LELONG, Lucien

BORN: PARIS, FRANCE, 1889
DIED: BIARRITZ, FRANCE, 1958

Son of the owner of a textile business, Lucien Lelong's debut collection was shown after the First World War. Although his contemporaries were in opposition, Lelong felt – quite rightly – that there was a market for a more diluted version of what he had already produced. The result was a diffusion line called 'Lelong Éditions'.

In the 1920s Lelong married the beautiful Princess Natalie Paley, who effectively became a walking advertisement for his latest collections. In 1925 he showed his elegant eveningwear in Paris, and at the Café de Paris in London.

Lelong was credited with preventing the disintegration of Paris couture during the war years. As president of the Chambre Syndicale de la Couture Parisienne from 1937–47, he persuaded the Germans that couture be exempt from rationing, keeping creativity alive.

Christian Dior worked with Lelong for a decade before unleashing his New Look on the world. He recalled his time working at Lelong as, 'a delightful experience – I had none of the responsibilities of putting my designs into practice on the one hand, nor the burden of an executive job on the other.'

LESAGE

FOUNDED BY ALBERT LESAGE IN 1868

France's oldest and most revered embroiderers, Lesage is the Nijinsky of the sequin, the Midas touch of craft, the glossy, priceless full stop no couture house would be without. Everyone – from Worth to Chanel to Dior – has employed the skills of France's foremost monument to elegance, the atelier that works on individual vision rather than season, where craftswomen turn couture into pieces of fine art.

Lesage's reputation has been built on its extraordinary skill in beading and its ability to construct anything a designer draws. Breathtakingly beautiful, and often working in three dimensions rather than on a flat surface, some of the most notable Lesage inventions include a sizzling lamé bow and a celebration of the Fabergé egg. They have also created a trompe l'oeil shower for Karl Lagerfeld, a Byzantine breastplate for Christian Lacroix, an angular Picasso profile for Yves Saint Laurent, and a glittering bunch of succulent sequinned grapes and spiked leaves, which hung from the shoulder of an Yves Saint Laurent satin jacket and was described by *Vogue* in 1988 simply as, 'A vintage season of Lesage embroidery.'

LESTER, Charles & Patricia

FOUNDED BY CHARLES AND PATRICIA LESTER IN 1964

Makers of Fortuny-esque dresses, Charles and Patricia Lester have forged a niche in perpendicular pleating. Their dresses sell in Japan, Italy and America, and customers range from the Duchess of Kent to Barbra Streisand – with Shakira Caine and Bette Midler in between. Using a mix of silk-screen printing techniques and permanent pleating, the Lester look is opulent and exotic, and spans everything from evening dresses to cushions to waistcoats.

Charles was originally a textile physicist, while Patricia – with no formal training – began designing in 1964 and in June 1988 was appointed a MBE. Working from their studio on the River Usk in Wales, the Lesters use a mixture of hand-dyeing, tie-dyeing, batik and silk-screen printing to create a look that is richly coloured with an air of fluidity.

LIBERTY

FOUNDED BY ARTHUR LASENBY LIBERTY IN 1875

Over a century after its inception, Liberty, Rossetti and the Pre-Raphaelite movement still go hand in hand. Founded as a fabric and clothing emporium to extol the aesthetic movement, Liberty was instrumental in liberating women from corsetry. The store was famous for importing fabrics and re-dyeing them in exotic colours; it was also a popular source of inspiration for Paris couturiers.

Although Liberty's influences were firmly rooted in the Greek, Roman and Medieval period when clothing was at its most simple, its style always centred on opulence and used fabrics such as devoré velvets and silk satin. Curiously, while the space race gained momentum in the 1960s, Liberty enjoyed a renaissance, with an influx of young designers and psychedelic colours. Spiritual home to Jean Muir and haven for legions of customers, who rate it as the most beautiful store in the world, Liberty is undergoing a revamp to coincide with the millennium.

RIGHT **A vintage season for Lesage: bunches of glossy grapes in three dimensions, sprouting leaves on an Yves Saint Laurent jacket, 1988.**

LOEWE

FOUNDED BY ENRIQUE LOEWE IN 1846

Famous for its heritage of impeccable craftsmanship and soft leathers, Loewe is the most recent luxury goods company to undergo a revamp. The Spanish company – based in Madrid with branches around the world – appointed Narciso Rodriguez as its design director in 1997. Rodriguez, who created Carolyn Bessette Kennedy's wedding dress in 1996, felt the contract was a meeting of minds: 'Loewe's Latin and I'm Latin,' he said succinctly. Rodriguez, who was brought up in New York but is of Spanish descent, is used to cross-cultural referencing. He has continued to nurture the Loewe label, directing it beyond accessories and into a collection which contains luxurious references and spicy colouring.

LOUBOUTIN, Christian

BORN: PARIS, FRANCE, 1963

A French shoemaker of considerable note with a long line of celebrity clients, including Inès de la Fressange, Princess Caroline of Monaco and Catherine Deneuve, Christian Louboutin works in the tradition of his hero, shoe designer Roger Vivier. Colourful and beautiful – particularly when they are embroidered – Louboutin shoes are not particularly practical or simple, veering instead towards the fantastical.

LOUISEBOULANGER

FOUNDED BY LOUISE BOULANGER IN 1927

Louise Boulanger started out as a 13-year-old apprentice before becoming a designer at the house of Chéruit, eventually opening Louiseboulanger, her own business, in 1927. She made regular appearances in *Vogue*, often alongside her contemporaries – Madeleine Vionnet, Edward Molyneux, Coco Chanel and later, Elsa Schiaparelli. Louiseboulanger's skill was in switching from tailoring to eveningwear, from day dresses to cocktail ensembles. As the decades progressed, Louiseboulanger retained the ability to move on, never sticking to one single style, but adapting to fluctuating hemlines and radical shifts in taste. She was one of the first designers to recognize the potential of evening wraps, was an expert in little black dresses and could make fluid evening gowns comparable only to Vionnet's. A vastly underrated designer, Louiseboulanger was a *tour de force* and regular fixture on *Vogue*'s fashion pages for 20 years.

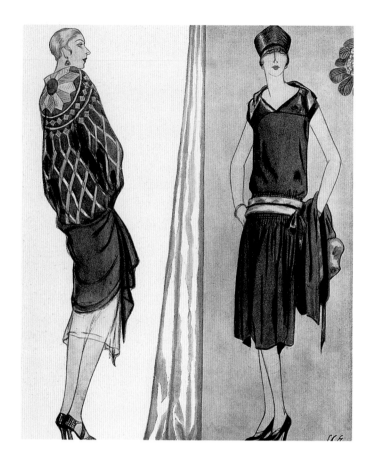

ABOVE 'Black returns to Chic, via Paris': Louiseboulanger's chiffon evening wraps, eloquently embroidered. Right, black crepe Romain dress, 1926.

LUCAS, Otto

BORN: GERMANY, 1903
DIED: BELGIUM, 1971

London's most stylish hatmaker during the 1950s, Otto Lucas opened his business in 1932, and directed the shape of British millinery from his salon in central London. Presiding over an enormous workroom, Lucas's precise attention to detail, wonderful proportions and expertise at handling a variety of fabrics and multitude of styles made him one of the key players during the decade when accessories were imperative to the total look. Tragically, he was killed in a plane crash.

Working for Britain's most prolific milliner was not all sweetness and light: Lucas was described by one ex-employee – who did not wish to speak ill of the deceased – as having 'wonderful style – but hell to work for'.

McCARDELL, Claire

BORN: FREDERICK, MARYLAND, USA, 1905
DIED: NEW YORK, NEW YORK, USA, 1958

The post-Second World War precursor to Donna Karan, Calvin Klein, Ralph Lauren and a coterie of American classicists, Claire McCardell is the mother of American sportswear. In *Vogue* in 1941 she was described as, 'The typical American girl – whom you never saw but read about in print.'

McCardell's penchant for pattern cutting and dressing up began in her childhood, and she eventually progressed to re-modelling clothes with the use of a small sewing machine. She graduated from Hood College in Maryland, and later attended Parson's School of Design in New York, living at the Three Arts Club – a home and club for women in the arts. McCardell was then transferred to the Paris branch of Parson's, situated in the place des Vosges. 'I was learning important things all the time; the way clothes worked, the way they felt, where they fastened,' she reflected later of her invaluable year in the fashion capital. She returned to New York to complete her final year in 1928. Her first job was as an illustrator with Emmet Joyce, for which she received the princely sum of $20 per week. From there, McCardell progressed to designing knitwear, and eventually scouring rival stores for a company called Robert Turk. When Turk switched jobs he took McCardell with him; when he drowned in a tragic accident, she became head designer. Although McCardell did the designer rounds – travelling to Paris, making sketches and interpreting various styles – she knew there was a market for real Americanism.

The turning point came when McCardell made an Algerian-style evening dress with a sportswear slant to wear to the Beaux-Arts Ball. The shorter version she'd made for herself prompted compliments and naturally found its way into the collection. This invention kick-started the rest of her range – an instinctive line of revolutionary, pragmatic designs.

McCardell's creations were always based on logical thought rather than playing with proportion. She invented the Pop-over, a sturdy denim wraparound smock, which became an American classic; she used heavy-duty linen to make feminine versions of male workwear; jersey exercise suits; silk playsuits. Every pocket

RIGHT Claire McCardell's effortless, modern playsuit of 1953, buttoning at the front, tied at the waist, and worn with a beret. Perfect for beach bathing.

placement, diameter of strap, twin stitching or length of a skirt had a reason, otherwise it wouldn't be there. Her consummate flair was for simplicity and her approach was based on the belief that necessity is the mother of invention. McCardell was the personification of the word 'utility'. In 1987 the Fashion Institute of Technology in New York staged an exhibition celebrating the work of Madeleine Vionnet, Rei Kawakubo and Claire McCardell, three women with differing styles, bound together by a common thread of intelligence.

McCARTNEY, Stella

BORN: LONDON, ENGLAND, 1972

Appointed design director of Chloé in 1997 to a chorus of criticism and accusations of 'nepotism' – her father, Paul, wrote the most mesmerizing songs of the century – Stella McCartney has proved she can deliver the goods, and that she is much more than a PR puppet. She has put a fresh new slant on the Chloé label, and her collections have been rapturously received. More importantly, customers are putting their money where their mouths are: sales of Chloé have shot up by 500 per cent.

McCartney was educated at a comprehensive school in Sussex; she studied fashion at London's Central Saint Martins College of Art and Design, and worked at Christian Lacroix and Betty Jackson before securing the position at Chloé. Like her mother, Linda, who pioneered vegetarianism, faced the wrath of Beatles' fans and smiled in the face of breast cancer, it will take more than the odd poison arrow to knock McCartney off kilter.

RIGHT **What Stella McCartney does best: simple shifts – in this case, lace-panelled and secured with wide straps, 1997. Bright tights optional.**

'I had a lot of those stupid millennium questions – but why would I do a white number or a 2001 theme?' she told *Vogue* in 1999. 'What the next millennium is about, for me, is confidence.'

MACDONALD, Julien

BORN: METHYR TYDFIL, WALES, 1974

A clever, inventive knitwear designer, who was born in Wales and works in London, Julien Macdonald was spotted by Karl Lagerfeld, who employed him almost as soon as he left London's Royal College of Art in 1996. MacDonald is an experimentalist – a bold designer who is more than happy to dip his toe into unchartered waters. He mixes crocheting with conventional knitting, sparkle with stretch, unidentified flying objects – namely sweet wrappers, real gold and crystals – with pure new wool. His speciality is dresses which leave areas of flesh on show, effectively revealing and concealing at the same time. More suited to one-offs than the constraints of commercial enterprise, MacDonald successfully pushes the boundaries – lifting knitwear out of its more conventional sphere. He currently sells in the USA, Tokyo and Paris, and his celebrity clients range from Nicole Kidman to Madonna.

McFADDEN, Mary

BORN: NEW YORK, NEW YORK, USA, 1938

Instantly recognizable by her sharp black haircut and existentialist looks, Mary McFadden attended the École Lubec in Paris during the 1950s, before studying fashion at the Traphagen School of Design and Sociology in New York. By the time she decided to settle on the fashion industry she

already had various work experiences: director of public relations at Dior, merchandizing for South African *Vogue*, political columnist and jewellery designer. In addition, she had founded a sculpture workshop in Rhodesia and had an acute knowledge of classical art and ancient civilization.

McFadden's experience of cross cultures and diverse social types has meant that her clothes have surprising elements – simple lines and exotic prints. She readily admits she's more into fabric than fashion. Her business kicked off in 1973 when Geraldine Stutz, then president of New York store Henri Bendel, encouraged her to explore the medium of fashion. The result: a white strapless column for Jacqueline Onassis. She has also dressed Diana Vreeland, Ethel Kennedy and Evelyn Lauder.

MACKIE, Bob

BORN: LOS ANGELES, CALIFORNIA, USA, 1940

Theatrical, camp and unashamedly over the top, Bob Mackie is best known for his sequinned creations worn at the Oscars, on videos and at every appropriate photo opportunity by singer-turned-actress, Cher. Mackie's forte is turning women into showgirl parodies, Caesar's Palace extras and glossy exotic insects. His natural habitat is Las Vegas; his favourite mediums are feathers, sequins and tantalizing sheers. In 1990 Mackie tried his hand at American folk art, drawing inspiration from what he described to *The New York Times* as 'the men and women that forged the wilderness'. The uninitiated expected homespun values but the result was typically flamboyant: *Custer's Last Stand* crossed with *La Cage Au Folles*.

Mackie became known in the USA for his work with comedienne Carol Burnett. He was responsible for her on-set wardrobe – which included relatively quiet suits and character costumes – for over a decade. When Mackie entered the ready-to-wear market, his name was already associated with glitz. He did not disappoint, and his shows gave a taste of showmanship to the sedate proceedings. Mackie has the ability to produce quiet suits, but his forte will always be more Las Vegas than Sunset Boulevard. As a result, his customers are women who want to make an effect. Speaking to *People* magazine in 1998, Chastity Bono, daughter of Cher, recalled: 'She didn't pick me up in Bob Mackie gowns or anything, but she didn't look like June Cleaver either.'

RIGHT **Viva Las Vegas: Bob Mackie's unmistakable glamour: head-to-toe sequins, swirling headdress and reflections in all directions, 1989.**

McQUEEN, Alexander

BORN: LONDON, ENGLAND, 1969

The self-styled bad boy of Paris couture, Alexander McQueen is the son of a taxi driver who found himself, virtually overnight, in the hot seat at Givenchy. McQueen was discovered by *Vogue* stylist Isabella Blow, who was sitting in the audience at his MA show. She took the collection, wore it in a *Vogue* shoot in November 1992, and relentlessly promoted him. It was Blow who persuaded McQueen to change his name from Lee to the more exotic-sounding Alexander.

McQueen is brilliant at self-publicity and causing a controversy; much has been made of his working-class roots, cockney accent and outspoken opinions. Pre-Central Saint Martins School of Art and Design, London, McQueen was already adept in the technical aspects of making clothes. His career began at the Savile Row tailor Anderson & Sheppard. McQueen moved to Kohji Tatsuno as a pattern-cutter and flew to Milan on a whim, eventually securing a position with Romeo Gigli before returning to London to do an MA.

On graduating, he formed his own line and then had a hit: his bumster trousers – a style which exposed the upper part of the posterior (more commonly seen on building sites) – caused a minor sensation and made his name. He received the British Designer of the Year Award in 1996 and, when John Galliano moved from Givenchy to Christian Dior, McQueen filled the position. He swept into Paris, slating everyone in his wake, including Vivienne Westwood and John Galliano. Hubert de Givenchy – the founder of the house and one of the most respected designers of the century – was dismissed as irrelevant by McQueen.

Ironically, McQueen's first collection for Givenchy was universally panned. At least he had the grace to admit it himself. 'I know it was crap,' he told American *Vogue* in October 1997 with typical candour, vowing to make amends with the next collection. McQueen is one of the few Central Saint Martins' graduates with real technical ability and a Savile Row training. His triumphs include Kate Winslet's wedding dress in 1999. McQueen's shows are always sensational, but his collections blow hot and cold. 'If you want a starving Ethiopian on a jacket, then come to McQueen in London,' he told *Vogue* in 1997. 'If you want luxury, come to Givenchy. I do both. I'm a fashion schizophrenic.'

LEFT Savile Row-trained McQueen uses a blend of angles, curves and subtle colour to make suits that are anything but straight, 1998.

MAINBOCHER

BORN: CHICAGO, ILLINOIS, USA, 1890
DIED: NEW YORK, NEW YORK, USA, 1976

Mainbocher was the American who took Paris by storm in 1929 and returned, triumphant, to the USA having been editor at French *Vogue*, established his own couture house and designed the Duchess of Windsor's trousseau. Mainbocher's grounding served him well for his new couture house in New York: several years as editor of French *Vogue* taught him the importance of publicity, as well as a remarkable ability to foresee exactly which direction fashion was going. He was, in effect, a detached designer with a flair for publicity and an antennae for style.

Born Main Rousseau Bocher, he attended the Chicago Academy of Fine Arts, and had various occupations – including illustrator and writer – before leaving *Vogue* to set up his own

BELOW 'The modern full dress' at Mainbocher: left, crepe dress, with fringed scarf; right, white crepe gown with 'cock feather' appliqué, 1932.

OPPOSITE 'The easiest city look' – perennial white shirt, cotton jersey vest top, gaberdine trousers and body bag – Martin Margiela for Hermès, 1999.

house. From the outset, Mainbocher established himself as a name that was synonymous with luxury and exclusivity. He made several dresses for the Duchess of Windsor – including her bias-cut wedding dress – thus satisfying her dual needs for French style and American patronage. Other notable clients included the Vanderbilts and socialite C Z Guest. Curiously, for a designer with inside knowledge of how the fashion industry, works, Mainbocher had no compulsion to exploit his name. He remained a couture designer, with a slight concession to ready to wear, until the end.

MARGIELA, Martin

BORN: LOUVAIN, BELGIUM, 1957

A key member of the Belgian avant-garde and former assistant to Jean Paul Gaultier, Martin Margiela introduced the word 'deconstruction' into the fashion vocabulary, and made the notion of the designer interview passé. Margiela is so low profile that he's virtually invisible. Initially training as a fine artist, he became a stylist, and then design assistant to Gaultier in 1985; he showed his first collection in 1988. Margiela's talent is for pushing the boundaries: his reference points are punk, medieval detail and recycling old clothes (T-shirts made out of used shopping bags, sweaters constructed out of socks). His approach to where he holds his shows is equally unconventional, with collections shown in both a cemetery and a disintegrating fire station.

Margiela uses colour in conjunction with what it means to people; he totally understands the subliminal messages given out by red as opposed to black. In 1997 he was appointed to design Hermès' ready-to-wear collection – an inspired choice to attract the fashion literate and reinvigorate the label. In 1999 he turned his talents to designing for the French catalogue *3Suisses* – along with Karl Lagerfeld, Thierry Mugler and his former boss, Jean Paul Gaultier. Although his work is widely viewed as an art form, Margiela does not put fashion on a pedestal: 'Fashion is a craft, a technical know-how and not, in our opinion, an art form,' he told the *Guardian*. 'Each world shares an expression through very divergent media processes.'

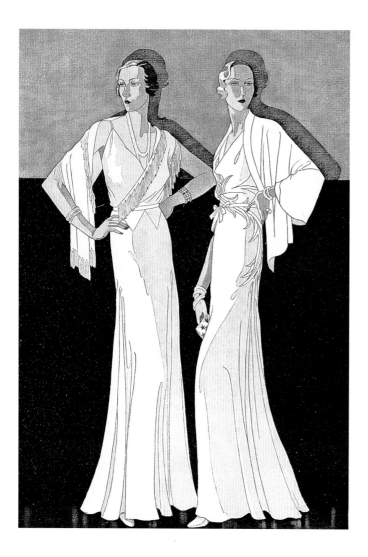

MATSUDA, Mitsuhiro

BORN: TOKYO, JAPAN, 1934

Mitsuhiro Matsuda travelled to Paris with his contemporary, Kenzo, in the 1960s. Tellingly, he returned to Japan while Kenzo remained. The designs say it all: Matsuda has retained the Japanese aesthetic for non-conformist cutting.

Matsuda started his career as a designer of ready to wear, then formed his own company, Nicole Limited. He eventually launched his own line in 1987. Matsuda's influences are diverse: from Pre-Raphaelite paintings to the Arts and Crafts movement. His clothes contain lush embroidery, medieval construction and subliminal references to jazz. Like Romeo Gigli, his collections have a medieval touch which appeals to renaissance women.

MAXMARA

FOUNDED BY ACHILLE MARAMOTTI IN 1951

Italy's leading ready-to-wear company, MaxMara, was founded by Achille Maramotti, who began with a miniscule capsule collection of one coat and two suits. This eventually metamorphosed into an international powerhouse with five manufacturing companies. The MaxMara empire encompasses 16 labels, which include MaxMara, Sportmax and Marella.

The quality of MaxMara's collections is always impeccable. Many famous designers have contributed to the label, including Karl Lagerfeld, Jean-Charles de Castelbajac, Emmanuelle Khanh and more recently Guy Paulin and Dolce et Gabbana. Photographers who have added to the company's corporate image and international cachet include *Vogue* contributors Peter Lindberg, Arthur Elgort and Paolo Roversi.

MARNI

FOUNDED BY CONSUELO CASTIGLIONI IN 1992

Described as bohemian, sensory and superluxe, the Marni label treads a fine line between precise detail and considered disarray.

Swiss-born Consuelo married Gianni Castiglioni, president of Ciwi furs, a branch of Fendi's family tree, when she was 25 years old. After having two children, Castiglioni became a fashion consultant for the company. She progressed to produce her own line, unveiling her first collection of immaculate leathers in 1992 and going on to use natural fabrics – thus creating the look that has personified the late 1990s: antique chic. Her expertise lies in knowing how to encapsulate the twin Italian strengths of gorgeous fabrics and a fabulous finish. In March 1999 she created a new collection of accessories.

MISSONI

FOUNDED BY OTTAVIO AND ROSITA MISSONI IN 1953

The company founded by Ottavio and Rosita Missoni produces fine yarns, ripples of colour and, above all, fantastic knitwear. No-one knows how to knit like the Italians, and Missoni knitwear is finely tuned, with a background of supreme technology. Missoni have managed to make their yarns look and feel like precious antiques, even though they are totally modern in concept. The Missonis have always followed their own line – a mixture of checks, spots and, as we go into the millennium, multiple patterns.

MIYAKE, Issey

BORN: HIROSHIMA, JAPAN, 1938

Issey Miyake thinks form before fashion and concept before clothes. He never ceases to amaze with his ability to transform clothes into organic objects. Miyake's collections have been called monastic, aesthetic and completely unfathomable. This last is probably because Miyake always questions rather than follows: when he launched his 'Permanente' collection in the 1980s, the Oscar-winning actress Maggie Smith enthused in *The Sunday Times*, 'It's an amusing idea and above all the clothes are fantastically comfortable. They are so easy you can do anything in them. I always wear them for rehearsals because their theatrical quality helps.'

Miyake was 7 years old when he witnessed the atom bomb which killed 200,000 of Hiroshima's inhabitants and reduced two-thirds of the city to ashes. Three years later he developed osteomyelitis, a disease of the bone marrow; his mother died shortly afterwards. He put the moment of mass-destruction out of his mind and became a graphics student at Tama Art University in Tokyo, moving to Paris in the 1960s and working with Guy Laroche and Hubert de Givenchy. Miyake then moved to New York and worked with Geoffrey Beene.

When he returned to Tokyo in 1970, Japan had undergone a sea change. Kimonos and Western shapes had interbred – it was the perfect moment to forge a new direction. His first collection had a

LEFT **Celebrating *Vogue*'s seventy-fifth anniversary, Miyake's jacket of pewter silk plissé, over chequer-board bloomers, 1991.**

OPPOSITE **Showing how structure should be handled: Issey Miyake's sculptured coat with wind hood to combat the outside elements, 1986.**

girl systematically stripping off her Miyake creation. The show caused a scandal and Miyake became an overnight sensation. Eight years before Comme des Garçons took Paris by storm, Miyake showed his unconventional collection in Paris.

Miyake's clothes never start from a sketch, but from scratch – a piece of fabric, a notion of movement. In the 1980s he staged a Bodywork exhibition with black silicon models – some suspended from the ceiling, others submerged in darkness. He launched his collection for men in 1982, wearing a variation on a shirt-jacket, which he had been designing since 1975: 'Men who follow fashion can look ridiculous,' he told *Vogue*.

In 1988 Miyake collaborated with photographer Irving Penn to produce a book of startling photographs. He designed the Olympic Games outfits for Lithuania and vestments for Winchester cathedral in 1992. Accolades are numerous: the following year Miyake was awarded the Légion d'honneur by the French government, followed by an honorary doctorate from London's Royal College of Art.

The link between Issey Miyake and art is inextricable. All his collections – from 'Windcoat', a collection of outerwear to 'Pleats Please', a range of polyester pieces – contain aesthetic reference points. His customers are creative thinkers; his collections celebrations of pliable human sculpture. As guest artist Yasumasa Morimura commented, 'Miyake questions, "Why?" and "Wait a minute!" about his own clothing designs. This "?" is a source of creative energy. "Why?" has the power to shake one's thoughts. This is called an *étonnement*; the French word for shaking, disturbance, or astonishment.'

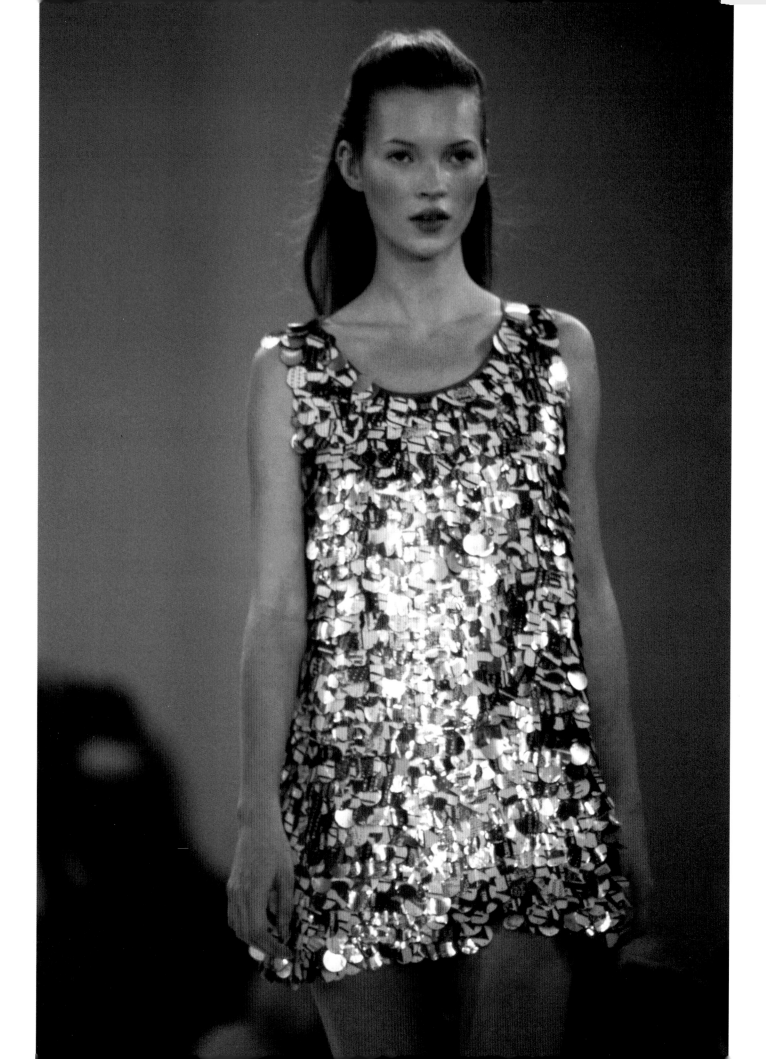

MIZRAHI, Isaac

BORN: NEW YORK, NEW YORK, USA, 1961

Isaac Mizrahi arrived on the fashion scene in 1989 to a flurry of praise, a flash of sequins and a headline that called him a 'shooting star'. Then 27, Mizrahi had an exuberant sense of colour, an infectious energy, and a youthful eye with an edited grown-up outlook. His earliest design influences stemmed from his mother's all-American wardrobe, which included clothing from Halston, Geoffrey Beene, Claire McCardle and Norman Norell. 'The American ethos is very simple, very underdone, not over-constructed,' he said, while sending immaculate cashmere sweaters and sparkle-knit shifts down the catwalk. 'I don't really want to do clothes for 18 year olds. They look best in jeans and funny little things they put together themselves.'

Mizrahi graduated from Parsons School of Design in New York in 1982. He then worked for Perry Ellis and Calvin Klein before forming his company in 1992. Three years later, *Unzipped* was launched at the Cannes film festival. The film was a fascinating, fly-on-the-wall documentary which followed an often tortured Mizrahi as he designed his autumn/winter collection, dreamed up an arresting catwalk show, and interacted with supermodels including Naomi Campbell and Cindy Crawford. Such a revealing insight served both to heighten Mizrahi's profile and leave him exposed at the same time – he was the first designer to be caught on camera in the process of being crushed by the critics.

Despite the success of his subsequent collections, by 1998 Mizrahi was a fashion casualty; when his studio closed it was considered a sufficiently newsworthy event to make the front page of *The New York Times*. For Mizrahi, the sadness was tinged with a sense of relief: at least the photograph was a slimline one. His parting shot – a quote about fashion getting tougher – allowed him to concentrate on what he enjoys doing most: airing his opinions with self-deprecating wit, and nurturing his status as a 'personality'. Mizrahi is a regular contributor to American *Vogue*; he also writes for various other publications and makes numerous television appearances.

MODEL, Philippe

BORN: SENS, FRANCE, 1956

Milliner and shoe designer, Philippe Model grew up in the French countryside. His father ran a leather tannery and he spent his childhood reworking leather offcuts into feasible accessories. At the age of 20, the department store Galléries Lafayette promoted a military cap designed by Model, which proved to be a bestseller and launched him as a designer. Model then embarked on a career in which his contemporaries were to present him with an award for Best Craftsman in France. He became a distinguished maker of quirky and covetable accessories, designing under his own name and also that of Michel Perry. Model established his own company in 1981 and by 1993 his designs were distributed to over 200 stores throughout the world, including three of his own shops in Paris.

He has worked with Jean Paul Gaultier, Claude Montana, Issey Miyake and Thierry Mugler, and has accessorized the elegant outfits of a series of French movie stars, as well as Princess Caroline of Monaco.

Unusually, Model is known equally for his millinery and his footwear – neat, elasticated shoes formed from stretch material which have been widely copied. Additional lines include men's knitwear, perfume, interior design and costumes and shoes for opera, one of Model's passions.

MOLINARI, Anna

BORN: CAPRI, ITALY

Anna Molinari, the designer behind Blumarine, began the business in collaboration with her husband in 1977. Initially concentrating on knitwear, Molinari won the Designer of the Year Award in 1980. In 1990 the company, based in Italy, expanded abroad to Spain, Austria, Paris and Japan. The Anna Molinari label, known for its brilliant use of colour, is now designed by Molinari's daughter, but the Blumarine line, designed by Molinari herself, continues to personify the designer's signature style of creating sexy glamorous clothes. Believing that every woman has a dual fashion personality, known as the virgin/whore complex, Molinari has striven to incorporate both in her collections, attracting a following of ultra-feminine customers in the process. As the millennium approaches, Blumarine's bestseller is a fitted cardigan edged with real fur.

MOLYNEUX,
Captain Edward

BORN: LONDON, ENGLAND, 1891
DIED: LONDON, ENGLAND, 1974

A respected, immaculately dressed couturier of Irish descent, Edward Molyneux's strength was his sense of propriety and understanding of wearability. Described by Pierre Balmain, an ex-employee, in his autobiography, *My Years and Seasons* (1964) as an 'elegant, aloof Englishman who held the fashion world in the palm of his hand during the 1930s', *Vogue* put it more succinctly: 'His is the suit that lives forever.'

Molyneux's clients encompassed diplomatic and court circles, and during the 1920s and 1930s no social occasion was complete without a Molyneux outfit making an appearance. The epitome of simplicity, the clothes were constructed on the perennial ideals of perfection and taste. Molyneux initially intended to be an artist, and was diverted into the fashion world when he won a contest sponsored by the famous couturière Lucile, alias Lady Duff Gordon, who subsequently employed him as an illustrator. He travelled the world as her assistant, was conscripted into the army, became a captain and lost his sight in one eye.

Post-Second World War, Molyneux opened his own couture house in London, later opening branches in Cannes and Monte Carlo. In 1950 he was the first dress designer to be honoured with the title of Royal Designer for Industry. Molyneux retired to Jamaica in 1950, but attempted a comeback during the 1960s. Unfortunately, fashion had moved on. His impeccable taste had been elbowed out of the way by outlandish visions of the future. The house of Molyneux, which Balmain described as 'a temple of subdued elegance', could not be resurrected.

MONTANA, Claude

BORN: PARIS, FRANCE, 1949

Noted for his huge shoulder pads, exaggerated proportions and fetishistic tendencies, Claude Montana has survived since the 1960s on a diet of leather and aggressive silhouettes. He has a hard-core client base and his hero, curiously, is Cristobal Balenciaga.

Montana became most famous during the 1980s when his outlandish silhouettes – enormous shoulder spans and tiny waists – perfectly captured the more extreme elements of

power-dressing. Later in the decade he experimented with angular silhouettes which did not involve any extraneous padding.

In January 1989 Montana unveiled his first couture collection for Lanvin, telling the *International Herald Tribune*, 'For this collection I feel the need to return to my roots. Things are very pure, structured, aggressive. It is time for that again.' Three years later, with reputed losses of $25 million, Montana was out on his ear. 'We do not wish to continue with Montana for haute couture,' Lanvin's president stated in the *International Herald Tribune*, 'we will definitely not renew our contract with him.' Montana, however, survived, almost immediately launching a lower-priced range called Odyssée, and putting his fashion spat down to experience. 'I brought Montana to them; I brought myself there, all my art, and soul and everything,' he told *W* magazine in his defence. 'It was me. Nobody asked me to be anything but that.'

MORTON, Digby

BORN: DUBLIN, IRELAND, 1906
DIED: LONDON, ENGLAND, 1983

'Digby Morton is an Irishman who saw and exploited the beauty of Irish tweeds. He turned them from shy, shapeless garments into immaculately racy, tailored suits,' said *Vogue* in 1946. Morton began designing in 1928, after leaving the Dublin Metropolitan School of Art because he felt that 'it really would take too long to become an architect'.

He moved to London and by 1936 was heading his own company. Morton was one of the most prominent designers of the war years, involved in the design of the government utility collection, and expressing his hobbies as war-time innovation and the preparation of highly seasoned casseroles. He shaped Lachasse into a house with a formidable reputation, and left in 1933 to form his own couture house. His skill with tweed was legendary, as was his ability to tailor. Morton was instrumental in encouraging Scottish weavers to switch from neutral tones to pastels. With an intense dislike of vivid colours, he preferred black, half-tones and pastels, and cited the beauty of Irish tweed as the main reason he switched careers.

OPPOSITE **A 'striking cape-costume' of 1922 by Edward Molyneux: a silk jersey machine-embroidered dress, with a cape held in place by silver plaques.**

RIGHT **'Svelte and structured', the exaggerated proportions of Claude Montana's angelic gown, 1985, is a typical example of the designer's love of powerful clothes with big shoulders.**

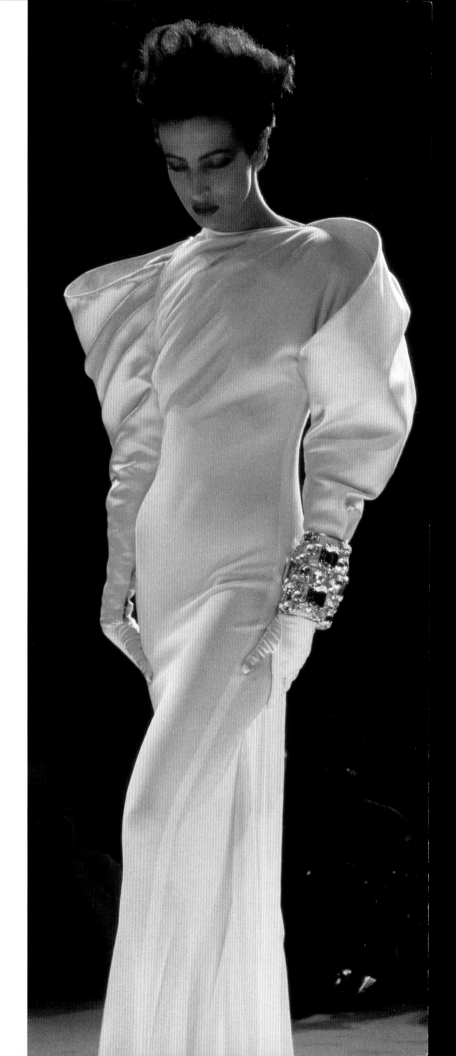

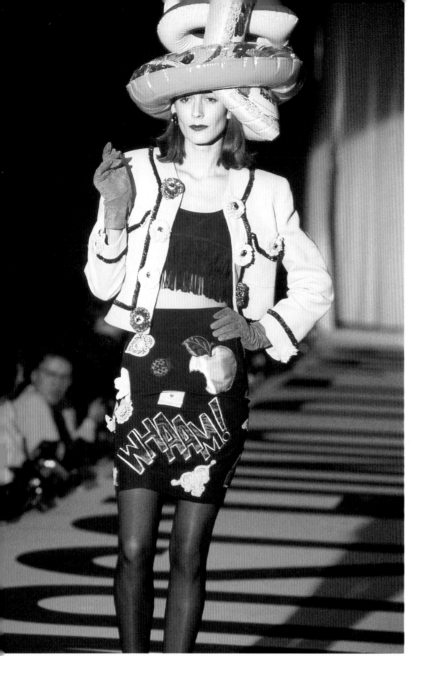

LEFT **Moschino 'breaking the rules' in 1988: colourful, crazy, and deliciously over the top – a skirt that says 'Whaam!' and rubber rings on the head.**

OPPOSITE **'Red's hot' in August 1995: Thierry Mugler's curvy, spiky suit with powerful shoulders, sweeping scarves, clever seaming and scorching colour.**

naturally enough, was René Magritte. A typical Moschino statement was to send models down the catwalk wearing carrier bags. In 1993 he staged an exhibition celebrating ten years of fashion called, 'Moschino: X Years of Kaos!'. His favourite ploy was appliqué with a play on words: a jacket with 'Waist of Money' written across it, 'Fashion is Full of Chic' or 'Ready to Where?' Moshino signed his last collection for autumn/winter 1994, which included a waistcoat with the words 'LESS IS MORE' emblazoned across it in black and red. As he described himself, 'Moschino, the Revolutionary, the Prankster, the Provocateur, as always.'

MUGLER, Thierry

BORN: STRASBOURG, FRANCE, 1948

With the original intention of being a ballet dancer, Thierry Mugler leapt through the 1970s and 1980s on a wave of exaggeration, quickly establishing himself as a designer who, whether you love or loathe his work, cannot be ignored. Mugler's inspiration comes from his interpretation of the ultimate femme fatale: Hollywood starlets, vamps, vixens. The woman who would cross the line between divine vision and drag queen. His ideal is Jerry Hall.

Mugler decided to swap a life at the *barre* for a liaison with a pincushion. He discontinued his plans to be a dancer with the Rhine Ballet – 'I couldn't stand to dance the *Swan Lake* one more time,' he told the *Guardian* – and travelled to Paris, working as a window-dresser. After spells living in London and Amsterdam, he returned to Paris and launched his own line in 1974. Throughout the 1970s, 1980s and 1990s, Mugler has kept resolutely to his own course: dispensing a seasonal mix of fetishism, glamour and sexiness, safe in the knowledge that the majority of the world's population would put cleavage over practicality every time.

In 1998 Mugler, who had been taking photographs since 1978, shot a series called 'Sex Couture' for the forty-fifth anniversary issue of *Playboy* magazine. Invariably branded a feminist's nightmare, misogynist fascist and insult to women, Mugler remains completely non-plussed by the criticism. His fragrance, Angel, launched in the mid-1990s, is a bestseller; his clothes sell in droves; his collections always cause a stir. He knows that whichever way the wind blows, the phrase 'sex sells' is a truism for all eternity.

MOSCHINO, Franco

BORN: ABBIATEGRASSO, ITALY, 1950
DIED: BRIANZA, ITALY, 1994

A fine artist who fell into fashion by accident, Franco Moschino was the self-styled court jester who sported a crew cut and cocked a snook at convention. His speciality was making a fortune out of irony – he called his labels COUTURE! and CHEAP & CHIC. His belts and bags with 'MOSCHINO' written on them were bestsellers.

Moschino started out as a freelance illustrator, working for, among others, Gianni Versace. In 1969 he progressed to design via an Italian company called Cadette, and launched his own company in 1983. A surrealist at heart, Moschino had more in common with Elsa Schiaparelli than any other designer and his favourite artist,

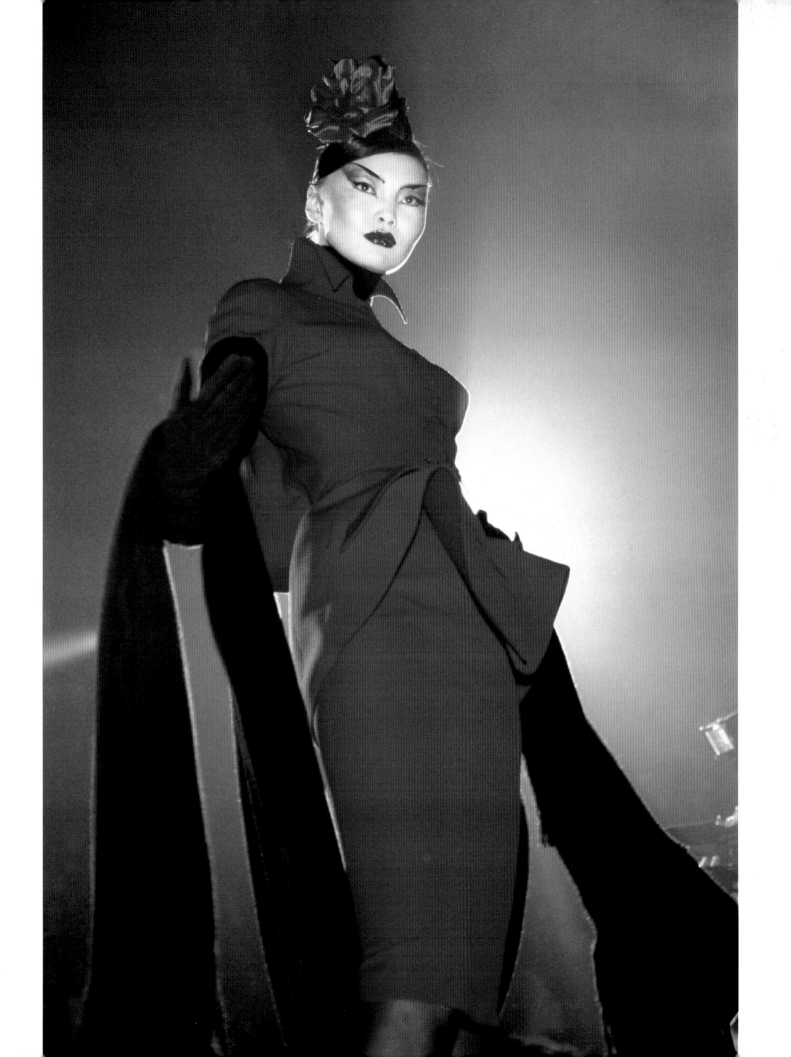

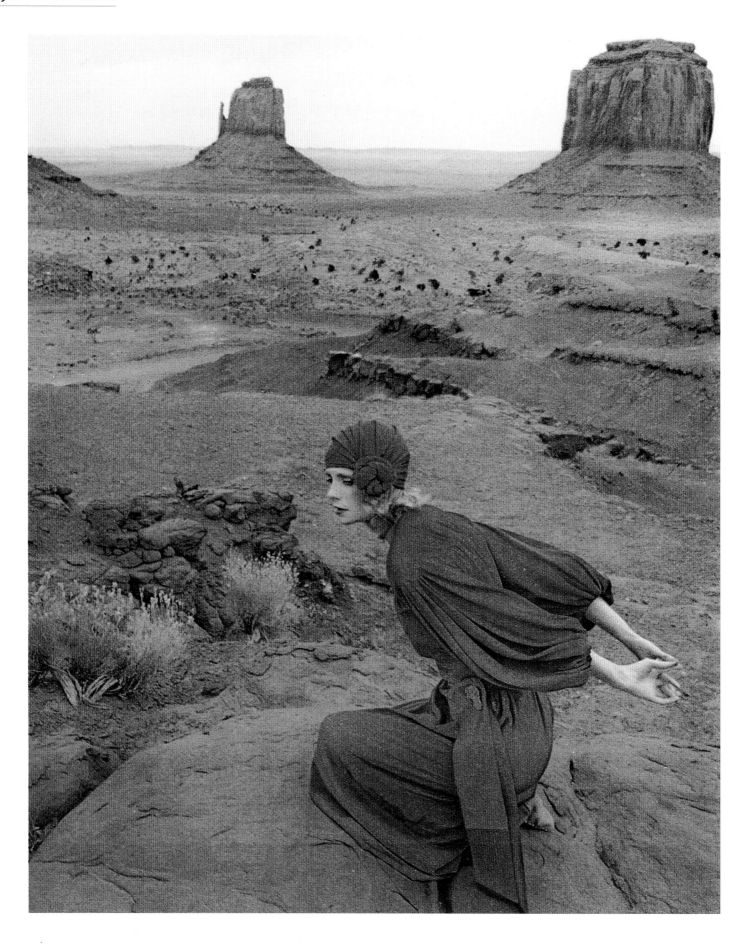

MUIR, Jean

BORN: LONDON, ENGLAND, 1928
DIED: LONDON, ENGLAND, 1995

Jean Muir, the doyenne of dressmaking, had the hands of a craftswoman, the mind of an engineer and the sensibility of a Scot. A romantic expressionist with a rod of steel running through, Muir detested the word 'fashion'. 'Don't call me a fashion designer – a self-important, pretentious term,' she told *Vogue* in 1978. 'Just do it importantly.' A perfectionist without compare, in a world of plummeting standards and disintegrating loyalty, Muir was revered by her contemporaries and respected by her rivals. She was one of the few British designers to survive the 1960s.

Muir began her career at Liberty, which she described as her spiritual home and the art school she never attended. She spent six years as a designer at Jaeger, before designing under the Jane & Jane label. By the early 1960s, when others were transfixed by youth, Muir had formulated her vision – the look that made her famous – jersey, leather and suede worked into fluid shapes and perfect proportions.

During her illustrious career, Jean Muir accumulated a string of academic, industrial and international awards: Doctor of Literature at Newcastle University; a CBE in 1984; an Honorary Citizen of the City of New Orleans in 1973; Neiman Marcus awards; the Hommage de la Mode by the Fédération Française du Prêt à Porter Feminine in 1985; Master of the Faculty of Royal Designers for Industry in 1994. In France they simply called her 'la Reine de la robe'. Muir's customers included the cream of the artistic and theatrical worlds – Bridget Riley, Elizabeth Fink, Dame Maggie Smith, Barbra Streisand, and the most famous ex-house model, Joanna Lumley. Geraldine Stutz, ex-president of New York department store, Henri Bendel, described her clothes as 'worth swimming the Channel for'.

Muir was a puritan, an enthusiast, and an original who was always associated with navy blue but whose colour sense was pure celtic. She could hold her own in politics, art, business and design; her favourite subject was the resurgence of the artist-craftsman, a renaissance she nurtured and predicted a decade before it occured. A human whirlwind, with succinct expressions and a wonderful sense of the ridiculous, Muir was a brilliant one-off. 'She should, *of course*, have been made a Dame,' said the ex-editor of British *Vogue*, Beatrix Miller, in Muir's obituary of 1995, echoing the sentiments of admirers everywhere.

OPPOSITE **Muir's signature jersey. Caught in a breeze in 1971, it blends into the landscape at Monument Valley, Arizona, USA.**

RIGHT **Sleek tailoring with seams precisely positioned for maximum fit and flare effect: Muir's perfect suit, 1986.**

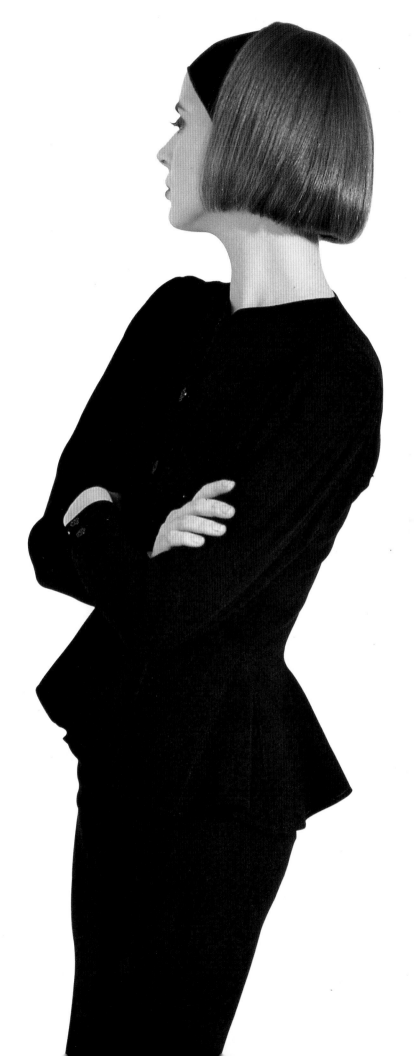

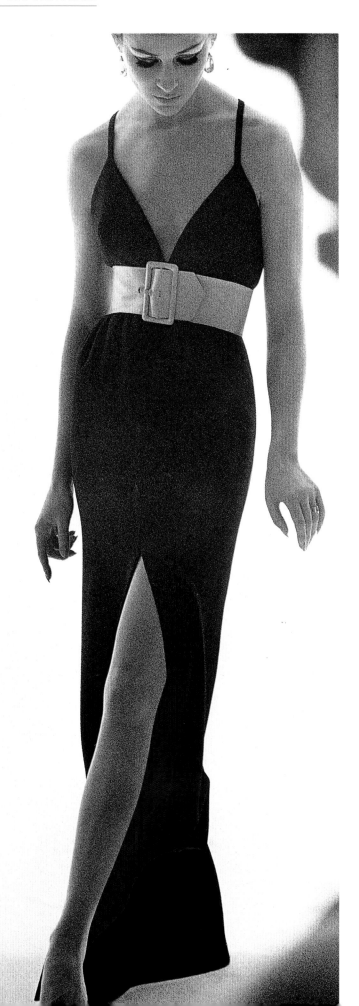

NORELL, Norman

BORN: NOBLESVILLE, INDIANA, USA, 1900
DIED: NEW YORK, NEW YORK, USA, 1972

Called the 'dramatist of New York designers' in his heyday, Norman Norell was the legendary minimalist of American design. Isaac Mizrahi, an ardent admirer, described his design in *Vogue* as 'so egoless, simply the most glamorous clothes said in the fewest words'.

Norell was a sickly child. His mother was the fashion plate in his native Noblesville, which had a population of 5,000. The Norell family moved to Indianapolis when he was 5 years old. On leaving high school he enlisted with the military, and at 19 he enrolled at Parson's School of Design in New York. He left on a whim to open a batik shop, before returning to study fashion at New York's Pratt Institute, where he was awarded first prize in a blouse competition, winning $100 in the process.

Norell left the Pratt Institute believing that costume design was his destiny, and through a connection in the film industry worked with Valentino, Gloria Swanson and Greenwich Village Follies. This last position led to jobs with Brooks Costume Company, Charles Armour and in 1928, Hattie Carnegie, where he remained for 13 years, travelling with her to Europe, where he was exposed to the best designs of the day.

In 1941 he founded Triana-Norell with clothing manufacturer Anthony Triana. From the very first collection under the new label, Norell established himself as a major new talent. His logical mind led to the creation of fur trousers, cut to a shorter, more manageable length, and jersey shifts. He also pioneered the wearing of black and white when American women were wearing a uniform of florals.

Over the years Norell continued to set numerous trends that have become part of our fashion vocabulary today. He was the first to show long evening skirts topped with sweaters; he revived the chemise and perfected jumpers and pantsuits. In the tradition of American design, Norell had conviction, a sublime understanding of understatement and a talent for originality without alienation. He detested superfluous detail unless, as he commented at the time, 'it has a darn good reason'.

LEFT **The ultimate American classicist: Norman Norell's 'deep new, deep slit' dress of 1967, with very low front. The long skirt reveals a length of leg.**

NUTTER, Tommy

BORN: LONDON, ENGLAND, 1943
DIED: LONDON, ENGLAND, 1992

Tommy Nutter spearheaded the radical shake-up of London's
sleepy Savile Row in the 1960s, taking traditional clothes and
turning them into fashion statements; he dressed every mover
and shaker on the circuit.

Nutter's introduction into the fashion world was unconventional
to say the least. He studied plumbing at Willesden Technical College
and originally worked in the building trade before taking a tailoring
apprenticeship at Donaldson, Williams & Ward in Burlington Arcade,
London. In 1968 Tommy Nutter positioned himself in Savile Row,
dressing the hip aristocracy – John Lennon and Yoko Ono, Mick
and Bianca Jagger – as well as the traditionalists – Hardy Amies
and the Earl of Snowdon.

Nutter was an expert self-publicist, dispensing off-the-cuff
comments on the correct buttoning, the minutiae of English fabric
and how he had single-handedly shaken up Savile Row. He
ventured into ready to wear in 1978 under the Austin Reed label.
Examples of his suiting are housed in Bath Museum of Costume
in England and Los Angeles Museum of Art in the USA.

OLDFIELD, Bruce

BORN: LONDON, ENGLAND, 1950

The most famous Barnado's boy in the world, Bruce Oldfield was
brought up by a Miss Masters in Durham, England, until the age
of 13. At 7 years old, his case history read, 'Violet Masters firmly
believes this boy will become a fashion designer.'

Oldfield fulfilled his foster mother's prediction. He fought his
way into Central Saint Martins College of Art and Design in London,
and established his own company. His first *Vogue* cover appeared
in the 1970s, featuring a couple intertwined with a pair of Manolo
Blahnik shoes. Oldfield's style is sexy and feminine. He has
dressed many celebrities, including Charlotte Rampling, Catherine
Zeta Jones and Jemima Goldsmith at her wedding to Imran Khan in
1995, but his most famous client was Diana, Princess of Wales, for
whom he made many frocks including a turquoise and silver ruffled
evening dress, which she wore on her Australian tour of 1983.

Awarded an OBE in 1990, Oldfield has survived the vagaries of
taste through a combination of skill, charm and steely determination.
'I have been in and out of fashion more times than I remember,' he
said after 20 years in business. 'Fashion and clients are fickle.'

ABOVE **Oldfield's ivory-silk dupion
sleeveless top, with an ivory and
burnt sienna full skirt, 1996.**

OLDHAM, Todd

BORN: CORPUS CHRISTI, TEXAS, USA, 1961

Todd Oldham is the innovative man behind America's most outlandish label – a designer who started his career in fashion doing alterations in a Dallas department store, before moving to New York in 1988 where he started his Times 7 line. He has collaborated with artists Kenny Scharf and Ruben Toledo, and is best known for his use of colour and erratic prints.

Oldham takes simple shapes and adds unconventional touches. He is expert at surface decoration: sequins, trompe l'oeil and unusual buttons, which metamorphose into animated dresses. He is vehemently anti-fur – his conviction extends to appearing naked in advertisements to underline his case. In 1991, at the age of 30, Oldham received the CFDA Perry Ellis Award for New Fashion Talent.

ORRY-KELLY

BORN: SYDNEY, AUSTRALIA, 1898
DIED: USA, 1964

Orry-Kelly is responsible for the wonderful opening scene of *The Gold Diggers of 1933*. when a host of Hollywood lovelies run riot across the screen singing, 'We're in the Money', and wearing costumes constructed from coins. His Oscar-winning work includes his costume for *Les Girls* (1957) and the Marilyn Monroe classic, *Some Like It Hot* (1959).

Born Walter Orry Kelly (the film studio dropped the Walter and added a hyphen), he migrated from Australia to America in 1923 with the intention of becoming an actor. He began a career in costume design via illustrating titles for silent movies and a friendship with Cary Grant, eventually becoming a designer at Warner Brothers. He stayed there from 1923–43, during which time he designed for Bette Davis in *Jezebel* (1938) and *The Little Foxes* (1941). He also designed the cream satin wedding dress she wore in *The Old Maid* (1939) and costumed the Humphrey Bogart classic *Casablanca* (1942). In 1943 Orry-Kelly moved to Twentieth-century Fox, then Universal Studios, and finally MGM.

RIGHT **'Newest arrival in the strong tradition of architect-turned-dress designer': Turkish-born Rifat Ozbek's frilled shirt, capri pants and sock hat, 1986.**

OZBEK, Rifat

BORN: ISTANBUL, TURKEY, 1953

Rifat Ozbek travelled from Istanbul to Liverpool to study architecture and then switched to fashion at Central Saint Martins College of Art and Design in London. His first job was at Monsoon and he later established his own company. Ozbek's clever use of Moroccan colour and embroidery – often accessorized with a fez – prompted *Vogue*'s Grace Coddington to comment in 1986: 'At the moment dance is in the air and so is Rifat. He's done a collection where the ballet theme goes right through – but it's not exaggerated, it's immensely wearable *and* fun.' *Women's Wear Daily* was equally effusive, calling his collection 'a healthy dose of the unexpected'. In 1987 Ozbek launched the Future Ozbek diffusion line, and in 1990 he presented a pure white collection and made a video in conjunction with film director John Maybury. Quiet, low-key and rarely seen on the fashion circuit, Ozbek showed his sense of humour when he parodied ex-*Vogue* editor Diana Vreeland in *Tatler*, with a necklace made from spanners from photographer David Bailey's tool box. The fashion directive was: 'Think Sink!'

PAQUIN

FOUNDED BY JEANNE BECKERS AND ISIDORE JACOBS IN 1891

When it was founded, the house of Paquin was situated in modest quarters at 3 rue de la Paix in Paris, but soon occupied the whole building. Jeanne Beckers learnt her craft working for Maggy Rouff, and Isidore Jacobs acquired his business skills on the Bourse (the couple became known as Monsieur and Madame Paquin). By 1915 the export trade had been sufficiently explored to enable Paquin to open in London, Madrid, Buenos Aires and New York. Beckers was the company's best advertisement – tall and beautiful, *Vogue* described her as 'a mother-of-pearl woman. She has the will of a man and is a genius in business organisation.' Her personal fortune was estimated at four million francs. She appeared regularly at Longchamp and Chantilly, averting all eyes from the horses and keeping the copyists in jobs. Unsure of which direction the house should take, she turned to Paul Iribe and Léon Bakst, but their contribution was not a success. Rated by *Vogue* as 'definitely in the first rank of the Grandes Maisons', Paquin was internationally known for its dexterity in mixing evening fabrics with fur – such as wraps in matt-white crepe, edged with sable.

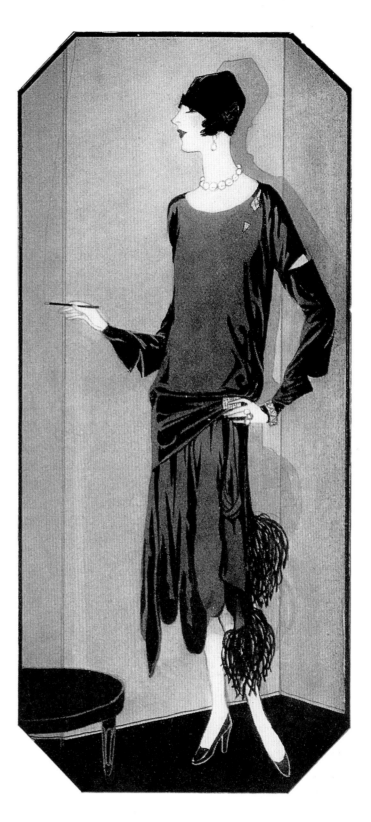

ABOVE **Paquin's crepe georgette dress with a bloused bodice, snug girdle and wrinkled sleeves, 1925: 'very much of the present moment, full of interesting points'.**

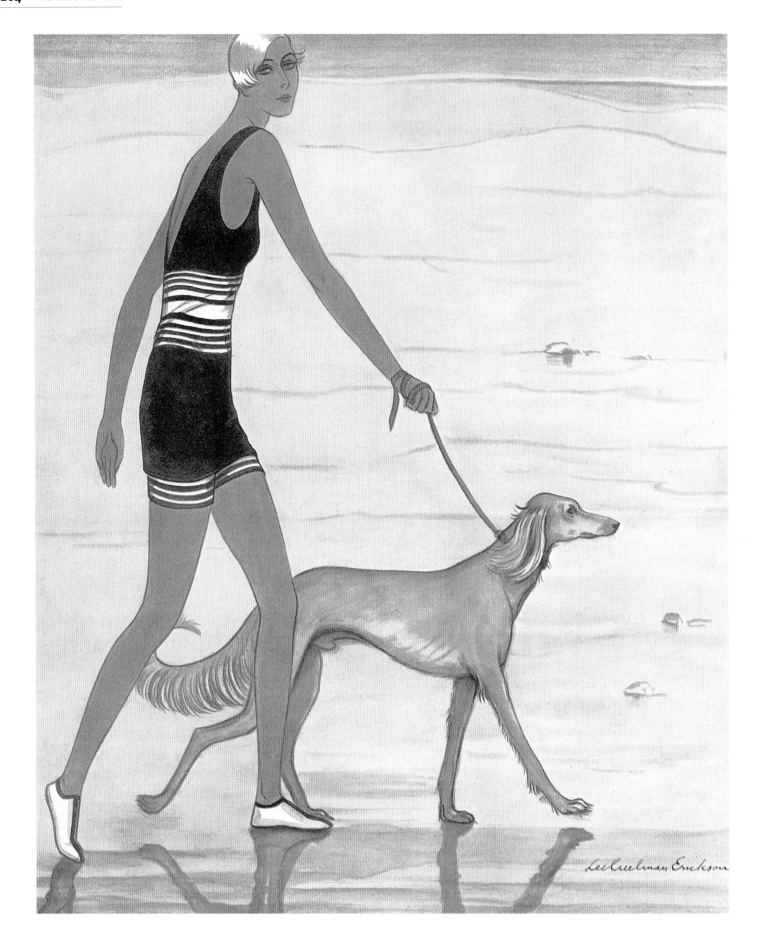

PATOU, Jean

BORN: NORMANDY, FRANCE, 1880
DIED: PARIS, FRANCE, 1936

Jean Patou established his business during the First World War and opened his salon on the rue Saint Florentin just after Armistice Day. His shows were one of the social high points of Paris in the early 1930s, where the audience was a blend of 'buyers and silk manufacturers, diplomats, artists and smart ladies, presenting a company as amusing as any first night of a new play'. In 1932 Patou dropped the waistline and revived the classic Moyen-Âge silhouette. The result was assessed as 'dreams of beauty', with Vogue reiterating: 'Patou states that it was not as a couturier, but as a man that he designs his costumes.'

By 1950 the house had branches in Monte Carlo, Deauville and Venice, and was directed by Patou's sister and her husband, Madame and Monsieur Barbas. 'The house still caters to a distinguished Old World clientele, and is still outstanding for its fine workmanship and hand details,' said Vogue in 1950.

PEARCE FIONDA

FOUNDED BY REN PEARCE AND ANDREW FIONDA IN 1994

Two fashion graduates from Nottingham Trent University, who joined forces after completing their respective MAs, Ren Pearce and Andrew Fionda describe their style as 'very modern eveningwear, mixed with tailoring. We always balance it within the collection.' Pearce had previously worked with John Galliano and Roland Klein, Fionda with high street giants Marks and Spencer and Alexon. Together they make clothes which have caught the imagination of Nicole Kidman and Iman. Winners of major awards such as New Generation and Glamour from the British Fashion Council, and the World Young Designer's Award in Turkey, they told Vogue in 1998: 'We're not interested in tricksy street fashion. We want to offer women sophisticated, grown-up clothes.'

PERTEGAZ, Manuel

BORN: ARAGON, SPAIN, 1918

A Spanish designer of elegant, refined eveningwear, Manuel Pertegaz is known for his simplistic approach and lack of ostentation. Pertegaz became a tailor's apprentice and opened his own salon in Barcelona in 1942. He became world famous, as well as a household name in his native Spain, for his dexterity in both the couture and ready-to-wear markets. He was a couturier in the Cristobal Balenciaga tradition – if flounces were used, they had a subtlety which combined Spanish flair with Parisian control. His tailoring was understated and easy – curved to give the illusion of fit. Pertegaz was one of the first Spanish designers to be featured in Vogue in the early 1950s – the 'newest of the European fashion groups to make their influence felt on an international scale' – and often talked about in the same sentence as Emilio Pucci.

PERUGIA, André

BORN: NICE, FRANCE, 1893
DIED: CANNES, FRANCE, 1977

An original master craftsman, André Perugia is the shoemaker most admired by his modern-day equivalent, Manolo Blahnik. The son of a shoemaker, Perugia excelled in the absolute precise proportions of couture footwear. The inward curve of the heel perfectly echoed the position of the straps; corkscrew heels created a balance between fantasy and comfort. Of Italian and French parentage, Perugia opened his own shop in Nice when he was 16 years old. He was commissioned to provide shoes for Paul Poiret and Elsa Schiaparelli, and later for the collections of Hubert de Givenchy and Jacques Fath. He also shod Hollywood stars and aristocrats. His surrealist tendencies – outlandish designs that were still wearable – ran parallel to his more understated shoes. Thanks to his solid grounding as a craftsman, Perugia was able to produce fantastical creations which did not cause undue discomfort.

PIGUET, Robert

BORN: YVERDON, SWITZERLAND, 1901
DIED: LAUSANNE, SWITZERLAND, 1953

Heralded by Vogue as 'master of the little wool dress', Robert Piguet was a pupil of Paul Poiret's and an employee of John Redfern's before he branched out on his own prior to the Second World War. Piguet – who had Poiret's colour sense, but a less ornate approach – designed for chic Parisians who wore dresses with matching jackets, crisp coats and romantic evening gowns.

OPPOSITE **Walking the dog in Deauville, 1927, in Patou's two-piece bathing suit 'cut down very much at the back for sunbathing'.**

PINET, François

Born: Château-le-Vaillère, France, 1817
Died: France, 1897

Trained in the complex art of shoemaking by his father, François Pinet arrived in Paris and quickly became known as shoemaker to the chic. In 1861 he won the Nantes Prize and in 1863 he opened an establishment on the rue Paradis Poissonnière. Pinet developed his own style of heel – an elegant, slimline version of the norm that was christened, naturally enough, the Pinet heel.

PLUNKETT, Walter

Born: Oakland, California, USA, 1902
Died: 1982

Most famous for his costumes for Vivien Leigh as Scarlett O'Hara in the cinematic classic *Gone with the Wind* (1939), Walter Plunkett was a specialist in historical costume. He reduced Leigh's waist from 23 inches to 18 inches, tactfully saying: 'We know how to give the illusion of a small waist in the pictures – that's all part of costuming.'
 Plunkett learnt his craft on the vaudeville circuit; he went to Hollywood in 1925 and danced in Erich von Stroheim's *The Merry Widow*. He was eventually appointed within the costume design department of FBO (later RKO), designing costumes for the early Fred Astaire and Ginger Rogers musicals, including *The Gay Divorcee* (1934). Plunkett left RKO in 1934 to pursue a freelance career, costuming Katharine Hepburn in *Mary of Scotland* (1936). He later joined MGM, where his two most famous productions were *Singin' In The Rain* (1952) and *Seven Brides for Seven Brothers* (1954). In 1951 he won an Oscar for his work on *An American in Paris* (1951).

POIRET, Paul

Born: Paris, France, 1879
Died: Paris, France, 1947

Paul Poiret was the twentieth century's most dazzling *enfant terrible*. An incurable Orientalist, he brought opulence, a new silhouette and a sense of elegance which has never been equalled. His vision shaped

LEFT Poiret's suit 'for a tailleur with an air'. Overlapping pointed coat, cire collar and starched ruff running down the front, 1922.

Poiret was instrumental in stabilizing the Parisian fashion industry. It was his idea to form the Syndicat de Défense de la Grande Couture Française, of which he became president. It was also he who made the unprecedented move to exhibit Parisian collections – both his and those of his contemporaries – in the USA. Poiret was the first designer to understand the value of public relations, personally presenting collections in London. He was also a keen driver and collaborated with Renault cars in advertisements.

Poiret travelled to Russia and the Far East in search of original fabrics. He adored Chinese art, spoke several languages and delivered lectures in English. He could play the piano and the violin; he also painted portraits and wrote poetry. When the First World War broke out, Poiret, then in his late thirties, was among the first reservists called to serve in the French infantry. His house

Late September

PAVL POIRET
WILL
PERSONALLY PRESENT
HIS
WINTER CREATIONS
ON
THVRSDAY OCTOBER 2ND
AT 3. P.M.
AT
YVONNE CHASTEL LIMITED
7 ALBEMARLE ST. W. I.
TELEPHONE GERRARD 7560
ADMISSION BY TICKET ONLY
OBTAINABLE IN ADVANCE

the way we dress now. By his own admission he 'freed the bust but shackled the legs'. A former pupil of Charles Worth and Jacques Doucet, Poiret first attracted the attention of the press in 1903 when he staged a presentation in a shop in rue Auber, Paris, where, to an audience constricted by sinuous corsets and boned necklines, he showed dresses decorated with autumn leaves and Oriental embroideries.

In 1905 Poiret married Denise Boulet – a natural beauty from Normandy and an advocate of aesthetic dress. Breaking the mould of conventional couture, he positioned his salon in the quartier de l'Opéra on l'avenue d'Antin and rue du Faubourg-Saint-Honoré. The house was elegant inside and out, with a lawn patterned in the manner of André Le Nôtre (who designed the gardens at Versailles), a gravelled drive and a uniformed Swiss guard. The salons were spread with lush red carpets and tricolour silks; the models – gorgeous figurines in Poiret's vision of Orientalism – filed silently through. 'All this combines to create a fearsome air of luxury in which the most prudent female minds lose the sense of economy and yield themselves to the sheer intoxication of elegance,' said *Vogue*, obviously seduced by his 1915 collection.

closed for the duration of the war and when it re-opened, the economic situation was radically different. This had a catastrophic effect on the designer, who lived for luxury. Poiret persevered – personally presenting his collection in London during the mid-1920s. However, he had to face the fact that his talent for beauty no longer applied to the new, more streamlined, look. Struggling to survive in a world which had moved on to plainer clothes and abbreviated lines, Poiret died penniless in 1947.

PORTER, Thea

BORN: JERUSALEM, ISRAEL, 1927

For Thea Porter read: bohemian, advocate of flower power and free-thinker. She made ethnic clothes for hippie sensibilities, with flowing lines, seductive colours and lavish surface textures. Part-hippie, part-dreamer, her ethereal clothes often combined cultural influences – a Nehru collar with a flounced sleeve – and reflected the bohemian tendencies of the time.

Porter spent her childhood in Damascus. She studied French and then art at London University. In 1967 she opened her own boutique, selling exotic textiles and, later, her own clothes. Porter concentrated on simple lines and exotic fabrics – panne velvet, brocade, crepe de Chine and chiffon. Her forte was the full-length evening dress or kaftan. In 1971 she collaborated with Hungarian fabric designer, Michael Szell to produce her 'romantic and ravishing evening dresses'. Later, she became both a dress and interior designer, working on a freelance basis.

RIGHT **Thea Porter's black fur coat, appliquéd with a mosaic of Beirut carpet embroidery, worn with ethnic bag and chunky embroidered boots, 1970.**

PRADA

FOUNDED BY MARIO PRADA IN 1913

It would be simplistic to say that Prada built its empire on a nylon bag, but during the 1990s the infamous black bag with its simple silver insignia became the fashion editor's favourite and a phenomenal money-spinner. Since then, Prada has concentrated more on clothes, and the look is in line with the company's design directive: discreet labels and refined tailoring. Young enough for the twentysomethings and sufficiently non-threatening to the over-thirties, Prada has a strong sense of self and is now headed by Miuccia Prada, the granddaughter of the founder, who has a PhD in political science and is a patron of the arts; she also has an astute marketing mind. Although it was founded as a leather goods company in 1913, Miuccia, who took over in the 1970s has helped make the Prada name known internationally: there are flagship stores in New York and London, and in 1992 the diffusion line, Miu Miu, was added to the Prada portfolio.

OPPOSITE **Technological fabrics given the Prada treatment in 1998: satin and latex top, waxed cotton pedal pushers and very high-heeled linen mules.**

PRICE, Antony

BORN: KEIGHLEY, ENGLAND, 1945

One of the first designers to bridge the gap between fashion and pop music, Antony Price was instrumental in directing and designing the look of seminal rock band Roxy Music in the 1970s. Brilliant at building characters, constructing stage sets and re-drawing uniforms, Price dressed Bryan Ferry as a dashing GI and a debonair gigolo. One of his tongue-in-cheek outfits was dubbed 'The Spanish Traffic Warden', and he also turned Jerry Hall into a mermaid wrapped around the rocks. 'I love putting together videos for Roxy,' he told Vogue in 1980. 'I can play Cecil B De Mille on a small scale. It's a bit of old Hollywood – all the glamour, the rocks, the posing.'

Price trained at Bradford School of Art, before moving on to study fashion at the Royal College of Art in London. He worked as a designer with Stirling Cooper, then Plaza, and opened his own shop in London's King's Road in 1980. The stark new outlet was simply designed and lit with soft shades of violet.

Price's customers have always been rock stars, the wives of rock stars, and wannabees. His structured dresses are designed to make an impact, and he doesn't know the meaning of the phrase 'dressing down'. Dubbed 'The Leader of the Glam' by Vogue in 1990, and once rumoured to be in line for a position at Versace, Price told The Sunday Times in 1998: 'God comes in the shape of an Italian factory and if he doesn't you're f****d.'

RIGHT **Famed for his 'result wear', Antony Price's gold dress of 1980 has curvy lines, vampish tendencies, and a touch of Hollywood.**

PUCCI, Marchese Emilio

BORN: NAPLES, ITALY, 1914
DIED: FLORENCE, ITALY, 1992

Worn by Marilyn Monroe and a variety of other twentieth-century sex bombs, Pucci has metamorphosed from Italian print to cult pattern in the latter part of the century and is collected and coveted by supermodels and fashion cognoscenti. At the core of the Pucci look is its distinctive colour and bold, swirling patterns. Vogue christened the designer 'Pucci, the print maestro'.

Educated in Milan and Florence in Italy and Georgia and Oregon in the USA, Emilio Pucci served as a pilot in the Italian air force during the Second World War and had a long-term interest in politics, serving two terms in the Italian Chamber of Deputies in the 1950s. He entered the world of fashion after being photographed on the ski slopes by Toni Frissell of Harper's Bazaar, wearing ski pants of his own design. On the strength of the interest these attracted, the magazine asked him to creating some winter clothes for women, which were subsequently sold in stores in New York.

Pucci prints came to epitomize Italian colour and the post-war movement; they were perfect for the psychedelic 1950s. Pucci's greatest work was the shirt, which whirled on the body and was often bordered with graphic patterning. Later, came a range of accessories including scarves and silk handbags. Pucci's palazzo pyjamas were worn with jewelled sandals and described in 1964 as, 'Equally at home in the palazzo and at parties that end at dawn; they speak of an atmosphere that's rarefied – sun-tossed, and moonlit.'

During the 1990s, newly directed by Pucci's daughter Laudomia, the label enjoyed a renaissance with the famously vivid patterns appearing on Lycra leggings rather than silk shirts.

OPPOSITE **Marisa Berenson wears Emilio Pucci's stretch bikini and matching velvet robe, printed with opulent patterns and grandly clashing colours, 1968.**

QUANT, Mary

BORN: LONDON, ENGLAND, 1934

Widely credited with inventing the miniskirt, Mary Quant doesn't lay claim to designing what was already in the air. Much more importantly, she took the mini (then in its infancy) and marketed it – making it the most potent symbol of the 1960s.

Together with her husband, Alexander, who she met at London's Goldsmith's Art College, Quant opened her shop, Bazaar, in London in 1955; underneath it was her husband's restaurant. Quant had a cataclysmic effect on London, with her simple daisy motif, short skirts, mix of music and model, Twiggy. By 1963 she was famous enough to have made an impression on American *Vogue*, who called her an English adventurer in London: 'She looks like one of those wispy child heroines – leggy, skinny, with soup-bowl bangs, very

pale painted mouth, heavy black liner on upper and lower lashes,' the magazine wrote. Immediately after her first trip to the USA, Quant launched her Ginger Group – a less expensive line of mix-and-match coordinates, including knickerbockers and waistcoats, assessed by *Vogue* in 1963 as, 'a snowball of a wardrobe ... that will mix and match up endlessly'. In 1966 Quant had built up a multi-million pound business, written her autobiography *Quant by Quant*, and been awarded an OBE. In 1970 she gave birth to her son, Orlando, and had moved on from designing for adolescent proportions to designing interiors. Her internationally known name and logo, associated with youth and freshness, enabled her to change direction and encompass kitchenware, stationery and fabulous make-up.

By 1977 Quant had a holiday house in Nice, and had relocated to Surrey with her husband and son, and a Jaguar 'with a large dent'. Elected into the British Fashion Hall of Fame, the Quant name has transcended into fashion folklore.

RABANNE, Paco

BORN: SAN SEBASTIÁN, SPAIN, 1934

Called 'Wacko Paco', and an assortment of other names which basically mean 'lost the plot', Paco Rabanne was a designer of seriously radical dresses during the 1960s. It is only recently that he has metamorphosed into a blatant attention-seeker.

In 1939 Rabanne left Spain, eventually ending up in Brittany, France. He trained as an architect, switched to fashion and started making jewellery. Rabanne made a real impact on 1960s fashion, with his signature use of plastic discs inter-linked with wire, and love of sharp shapes. In 1966 he hit the headlines with his futuristic use of multicoloured plastic discs (with matching earrings), chain mail, and aluminium diamonds on eveningwear. He then progressed to moulded dresses and furniture. In between man landing on the moon and the millennium, however, he lost his way. Or rather he decided to re-write history and reinvent himself at the same time. Today, Rabanne talks little of fashion and clothes and more of astral travels, guardian angels and good vibrations. In 1999 he used his heavenly powers to predict that President Chirac would be assassinated, and that the last eclipse of the millennium would herald the destruction of Paris. Chirac, as we go to press, is still alive and kicking. Ditto: Paris.

He produced his final collection in July 1999, which featured a satellite dress, mirrors and other flying objects. He has also published two books, *Journey – From One Life to Another* (1997) and *Dawn of the Golden Age*; *A Spiritual Design for Living* (1999), both filled with celestial musings on all matters mystical.

RAYNE, Sir Edward

BORN: LONDON, ENGLAND, 1922
DIED: EAST SUSSEX, ENGLAND, 1992

Edward Rayne served a lengthy apprenticeship in the factory of his family's firm, H&M Rayne, learning all about the complexities of making shoes. In 1951, at the age of 29, Rayne became managing director of the business which had been founded by his grandparents in 1889. Under Rayne's direction the company – with three royal warrants – grew into an international concern, with licensing deals with American department stores Bonwit Teller and Bergdorf Goodman.

In 1960 Rayne was appointed chairman of the Incorporated Society of London Fashion Designers; later, when it became the British Fashion Council, he became its president for five years. Awarded a CVO in 1977 and knighted in 1988, Sir Edward was instrumental in putting British fashion back on course, and for generating international interest. Jean Muir called him, 'the best British shoemaker of his age'.

REBOUX, Caroline

BORN: c 1830
DIED: PARIS, FRANCE, 1927

A major player in the history of millinery, Caroline Reboux was credited simply with the name 'Reboux', which became synonymous with chic hats throughout the early part of this century. With an instinctive French flair for shape and form, Reboux collaborated with Madeleine Vionnet and had many high-profile clients.

REDFERN

FOUNDED BY JOHN REDFERN IN 1881

English tailor, John Redfern, established himself in Paris in 1881 with a salon on the rue de Rivoli. He was appointed dressmaker to Queen Victoria in 1888 and created the first women's uniform for the Red Cross in 1916. Redfern caused a furore by making eye-catching costumes for Jane Hading in the role of Madame de Pompadour: 'He is both conservative and very individual, and has always had a clientele who hate banality,' *Vogue* wrote in 1923.

Redfern's full-page advertisement of 1920 cited branches in London, Paris, Nice and Monte Carlo. 'Costumes for the races, Gowns for Henley, Gowns and cloaks for their Majesties Courts, millinery for all occasions, furs and lingerie,' read the copy. Redfern's customers included Sarah Bernhardt and Madame Pierat, with whom he collaborated at the Théâtre Français. His royal front row included the Queen of Romania (who committed the fashion faux pas of wearing a black Lanvin coat for the presentation of his autumn 1920 collection). What they saw was typically Redfern: long coats which nodded to the style of the last century, a suit called Grand Siècle and fur coats of mole, kolinsky and mink. *Vogue*'s headline read 'Redfern Opens Brilliantly'. The slightly historic collection harked back to the fifteenth and eighteenth centuries. Among Redfern's specialities were a short, fur-trimmed overcape, a camel-hair suit, brocade dresses and draped satin.

RHODES, Zandra

BORN: CHATHAM, ENGLAND, 1940

A self-confessed workaholic who has followed her own vision since the 1960s, Zandra Rhodes lives, eats, sleeps and breathes textiles. 'I've had six or seven original ideas in my life and that's all,' she admitted to *Vogue* in 1978. 'With me, it's fifteen per cent talent, and the rest is sloggin' your guts out.'

Rhodes, who believes 'showmanship *is* the business', has one of the strongest identities in the industry. She has brightly coloured hair, dramatic make-up and imaginative dresses which are indisputably her own design. Her signatures include zigzags, lipsticks, Art Deco motifs, stars and teardrops. Adored in America, Rhodes's clothes have been bought and worn by a variety of women, from Tina Chow to Vanessa Redgrave. Her royal contributions have included Princess Anne's engagement dress, and eveningwear for Diana, Princess of Wales. In December 1998 she made a pink-haired fairy for the royal Christmas tree.

OPPOSITE **Zandra Rhodes's perpendicular pleating, printed in her inimitable style, with bois-de-rose collar and hat by Graham Smith, 1975.**

Rhodes – eternally grateful that her parents put a 'Z' instead of an 'S' in her name – is the daughter of a lorry driver and an art teacher. She spent her childhood copying illustrations from Cicely Mary Barker's *Flower Fairy* books. Rhodes studied textile printing and lithography at Medway College and then at the Royal College of Art in London, which she left in 1964. By 1969 her designs were appearing in *Vogue*. In 1970 she dyed her hair green.

First and foremost Rhodes is a textile designer, creating handscreened fabrics such as chiffon, tulle and silk; she has always designed her clothes around the pattern, never the other way around. Her portfolio of achievements is impressive: she has exhibited in Australia, Tokyo, Paris and Manchester; her clothes are housed in museums from Brighton to Chicago. She has lectured from Colorado to Kansas. Her most recent project is the building of a Fashion and Textile Museum in Bermondsey. In 1995 she received a Hall of Fame Award from the British Fashion Council; in 1996 she was given a Lifetime Achievement Award in California, and in 1997 a CBE – all richly-deserved accolades for the woman the *Los Angeles Times* once called, 'London's lovely fashion lunatic'.

RICCI, Nina

BORN: TURIN, ITALY, 1883
DIED: PARIS, FRANCE, 1970

A respected house, which opened in 1932, the Nina Ricci label has become synonymous with impeccable taste and French refinement. Born in Turin, Ricci relocated to France as an adolescent and from the age of 13 undertook a traditional apprenticeship with a couturier, learning the intricacies of making couture garments. Supported by her husband, a jeweller, she opened her house at a time when Elsa Schiaparelli and Coco Chanel were grabbing the headlines and surrealism was the word on everyone's lips. Admired for her technical skills and high standards, Ricci specialized in the complete look, rather than individual experiments or ground-breaking statements, and the elegant, graceful clothes that her house produced became popular with sophisticated women. The house has survived by keeping to its original brief and not deviating from the principles of its founder.

ABOVE **Pre-war tailoring in the best tradition by Maggy Rouff, 1940. Perennial Oxford grey flannel redingote – classic and perfect.**

ROCHA, John

BORN: HONG KONG, 1953

A designer of Chinese and Portuguese parentage, John Rocha worked as a psychiatric nurse before moving to London in 1970 to study fashion at Croydon College of Design and Technology. He used Irish linen in his graduation collection and this prompted him to visit Dublin, where he opened a boutique for which he designed tailored linen suits. He has lived in Dublin for the past 20 years with his wife and business partner, Odette.

The Rocha look – which soon attracted international attention and led to him showing in Paris in 1994 – is plain, simple and covetable. It cleverly combines Oriental thinking with Irish craft. In addition to his fluid tailoring and work with linen, Rocha is also known for his use of rich, hand-painted fabrics, crocheted knitwear and sheer eveningwear. Rocha has worked in conjunction with Waterford Crystal, and produced complementary lines including John Rocha Jeans and John Rocha Home. He also collaborated on the concept and design of the Morrison hotel, which opened in the centre of Dublin in 1999.

RODRIGUEZ, Narciso

BORN: NEW JERSEY, USA, 1961

Narciso Rodriguez was catapulted out of obscurity and into the forefront of the media when, as a complete unknown, he was commissioned to design Carolyn Bessette's wedding gown for her marriage to John F Kennedy jnr in 1996. The result was a triumphant combination of satin-backed crepe and supremely understated, elegant design. The famous shot of the stunning new Mrs John Kennedy, with her handsome husband kissing her hand, kick-started days of press speculation about the designer of the most significant wedding dress of the decade.

Bessette and Rodriguez met while working together at Calvin Klein – Bessette as a publicist, Rodriguez as a design assistant. Their friendship extended beyond working hours and culminated in the commission of a lifetime.

Son of a Cuban longshoreman and brought up in an unsalubrious area of New Jersey, Rodriguez studied fashion at Parson's School of Design in New York. It was while he was working as design consultant at Cerruti in 1997 that he was offered the position of design director at Loewe. He accepted the job, and continued to produce his own line in conjunction with Alberta Ferretti's Italian manufacturing base.

ROUFF, Maggy

BORN: PARIS, FRANCE, 1896
DIED: PARIS, FRANCE, 1971

Maggy Rouff had a natural induction into the fashion world as both her parents were directors of the house of Drécoll and it was there that she learnt her trade. Rouff founded her own house in 1928, and gained a reputation for dazzling eveningwear, which she designed using fabrics normally associated with lingerie. She also designed lingerie, daywear and sportswear.

By 1950 the business was headed by Rouff's daughter, the Countess d'Arncourt. 'The house has a great feeling for the details and elaborately contrived evening dress, and has won great favour among Paris matrons,' commented *Vogue* in 1950. The house closed during the late 1960s.

RYKIEL, Sonia

BORN: PARIS, FRANCE, 1930

One of the major figures in French fashion circles, Sonia Rykiel is best known for her chic knitwear, Left-Bank look, and stark white complexion, accessorized by her flame-red hair.

Despite having no previous commercial experience, Rykiel began her career as a freelance designer for Laura Boutique, which was owned by her husband Sam Rykiel. Even though she had an untrained eye, Rykiel's clothes had both aesthetic appeal and commercial clout – and she consequently opened her first Parisian boutique in 1968. Firmly established by the 1970s, and specializing in knitwear – especially fluid, often figure-hugging sweaters in soft wools and jersey – Rykiel then added menswear, childrenswear, cosmetics and a household line to her repertoire.

Rykiel has been honoured both in her own country – by the French Ministry of Culture – and abroad. In addition to a retrospective in Paris, she has had retrospectives in Tokyo and Luxembourg. Her clothes sell internationally.

Known as the 'Queen of Knitwear' in her homeland, as well as a cultural icon and multi-talented designer who can turn her hand to creating hotel interiors, corporate uniforms and children's books with equal success, Rykiel has launched three fragrances, the most recent of which is contained in a bottle designed in the shape of a sweater.

In 1998 Rykiel celebrated 30 years of working in the fashion industry and held a show which encapsulated her highly successful look. She also received a tribute in French *Vogue*.

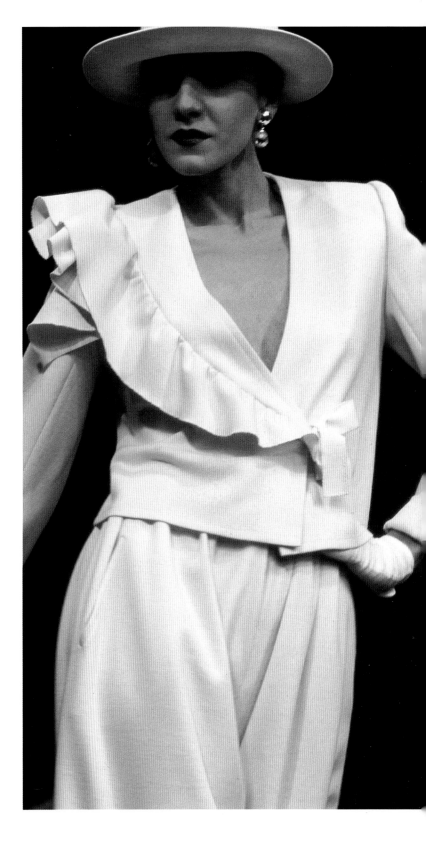

ABOVE **A name that means French chic: Sonia Rykiel. Soft wool wrap-over jacket with frilled collar and gathered skirt, 1983.**

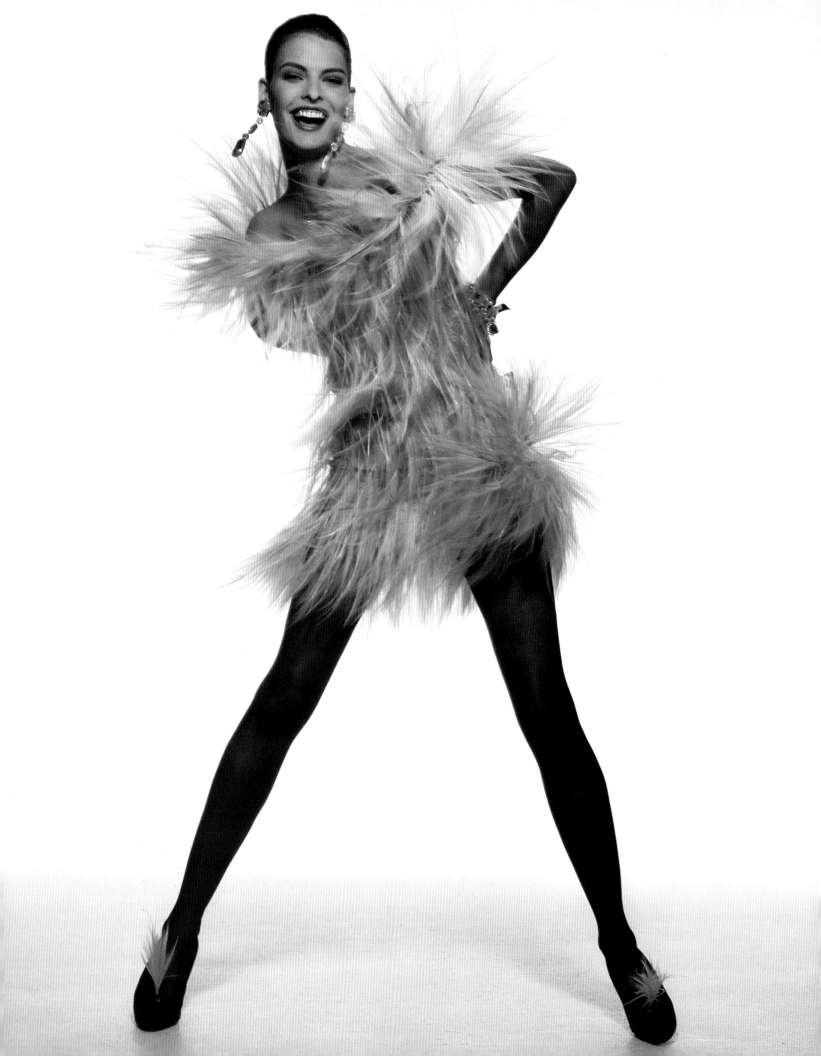

SAINT LAURENT, Yves

BORN: ORAN, ALGERIA, 1936

Yves Saint Laurent – tortured genius, prolific inventor and owner of the century's most notable initials – spent his childhood in the searing heat of Oran, making paper theatres and costumes for his sister's dolls and dreaming of living in Paris.

Known as 'The Saint' in fashion circles, Saint Laurent put his foot on the first rung of the ladder when he won a competition sponsored by the International Wool Secretariat in 1954, and was introduced to Christian Dior by *Vogue*'s Michel de Brunhoff. He was then hired by Dior to work alongside him as a design assistant. Two years later, after Dior's premature death, 21-year-old Saint Laurent was thrust into the limelight. More than a mere hemline issue, his first collection was a life or death situation. The verdict was unanimous: 'Saint Laurent has saved France.' That said, his collection for Dior was a radical departure from the refined femininity and curvaceous tailoring of its founder. Saint Laurent spiced it up, producing Trapeze lines and, in 1960, the Beat Look, which shocked his more conservative customers but thrilled the Left Bank. Saint Laurent was conscripted into the army in 1960 but discharged after two months due to ill health. In 1962 he founded his own house and by 1969 he was a walking contradiction: infatuated by fashion, but pulled into artistic pursuits. *Vogue* was heralding the YSL signature as 'the most sought after look of today', but Saint Laurent felt pulled apart: 'I wish I could break my fingers when I think of what my love for sewing and dressing has become. But it was always there,' he said.

Saint Laurent's temperament has always been more suited to creativity than to business. His fortuitous partnership with Pierre Bergé has allowed him to design without the financial stress, and business has been crucial to Saint Laurent's success. In addition, Bergé's direction enabled Saint Laurent to become one of the first fashion designers to successfully reinvent his look – from couture to ready to wear. His second line, a ready-to-wear line, Rive Gauche, was a triumph. In 1970 Saint Laurent shocked the world by posing nude in an advertising campaign.

On celebrating his thirtieth anniversary at the Opéra de la Bastille in Paris in 1992, Saint Laurent was joined by his friend, Catherine Deneuve, a long-standing customer. All his genius and inspiration was on display, including his homage to Léon Bakst's designs for the Ballet Russes, and to Piet Mondrian. There was also his masterly Le Smoking jacket, the feminized tuxedo, with just the right amount of angles and curves, and his beautiful vintage season jackets, immaculately embroidered with glittering vineyards by Lesage.

After over 30 years of creating immaculate clothes, Saint Laurent designs the couture, while Alber Elbaz, a protégé of Geoffrey Beene, directs the Rive Gauche line.

OPPOSITE **Yellow and smokily pale ostrich-feathered slip of flesh-coloured muslin, accessorized by barley sugar glass drop earrings, 1987.**

ABOVE **The unmistakable outline from Yves Saint Laurent's sketchbook of May 1986: polka-dot silk faille with silk crepe blouse and couture touches.**

SANDER, Jil

BORN: WESSELBUREN, GERMANY, 1943

Jil Sander's clothes need no explanation, have no age limit and do not require accessories. Clean, precise and to the point, her minimalist style is based on design without decoration, perfect proportions and fluid lines. Her collections have made her one of Germany's most prominent fashion designers and most successful businesswomen – her company carries an approximate price tag of $200 million.

It is telling that Sander studied textile design and was a fashion editor for American and German women's magazines, before becoming a freelance designer. Her combined skills in the making and marketing of clothes have culminated in one of the most successful labels of modern times. A believer in growing a label at a slow, steady pace, Sander opened her first

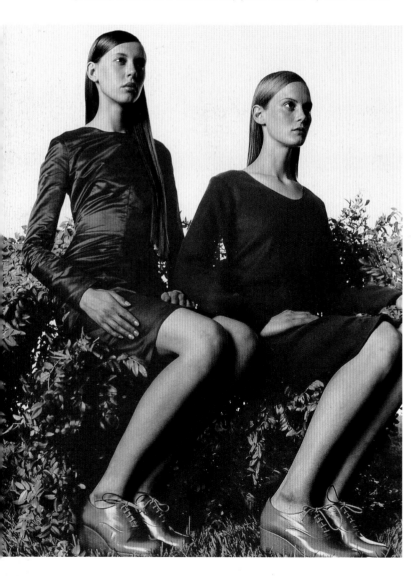

boutique in Hamburg in 1968. By 1975 she had launched her own label, and pre-empted Japanese designers by showing her work in Paris, soon achieving international popularity. Sander always talks about intelligence in conjunction with the clothes she designs, and has said categorically that her label is for 'women with brains'.

SANT'ANGELO, Giorgio di

BORN: FLORENCE, ITALY, 1936
DIED: NEW YORK, NEW YORK, USA, 1989

Giorgio di Sant'Angelo shot to fame in the 1960s, wavered during the 1970s and 1980s and made a resounding comeback in 1989. Sant'Angelo started out with fantastical ethnic dresses and ended up spearheading the Lycra revolution. 'I'm an artist who works in fashion, an engineer of colour and form,' he told *Vogue*. 'The minute a designer adds a zipper, it becomes junk.'

Sant'Angelo spent his childhood moving between Florence and Argentina. He studied architecture, dabbled in ceramics and also worked at Walt Disney for three weeks. Sant'Angelo moved to New York in the early 1960s, designing textiles before moving on to jewellery. Impressed by his talent, *Vogue*'s editor, Diana Vreeland, sent him into the Arizona desert with fabric, scissors, tape, and the model Verushka, and told him to invent clothes. The end result was featured over four double-page spreads.

Sant'Angelo won the Coty American Fashion Critics' Award in 1970. In and out of favour, his last collection was the perfect comeback. 'One cannot lose talent,' he told *Women's Wear Daily*. 'If one is good, he is good.'

SASSOON, Bellville

FOUNDED BY BELINDA BELLVILLE AND DAVID SASSOON IN 1958

The cumulative talents of Belinda Bellville and David Sassoon cornered the market in great British eveningwear. 'I've never gone over the top,' said Sassoon to *Vogue* in 1998, when he was celebrating 40 years in business. 'The customer comes

LEFT **Young, fresh, and produced for 'women with brains' – Jil Sander's silk satin dress, left, and wool cashmere dress, right, 1999.**

OPPOSITE **Javier Vallhonrat's 1990 shoot inspired by Rothko colours: Giorgio di Sant'Angelo's cobalt jersey bodysuit, indigo cloak and boots by Blahnik.**

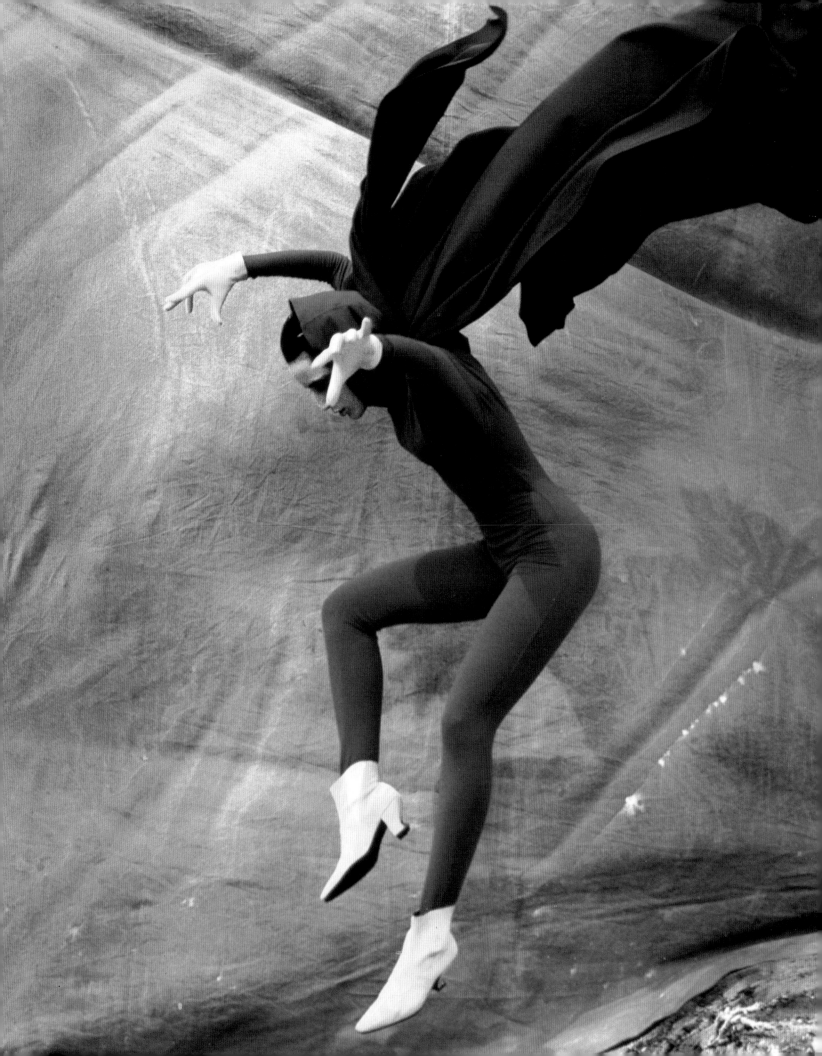

LEFT **Bianca Jagger dining out at Maxim's, 1977, in Scherrer's fur-trimmed, sequinned 'Snow White' extravaganza and rhinestone veil.**

SCAASI, Arnold

BORN: MONTREAL, QUEBEC, CANADA, 1931

Arnold Scaasi had an illustrious induction into the fashion world: he studied fashion in Montreal and Paris, worked with Jeanne Paquin and milliner Lilly Daché, and returned to New York in 1951 to work with the inimitable Charles James. Like James, Scaasi's clothes make both a statement and an impact. His work is a slice of Parisian couture in the middle of Manhattan. His designs often start with a sculptural idea, rather than a notion of a seamline or detail, and his elaborate dresses make an entrance rather than an exit.

Scaasi launched his elegant collection at an odd time – the early 1960s. He staged a retrospective of his work in New York's Lincoln Center in 1975, and has dressed an assortment of social butterflies including Ivana Trump, Joan Rivers, Elizabeth Taylor and, most famously, former first lady Barbara Bush for her inaugural ball. Scaasi's clientele are women who enjoy high-profile lunches and live for their charity work.

SCHERRER, Jean-Louis

BORN: PARIS, FRANCE, 1936

Initially training as a classical ballet dancer, Jean-Louis Scherrer switched to study fashion at the Chambre Syndicale de la Couture Parisienne. Scherrer was an assistant at Christian Dior during the 1950s, later working with Yves Saint Laurent. He moved to Louis Féraud before founding his own label in 1962. During the 1970s Scherrer's career took off: his clients ranged from royalty – Queen Noor and Baroness Thyssen, to actresses including Sophia Loren and Raquel Welch. *Vogue* called him 'The Aladdin of the Couture'.

Scherrer started his career concentrating on couture, formulating boutique and ready-to-wear lines by 1971. His forte was blending the exotic with the everyday, but his heart has always belonged to haute couture: 'You can use marvellous fabrics, have wonderful, impossible embroidery – in fact, be superluxe,' he told *Vogue* in 1974, 'and superluxe is what the couture is all about.' In 1992 Scherrer was fired from the house he founded due to 'unsustainable losses'. He was replaced by Erik Mortensen, who said: 'I will do Mortensen chez Scherrer. But I do have a very strong image of Jean-Louis Scherrer.'

first. You don't remain in business for 40 years if you don't sell.' On Belinda Bellville's retirement in 1987, Sassoon was joined by designer Lorcan Mullany.

Bellville Sassoon has a loyal clientele which has continued from generation to generation. The company dressed Diana, Princess of Wales in her early years – including outfits such as her sailor-collared going-away ensemble, red and white stripes for Ascot in 1981 and an embroidered evening dress which she wore on an official visit to Canada and which ended up in Christie's sale of her clothes in 1997. Sassoon also once made a bridesmaid's dress for the wedding of Princess Anne; called to Buckingham Palace for the fittings, he recalled to *Vogue* in 1998 the Queen's only comment on viewing the dress: 'Is it washable?' the monarch wanted to know.

SCHIAPARELLI, Elsa

BORN: ROME, ITALY, 1890
DIED: PARIS, FRANCE, 1973

Elsa Schiaparelli and the surrealist movement were an unstoppable force in the 1930s – the seminal moment when fashion and art came together – with the mutual massaging of the wearable and the unorthodox. Schiaparelli made her *Vogue* debut with a trompe l'oeil sweater in 1927 (the same year she opened her Parisian boutique on rue de la Paix): 'Chic, modern sweaters are, of course, triumphs of fitting and this one from Schiaparelli is an artistic masterpiece.' She worked with Salvador Dalì, Christian Bérard and Jean Cocteau. Schiaparelli progressed from sweaters to tailoring, with touches that made the observer look twice: pockets like drawers, lobster and acrobat buttons, and in 1936, leather bands painted to look like rippled ribbon. In 1934 she used 'Cosmic' fabric, which comprised two layers of rayon tulle in contrasting colours. Together, they gave a watered, wavy effect. Schiaparelli's hats encapsulated her extraordinary approach – among them a shoe hat suggested by Salvador Dalì and a wicker basket filled with cellophane flowers: 'only for life's lighter moments – for lunch, afternoon, or dinner when your spirits are extremely high.'

During the 1930s, Schiaparelli was the star whose ability to amuse put every other designer in the shade. Her perfume, Shocking, appeared in 1945. The bottle was based on the voluptuous curves of actress Mae West, for whom Schiaparelli had made a series of dresses including one in lilac broadcloth, and another in black tulle with pink taffeta roses and green leaves for her appearance in a play provisionally entitled *Sapphire Sal*. The following year she launched a perfume called The Roy Soleil in a glass bottle designed by Dalì. One of the first editions was sent to The Duchess of Windsor, Wallis Simpson.

In 1945 Schiaparelli was back in Paris after a four-year absence in America – 'the reception was of heartbreaking spontaneity, with tears of excitement, tears for all that had passed in the last four years and a childish faith that a miracle of inspiration, energy and production would now take place.' Her comeback was rapturously received.

Schiaparelli closed her house in 1954 and started to write her memoirs, fittingly entitled *Shocking Life*. In them she mused on alternative career paths that she could have taken, which included being a juggler, doctor, writer, cook, courtesan and a nun. She wrote *The Twelve Commandments for Women* which recommended shopping alone or with a man and included the cautionary advice: 'Remember – twenty per cent of women have inferiority complexes. Seventy per cent have illusions.'

SCHÖN, Mila

BORN: DALMATIA, YUGOSLAVIA, 1919

Initially a customer of Cristobal Balenciaga, Mila Schön used the couturier's influence to start her own house in 1959 and quickly established it as an outfit that put quality before cost. Schön began to design menswear in addition to womenswear in 1972 and since then she has diversified into homeware, eyewear and jewellery. Referred to in the same breath as Fendi and Valentino, Schön's high level of quality is maintained by her refusal to compromise. In 1995, with a branch in Moscow, she was brought out of retirement to re-direct the house she founded.

SHARAFF, Irene

BORN: BOSTON, MASSACHUSETTS, USA, 1910
DIED: NEW YORK, NEW YORK, USA, 1993

Awarded 16 nominations and five Oscars during her career, Irene Sharaff was best known for her ability to blend choreography with the demands of costume. She cut her teeth in repertory theatre, moving on to Irving Berlin musicals. From 1940 she worked on some of MGM's most popular musicals, including *Meet Me in St Louis* (1944). She was one of the designers on *Ziegfeld Follies* (1946) and *An American in Paris* (1951), where she created both sets and costumes for Gene Kelly's climatic ballet scene. Sharaff's other triumphs included *The King and I* (1956) and *West Side Story* – both the Broadway and film versions – during the early 1960s. She designed Pearl Bailey's costumes in *Porgy and Bess* (1959) and won an Oscar for her costume design for Elizabeth Taylor in *Cleopatra* (1963). Three years later she won her second Oscar, dressing Taylor in *Who's Afraid of Virginia Woolf?* (1966).

SITBON, Martine

BORN: CASABLANCA, MOROCCO, 1951

Maker of colourful modern clothes with a historical slant, Martine Sitbon is one of France's best-known exports. She studied at the Studio Bercot in Paris and then travelled extensively, returning to Paris to produce her first collection in 1985. Two years later she took over from Karl Lagerfeld at Chloé and designed there for nine seasons.

The first Martine Sitbon shop opened in Paris in 1996. Today, she continues to design her own line – including eyewear – and keeps to the original design directive she devised in the mid-1980s.

SMITH, Graham

BORN: BEXLEY, ENGLAND, 1938

One of Britain's foremost milliners, Graham Smith studied at Bromley College of Art, before moving to the Royal College of Art in London. Following his graduation, he went straight to Paris to take up the position of chief milliner at Lanvin.

Smith made the cover of *Vogue* in March 1965, with a pink silk twill hat decorated with huge spots. (A striped version was commissioned by Elizabeth Taylor, who was staying at the Dorchester at the time.) From 1981–98, Smith worked with Europe's largest hat company, Kangol. He collaborated with Jean Muir on her collections and with photographer Norman Parkinson on his Pirelli calendars. His royal productions have included a maple leaf hatpin for the Duchess of York, and a white sailor hat for Diana, Princess of Wales.

Smith celebrated 30 years of hat-making in the summer of 1989, when he confessed that he felt no affinity to Ascot. 'I've only ever been once,' he told *Vogue*. 'Not my cup of tea. Can't be doing with those penguin suits.'

SMITH, Paul

BORN: NOTTINGHAM, ENGLAND, 1946

The shrewdest and most successful designer Britain has ever produced, Paul Smith founded his first shop – which was open on Friday's and Saturday's only – on Byard Lane in Nottingham in 1970, where he sold his own work as well as clothes by other designers. He presented the first Paul Smith collection in Paris in 1976, opened his first London shop in Covent Garden in 1979, and introduced womenswear in 1994. Smith, who enjoys worldwide success, currently has an annual turnover of $173 million, and over 200 branches in Japan. 'Persuasion or flattery is one skill,' he told the *Independent*, 'but not letting people down afterwards is another. You've got to deliver the goods.'

With no conventional training, Smith has become a multi-millionaire and Japanese icon. Through thinking logically, understanding his customer and never going over the top

OPPOSITE **Layering one jacket on top of another in Paul Smith's early foray into womenswear – slim lines and ankle boots elongate the silhouette, 1994.**

in his designs, his business offers a retailing benchmark to other traders. It also includes essential ingredients such as consistent high quality, clever marketing and a quirky sense of humour. In addition, Smith has never been guilty of trying to run before he could walk.

Smith's accolades include an honorary degree from Nottingham Polytechnic and a Royal Designers for Industry Award. In 1994 he was awarded a CBE, and the following year the Queen's Award for Export. In 1992 he declined a British Designer of the Year nomination.

Paul Smith's CV is a roll call of retail openings, achievements and exhibitions. In 1998 he opened the stunning Westbourne House in Notting Hill, London, an eclectic cross between a shop and a home, selling made-to-measure suits, antique clothes, amusing nick-nacks and Smith's own fashion lines, including his best-known item – his signature shirts in unconventional colours and patterns.

SPROUSE, Stephen

BORN: OHIO, USA, 1953

Unusually for a designer with avant-garde leanings, Stephen Sprouse started his career at the refined end of the American market, working with two of its most famous names – Roy Halston and Bill Blass. Sprouse took the influence of London punk, which was prevalent in the late 1970s, and reinterpreted it, American style.

A high-profile figure in New York's social scene during the 1980s, Sprouse secured his name when he collaborated (like Vivienne Westwood) with artist Keith Haring, and was best-known for his stage clothes for stars of the rock world including Mick Jagger and Iggy Pop. He initially came to fame after dressing Debbie Harry during her Blondie period in the 1970s. Her peroxide hair was the perfect accessory for the day-glo colours –especially hot pink and yellow – favoured by Sprouse. Poised for a comeback in 1990, Harry candidly told *Vogue*: 'Before I met him I was a total mess. Don't ask what I wore. First I was a hippy, then it was cowboy boots and forties' dresses.' Sprouse provided the direction, the dresses and the colour, while Harry – with her unmistakable angular cheekbones – did the rest.

OPPOSITE **Stephen Sprouse's 'superhero' outfit, ready for take-off in silver leather, with matching boots and lots of functional details, 1984.**

STARZEWSKI, Tomasz

BORN: LONDON, ENGLAND, 1961

The son of Polish refugees, Tomasz Starzewski is one of the designers who has breathed new life into British couture. He started his own business after he was expelled from London's Central Saint Martins College of Art and Design for staging an alternative fashion show. Starzewski began at the top, making Victoria Lockwood's fur-trimmed wedding dress for her marriage to Charles Spencer, as well as suits for Diana, Princess of Wales, a cocktail dress for Camilla Parker Bowles and, most recently, a steel-grey engagement suit for the Countess of Wessex. His clients are ladies who lunch, European royalty, and the occasional singing diva: Shirley Bassey often sits in his front row. In addition to couture, he produces men's and women's ready to wear.

Starzewski's forte is colour and shape – the cocktail dress, the classic suit, the jewel-buttoned jacket in which the wearer glides seamlessly from lunch to dinner, from fundraiser to racecourse. He puts himself in the same league as the Parisian and New York superpowers: 'I am the client's designer like Saint Laurent, Givenchy and Oscar,' he insisted in *Tatler* in 1991. 'We all give the customer what she wants.' In spring 1999 Starzewski switched his allegiance from London Fashion Week, to show in New York.

STEELE, Lawrence

BORN: HAMPTON, VIRGINIA, USA, 1963

Born into a military family who travelled extensively throughout his childhood, Lawrence Steele graduated with a fine arts degree from the Chicago Art Institute in 1985. He became assistant designer at Moschino from 1985–90, leaving to collaborate with Miuccia Prada on the women's collection. His first collection was presented in 1994 and shown in Italy, with a knitwear line two years later. In 1999 he launched Lawrence Steele Design – a new range of technical active wear for both men and women. It blends what he does best: a mix of sportswear with an elegant edge.

STIEBEL, Victor

BORN: DURBAN, SOUTH AFRICA, 1907
DIED: LONDON, ENGLAND, 1976

Victor Stiebel started his fashion career as a student at Cambridge University, where he followed in Norman Hartnell's footsteps, designing costumes for the Footlights revue. He trained at Reville

and Rossiter before opening his own salon in 1932; two years later he was being compared to Digby Morton, Norman Hartnell and Charles Creed. Interrupted by the Second World War, during which he served in the British army, he took up employment at Jacqumar before reopening his own business in the more favourable economic climate of the 1950s.

Famous for his romantic dresses and thespian clientele, Stiebel had a superb eye for proportion – often experimenting with the positioning of stripes, plaid and accordian pleats to incredible effect. He could also effortlessly switch his talents from couture to mass-market. During his career he designed uniforms for the Wrens, as well as making elongated evening gowns for members of London's theatrical fraternity, in particular Vivien Leigh.

STOREY, Helen

BORN: LONDON, ENGLAND, 1959

The eldest daughter of David Storey, author of the best-selling novel *This Sporting Life* (1982), Helen Storey made her mark on British fashion during the late 1980s. 'She became tremendously streetwise, largely through mixing with some rather alarming people,' her father remarked to *The Sunday Times*.

Storey graduated from Kingston Polytechnic in 1981, and worked at Valentino in Rome before producing her first collection under the Amalgamated Talent organization in 1984. In 1987 she joined forces with fellow designer Karen Boyd and opened Boyd and Storey in Soho.

By March 1990 the pair had gone their separate ways, and Storey's solo collections veered more towards the esoteric. Her spring/summer 1991 collection was entitled 'Rage', and she admitted to the *Daily Telegraph*: 'It's morally difficult for me just to design a frock.' In 1995 Storey showed her collection in a London Underground station, and her business went into receivership. She wrote her autobiography, *Fighting Fashion*, in 1996, in which she reflected, 'The tunnel was on the way to somewhere else, but I have yet to arrive.'

SUI, Anna

BORN: DEARBORN HEIGHTS, MICHIGAN, USA, 1955

Anna Sui studied at Parson's School of Design in New York, but left after two years to work as a design assistant in a sportswear firm. Heavily influenced by the American take on punk, Sui

assisted Steven Meisel in the styling of his photographs. In 1980 she produced a capsule collection of six pieces, which were picked up by Macy's. Following her discovery by the New York department store, Sui started running her own business from her apartment.

By 1987 she decided to get more serious about design and found a manufacturing base. She made her first solo fashion statement in 1991, described by *The New York Times* as, 'a pastiche of hip and haute styles'. The winner of the coveted CFDA Perry Ellis Award for New Fashion Talent in 1993, Sui's celebrity clients include Courtney Love, Stevie Nicks and Lisa Marie Presley. Her favourite band is the Smashing Pumpkins.

TARLAZZI, Angelo

BORN: ASCOLI PICENO, ITALY, 1942

A former student of political science, Angelo Tarlazzi switched to fashion in 1961 when he joined the house of Carosa to design eveningwear. In 1966 he relocated to Paris, assisting Michel Goma at Patou. He left to pursue a freelance career in America before rejoining Patou as artistic director, and finally opening his own house in 1978. The Tarlazzi look is unconventional and free-flowing. In common with the American minimalists, his clothes combine practicality with fluidity.

TATSUNO, Koji

BORN: TOKYO, JAPAN, 1964

Maker of singularly unique pieces, which he described in 1990 as 'eclecticism in cloth … a spontaneous, non-academic approach which displaces the expected', Koji Tatsuno mixes cultures, antique textiles and touches of the unexpected in order to produce collections that combine modernity and history, tailoring and sculpture.

Tatsuno dropped out of school at the age of 14; by the time he was 18 he was living in London (although he spoke no English), and making clothes from antique fabrics. His recycled pieces caught the imagination of the buyers at Browns.

In the mid-1980s he designed under the Culture Shock label, followed by John Galliano, Paul Smith and John Richmond. His first salon in Mayfair, initially backed by Yohji Yamamoto, specialized in blending the sartorial antique with the bespoke coat – and employed a fledgling pattern cutter called Alexander McQueen, who had trained on Savile Row.

THOMASS, Chantal

BORN: PARIS, FRANCE, 1947

Very French, extremely colourful and internationally renowned for its ability to suit every fashion capital, the Chantal Thomass label is one of France's greatest exports. Thomass started her career by making simplistic dresses out of silk scarves. In 1967 she formed her own company with her husband; nine years later it was re-christened Chantal Thomass. Now known as much for her lingerie as her outerwear, Thomass specializes in beautiful lace, feminine shapes and typical Parisian chic.

TREACY, Philip

BORN: COUNTRY GALWAY, IRELAND, 1967

Philip Treacy is the master of fantastical hats that suit statuesque supermodels and attract flashbulbs like a moth to a flame. His millinery extravaganzas have included a swirl of felt with a feathered monocle, and a sailing ship constructed from feathers.

Treacy trained at the Royal College of Art in London, where his final collection was a first-class celebration of the most difficult craft in fashion, a skill which he says is 'the nearest thing to mathematics'. He has lost count of the collections he has collaborated on – starting in 1991 with Victor Edelstein and Marc Bohan for Norman Hartnell. Now his roll call of co-designers is a who's who, ranging from Karl Lagerfeld to John Galliano. His celebrity clients run the gamut from Oscar winners to It Girls. Most commonly spotted on the runway and at racecourse meetings or society weddings, Treacy's hats are celebrations of incredible shapes.

Treacy has reinvigorated an industry which was sadly lacking in publicity. His technical team is unrivalled. 'Millinery is full of secrets,' he told *Vogue* in 1991. 'It's about tricks, and someone has to be generous enough to show you them.'

TRIGÈRE, Pauline

BORN: PARIS, FRANCE, 1912

Pauline Trigère is credited with putting French elegance into Manhattan, and for rarely being seen without her trademark shades. The daughter of tailors, Trigère married a clothing manufacturer and learnt about fashion in the best way possible – through first-hand experience. For decades she was a symbol of French chic, chanelling her creative energy more into couture than ready to wear.

ABOVE **Philip Treacy's fantastical galleon: Seventeenth-century French sailing ship hat in satin with pheasant feather bones.**

In 1994, still elegant at 82 years of age, she started to concentrate on accessories. 'I'm only designing things you don't have to alter. I just got tired of sizing things,' she said. Winner of two Coty Awards, and an avid collector of turtles – the Chinese symbol of longevity – Trigère celebrated her fiftieth anniversary in business in 1992. When asked her age, she told *The New York Times*, 'I'm past 75. I still walk and I don't dye my hair blonde, and I don't touch it up.'

TYLER, Richard

BORN: SUNSHINE, AUSTRALIA, 1946

Son of a seamstress, Richard Tyler trained as a tailor before opening his own shop, Zippity-doo-dah, in Melbourne with his mother in the late 1960s. By 1970 he was known on the rock circuit – his clothes were bought by Cher and Rod Stewart for his Blondes Have More Fun tour in 1978. Tyler eventually opened his own shop in 1988, and was fêted by the resident rock fraternity, selling his

clothes to Diana Ross and Ozzy Osbourne. He later admitted to *Vogue*: 'I got the leopard skin out of my system with Rod Stewart.'

In 1993 – by now in his mid-40s – Tyler won the CFDA Perry Ellis Award for New Fashion Talent; in the same year he became head designer for the Anne Klein label, describing his new appointment as 'a dream come true'. The collaboration lasted a year. Tyler now designs for Italian label, Byblos, in addition to producing his own range – Richard Tyler Couture and Richard Tyler Collection.

UNGARO, Emanuel

BORN: AIX-EN-PROVENCE, FRANCE, 1933

Sizzling colour, feminine shapes and wild flowers are the signatures of Emanuel Ungaro, Italy's master colourist, and a resident in Paris.

As a child, Ungaro's first toy was not the expected train set but a Singer sewing machine. His father taught him how to use it and by the age of 13 he was working in the family business. He worked with Cristobal Balenciaga, whom he called 'the father of modern couture', and then briefly for André Courrèges. He established his own label in 1965, producing a look which was a combination of the two designers – Balenciaga's discipline with Courrèges's appreciation of youth. The look which Ungaro developed concentrated on his love of colour, floral prints and sinuous shapes; he often includes draping and appliqué. His Ungaro Parallèle line, which made its debut in 1968, centres on clear blocks of colour and classic shapes. 'You get surprises as you work with the fabrics, with ideas,' he told *Vogue* in 1974. 'And, of course, the surprises are essential – although they can often be bad surprises.'

Ungaro celebrated his twenty-fifth anniversary in 1990 at the Pavillon in Paris. At the same time he launched a book that despaired of the way in which the industry was going. 'Couturiers have been turned too much into stars! Who knows if that is not going to recoil on them?' That said, Ungaro was more than happy to feature his celebrity clients, including Texas socialite Lynn Wyatt and actress Anouk Aimée, in a series of Ungaro advertisements. He also made the floral wedding dress for Raine Spencer (stepmother of Diana, Princess of Wales) for her marriage to the Count de Chambrun. 'I adore the British,' he once said, 'they are the strangest people in the world and certainly the most exotic. And they do strange things too.'

LEFT **A native Australian resident in America, Richard Tyler's suiting is worn on and off stage by a variety of rock icons. Here, on the catwalk, 1995.**

OPPOSITE **'Paris couture as you would expect it to be', 1995: Ungaro's extravagant silk taffeta ballgown with sweetheart neckline and crinoline skirt.**

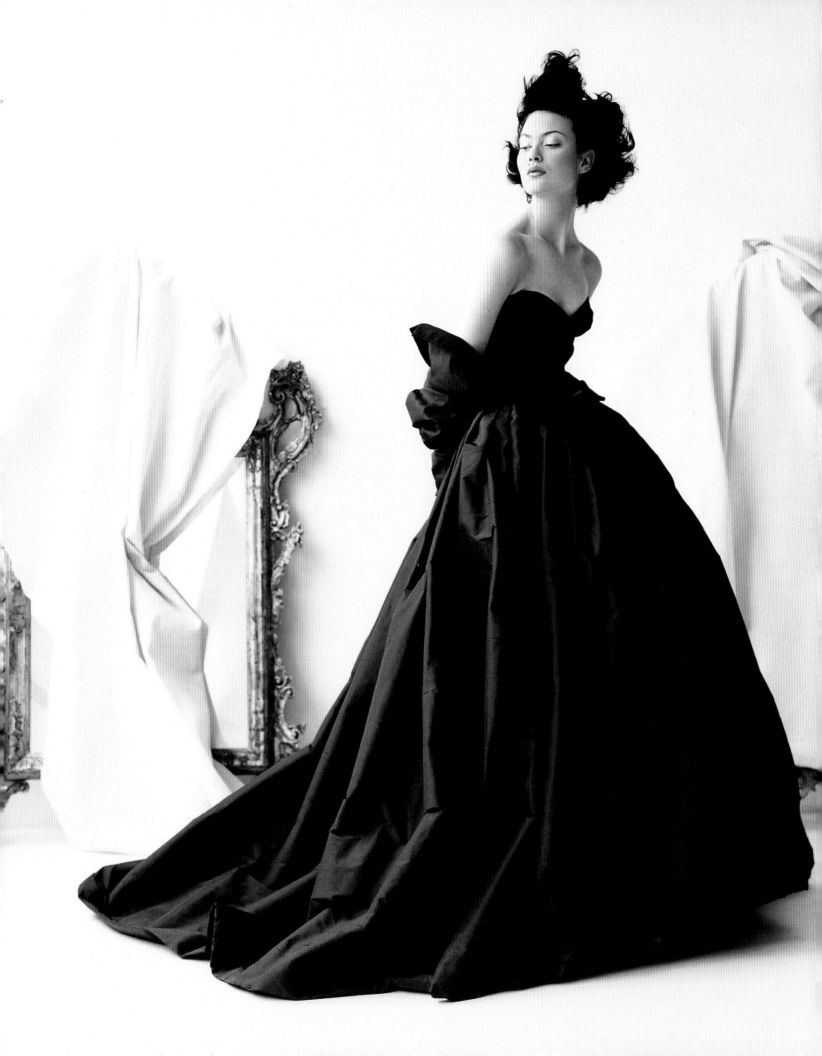

VALENTINO

BORN: VOGHERA, ITALY, 1932

Like his movie-star namesake, Valentino is a talent of gargantuan proportions, an Italian icon for whom an entourage and red-carpet treatment come as standard. He is not exclusively synonymous with glamour – his name gives subliminal messages of his signature colour, red, described by art historian Federico Zeri as, 'Not cardinal red, not tango red, but Valentino red.'

Born Valentino Garavani, he studied French and fashion design at Milan's Accademia dell'Arte before perfecting his technique at the Chambre Syndicale de la Couture Parisienne. In 1950 Valentino assisted Jean Dessès, the Greek couturier who specialized in draping, for five years. He moved on to Guy Laroche and assisted Princess Irene Galitzine before establishing his own business in 1960 on Rome's Via Condotti. His first collection was shown two years later.

Valentino's 'White' collection – unveiled in 1968 – generated sufficient press attention to make his name. He dressed Jacqueline Kennedy (publicly wooing her from Oleg Cassini) for her marriage to Aristotle Onassis. In 1991, Elizabeth Taylor asked Valentino to design a dress for her eighth trip up the aisle. The creation had a plunging lace neckline and woven ribboned waist.

For Valentino, read lavish lifestyle, glittering friends and decades of mingling in the most illustrious company. He has homes in London's Knightsbridge, New York and Capri, as well as a villa on the outskirts of Rome and a chalet in Gstaad. The cherry on the cake is a 43-metre (140-foot) yacht in which to survey the world's oceans. Valentino's office is a six-storey, seventeenth-century Roman palazzo, and he always works with his favourite pugs by his side. Immaculately groomed and permanently tanned, he buys his ties from Turnbull & Asser, and his shoes from John Lobb. At the weekend he wears Ralph Lauren.

Valentino's creations – clothes are too nondescript a term – are for women with cleavages, curves and bottomless bank accounts. His forte is dressing the elegant partners of exceedingly rich men. He once said, 'I don't think any man in the world wants to go out with a woman dressed like a boy.'

In 1987 he presented a fashion show in his home town of Voghera. He celebrated 30 years in business in 1991 with a three-day spectacular – encompassing 1,600 guests at an approximate cost of $5 million. The extravaganza culminated in dinner at the Villa Medici, attended by a host of international high-profile guests including Nan Kempner, Nancy Kissinger, Gina Lollobrigida and guest of honour Elizabeth Taylor. Fellow designers Gianfranco Ferre, Emanuel Ungaro and Hubert de Givenchy also lent their support. Valentino, who has exhibited in California, Rome and New York, has dressed the who's who of showbusiness, diplomatic and social circles.

RIGHT **Valentino's design for ladies who lunch, socialize, and always want to look as feminine as possible: tailored jacket, stole and soft pleats, 1980.**

OPPOSITE **'The perfection of prettiness': Evangelista in Valentino's couture oyster chiffon evening dress with crossover bodice and sable shoulders, 1991.**

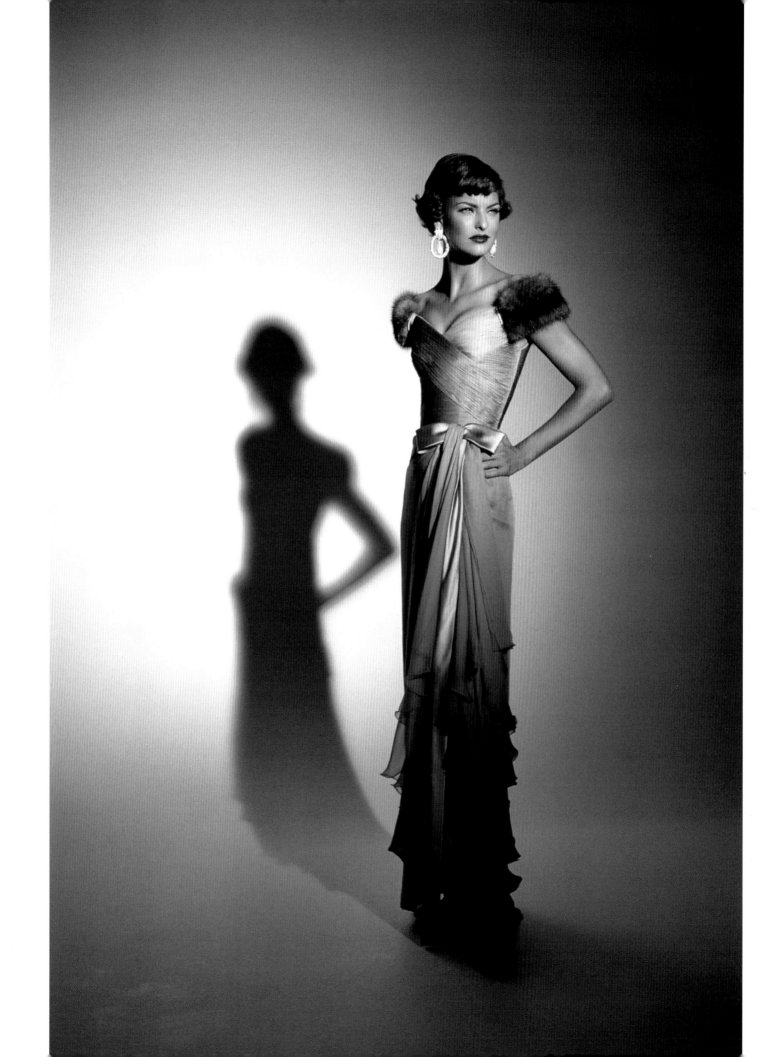

VANDERBILT, Gloria

BORN: NEW YORK, NEW YORK, USA, 1924

During the 1970s, at the height of the flamboyant disco era, Gloria Vanderbilt's name, face and figure were associated with skin-tight jeans complete with gold-stitched logo. Her publicity campaign was so successful that, together with Calvin Klein, she momentarily put Levi's in the shade and set the trend for designer jeans.

Vanderbilt left school at the age of 17 and went on to marry a string of famous men. First was Hollywood agent Pasquale DiCicco, followed by conductor Leopold Stokowski, who was 40 years her senior, film director Sidney Lumet, and finally, writer Wyatt Emory Cooper, who died in 1978.

Heiress to one of America's largest fortunes, Vanderbilt did not need to work, but claimed, 'The only money that means anything to me is the money I make myself.' Her business was founded on a remarkable licensing strategy that turned its creator into a household name. It started with jeans, when Murjani International requested permission to license her name to their design – which were the bestselling jeans in America by the early 1980s – and later spread into home furnishings, fragrances, greetings cards, luggage and footwear. Vanderbilt crossed the line from fashion designer to stylish dietitian when she licensed her name to a low-calorie dessert. At the height of her success she was frequently mobbed when she made appearances to promote her derrière-hugging jeans.

VAN NOTEN, Dries

BORN: ANTWERP, BELGIUM, 1958

Low key and low profile, Dries Van Noten is part of the Belgian contingent who formed the world's sixth fashion capital. Van Noten studied fashion at Antwerp's Royal Academy of Arts, and started his own company in 1985. It was not until the 1990s, however, that his label became sought after and his name synonymous with eclectic and desirable clothes.

Van Noten's designs are precious and antique in feel, considered and unique in thought. He has an extraordinary colour sense, a wonderful feel for fabric and the most mouthwatering way of mixing textures together. He constructs rather than deconstructs, layering one texture on top of another. Van Noten's collections have been described as bohemian and incurably romantic – and always contain a crossing of cultures.

Customers view his clothes as wearable works of art. His influences are as diverse as, 'a car in the right colour, an African woman in Antwerp with a turban and classical raincoat', according to a profile of him in the *South China Morning Post* in 1997. 'Really, for me, an image in a book can be more inspiring than three weeks' travelling,' he said. 'It's nice to have a glimpse and then fantasise.'

LEFT **Dries Van Noten, who is normally noted for his way with ethnic embroidery and antique effects, dilutes the look for the catwalk, February, 1997.**

OPPOSITE **Leading the fashion for mixing and matching, Van Noten layers textures and colours for a cross-cultural style that looks glamorously eclectic, 1996.**

VERSACE, Gianni

BORN: REGGIO CALABRIA, ITALY, 1946
DIED: MIAMI, FLORIDA, USA, 1997

BELOW **'Psychedelic butterfly' by Versace, naturally, in 1993. Multicoloured crepe de Chine jumpsuit, with criss-cross bodice and masses of flare.**

OPPOSITE **Versace's 'silver starburst of a dress': delicate, translucent, metallic and achieved by layering fine silver sequins on top of chiffon, 1999.**

Like a riveting blockbuster, Gianni Versace brought sex, glamour and a star-studded line-up to fashion during the 1990s. His dresses – a mixture of curve, glitter and slink – were worn by supermodels, the world's celebrities and, after her divorce, Diana, Princess of Wales.

Versace was not an instant hit. He moved to Milan in 1972, working as a freelance designer for companies including Callaghan and Genny. His first solo collection was for Complice in 1975. On 28 March 1978, the Gianni Versace label was launched at the Palazzo della Permanente in Milan. Versace's brother, Santo, handled the business side. In 1979 Versace produced his first advertising campaign in conjunction with photographer Richard Avedon. This was an inspired move that was to prove a long-running collaboration.

Versace captured a corner of the market not known for its solidarity to one particular designer. A decade after its formulation, the Gianni Versace label was being worn by the world's most powerful rock'n'rollers – Bruce Springsteen, Sting, Prince, Eric Clapton and George Michael. He held court at his palatial residence, the Villa Fontanelle on Lake Como, dubbed 'Versace's Rock'n'Roll Palace' by *Vanity Fair*. Elton John became a close friend: 'He's a sweetheart,' Versace told *Vogue* at the time. 'For his last show he said, "I want a new image – but I'm too old to wear a Mickey Mouse jacket. So we did something simple but just left the little hat."' In a spoof on his previous advertising campaigns, Avedon photographed Elton John in Versace dresses for *The Sunday Times* – with the headline, 'Ciao Chubby'.

In 1990 Versace held his first haute couture show in Paris at the Ritz hotel. His turnover was 600 billion lire. He had 320 outlets. The Versace boutique on Los Angeles's Rodeo Drive made $500,000 in a single month. Versace, supported by his brother Santo, sister and muse Donatella, and her husband Paul Beck, had the world at his feet. Interviewed by *Women's Wear Daily* in 1990, he said: 'In Italy I cannot compete with anybody. There are only three designers who give me the energy to fight – Yves Saint Laurent, Christian Lacroix and Karl Lagerfeld.'

When Versace was tragically killed in Miami on 15 July 1997, his sister Donatella carried on, somehow managing to complete the collection they had been working on. 'I knew Gianni would have wanted me to continue,' she told *Vogue* in 1998.

'Yes, I could have walked away, never done another day's work, but as a housewife I'd be a disaster.' A benefit was held at the Metropolitan Museum of Art Costume Institute in New York to celebrate the life and work of Gianni Versace; it raised a staggering $2.3 million. 'To see so many of Gianni's friends in one of his favourite places on earth made me so happy,' said Donatella to American *Vogue*. 'The atmosphere in the room was festive and spiritual all night.'

VIONNET, Madeleine

BORN: CHILLEURS-AUX-BOIS, FRANCE, 1876
DIED: PARIS, FRANCE, 1975

The supreme sculptress, who turned fabric into the purest form of fine art, Madeleine Vionnet knew exactly why there was a gulf between drawing and the final product. Lines drawn on paper can never simulate the feeling of fabric on skin. Simplicity was the watchword. Naturally, her perfumes were called A, B, C and D.

Vionnet became a dressmaker's apprentice at the age of 11. She married at 18, divorced, moved to London and worked briefly with Kate Reill before returning to Paris to work with Madame Gerber at Callot Sœurs, then with Jacques Doucet in 1907. Vionnet was about to open her own house when the First World War broke out, so she delayed it until the winter of 1918. By the early 1920s Vionnet had relocated from rue de Rivoli to a private house at 50 avenue Montaigne. In 1923 she married a younger man, but they divorced 20 years later.

Although Vionnet did not invent bias-cutting, she was the undisputed doyenne of it. Her technique was unequalled – liquid in motion and the pinnacle of minimalist perfection. Using her favourite fabric – silk crepe Romain – Vionnet took the timeless shapes – circle, rectangle and triangle – and transformed them into fluid sculptures. These were counterpointed by her complicated structures, which flowed over the body, held together by a single seam. Madame Raymonde, a former hand in the workroom, who later worked at Hardy Amies, said: 'She was simplicity itself. There was no decoration. None whatsoever. One toile had one seam, another there was a balance mark here, there and everywhere and when you draw the balance mark together it forms an enormous bow. Now, that's what I call genius. It is sculpture.' Vionnet's talent extended beyond the creative stage: she ran an impeccably managed house, with ten models, a nurse and separate kitchens for the *vendeuse* and workgirls.

In 1939 Vionnet showed her last collection, but lived to be almost 100 years old. She is adored by contemporary designers including Azzedine Alaïa, Issey Miyake and Vivienne Westwood. With Cristobal Balenciaga, it was a case of mutual admiration. Vionnet was 'a genius', he said. 'No one has ever carried the art of dressmaking further.'

VITTADINI, Adrienne

BORN: BUDAPEST, HUNGARY, 1944

Dubbed 'Knitwear Queen' in America, Hungarian Adrienne Vittadini studied at the Moore College of Art in Philadelphia, Pennsylvania, and won a scholarship to apprentice with Louis Féraud in Paris in

ABOVE **Evening wraps 'that's one of the big bombshells of the season' by Madeleine Vionnet. Duventine cape over panne velvet dress, tied with cords.**

OPPOSITE **Flawlessly-cut Vionnet – 'no evening gown has greater elegance' – in pure white crepe Romain with asymmetric hemline and silk tassel, 1926.**

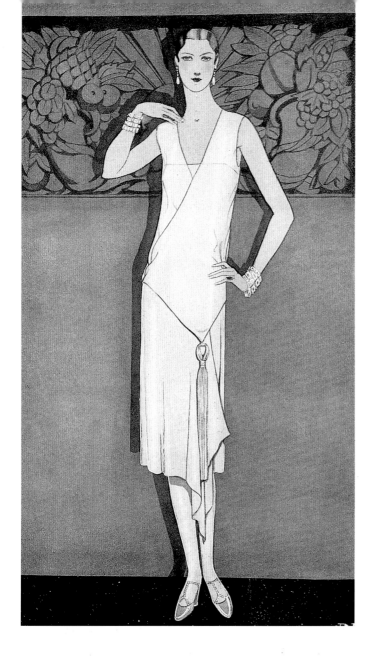

1965. Vittadini relocated to New York, specializing in the knitwear divisions of sportswear companies. She launched her own label in 1979, offering a collection that spanned sportswear, childrenswear, petites and swimwear. Approximately 60 per cent of her collection concentrated on knitwear, and her bestseller sold 26,000 pieces in one season. Vittadini sold her company in January 1996 but remained as chairwoman. She resigned, with her husband and business partner Gianluigi, in 1998. The label continues under new management.

VIVIER, Roger

BORN: PARIS, FRANCE, 1913

Roger Vivier studied sculpture at the École des Beaux-Arts in Paris, and became a shoemaker by default when he was invited to try his hand at making shoes at a friend's factory.

Vivier became hooked, and opened his own house in 1937. Although he was a creative force in his own right, he designed for many other shoemakers including François Pinet in France, Herman B Delman in the USA and Sir Edward Rayne in England. The association with Delman proved lucrative – by the late 1930s Vivier was living in New York. In 1947 he returned to Paris, collaborating with Christian Dior when he opened a complementary shoe range.

A retrospective at the Musée des Arts de la Mode in Paris in 1987 revealed Vivier as not just an incredibly consistent creator, but also as an innovator, explorer and experimentalist, working with plastic, and turning extreme curves and angles into feasible shoe designs.

VON ETZDORF, Georgina

BORN: LIMA, PERU, 1955

One of the instigators in moving evening fabrics from night to day during the late 1980s, Georgina Von Etzdorf is a textile designer whose work is distinctive, colourful and always associated with quality. She graduated from Camberwell School of Art, London, and formed her own company in the country producing silk-screen printed velvets and silk twills. Her early designs centred on scarves and shawls, but she has since graduated into pyjamas and dressing gowns, using silk-screen printing techniques.

VON FURSTENBERG, Diane

BORN: BRUSSELS, BELGIUM, 1946

Diane Von Furstenberg is the woman who launched the wrap dress. She also had the longest legs in the business, prompting Tom Ford of Gucci to tell *Vogue* in 1988: 'Diane Von Furstenberg is the sexiest woman I have ever met.'

Born plain Diane Halfin, she studied at the University of Geneva, before marrying Prince Egon Von Furstenberg in 1969, and relocating to America. Her new-found aristocratic status eased Von Furstenberg into the American fashion industry. Although she had no formal training, she possessed an innate understanding of people, places, occasions and social situations. In short, she knew her market to the extent that her signature wraparound dress became a bestseller, selling in droves when Diana Vreeland featured its uncomplicated jersey form on the pages of American *Vogue*.

In 1972 Von Furstenberg opened a showroom on Seventh Avenue, and made the cover of *Newsweek* at the age of 29. For the next 18 years she rode the wave of fluctuating tastes, re-entering the fashion fray in 1990, swiftly finding a new generation of customers who could relate to her work: 'I never played with dolls, I never dreamt of getting married or having children. I dreamt about love, passion, seduction and a bohemian life,' she told *Vogue* in 1998. 'To me, the most important thing is freedom. The only way you can be free is if you don't lie to yourself or others and you assume responsibility for yourself.'

VUITTON, Louis

FOUNDED BY LOUIS VUITTON IN 1854

One of the world's most unmistakable signatures, the Louis Vuitton logo is associated with big cheques, Lear jets and international lifestyles. For over a century, Vuitton luggage has been criss-crossing the globe, adding credibility to its owners. The Vuitton speciality is for luxury containers that cause a stir in VIP departure lounges. From the perfect stitchwork to the shade of its leather, Vuitton epitomizes the French flair for impeccable craftsmanship.

Echoing the trend for American designers to take the helm at luxury goods empires, Vuitton appointed Marc Jacobs in 1996 to invigorate the label's accessories and add a ready-to-wear line. It was an unusual choice, as he is known for his hip, bohemian tendencies rather than his deference to luxury leather. In 1999 he was photographed in *Vogue*, wearing low-slung trousers and holding a bottle of Jack Daniels. Staring straight into the camera, he surveyed his surroundings and mused, 'It's like Disneyland to me here.'

WAKELEY, Amanda

BORN: CHESTER, ENGLAND, 1962

Amanda Wakeley, who sums up her style in four words: 'modern, quiet, comfort, confidence', launched her own label in 1990. A former pupil at Cheltenham Ladies College, Wakeley worked as a house model in America for four years. Eveningwear is her forte, and she has won the British Fashion Award for Glamour three times and been nominated every year since 1993. Her first capsule collection contained her best-selling cashmere sweaters lined with silk satin. She now has a flagship store and two bridal collections, 'White Label' and 'Black Label', as well as her own collection and a range she designed with Principles.

WALKER, Catherine

BORN: AIX-EN-PROVENCE, FRANCE, 1945

Catherine Walker is the designer who made Diana, Princess of Wales look even more stunning than before. Taking her model proportions and photogenic looks, Walker transformed Diana from fashion plate to unforgettable presence. Always discreet, she understood that close inspection from all angles demanded a rigorous attention to detail.

Walker arrived in London from France with two baby girls, a British husband and a doctorate in philosophy. When her husband died shortly afterwards, she immersed herself in work, making children's and maternity clothes. In 1978 Walker established the Chelsea Design Company and although she had many famous clients – including Shakira Caine – it was the Princess who personified her eye for proportion. Dubbed 'Diana's Hidden Asset' by the tabloids, Walker dressed 'the dancing princess' in Australia, gave her a military suit to greet King Fahd, and a slinky navy number to complement her slicked-back hair at the CFDA Awards in New York. At the Christie's sale of Diana's dresses in 1997, out of 80 lots, 50 bore Walker's label. Ignoring the licensing deals and corporate contracts, she could make a million through her link with the Princess; but that's not her style. As she told *Vogue* in 1989: 'I'm not a commercial person at heart.'

WATANABE, Junya

BORN: JAPAN, 1961

A graduate from Tokyo's Bunka Fashion Institute, Junya Watanabe is best known as protégé of Rei Kawakubo, for whom he started to work in 1984. His design keeps to the Comme des Garçons aesthetic of pure lines, stark shapes and an appreciation of avant-garde cutting.

WESTWOOD, Vivienne

BORN: GLOSSOP, ENGLAND, 1941

Vivienne Westwood is England's most extraordinary ideas person. A revolutionary without equal and owner of a fertile imagination, she has unleashed punk, radical cutting, buffalo girls and underwear as outerwear, with bras worn over dresses, on an unsuspecting world. Only Westwood could defy logic by constructing a crown from scraps of Harris Tweed – the epitome of quirkiness, which became a Westwood bestseller. She despairs at the decline in elegance, the influx of American sportswear – faceless tracksuits and trainers – which she condemns as the 'brain-damaged look' of Britain's youth.

Born in a cottage in the Derbyshire countryside, Westwood was the eldest of three children. When she was 13, her parents bought Tintwistle post office. She went to Harrow Art School for one term before leaving to became a teacher and marry

Derek Westwood. At the age of 22 she had a son, Ben. She then met Malcolm McLaren, ex-manager of the New York Dolls and manipulator of the Sex Pistols, and in the early 1970s they also had a son, Joe. The meeting of minds produced the moment when fashion stopped, looked and listened. They opened a shop on London's King's Road at the height of the punk movement, selling fetishistic clothes in leather and rubber and tapping into the anarchic youth culture. Both the shop and McLaren's band brought the couple a great deal of media attention. When the split came, it was both professional and personal.

Westwood carried on alone, opening her shop, Nostalgia of Mud, and proving to her detractors that she was not a collaborator, but an inventor in her own right. The themes of her collections have continued to amaze and revolutionize – from her Pirate line with petti-drawers, ringlets and gold teeth in 1981 to her 'Buffalo Girls', 'Witches', 'Mini-Crini', 'Pagan', 'Anglomania' and 'Erotic Zones' collections. In 1992 she married her former design assistant, 27-year-old Austrian Andreas Kronthaler. Westwood's heroes are Christian Dior, Madeleine Vionnet and the writer Aldous Huxley. She uses and promotes British woven wools: 'I couldn't function as a designer without them,' she said in 1993, a year after receiving an OBE from the Queen, 'not only that, I wouldn't want to.'

Unquestionably one of the most influential figures in the fashion world, Westwood is a designer who reinvents, exploits and refuses to compromise. Her sexy, beautiful and sometimes outrageous clothes, although frequently criticized, are relentlessly copied – albeit in a more diluted form.

Known for her forthright opinions, anti-establishment views, disarming honesty and never wearing knickers in the presence of royalty, Westwood is funny, down-to-earth and devoid of any malice or fakery. She is a creative whirlwind, who rides a bike and doesn't give a damn about her detractors. Financial acumen is a common newspaper theme. But Westwood has always known her worth – and money never comes into it.

LEFT **Incorporating graffiti prints by Keith Haring, Westwood's tubular skirt; top, and Smurf hat sold in 1983 at her shop, Nostalgia of Mud.**

WORKERS FOR FREEDOM

FOUNDED BY RICHARD NOTT AND GRAHAM FRASER IN 1985

Originally founded by Richard Nott and Graham Fraser – who were named British Designers of the Year in 1989 and given their award by Diana, Princess of Wales – Workers for Freedom was a perfect balance of clean lines and crisp design, often with strategically placed embroidery. Their favourite combination was black and white.

Fraser studied accountancy and retailing, working for Harrods, the Wallis Group and Liberty, while Nott was a design assistant at Valentino in the early 1970s and a lecturer at the School of Fashion at Kingston University for a decade. The company re-located to France in 1993, intending to continue its more expensive clothing alongside the wholesale collection designed under contract with Littlewoods. However, the venture was short-lived and Workers for Freedom returned, showing in London a year later.

WORTH, Charles Frederick

BORN: LINCOLNSHIRE, ENGLAND, 1825
DIED: PARIS, FRANCE, 1895

Regarded by many as the founder of Paris couture, English designer Charles Worth made fashion a personal issue when he used his wife, Marie, as his model after founding his house in the mid-nineteenth century. 'He conceived the idea of a dressmaking establishment where a woman should be dressed as befitted her type – an idea new to his day of impersonal methods,' noted *Vogue* in 1925.

Worth's mother was forced into domestic service when she was widowed. Her son, then 12 years old, was apprenticed to Swan & Edgar haberdashers. In 1843 he arrived in Paris with £5 in his pocket and secured a job with Gagelin & Opigez, selling accessories and fabrics. There, he met his wife Marie Vernet, a sales assistant, and started to dress her. Her new look began to attract compliments and eventually Worth's employers allowed him to have some floor space – in effect, his first designer concession.

Worth's talent was for instigating new trends, his fame for being the couturier of queens. He pushed the boundaries by employing a softly-softly approach to new sleeve variations, trimmings, colours and accessories (he pioneered the wearing of jet). Worth was also one of the first designers to show his creations on a house model rather than a static mannequin – a new device at the time. He shocked society by talking his wife into appearing at the prestigious Longchamp meeting wearing a dress without a shawl.

After the death of its founder, the house of Worth carried on under the direction of his sons and grandsons. Worth, the pioneer of Paris couture and precursor to Paul Poiret was, in *Vogue*'s opinion, 'very original, very much an artist, having opinions of his own and expressing them without fear or favour'.

LEFT **Worth's 'Chrysis' gown of georgette crepe, secured by an ornament of pearls, worn with a turquoise turban and hung with jet for dramatic effect, 1920.**

YAMAMOTO, Kansai

BORN: YOKOHAMA, JAPAN, 1944

Theatrical, spectacular and designed for optimum visual effect, the creations of Kansai Yamamoto are rooted firmly in Kabuki theatre. Yamamoto studied English and engineering at Nippon University, and graduated from Bunka College of Fashion in Tokyo in 1967. He trained with Junko Koshino and Hisashi Hosono before leaving in 1971 to open his own company, where he had six employees and approximately $8,000 in the bank. Yamamoto showed in London and Tokyo and made a dramatic entrance with his initial appearance in Paris in 1975. He opened his first Parisian boutique two years later. Yamamoto also staged a show in New York in 1981 – choreographing his models movements and directing the action on stage from behind a mask – to rave reviews.

An artist at heart, Kansai Yamamoto has diversified into complementary lines which include clocks, stationery and ladies' shavers. These lucrative licensing deals have allowed him to satisfy his social conscience. For example, in 1998 he staged a cultural extravaganza called, 'Hullo India' at the Jawaharlal Nehru Stadium in New Delhi. Entry was free to the 40,000-strong audience – thanks to Yamamoto persuading Sony, Toshiba, Nippon and Canon to provide sponsorship – and included acrobatics, theatre and fireworks. Japan's best-known fashion designer staged the show (as he did in Russia and Vietnam) to touch the senses: 'I want as many people as possible to see them and say, "Wow!"'

RIGHT **Kansai Yamamoto's theatrical 'brocade for dressing-up nights': padded satin circus print, enormous platforms and every colour under the sun, 1971.**

BELOW **One of the most beautiful kimonos to come out of Japan: bias-cut navy blue silk printed with cherry blossom, 1994.**

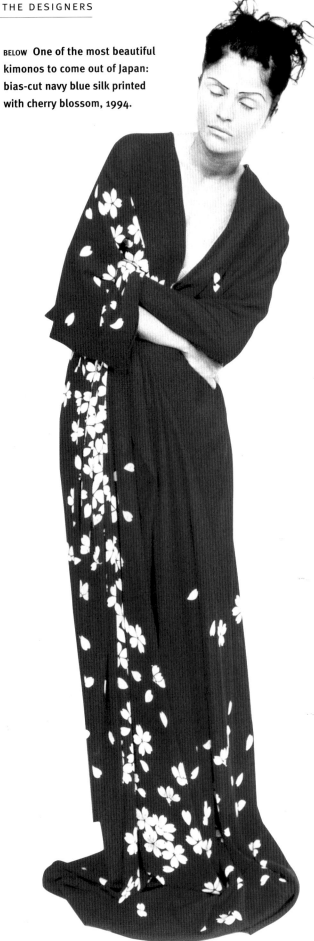

YAMAMOTO, Yohji

BORN: YOKOHAMA, JAPAN, 1943

'I have always liked asymmetry, both in design and in people,' said Yohji Yamamoto in 1990 – a statement that partly explains why the designer has always made clothes which are off kilter, question convention and kick-start the brain into overdrive.

Yamamoto's mother, a war widow, was forced to work as a dressmaker to provide for her only child. Yohji studied law at the University of Keio, but instead of pursuing a life of academia and legal wrangling, he switched to fashion, attending Bunka Fukuso Gakuin in Tokyo. He worked as a freelance designer before opening

his business, Y Company, in 1971. His early collections consisted of woven cottons and linens – deep armhole dresses with Oriental cutting and kimono detailing. Yamamoto's turning point came in 1981 when he showed in Paris and caused a furore within the press corps. His clothes were called 'Oblique Chic' and 'Japantheon' by *Vogue* in 1983, and described as the 'art of the unexpected, mis-shapen, mis-matched lava textures, more calculated disarray with knotting, tearing and slashing: the provocation of paint-bruised make-up and high-strung hair'. Yamamoto wraps and drapes the body in unstructured, voluminous garments, but is less extreme than Issey Miyake and more understandable than Comme des Garçons. Rarely called a fashion designer, Yamamoto is more likely to be given the elevated title of poet, intellectual or artist.

He is a believer in mystique, an explorer of the relationship between fabric and body, and a leader of the avant-garde.

With Belgian deconstructivists on the warpath, Yamamoto was momentarily written off as too serious – passé, even. Yet he had come full circle. Pioneering, astounding and experimenting, his avant-garde take thrilled spectators but wasn't out of step. 'I like the idea that there's no beginning and no end, only today,' he told *The Sunday Times* in 1990. 'And that's enough.'

BELOW **Catwalk bride: Jodie Kidd in a gargantuan silk crinoline dress, her oversized hat held aloft by bamboo poles, 1998.**

YUKI

BORN: GNYUKI TORIMARU, MIZKI-KEN, JAPAN, 1937

Master of drapery, Yuki is a Japanese minimalist working in England, who is best known for his refined, fluid, sculptural clothes. Originally trained as a textile engineer, Yuki was employed by an animation studio in Tokyo before moving to Britain in 1959 to learn English. He studied the history of architecture at the Art Institute of Chicago and then fashion at the London College of Fashion from where he graduated in 1966. Yuki worked with Louis Féraud, Michael Donellan and Norman Hartnell before spending three years in Paris with Pierre Cardin. He opened his own company in 1973 and presented his first collection to the Japanese in 1975.

Although he is best known for his dramatic, bias-cut eveningwear, frequently in silk jersey and designed to fall away from the body, Yuki has also produced swimwear and outerwear, often using soft jerseys, velvets and silk-jersey pleats. He has also designed costumes both for the theatre and television. Yuki enjoyed a renaissance when Diana, Princess of Wales diplomatically wore his dress for her state visit to

Japan for a dinner with Emperor Hirohito in 1986. The dress, constructed from perpendicular royal-blue pleating and embroidered at the neck and waist with blue bugle beads, raised over $25,000 at the Christie's sale in 1997.

In 1992 Yuki celebrated 20 years in fashion with a small retrospective at London's Victoria and Albert Museum.

ZORAN

BORN: BELGRADE, YUGOSLAVIA, 1947

Creator of designs that are precise, clean, balanced and pure, Zoran is a minimalist who uses a predominantly neutral palette of black, white, ivory and pale grey with the occasional touch of red. His pared-down style consists of luxurious, silky tunics and fluid trousers in sumptuous fabrics such as cashmere and velvet – practical, comfortable clothing with longevity. He cuts simple shapes and avoids, wherever possible, the use of buttons and zips and any unnecessary decoration. Each of his pieces carries a sky-high price tag and the assurance of minimalist status. It is a label that is worn by Isabella Rosselini, Lauren Hutton and a coterie of Hollywood purists. *Vanity Fair* called Zoran's signature collection, 'Gap for the very rich'.

Zoran graduated from the University of Belgrade with a degree in architecture and moved to New York in 1971. His first collection, designed around squares and rectangles and launched in 1977 on the cusp of disco and the precipice of punk, caused a sensation – extreme purity in a sea of safety pins. His relaxed and sophisticated look has a timeless quality. Today, he's still hot: 'He's at the very top,' Philip B Miller, chairman of New York department store, Saks Fifth Avenue, told *The New York Times* in 1999.

Exclusive and covetable, Zoran has resolutely kept to his original concept of working with a few capsule pieces, constructed from dimensions rather than drawings. He doesn't do drapery, bias-cutting or anything complex. In 1993 he told *The Sunday Times*: 'I hate long red nails. I don't like women who wear sunglasses indoors or high heels. Feathers belong on birds, not human beings.' In 1999 his annual sales were estimated at $25 million wholesale. Pure and simple.

LEFT **Yuki's 'softly softly silk', 1976, modelled by Jerry Hall; in cream jersey, the hem doubles up as a hood, the front is tucked at just the right point.**

OPPOSITE **Zoran's back to the future: his 'pure panache', 1986 white silk lamé, is cut in one piece and totally devoid of seams, with a single knot at the back.**

INDEX

Figures in italics indicate captions; those in bold indicate main references.

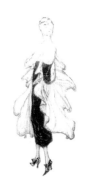

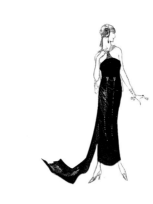

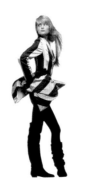
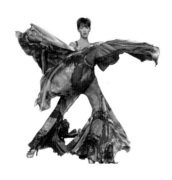
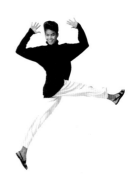

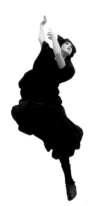

PICTURE CREDITS

The publishers would like to thank the following sources and The Condé Nast Publications for their kind permission to reproduce the pictures in this book:

t: top, b: bottom, l: left, r: right, tl: top left, tr: top right, bl: bottom left, br: bottom right, bc: bottom centre, bcl: bottom centre left, bcr: bottom centre right.

all images ©Vogue, The Condé Nast Publications Ltd.

American Press Association 20b
Antonio 154l
Tony Armstrong-Jones 46
Michel Arnaud 185, 195, 196, 217, 249
Clive Arrowsmith 63, 245, 253bcr

David Bailey 10bl, 55, 57br,tl, 61, 64b, 146t, 151, 215
Cecil Beaton 10cl, 34tr, 37, 38, 39, 40, 41, 156, 160–1, 223tr,bl
Maurice Beck & Helen Macgregor 27t, 138, 207tl
Edouard Benito 11cl, 26tr, 36
Christian Bérard 35, 177, 180
Eric Boman 67, 98, 178, 222
René Bouché 8, 49tr, 51t, 96, 112
Brad Branson 243

Regan Cameron 170, 184
Pierre Cardin 107
Oleg Cassini 108
Castaldi 139
Alex Chatelain 72, 74, 87tl, 99, 103, 130, 132, 252br
Willie Christie 97, 166–7
Henry Clarke 49bl, 52, 53, 56, 95, 125, 211, 149, 211, 250br
Clifford Coffin 7, 10c, 42tr, 43t,b, 44, 126

Corinne Day 9, 81
John Deakin 48
Patrick Demarchelier 73b, 75, 76, 80t, 87tr, 89, 175, 181, 218, 233, 253bcl
Anthony Denney 50, 256
Terence Donovan Archive 82, 229
Helen Dryden 10tl, 25
Brian Duffy 212

Rodger Duncan 240

Arthur Elgort 62, 73t, 83, 91, 159tl, 179, 242
Perry Ellis 131
Robert Erdmann 153, 172, 225
Carl Erickson 32tl, 34l, 42tl, 93, 204, 238
Lee Creelman Erickson 182

Hans Feurer 54, 92
Ann Fish 11cr, 29t

Oberto Gili 79
Ruth Sigrid Grafstrom 32b
Mats Gustaffson 146br

Michel Haddi 190, 252bl
Will Hammell 19
Anna Harvey 247
Don Honeyman 87bl, 173tl

Paul Iribe 17

Just Jaeckin 59
Mikael Jansson 110, 246

Donna Karan 164
Neil Kirk 122
Kelly Klein 105
Nick Knight 9, 86cr, 152, 174
Kim Knott 86tc, 124, 143
Eddy Kohli 86cl, 191

Andrew Lamb 80b, 84b, 87c, 158, 159br, 176, 192, 197, 230, 234, 235
Barry Lategan 64t, 66c, 69, 208, 248, 251br
Bruce Laurence 154r
Roger Law 58
Peter Lindbergh 77, 78, 128, 253bl

Andrew Macpherson 142, 236, 251bcr, 252bcl
Eamonn J McCabe 171
Frances McLaughlin-Gill 51b, 94
André Marty 31
Herbert Matter 86br, 134
Raymond Meier 102, 148, 254
Sheila Metzner 165
Baron Adolphe De Meyer 22br

David Montgomery 114, 115tl,br, 162, 251bcl
Tom Munro 85, 116, 186, 189, 209, 220, 237

Helmut Newton 109

Jacques Olivar 1, 3, 201, 241

Pablo & Delia 66
Norman Parkinson 90, 198
Penati 147tl, 251bl
Irving Penn 47
Douglas Pollard 27b, 188, 239
Antony Price 210

John Rawlings 183
Herb Ritts 71
Robert 11tr, 65
Richard Rutledge 45

St John 13
Yves Saint Laurent 219
Lothar Schmid 68, 199
David Sims 11br, 84t
Lord Snowdon 70
Bert Stern 200

Mario Testino 4–5, 87cr,bl, 113, 127, 145, 169, 231
Ronald Traeger 10br, 60tl,tr,b, 213

Valentino 232
Javier Vallhonrat 86tr,tl,bc, 135, 141, 163, 221
Marcel Vertès 6, 33
Justin de Villeneuve 100, 101
Tony Viramontes 144

Albert Watson 104, 155, 226, 253br
Martin Welch 202
Porter Woodruff 244, 250bcr

Every effort has been made to acknowledge correctly and contact the source and/copyright holder of each picture, and Carlton Books Limited apologizes for any unintentional errors or omissions which will be corrected in future editions of this book.

ACKNOWLEDGEMENTS

Very special thanks to Erika Frei for her encouragement
and advice on the fine art of tact and diplomacy.
To Joyce Douglas for being there.

Thank you to Vogue's superb library staff
– Darlene Maxwell, Chris Pipe, Nancy Kim, headed by
the brilliant Lisa Hodgkins – for their support, good humour
and company throughout this project.

Two people who were fundamental: endless thanks
to Francesca Harrison, picture editor, for being calm,
efficient and having a lovely eye. Emily Wheeler-Bennett,
Condé Nast's editorial business and rights director,
for being a complete professional and friend.

This book is dedicated to my mother, father and
brother Billy with love.